REFLECTIONS IN A GLASS EYE

REFLECTIONS IN A GLASS EYE

The acquisition, exhibition and publication of ICP's

permanent collections is intended to encourage and assist photographers

of all ages and nationalities who are vitally concerned with their world

and times, to find and help new talents to uncover and preserve

forgotten archives,

and to present such work to the public.

Cornell Capa
Founding Director Emeritus

Reflections in a Glass Eye

WORKS FROM THE INTERNATIONAL CENTER OF PHOTOGRAPHY COLLECTION

PREFACE BY
WILLIS E. HARTSHORN

ESSAYS BY
ANNE HOLLANDER, DIANE JOHNSON, ANN LAUTERBACH,
AND CHARLES SIMIC

INTRODUCTION BY
ELLEN HANDY

A BULFINCH PRESS BOOK
LITTLE, BROWN AND COMPANY · BOSTON NEW YORK LONDON
IN ASSOCIATION WITH THE INTERNATIONAL CENTER OF PHOTOGRAPHY, NEW YORK

This book was developed, prepared, and produced by Constance Sullivan Editions

Designed by Katy Homans
Duotone separations by Robert Hennessey
Photographs selected and sequenced by Ellen Handy and Constance Sullivan

First edition

ISBN 0-8212-2625-8
Library of Congress Catalog Card Number: 99-64187

Bulfinch Press is an imprint and trademark of Little, Brown and Company (Inc.)

Printed and bound by L.E.G.O., Vicenza, Italy
Color separations by Job Color, Bergamo, Italy

Contents

Acknowledgments

WILLIS E. HARTSHORN
Director

This publication marks the twenty-fifth anniversary of the International Center of Photography, and with it we celebrate both photography and this institution. Among the most important contributors to this book are those who have contributed to the growth of the museum's collection, and helped to define its shape during the past quarter century. My most profound thanks go to Cornell Capa who founded the institution and nurtured it and its collection for over twenty-five years. It has been my pleasure to have worked with him in many capacities since 1982, and I am grateful for his continued support of the institution and his trust in the staff and its leadership.

Many members of ICP's Board of Trustees have also played exemplary roles in the growth of the institution, as have the members of the Acquisitions Committee, whose continuing work it is to fund purchases and select works for the collection. Very special thanks go to Lois Zenkel, Anne Ehrenkranz, and Anne Fisher, who have been among the most devoted friends of ICP's collection to date.

Special acknowledgment is also due to Miles Barth, the first curator of ICP's collection, who for nearly twenty years successfully oversaw its growth and care. Connie Sullivan and Ellen Handy worked diligently together in producing this book, and are responsible for its unique character. Their professionalism and enthusiasm have informed the quality of this publication. To each of these people, and to all the others whose efforts have contributed to the success of this volume, I extend warm thanks.

Acknowledgments

ELLEN HANDY
Curator

Any book of this scale is necessarily the work of a large number of individuals, and this one required unusual effort and devotion from all who participated in the process. Space does not permit me to mention here everyone who contributed to the project individually, but sincere thanks go to all who aided in the many phases of bringing it to completion. In particular, the enthusiasm and teamwork of ICP staff in many departments made this book possible.

Greatest thanks go to the donors of photographs whose generosity has built ICP's collection and thus allowed this book to present so diverse a view of photography. ICP has been fortunate in its friends throughout its history, and we gladly acknowledge them here. Very special thanks are due to the photographers, families and representatives of photographers, and archive staff members who graciously granted permission to reproduce pictures and who assisted with research queries. Their patience and good will were remarkable, and are greatly appreciated.

Among those who have been most generous with their time and knowledge in the research for this project are Miles Barth, the first curator of ICP's collection, who acquired many of the works reproduced here and who answered innumerable questions, and Anna Winand, Steve Rooney, Ann Doherty, and Phil Block, all of ICP. We cannot thank sufficiently Cornell Capa, whose salutary skepticism about every aspect of the publication improved it considerably, but we can say that the book is a tribute to his spirit. Thanks, too, to Edith Capa, who shared in several long discussions with interest and kindness. This book owes its life to ICP's director, Willis Hartshorn, whose decision it was to commemorate the institution's twenty-fifth anniversary with a publication, and who has thoughtfully shepherded the project through every stage.

Members of ICP's Exhibitions Department have played important roles in preparing this volume: Cynthia Fredette managed the complex early phases of picture selection with great care, and contributed photographers' biographies; John McIntyre researched and wrote the captions, contributed to the biographical entries, and coordinated the project on a day-to-day basis with unfailing good cheer; Laura Latman punctiliously managed the movement of prints in and out of the museum for reproduction; Edward Earle provided support in many ways as the book took form; Ann Sass performed valuable caption research; and Helaine Posner warmly gave crucial assistance in the early planning phases. During the months when the book was in process,

numerous ICP interns aided in tasks large and small. Among them are Jenny Salomon, Channing Burt, Katie DeWitt, Kate Ruggiero, and Danielle Motelow.

Everyone involved in the production of this volume has done outstanding work, often under great time pressure. Adam Eidelberg, Lisa Martin, and David van der Steen prepared transparencies for the color reproductions with great professionalism and patience. Robert Hennessey, an acknowledged master of his craft, made the duotone separations skillfully and sensitively. Katy Homans designed a graceful and effective presentation for complicated material, working quickly and with assurance. Carol Judy Leslie and her staff at Bulfinch Press have embraced the project with enthusiasm and open minds, and proved sympathetic partners.

Abundant thanks are due also to the distinguished writers who contributed texts: Charles Simic, Anne Hollander, Diane Johnson, and Ann Lauterbach have greatly enhanced this volume with their eloquent and particular insights. Their presence honors us, and engages memorably with the richness of the photography. A team of diligent biographical researchers compiled the photographers' entries thoughtfully and thoroughly. In addition to members of the ICP staff mentioned above, the team includes Lisa Hostetler, Meredith Fisher, and Lisa Soccio. Mary Panzer, a very good friend to ICP, generously read an early version of my essay and provided illuminating comments. Therese Mulligan, also a good colleague from another institution, offered wise counsel and valuable encouragement over many months.

Final thanks go to Connie Sullivan, our partner in creating this book. Her expertise, energy, and care are responsible for bringing it into being, and her elegant, original and always insightful vision of photography is highly refreshing. From our dialogue about sequencing images to her capable management of production of the book, she has been an ideal collaborator. Her love of pictures is equaled only by her love of books, and her faith in the possibility of the impossible is a constant inspiration.

Preface

WILLIS E. HARTSHORN
Director

Much can be learned about a museum through its collection, for it is the physical manifestation of what the institution values and considers worthy of preserving. The selection of photographs here may be unexpected to those who know ICP for its commitment to photojournalism and documentary photography. While such work forms the foundation of the collection and runs through the book, ICP's holdings reflect the diversity of photography, and its many roles: as a medium of aesthetic expression, a tool for scientific or historical research, a repository for personal experience and memory, and an agent of social change and commercial practice. The embrace of photography in all of its applications has been central to ICP's mission and has actively defined its programs and its collection.

For twenty-five years ICP has been quietly collecting photographs. Being a young institution with limited resources, it has depended for many of its acquisitions on the resourcefulness of staff and the generosity of photographers, friends, and patrons. No patron has been more generous to the museum than its founder, Cornell Capa. The collection began with works he acquired through the International Fund for Concerned Photography, an organization he created to preserve and interpret photojournalism, which was the predecessor to ICP. Capa's vision is apparent throughout the collection and testifies to his many years of work in the service of photographers and photography. The museum is indebted also to Miles Barth, the first curator of the collection, who for nineteen years oversaw its development and organized many important exhibitions with works drawn from the collection. The efforts of these two men have had the greatest impact in shaping the content of the collection and in expanding it to its more than 45,000 pictures.

The cornerstone of the collection is the promised gift made by Cornell Capa of his archive and that of his brother Robert. Complementing this are the archives of Roman Vishniac, given by his daughter Mara Vishniac Kohn and of Weegee (Arthur Fellig), bequeathed by Wilma Wilcox. An important group of pictures amassed by an individual and donated to the museum is the Daniel Cowin Collection, which consists of some 3,000 photographs chronicling African-American life from the 1860's to the 1940's.

Reflections in a Glass Eye is the first book to be drawn from the full range of ICP's collection. ICP curator Ellen Handy and Constance Sullivan have been critical to the conception and development of the book. Rather than a traditional guide, whose structure would reflect the relative size of holdings in specific areas or periods, this is a book about pictures and the pleasures of seeing. In showing one image by each photographer represented, we have included as many photographers as possible. In many cases we have selected a lesser-known image by a given photographer, over a more familiar signature image. It is our hope that this is a volume full of surprises, one that reminds those who know photography well why they care about it, and that excites in the novice a desire to see and learn more.

The Anatomy, Philosophy, and History of a Collection of Photographs

ELLEN HANDY
Curator

To collect photographs is to
collect the world.
SUSAN SONTAG [1]

The mission of photography is to explain
man to man, and each man to himself.
CORNELL CAPA, quoting
EDWARD STEICHEN [2]

Photography is the most transparent of
the art mediums devised or discovered
by man. It is probably for this reason
that it proves so difficult to make the
photograph transcend its almost inevitable
function as document and act as work of art
as well. But we do have evidence that the
two functions are compatible.
CLEMENT GREENBERG [3]

[The camera's] inherent ability to
transcribe external reality gives it
documentary validity—it is, seemingly,
both accurate and unbiased.
More than any other medium,
photography is able to express the values of
the dominant social class and to interpret
events from that class's point of view, for
photography, although strictly linked with
nature, has only an illusory objectivity.
GISÈLE FREUND [4]

Collectors of Roman coins or Impressionist
paintings know the satisfaction and despair
that come with the realization that their tasks
might, at least in theory, be finally
completed. . . . The collecting of
photographs is a different and riskier sort
of search, filled with mysteries and
contradictions and unexpected adventures.
Even photography's eternal verities are
provisional, and its future is as unpredictable
as that of any other living species.
JOHN SZARKOWSKI [5]

This book [*A Book of Photographs from the
Collection of Sam Wagstaff*] is about pleasure,
the pleasure of looking
and the pleasure of seeing,
like watching people dancing through an open
window. They seem a little mad at first,
until you realize they hear the song
that you are watching.
SAM WAGSTAFF [5]

Above all, photography is the art of seeing, which offers us ways to view the world through eyes other than our own. This is a book about photography and therefore about seeing. The act of vision is better captured through photography than any other medium, and its surpassing diversity renders it the instrument of infinitely varied visions. A book of photographs by different makers brings these many visions together—it may have even more eyes than watchful Argus of Greek myth. The selection of pictures here ranges from the familiar to the unexpected, and often juxtaposes these extremes closely. Linking photographs never before seen together in this manner stimulates them to tell us new truths about themselves, about one another, and about the wide world before us. In this case, they are also revelations about the collection of the International Center of Photography.

By their very existence, museum photography collections pose the question "What is photography?" and each answers it differently. ICP's collection began with the work of a number of noted photojournalists, many of whom were members of the Magnum photo agency. Strength in photojournalism and documentary photography remains an essential foundation of the now rapidly evolving collection. These core holdings have been joined by examples of many photographic genres, and this compendium of images presents the collection in its widest scope. Thus, in these pages, great photographs in the documentary tradition meet striking images of other types in picture sequences that explore the common ground of all photography. These conjunctions affirm the medium's rich embrace of the world through varied human experience. Photography can tell the truth, tell lies, tell stories, evoke empathy, and enter the historic record. It concentrates and elaborates; it can be brutally direct or elegantly circumspect. It exercises the mind, the heart, and the eye. Looking at pictures allows us to engage with the world, to escape it, and to reinvent it.

The collection of photographs at ICP has grown to include more than 45,000 works to date, many more than can be meaningfully represented in a single volume. Photography is a house of many mansions, and like it, ICP's collection is a dwelling of many rooms, including extensive archives of individual photographers' work. This volume presents but a single work by each photographer selected, regardless of his or her representation in the collection; it assembles a chorus of many voices, each of different timbre, which

derives its power from their variety. Although conceived as an institution with a very specific focus, ICP has always embraced a generous, open notion of photography, and this book shows how that fundamentally democratic view of the medium is evident in the collection.

All photographs partake of a profound intimacy with the real world, though some claim the name of art and others that of reportage, historical evidence, advertising persuasion, personal witness, fiction, or abstraction. As Susan Sontag has observed, through assembled photographs we own the world—not merely in symbolic possession of terrain, but also through the imaginative claiming of experience, ideas, and visions we may find in photographs. Photographs can give us ourselves as well as the external world. By perusing a collection of photographs, we may find that we come to own our histories and a panoply of emotions, dreams and fantasies. Although photographs are made both with and without cameras, an inevitable trope is that of the camera lens scrutinizing an indubitably real, objective world—the world reflected and inflected in what Clement Greenberg called "the camera's glass eye".

In 1946, Greenberg argued that photography's unique talent and responsibility was to depict the world in recognizable terms: "Photography is the only art that can still afford to be naturalistic and that, in fact, achieves its maximum effect through naturalism." [7] But as Gisèle Freund wisely warned, that objectivity is illusory; the camera always expresses values at the same time it records information. Her insight about the relationship between photography and power is simply the obverse of another truth about the medium: that it may effectively be used as a tool for shaping public opinion and inciting social change. ICP's promotion of social activism through photography means that it endorses the association of the photograph with temporal, as well as aesthetic, power.

Cornell Capa, ICP's founder and now its Director Emeritus, coined the term "concerned photography" to describe philosophically engagé documentary photography committed to the values of classical humanism. The heart of the museum's collection is the work bequeathed to ICP by its predecessor, Capa's International Fund for Concerned Photography, which circulated traveling exhibitions and published books before ICP evolved to provide a permanent home for the Fund's activities. Two such exhibitions and books—*The Concerned Photographer* (1967) and *The Concerned Photographer 2* (1972)—presented the work of Werner Bischof, Robert Capa, Leonard Freed, André Kertész, Chim (David

Seymour) and Dan Weiner; and Marc Riboud, Roman Vishniac, Bruce Davidson, Gordon Parks, Ernst Haas, Hiroshi Hamaya, Don McCullin, and W. Eugene Smith respectively. [8]

Like one of his predecessors among photography's crusaders, Alfred Stieglitz, Cornell Capa has devoted himself with sustained passion to raising public awareness of the significance of the medium. But while Stieglitz created a commercial gallery, a journal, and a loose association of photographic artists as the institutional frame for his efforts, Capa has created a museum and school as well as numerous books. While Stieglitz's mission was to establish the parity of photography with the other arts, Capa's struggle has been to win comparable respect for journalistic photography and documentary work, securing for both the attention of posterity and the preservation of key images in archives and publications at ICP and beyond. While none of Stieglitz's institutions lasted throughout his lifetime, ICP is poised to remain responsive to a changing world. Both Stieglitz and Capa were brilliantly successful in their self-appointed tasks, and have compelled the attention of enthusiastic audiences for numerous distinguished photographers whose work they promoted. Capa's vision endures not just at ICP, but around the world, where it has been adopted by numerous museums that today present exhibitions of photographic reportage with as much respect as they do those of other arts.

Photography's indexical relation to reality makes documentary photography the richest of its manifestations. Through its allegiance to documentary practice, ICP is exceptional among photography museums for the degree of its commitment to the idea of a real world ready to be photographed. The world explored in the many individual works within ICP's collection is an imperfect place, and the tradition of partisan photographic humanism is one that assumes the world's evils may be alleviated through the work of dedicated photographers. Photography's stake in social change makes a very different point of origin for a collection from that of most museums, and unsurprisingly, ICP's collection differs considerably from many other museum collections of comparable age. How then does photography as a medium look when seen through a collection that puts documentary and not fine art at its center, and sets all else in relation to it?

Works of photojournalism were not initially considered museum objects or indeed as objects at all—rather, they functioned as vehicles for images, mere earthly bodies of transcendent souls. Photojournalism is a curiously dematerialized practice, in which images without physical definition, images without objects, are transmitted to mass audiences. Yet they come to rest in the ICP collection in forms as varied as magazine issues and tear sheets, rough work prints and contact sheets, and exhibition prints made for diverse purposes. In the Robert Capa Archive at ICP, for instance, there are 937 master prints made between 1990 and 1992 under the direction of Cornell Capa and Richard Whelan (Robert Capa's biographer and the consulting curator to the Archive), who selected these key images and had them printed in a uniform edition. Many do not exist outside the edition as prints. Also in the Archive are negatives, volumes of contact sheets, older prints, and—an important recent acquisition—a working notebook of contact prints from Robert Capa's work in China in 1938 assembled for use in the photographer's studio by Cornell Capa, his brother and at that time his assistant. Making a museum home for these works raises questions that do not arise from collections comprised primarily of fine art works, or from the presence of photographs in the marketplace.

At just the moment when photography's fine art status was being widely confirmed by unprecedented success in the marketplace, and the medium found itself increasingly institutionalized in the nation's art museums, ICP was established with a different vision. Its emergence diversified what otherwise would have been simply the story of the acceptance of the poor stepchild medium by the art establishment. ICP's promotion of the idea that photography's importance did not necessarily depend upon its art status or the commercial value of images separated it from the fine art photography boom, yet ICP has always kept one foot in the fine arts camp also. The ultimate significance of "concerned photography" lies in its dedication to unchanging human values, but such values are often conveyed in photographs from the fine art tradition as well as in the works of committed photojournalism—hence the presence of photographs of every description in ICP's collection. These images may assume subtle alterations in meaning through their presence here rather than in other, more one-sided collections.

A Brief History of the Collection

The International Center of Photography's holdings are a treasure trove for those who seek the immediacy of photography's rendering of the world. ICP's openness to diverse modes of viewing and depicting the world makes for an assemblage of instructively irreconcilable differences. The collection comprises many sub-collections, chief among them are the Robert Capa, Cornell Capa, and the Weegee Archives; major holdings of the work of Roman Vishniac, Chim (David Seymour), Lisette Model, and Henri Cartier-Bresson; the Daniel Cowin collection of images of African-American life; the print collection and personal papers of the critic Jacob Deschin; the prints and documents of Ivan Dmitri's Photography in the Fine Arts exhibition organization; and the W. Eugene Smith Legacy Collection. These large bodies of material are augmented by growing holdings in fashion and advertising photography, contemporary documentary work, and contemporary fine art photography, and numerous single works or smaller groups of work by individual photographers of all descriptions. The collection is strongest in its holdings of American and European reportage and documentation of the 1930s through the 1950s.

Protecting and promoting the work of photographers who might otherwise be forgotten was a central goal in Cornell Capa's creation of ICP. As he told the writer Jay Jacobs in a 1974 interview:

In 1954, my brother Robert and Werner Bischof were killed. David Seymour died at Suez in '56, and all three of them left their work behind in an interrupted state. While doing the work, you know, you don't prepare it for posterity. I was suddenly confronted with what amounted to forty or fifty years of work by these three great men. They made thousands—hundreds of thousands—of images, but who knows their work aside from magazine readers who see only an infinitesimal part of it that just happens to fit some art director's layout? ... When my brother died, after spending and losing his life in pursuit of a testimony of what happens to mankind, that testimony was not realized. Instead, it's in danger of melting away. [9]

ICP was founded to commemorate the heroism of great practitioners of photo-reportage, not so much as a memorial to the dead or a mausoleum entombing their work, but rather as a vibrant center consecrated to photographers and the living significance of their work. Although ICP was born in the image of Capa's dynamic vision, it has assumed a life of its own.

In recent years, and under the leadership of its second Director, Willis Hartshorn, ICP has been prompted to expand into a more rounded form while maintaining its allegiance to the founding traditions. This phase is marked by a thoughtful pluralism which recognizes the legacy ICP has built for itself with its exhibitions and programs. The collection grows in response to the museum's own varied history, and accordingly postmodern contemporary art practice and fashion photography find their places alongside the masterworks of "concerned photography." Establishing points of connection between seemingly disparate forms of photographic practice is the central challenge for ICP's collection in this phase. Although this essay sketches the outlines of ICP's collection, and briefly chronicles its evolution during its first twenty-five years, the overall purpose of this book is to explore pictures as pictures, set free in manifestation of the variety of the photographic medium.

ICP's commitment to documentary photography and photojournalism has flourished in tandem with its democratic, inclusive view of photography, which accepts the many facets and uses of the medium, and is the direct result of its founder's early policies. In an affectionate history of ICP, "An Improbable Dream in the Real World", Vicki Goldberg describes Cornell Capa's "stubborn resistance to and astonishing tolerance of imagery he did not necessarily appreciate." [10] The collection expresses the generous vision of photography that is ICP's hallmark, and which grows directly from Capa's acceptance of often very unfamiliar work despite his very European skepticism about much of it.

Today, the collection serves ICP's curatorial staff and the staffs of other museums preparing exhibitions and publications, as well as visiting scholars, researchers, and students. First developed and managed by Cornell Capa, the collection came of age under the careful stewardship of Miles Barth, who for nearly twenty years presided over the burgeoning collection, and organized many exhibitions drawn from it. He initiated ICP's first attempts at collections management, moved the museum's holdings to their first purpose-built home at the present ICP Midtown facility in 1991, presided over the designation of a gallery for the display of the collection in the same year, and oversaw the acquisition of many important bodies of work. For much of its history, he was the voice of the collection.

Appointed in 1980 with funding from an Andrew W. Mellon Foundation grant, Barth initially cared for about 3,000 works by about 100 photographers. By the time of the collection's move to ICP Midtown, it had grown to some 12,000 photographs, by more than 700 photographers. Important acquisitions of those years included the Photography in the Fine Arts collection of more than 700 prints broadly surveying the fine art, advertising and reportorial photography of the 1960s and commemorating Ivan Dmitri's ambitious series of traveling exhibitions (1959-1967) which arrived at ICP in 1980; a complete run of Stieglitz's magazine *Camera Work* (1903-1917), the most beautiful photographic periodical published, given by Daniel, Richard, and Jonathan Logan in 1984; and the rich resource of the Daniel Cowin collection of approximately 2,000 images of African-American life, which broadly survey the depiction of African-Americans from about 1860 to the 1940s, through studio portraits, family snapshots and repugnant but historically significant racist representations, as well as commercial images, donated in 1992.

The ICP Purchase Fund was inaugurated in 1982, and among its initial acquisitions were groups of prints by Weegee, Jacob Riis, and Lucien Aigner. In 1992, as a culmination of ICP's founding mission, the Robert Capa Archive was established, with the 937 master prints, some 2,500 earlier prints, as well as negatives, correspondence, and contact sheets on loan from Cornell Capa. Two years later, this archive was joined by another, when Wilma Wilcox bequeathed the Weegee Archive, consisting of some 13,000 of the celebrated tabloid news photographer's prints, perhaps 7,000 negatives, and numerous papers and films. The growing W. Eugene Smith Legacy Collection consists of bodies of photographs donated by winners of the W. Eugene Smith Fund annual awards, among them Donna Ferrato, Gilles Peress, and Eugene Richards, whose work perpetuates Smith's legacy of compassionate photographic reportage. This collection is owned jointly by ICP and the Smith Fund. Presently ICP's collection grows most abundantly through donation, and through purchases made with funds donated by the active Acquisitions Committee, whose members are the most important supporters of the collection. The Committee has sponsored extensive acquisitions in the past several years, with particular strength in fashion photography and contemporary work of various types. Many special friends of ICP made remarkable contributions to the collection during its early years, among whom Lois Zenkel and Anne and Joel Ehrenkranz are particularly prominent for their numerous and varied donations of work that has been crucial to the development of the collection.

Collections and Museums

As John Szarkowski wrote in 1973, collecting photographs involves a risky search, one filled with contradictions. His description of its "provisional" verities recalls Walt Whitman: "Do I contradict myself? Very well then; I contradict myself, (I am large, I contain multitudes.)" Taking the long view of the evolution of the medium, whose canon has been formed so rapidly, often around Szarkowski's own pronouncements, his essay ends with the thought that the future of photography lies with as yet unborn photographers. ICP's collection differs in many particulars from those of institutions more closely associated with the reifying process of designating canonical photographic masters, and from those of institutions whose photographic collecting practices are closely modeled on the connoisseurship of old-world print cabinets. At ICP, for example, later prints of images by the great twentieth-century photographers considerably outnumber those in collections that hierarchically distinguish between prints roughly contemporary with their negatives (so-called vintage prints) and other prints from the same negatives. ICP's collection is characterized also by numerous enlarged exhibition prints of images first presented in much smaller scale on the magazine page rather than seen in exhibitions of any description. Yet these differences may seem of little moment after another century, when those as yet unborn photographers may necessitate a reevaluation of the relations among those photographers we know today.

Museum collections may be seen as hoards of precious objects or networks of images and meanings; they are certainly evidence of a museum's fundamental identity: the outward and visible sign of the institution's values, desires, insights and shortsightedness. In its first decade, ICP was often too busy establishing itself and maintaining a breakneck exhibition schedule to spare much attention for the collection, quietly growing along side the exhibition and education programs. During the 1980s, however, ICP matured as a museum and recognized the central position of the collection at the heart of the institution.

When Miles Barth was appointed curator of collections, Cornell Capa noted that "the acquisition, exhibition and publication of ICP's permanent collections is intended to encourage and assist photographers of all ages and nationalities who are vitally concerned with their world and times, to find and help new talents, to uncover and preserve forgotten archives, and to present such work to the public." [11] Under Willis Hartshorn's directorship, ICP has increasingly promoted and cherished its collections, and begun to plan for their further development. This growing attention coincides

with a period of expansion and consolidation of ICP's vision of photography, and its embrace of the fullest range of the medium—tendencies that are increasingly reflected in the collection itself.

The photographs in this book were chosen from a collection large enough to resist description in simple terms. Each choice of picture makes many declarations—and more significant, every choice precluded many other possibilities. Much important work that reposes in ICP's collection is not to be found here, while some works included are unique examples of their type or of their maker's work within the collection. Not a history of photography or a diagram of ICP's holdings, but an affectionate evocation of photography's multiplicity, the book includes some pictures chosen in the belief that a photograph need not be a conventional masterpiece to compel our interest. Indeed, much of the appeal of photography lies in its unpretentious, improvisational ways and its presence in parts of our daily life where works of art are not typically found. What does this cross-section of the collection say about ICP? And what does it say about how this institution envisions the medium to which it is dedicated? As the canons of this young medium become fixed, it is salutary to redefine it. New touchstones emerge as preconceptions are interrupted and pictures are linked through subjective rather than historical or art historical contextualization.

In assembling a book about his own photographic collection, the gifted photographic connoisseur Sam Wagstaff suggested that such an assembly of photographs is inevitably about pleasure. ICP's very differently conceived collection explores many pleasures, but it also brings to mind the concept of *possibility*. Documentary and journalistic photography are the languages that most effectively limn the scope of possibilities in the world at large. Between pleasures and possibilities, between the sheer delights of images and the demands of the real world, ICP's collection—and its view of the photographic medium—are situated. Though an individual may well gather photographs as a hymn in praise of pleasure, institutions normally collect with a much wider mandate. Encompassing pain and trouble as well as pleasure, ambivalence and ambiguity as well as affirmation, fear and danger as well as triumph and celebration, is all in the job of a collection that follows Edward Steichen's prescription for photography to explain "man to man, and each man to himself."

Anatomy of a Picture Book

Pictures in sequences, like beads on a string, acquire nuances from their position and arrangement. Their glittering allure immediately suggests other patterns, while the thread linking them holds them in a single formation, however often they are imagined in new sequences. In this book, nine strings of pictures appear, constituting loosely thematic groups. Some of the photographs fit their categories overtly; others depart from them deliberately. Familiar themes find renewal in unexpected applications, and rather than represent each photographer's oeuvre, this selection invokes relationships among pictures. Between several of these suites of photographs are short texts that mark pauses in the pictorial order, something like entr'acte diversions in the theater. They maintain an autonomy from the sequences of pictures they separate, neither text nor pictures illustrating the other. If the nine strands of pictorial grouping were to be named, they might be described thus: pictures about seeing; still lifes and body fragments; style and fashion; interiors; cities and urban encounters; landscapes; war and disaster; everyday life; and portraits.

About Seeing

Photography is the codification of vision. Like the eye, the camera is a tool for viewing and recording the world in its infinite variety. Many photographers have made pictures that address this act of seeing, the very properties of photography itself, and the ways in which the world composes itself before the scrutiny of the camera's eye. Harry Callahan's *Collages* is such a picture, studiously constructed from fragments of other images, reassembled in an extravagant array that calls on the viewer to devise new ways of taking in an image in detail and as a whole.

Photography's characteristic tactics and methods include the magic of the close-up and of precise alignments of objects within the frame; the reduction of the world to graphic tones of black and white, or its proclamation in vivid color; the ability to stop time and transfix motion; and revelations of the intensity and mystery of individual lives. These are employed to show us life and death, what we fear and what we love, who we are and who we might have been, what we know and what we imagine. Photography scrutinizes the strangeness of ordinary things we normally overlook, observing humor, harmony and irony in transitory experience. In Ernst Haas's photograph of a London street market, reflections of the wider world are framed, one marked as "perfect," so that the image becomes a literal rendering of the medium's metaphoric abilities. Like Marc Riboud's view through a Chinese shop front, Werner

Bischof's meditation on worlds within worlds encapsulating Japanese paper flowers, and the vista of pies tidily displayed behind glass in Berenice Abbott's photograph of an Automat cafeteria, Haas's image offers several discrete visions of the world from which to choose.

Still Lifes and Body Fragments

Among the first photographs made were a great preponderance of still lifes. Technical limitations of early photography meant that objects might pose for the camera's slow stare more comfortably than people, who were apt to flinch or otherwise disrupt the stillness required for a successful exposure. Still lifes arranged for and rendered by the camera synthesize the potency of scrutiny and the mute poetry of objects. While some still lifes display treasures for vicarious consumption, others are constructed of metaphor and association: Dorothy Norman's tender image of absence and desire, for instance, which poses a photograph by her lover and teacher, Alfred Stieglitz, with a telephone, which has the look of silence in the face of long waiting.

In a bakery window neatly stacked with breads, jelly rolls, and marble cakes, the photographer's eye framed a succinct image of pleasures both sensual and innocent—an allegory of the sense of taste. Nathan Lerner invoked all the deliciousness in the world in this humble pile of pastries. All the rewards of learning and the wisdom of the world are similarly portrayed in Roman Vishniac's haunting picture of the books of Rabbi Hayyim Eleazar Shapira, which lean and tilt against one another in complicated irregularity, like a crowd of tired people with arms around one another's shoulders. The battered fragility of the books suggests their long service and preciousness to their owner. Their compositional similarity to the delicacies in Lerner's photograph recalls the traditional Jewish belief in the sweetness of education, expressed through several customs linking the words of the Torah with honey and other sweets, so as to develop children's associations of learning and sustaining pleasure.

The French tongue candidly renders "still life" as *nature morte*: literally "dead nature." This term reminds us of the origins of the genre, in which trophies of the hunt were as likely to be depicted as fast-fading flowers and fruits. Human bodies, however, are typically excluded from still life. Yet every rule elicits its own exceptions, and any number of bodies have crept into this grouping of photographic still lifes. The serene pleasures of objects arranged for the viewer's inspection give way to more disquieting sensations when traditional still life and anatomical fragments merge. These unconventional still lifes traffic in perversity

and anxiety, and produce a curious role reversal with the increasing animation of objects, and the corresponding rendering of bodies as static entities. Andrew Savulich's photograph makes a wrecked vehicle's twisted metal appear more animate than any possible survivor, while Hansel Mieth's image of a trapped predator expresses a frenzy of immobility: raging animal as stilled life.

Style and Fashion

Style is more than the sum of the products of the fashion industry; it is an attitude, a combination of factors, a way of responding to the world. The ebullient Cuban lady photographed by Clemens Kalischer in the 1940s might well have raised the eyebrows of the couturiers of her day through her lack of conventional fashion sense, but she projects superbly confident style. The triumph of verve over the dress designers' taste is a victory of life and personality over convention. The fashion industry has for generations promoted style in constantly varying guises—a process that may be paralleled, bettered, or subverted by the actions of individuals.

Like all advertising, fashion photography must wield a powerful associative influence upon the public's often inchoate desires. Seduction and fantasy are forces to be harnessed in all commercial visualizations of commodities, whether fashion or generic product shots. Photographs from the heroic decades of fashion photography (1920s-1950s) rely on the authority of elegance to convey their messages, and their superb management of this idiom has shaped our worldview. We can find equivalent beauty in the works of photographers situated far from the rarefied world of fashion photography: style in still life as well as fashion, Ruth Bernhard's elegant deployment of life savers or in the statuesque form of Hiroshi Hamaya's mud-plastered worker in a rice paddy. The same qualities emerge in images of performers and performances where spectacle renders life as form.

Photographic images of fashion normally construe it as the play of fantasies and desires, rather than as an industry that disseminates and hawks its products in a real world. Yet the suppressed aspects of this process are equally significant. Jeff Wall's carefully constructed factory tableau and Lauren Greenfield's casual depiction of pre-teen girls in formal dress remind us that sweatshops and conspicuous consumption both are part of the larger picture of fashion—and that postmodern practices in the fine arts and projects of social documentation are additional means for examining illusions of glamour and the modes of its production and consumption.

Interiors

Within rooms, enclosed spaces, and interiors, moments of heightened intensity or enduring contemplation unfold without diminution. In Nell Dorr's photograph, a tenebrous interior relieved by a flaring light is the setting for what might be an opera performed in a dream, or for a reverie about the indeterminacy of life. Such pictures involve emotion sequestered and excluded from the public sphere. Scenarios of inevitability rather than chance play themselves out, and character is seen as definite, precise and apprehensible. Among these photographs are some, like Dorr's, which speak of a continual present; still others pertain to distinct culminations. These compressions of experience within architectural frames, and the enclosures of encounters in rooms, create metaphors for identities.

Photographs of interiors are transformations of spaces; pictured scenes can look very different from their quotidian reality. Donna Ferrato's and Tina Barney's domestic interiors surround highly dissimilar encounters, but both violence and ennui pose dangers not always evident from the outside. In Erich Salomon's picture of the British prime minister J. Ramsay MacDonald speaking at a formal dinner, we see within an elite setting the intersection of a public man and history, while in an interior from the "Harlem Document," Aaron Siskind's artistry erases any trace of his encounter with the subject. In gazing at her, we almost believe that it is we who have the experience of watching a woman who, paradoxically, is completely alone. The rooms where these pictures occur, like photographic frames, are containers for moments, in which the minister's speech and the Harlem woman's inspection of her icebox are presented with equal respect.

Cities and Urban Encounters

The city affords the ultimate symbol of twentieth-century life. It is a place of possibility, where modernity defines itself through the frequency and intensity of chance encounters in the streets. Buildings, people, and moments, shadow and substance, the tangible and the ineffable, motion and stillness, distance and intimacy outline the syncopation and dynamic instability of urban life. Brassaï's magisterial view of the city of Chartres is more like those made by the great nineteenth century French photographers of cathedrals than it is like Brassaï's typical Parisian photographs. It establishes the city as an arena framed by architecture, which we view from above before plunging into its midst.

The density of experience gathered in cities is an unparalleled gift to photographers who find that abstraction may be generated through urban

architectural forms. Like so many others, Ilse Bing made of stately Paris material for non-objective patterning, while André Kertész extracted a taut modernist abstraction from an anachronistic horse-cart's passage through an intersection in a French provincial town. Such pictures depend almost entirely on the synchronicity of modern pictorial thinking and the invention of the 35-millimeter camera, and scarcely at all on the actual properties of the cities portrayed. The semi-Constructivist city as abstraction is countered by the city as repository of mystery, an idea which draws closer to the precincts of surrealism. There, night brings the saturation of darkness with atmosphere, while the allure of adventure and danger marks the kinship among all cities in their secret lives.

Landscapes

When even the delirious modern metropolis of twentieth-century photography palls, the landscape offers refuge. Leaving the city, we encounter a flock of sheep grazing amid the prehistoric standing stones of Avebury in Wiltshire—Bill Brandt's thick layering of nature, culture, and antiquity. Landscape photography today has become largely the portrayal of the exotic, as we find ourselves visiting landscapes rather than living or working in them, but for Brandt nature and habitation balanced readily. The contemporary unfamiliarity of landscape can confer a fascination on even straightforward views of unspectacular terrain. Landscape images in the ICP's collection tend to suggest the provisional place of nature in contemporary culture, a circumstance that makes nature all the more precious.

Shi-Ming Tsay's photograph of a vast flock of ducks pouring across a flat plain is an exercise in shifting perspective, not unlike European urban images of the 1920s and 1930s. Animated by this seething mass of fowl, the quasi-abstract landscape is seen from a remote, elevated vantage point. By contrast, Robert Adams's photograph of a modest drift of leaves across an empty highway indirectly indicates the presence of mankind in nature and conveys the landscape in a scale comprehensible to the human eye. Though the term landscape may connote the majestic sweep of terrain seen from a distance, it can encompass the sphere of intimate detail as well. In such close nature studies, the earth renders up still life subjects already composed for the camera's eye. These images often lack the suggestion of timeless order in nature characteristic of landscapes on the larger scale, and depict nature as fragile and provisional.

War and Disaster

War, death, famine, strife, misfortune and disaster are central to the practice of photojournalism because they are the stuff of which news is made. They are also subjects that have attracted artists for centuries. The task of bearing witness takes many forms, and photojournalism cannot be absolutely separated from fine art. Not for nothing do connoisseurs claim exceptional images made by working photojournalists as art, while social historians just as often find evidence in works made under the rubric of art. The great photojournalists possess eyes for composition as keen as those of the artists, many of whom share the photojournalists' passion for truth. Gilles Peress's photograph of a wounded Irish boy in his companions' arms, which falls in pose midway between a pièta and a deposition, is timeless in its pathos. Yet it is historically located with utter precision by such detail as the op-art pattern of the boy's shirt. Thus is the universality of human suffering figured in a highly specific context.

Photojournalism notoriously demands courage and insight, speed and endurance, judgment and commitment. The style and methods of modern photojournalism were forged in the crucible of the Spanish Civil War, and further annealed through the coverage of the World War II. Photojournalism was practiced in its purest form from the 1930s through the 1950s, in the years before television became widespread. The hegemony of the picture magazines that supported photojournalism began to decline in synchrony with public loss of confidence in the ability of single images or even picture sequences to capture the complexity of issues in an era when many were starting to question authority, government, and the media. By the 1970s, when David Levinthal re-created the Eastern Front campaigns of World War II with toys in his studio and photographed them in the manner of classic reportage, the recycling of images and photographic styles could encompass both ironic and admiring stances: homage and reinterpretation. The era of postmodernism had begun precociously, and graphic, immediate pictures like those Dmitri Baltermants made during World War II became fixed in viewer's eyes as history rather than as direct experience.

Everyday Life

Documentary photography most often takes everyday life as its central subject. But whose life does it chronicle? And which day is everyday? The most enduring task photography sets itself is this one, which sometimes is confused with the more immediate work of photojournalism. If we assume that documentary photography means factual

visual recording in the absence of breaking news, then we must recognize how hard it is to avoid classing all photographic practice under the heading "documentary." Photography is the documentary medium par excellence, and it has been employed to brilliant effect in numerous large-scale projects of visual inventory throughout its history.

The best-known of these is perhaps the U.S. government's Farm Security Administration photographic survey of the Great Depression which employed a wide variety of documentary subjects, styles, and media. Jack Delano's color photograph of a vignette from the Vermont State Fair is poignantly happy not piercingly tragic as expectation might have suggested for an F.S.A. image. His symphony in pinks is as sophisticated as the subject is delightfully naïve. The picture is built around the photographer's engagement with the girls, as well the charming randomness of their placement and the uniformity of color in their dresses. Delano's image comes from a world not far from that so familiarly depicted by Norman Rockwell, while photographers of the next generation like Diane Arbus and Larry Clark sometimes selected very different everyday activities as their subjects. Clark's group of youthful friends injecting amphetamines and Arbus's wistful prowar demonstrator represent fragmented subcultural experience of very different kinds. In unpretentious vernacular portrait images we find everyday people photographed by their families and by professional photographers, for their families and for broader audiences. With the passage of time, these images slip out of their immediate networks of associations to achieve broader, less precise significance as typical rather than unique images.

Portraits

There are more photographic portraits in the world than examples of any other picture type. While the majority of these owe their existence to the nearly universal urge to possess representations of loved ones, deep human desire to look at pictures of other people does not depend on relationships to the people pictured. How seldom it is that we can stare into the faces of strangers without awkwardness! We cannot look at them with the intimacy we use in gazing upon loved ones, but their very unfamiliarity piques desire all the more, and photography is a convenience to insatiable surveyors of the human countenance. Consuelo Kanaga's portrait of Annie Mae Merriweather is a ravishing depiction of the sheer beauty human skin can possess, and a potent psychological rendering that gratifies the longing to look long into another person's face.

ICP has consistently identified itself with the work of photographers who explore the human condition, and its collection assembles innumerable human countenances. Their gazes now meet the viewer's eyes instead of the photographers' in a reversal of the transaction of looking. This book ends with two photographs of the experience of looking that address the implications of vision and photography. In Chim's witty photograph of the celebrated art historian Bernard Berenson eyeing a neoclassical sculpture, and Henri Cartier-Bresson's intricately sensual depiction of a woman displaying her fine taste in millinery to a rapt audience of one, we viewers look on at the spectacle of someone else's looking. Photography is the art about looking, literally made through the act of seeing. The plate section in this book begins with pictures about seeing, and ends with others about looking, thus closing a circle of vision as easily as we can close our eyes.

The ICP Collection: a User's Guide?

This book, as has been suggested, is not a road map to or a manual to ICP's holdings as much an argument about ways in which the collection may be used to think about photography. A picture book invites the reader's participation without indicating a definite approach or structure for the encounter. One may pore over each plate, flip at random, or sample and savor the images in any order. Their positions don't change, but one's choices about looking at them can. One may read prefatory text dutifully or in hopes of guidance, one may refer to it only after first plunging into the pictures—or one may bypass it entirely without a thought. How one chooses to use a book is a measure of personal desires, habits and expectations. Picture books offer themselves to readers and viewers in all of these ways, and permit different strategies of approach on different occasions. This book is no exception; what one might not immediately notice about its organization, however, is that its structure derives from the values of the institution whose collection it presents. The freedom with which the reader is invited to peruse the book is precisely the same freedom that has allowed ICP's gathering and selection of its varied collection from the wide world of photography.

A museum's collection is visible evidence of its history neatly preserved like leaves and insects caught in amber. But a museum's collections are also like a family's children, messengers to the future, changing, growing and passing out of the control of those who love them and bring them into being. Living institutions change as life changes around them, while they preserve the heart of their original identities. ICP proceeds into its second twenty-five years, into a new century and a new millennium, nurtured by its strong roots but with new ideas about its goals and how to meet them. Reaching for the future is as essential as keeping faith with great traditions, and in these assembled images is ample evidence of the International Center of Photography's commitment to both.

Notes

1. *On Photography* (New York: Delta, 1973), p. 3.

2. *The Concerned Photographer 2* (New York: Grossman, 1972) n.p.

3. "The Camera's Glass Eye: Review of an Exhibition of Edward Weston," *The Nation*, March 9, 1946, reprinted in *Clement Greenberg: The Collected Essays and Criticism*, vol. 2, "Arrogant Purpose 1945–1949", ed. John O'Brian (Chicago: University of Chicago Press, 1986), p. 60.

4. *Photography and Society* (Boston: David R. Godine, 1980), p. 40.

5. *Looking at Photographs* (New York: the Museum of Modern Art, 1973), p. 12.

6. *A Book of Photographs from the Collection of Sam Wagstaff* (New York: Gray Press, 1978), p. 2.

7. Clement Greenberg, "The Camera's Glass Eye," p. 61.

8. *The Concerned Photographer 2* has a fine account of Cornell Capa's early activities on behalf of "concerned photography."

9. *The Concerned Photographer*, " Pertinent and Impertinent" column, *The Art Gallery*, Summer 1974, n.p.

10. "An Improbable Dream in the Real World," in *International Center of Photography Twenty Years 1974–1994,* (New York: ICP, 1994), p. 8.

11. Quoted in International Center of Photography press release "ICP Announces Appointment of Curator," February 1980.

About Seeing

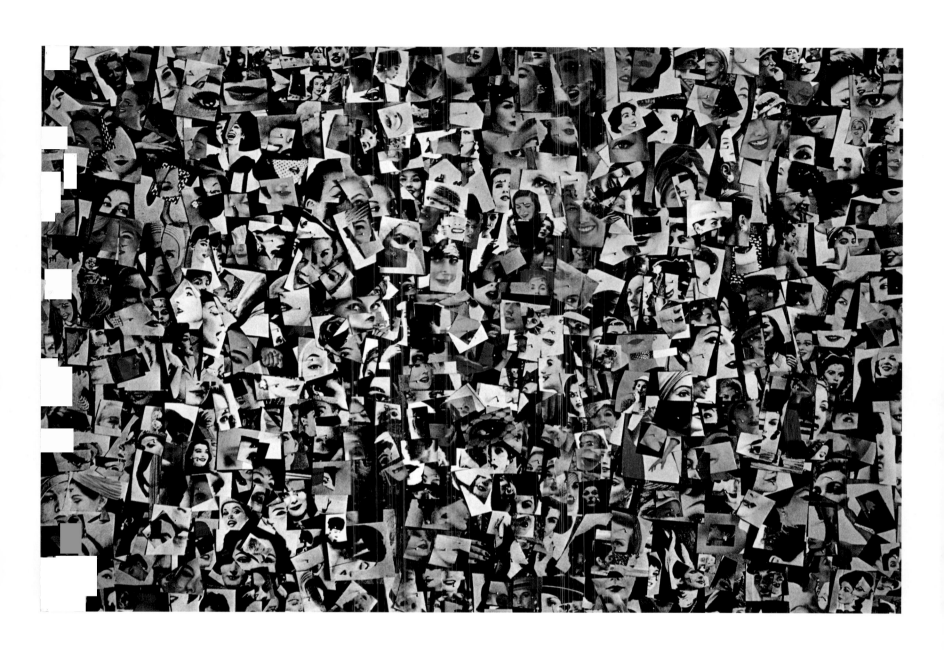

Harry Callahan
Collages, c. 1957
Dye transfer print, 1980
8¾ x 13½ inches
Gift of Louis F. Fox, 1980
70.1980

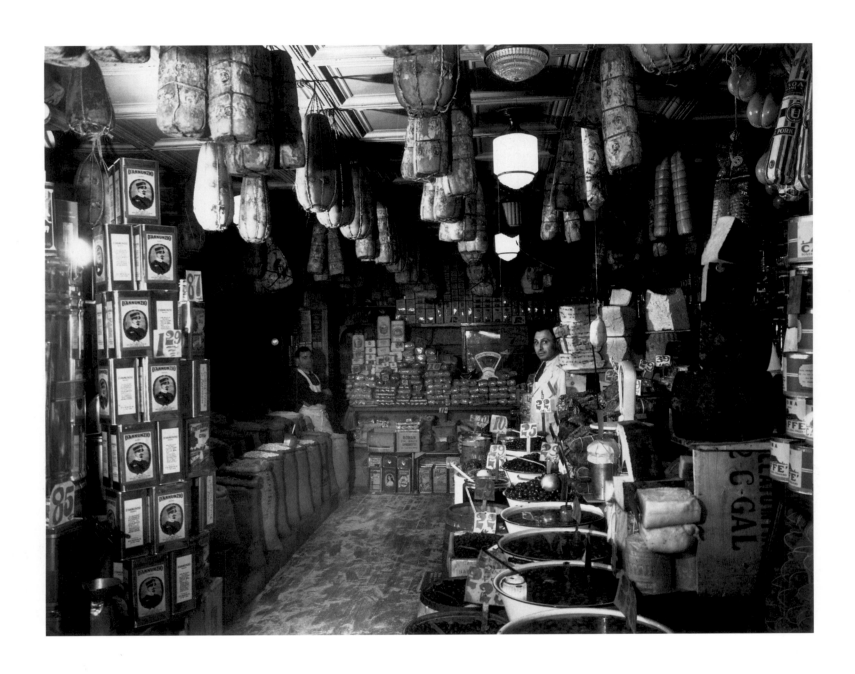

Arnold Eagle
The Grocery, c. 1940
Gelatin silver print
10 x 13 inches
Gift of the photographer, 1989
123.1989

2

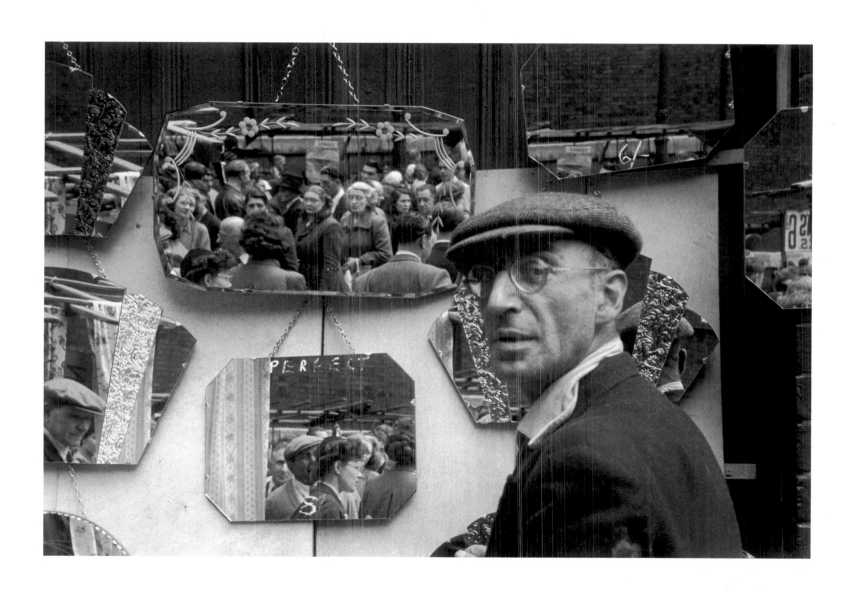

Ernst Haas
London, 1951
Gelatin silver print
8⅝ x 12⅞ inches
Purchased with funds from an anonymous donor, 1992
3734.1992

3

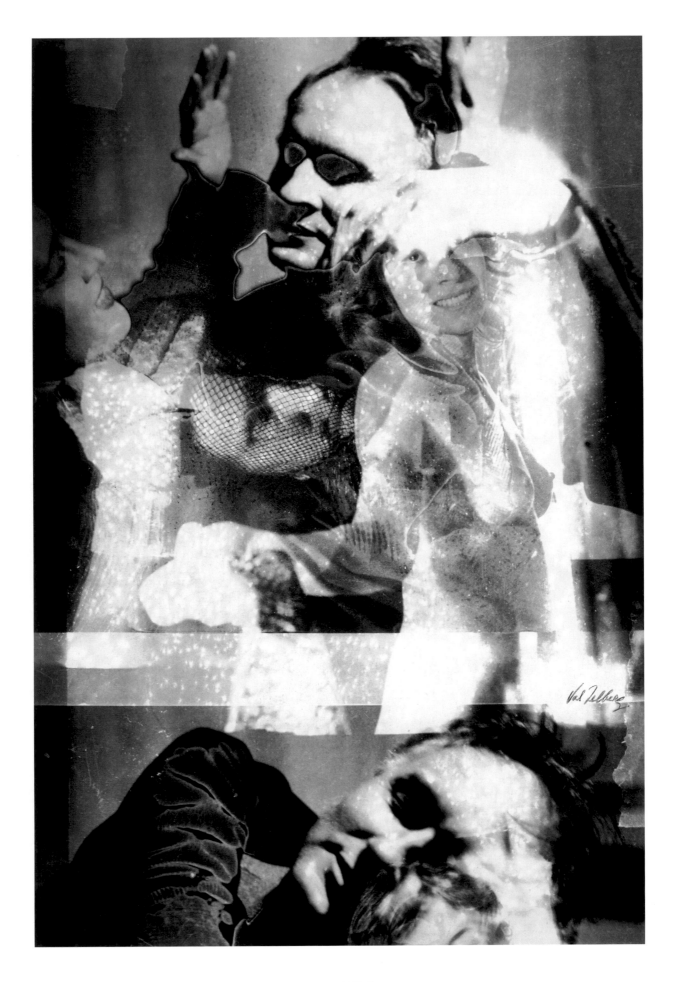

Val Telberg
Self-Portrait from Old Negatives, 1970–1979
Gelatin silver print
20 x 15⅜ inches
Gift of Toby and Lilyan Miller, 1992
3431.1992

4

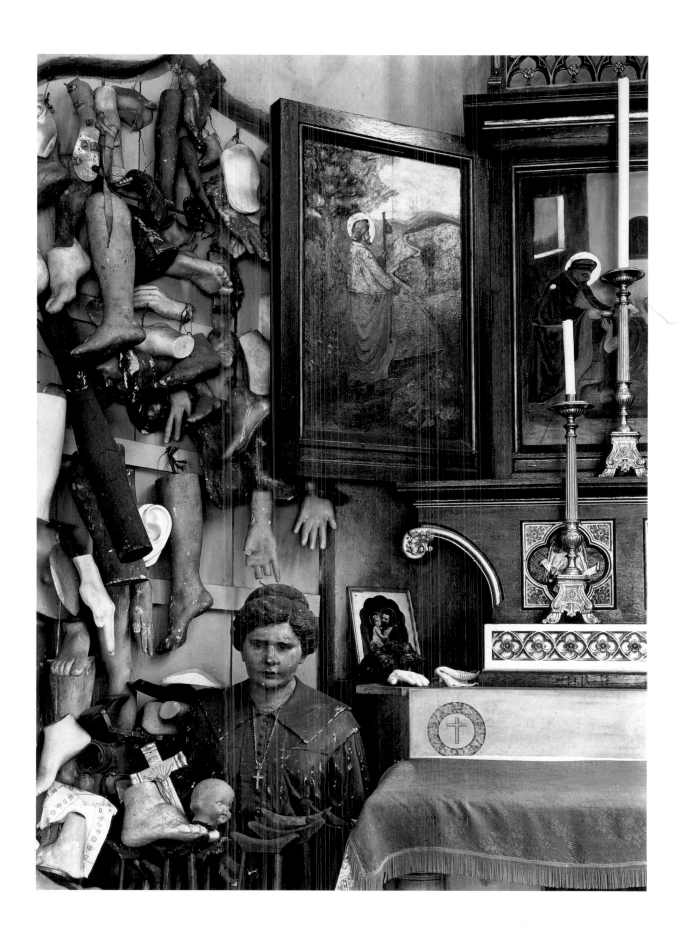

Edward Westor
St. Roch Cemetery, New Orleans, 1941
Gelatin silver print
9½ x 7½ inches
Gift of Anne E. and M. Anthony Fisher, 1997
144.1997

5

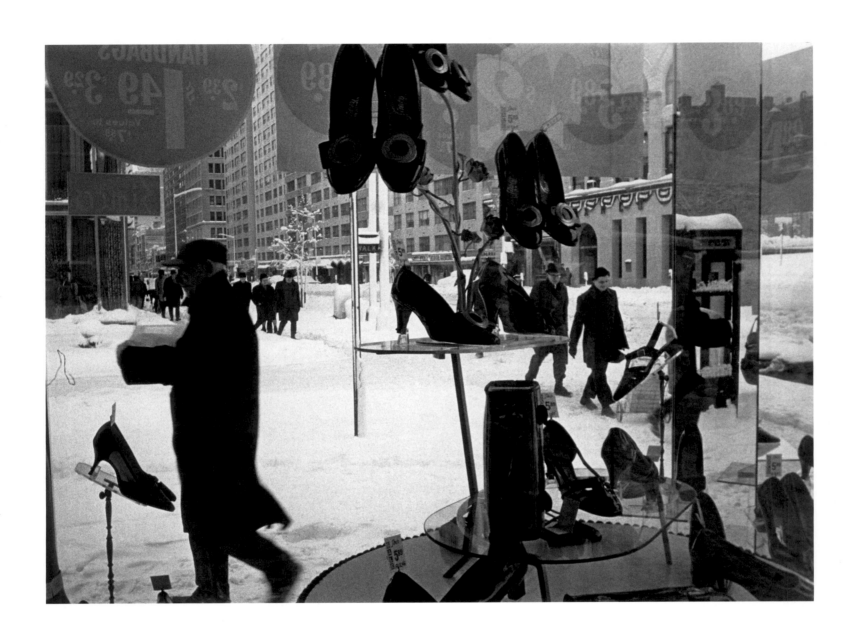

Harold Feinstein
Fourteenth Street Shoe Store Window, 1969
Gelatin silver print, c. 1980
9½ x 13 inches
Gift of Walter J. Lake, Sr., 1982
607.1982

6

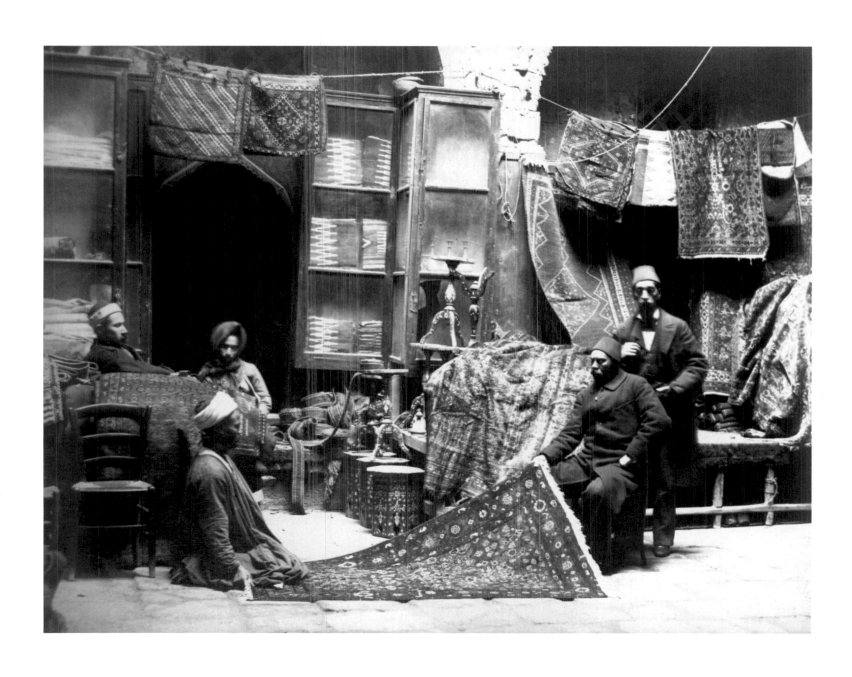

Photographer Unknown
In the Carpet Bazaar, Cairo, 1880s
Albumen silver print from glass negative, from an album of 104 prints
8 x 10½ inches
Gift of Duane Michals, 1983
639.1983

7

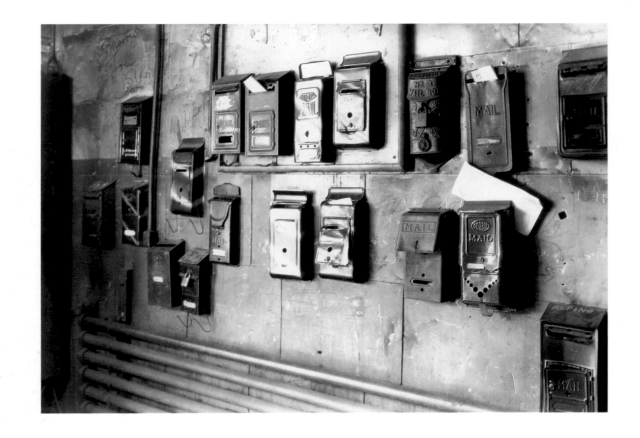

Lewis Hine
[Mailboxes, workers' housing], 1937
From the National Research Project, 1936–1937
Gelatin silver print
4⅝ x 6¾ inches
Gift of the National Archives, Washington D.C., 1975
1012.1975

8

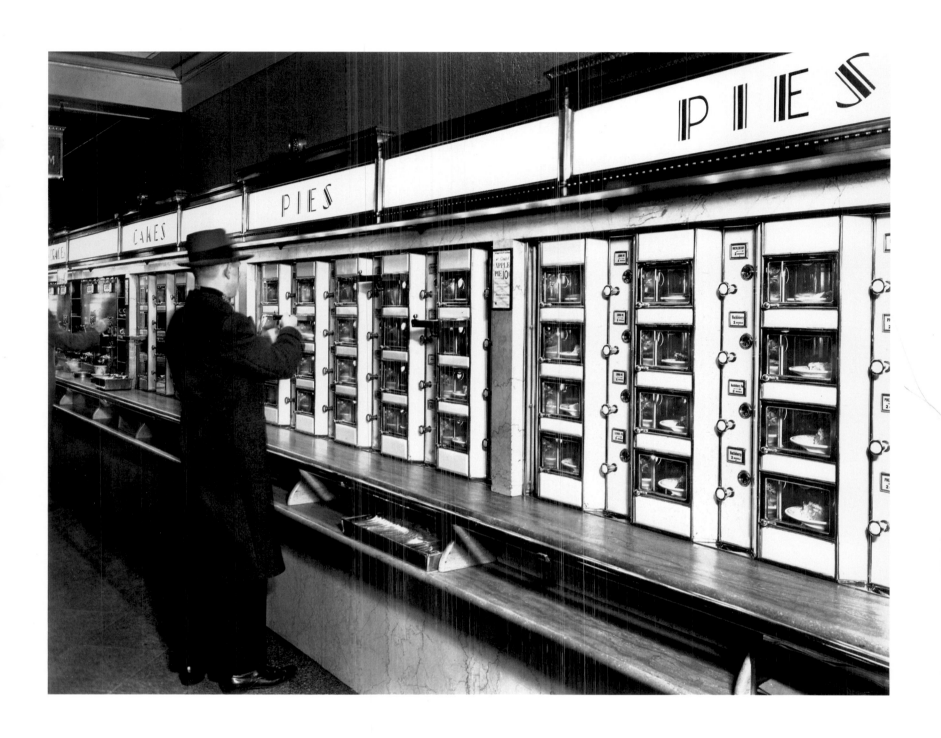

9

Berenice Abbott
Automat, 977 Eighth Avenue, New York, 1936
From the portfolio "Berenice Abbott Retrospective," 1982
Gelatin silver print, 1932
17¾ x 23⅛ inches
Gift of Jonathan A. Berg, 1984
675.1984

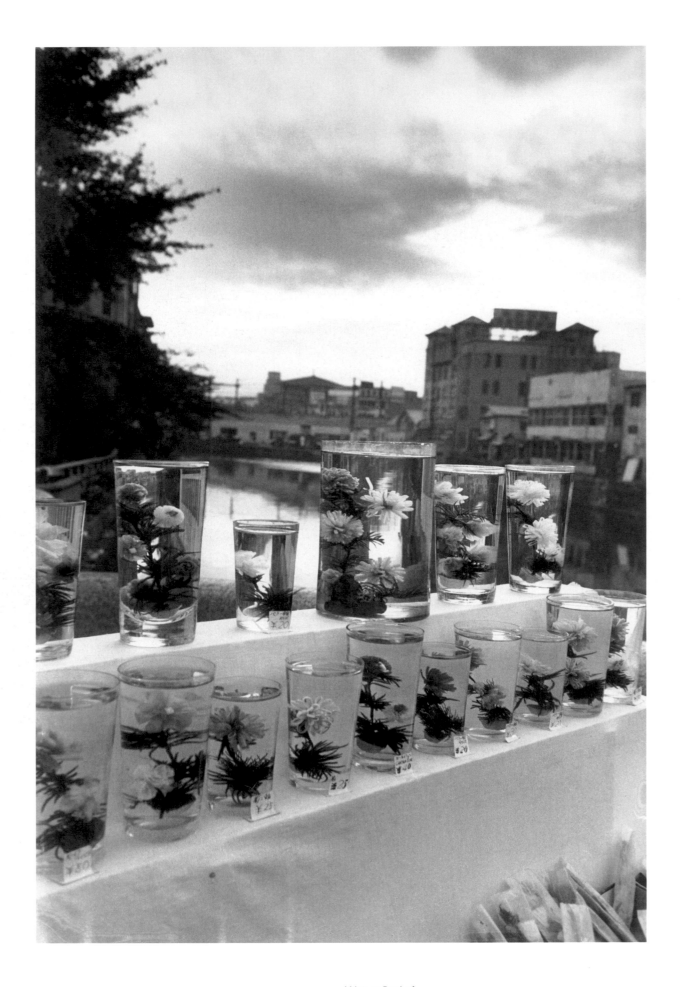

Werner Bischof
Paper Flowers, Tokyo, 1951
Gelatin silver print, 1970s
23 ¾ x 16 inches
Purchased, International Fund for Concerned Photography, 1974
933.1974

10

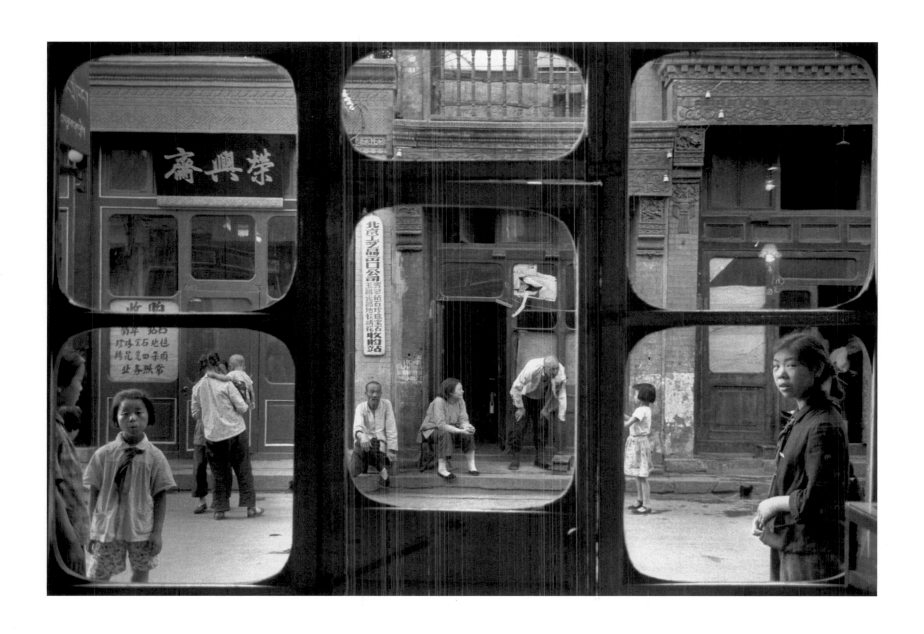

Marc Riboud
The Antique Dealers' Street, Peking, 1965
Gelatin silver print, 1970s
27½ x 41½ inches
Purchased, International Fund for Concerned Photography, 1975
126.1975

11

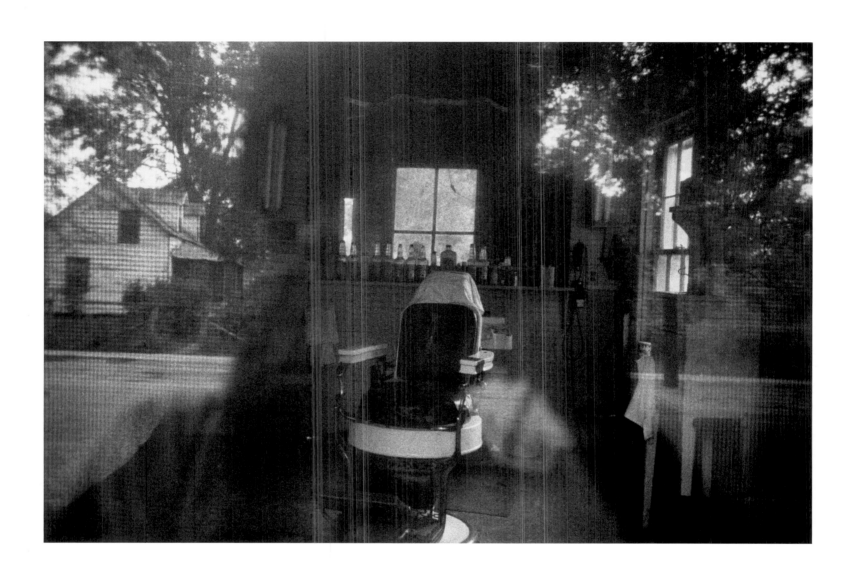

Robert Frank
Barbershop through Screen Door, McClellanville, South Carolina, 1955–1956
Gelatin silver print, c. 1970
8½ x 12⅞ inches
Gift of Tennyson and Fern M. Schad, 1996
225.1996

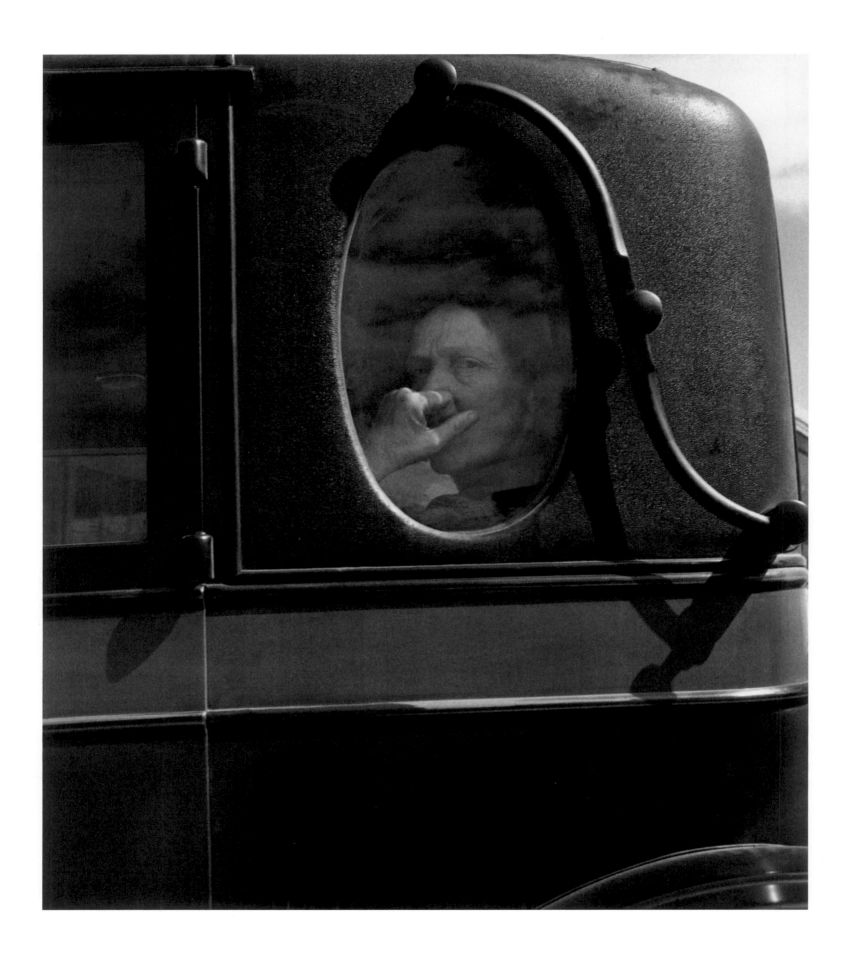

Dorothea Lange
Funeral Cortege, End of an Era in a Small Valley Town, California, 1938
Gelatin silver print, c. 1960
10½ x 9½ inches
Photography in the Fine Arts Collection, 1981

13

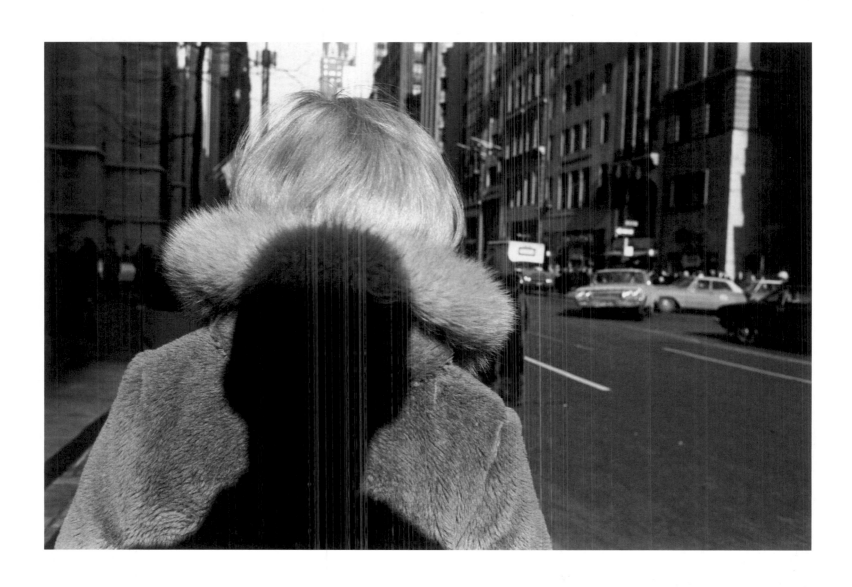

14

Lee Friedlander
New York City, 1966
Gelatin silver print
7⅜ x 11⅛ inches
Gift of Alfred Ordover, 1986
673.1986

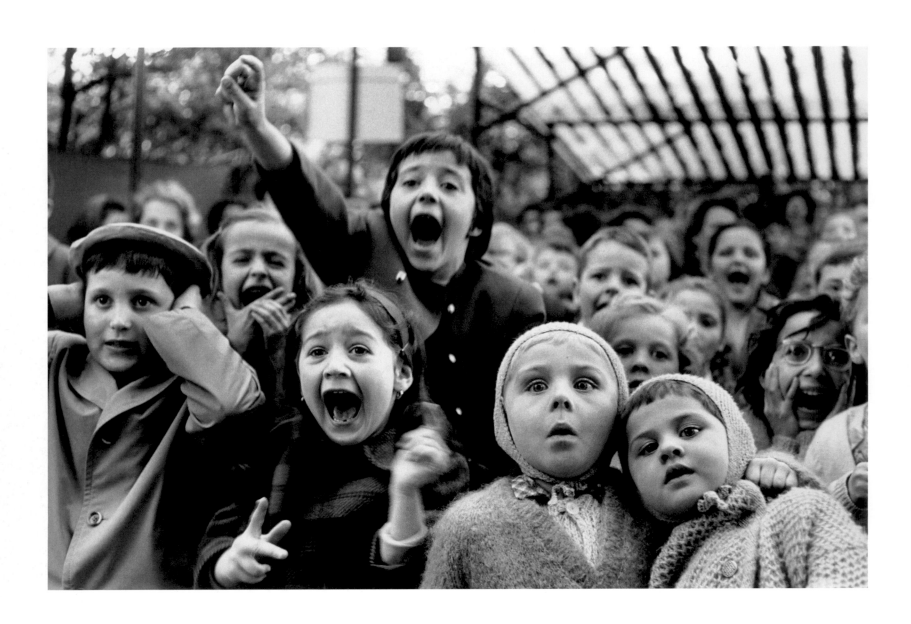

Alfred Eisenstaedt
*Children Watching the Story of "Saint George and the Dragon" at the Puppet
Theater in the Tuileries, Paris,* 1963
Gelatin silver print, 1980s
12½ x 19 inches
Gift of the photographer, 1989
293.1989

15

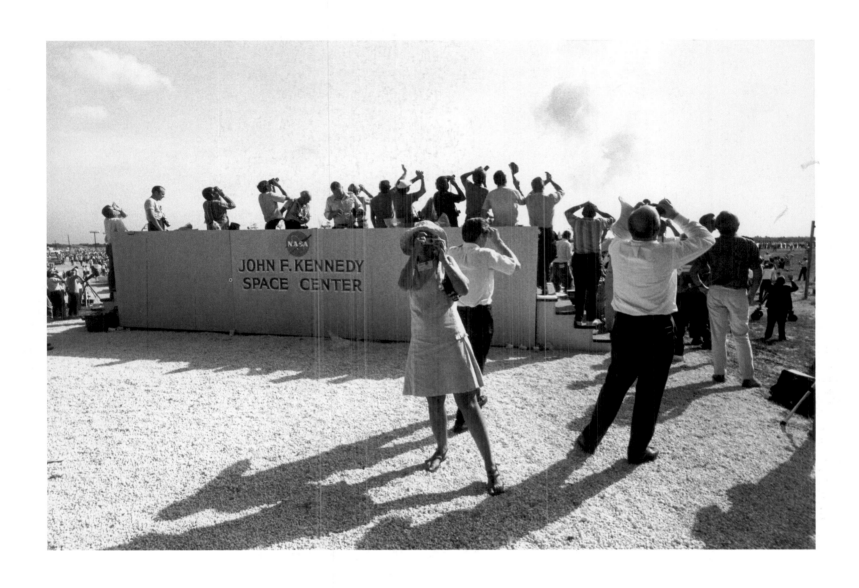

Garry Winogrand
Cape Kennedy, Florida, 1969
Gelatin silver print
9 x 13½ inches
Gift of Dr. Diane Chen, 1981
117.1981a

16

Still Life

In painting's traditional hierarchy of genres, which includes history (or narrative), portraiture, and landscape, still life was at the lowest rung. The apparent modesty of its concerns, centered around the vicissitudes of the domestic and its assortment of utensils and perishables, made it seem the visual equivalent of a journal entry: notional, inconsequential, ordinary. Even when elaborated by the stern moral warning of a *vanitas*, with its display of flagrant consumption and grisly skull, or by the starkly descriptive phrase *nature morte*, the subject matter of most still-life pictures appeared, at best, a form of homage to the brute fact of decay, unalieviated by either human heroism or spiritual transcendence. Devoted to the observation of earthly delights, to the rituals and necessities of common hungers, even the gorgeous artifice of Dutch flower painting brought us not much beyond a simple pathos.

But what does it mean to say that an image is a still life? It suggests that life, known to be restless and transient, is here held in place, *distilled*, rendered both essential and eternal. It means, among other things, that the things of nature have traversed the line into the things of culture: in Levi-Straussian terms, the *raw* has been *cooked*. There is, in these images, an implied resistance or brake, a desire to frame passage, to somehow convert the temporal into the spatial, transport the garden into the library. The objects, whether animate or inanimate, have been plucked from their narratives and rendered so that we are made aware of disparate layers: the endurance of material goods, the frailty of living things; perhaps most important, there is the recognition, however subliminal, of the labor and time the painter took to arrest the ephemeral.

With photography, the designation *still life* undergoes a radical, if subtle, shift. In fact, the idea of a photographic still life seems almost redundant. Because the camera captures the real, the living, without the laborious techniques of the brush, we do not need to consider the torsion between the brief life of the tulip and the long hours of attention it took the artist to render it, or to wonder at how the instability of the quotidian became a lasting image. No longer embedded in the habits of the domestic, but still indebted to the idea of materiality, these photographs reevaluate the complex visual rhetoric of cultural construction. The freedom of a photographer to move easily among the animate and inanimate things of the world, and to draw from them any instance, drastically alters the equation between the object and its implied significance, as the subjective act of perception itself takes precedence over the thing perceived, or preserved.

The photographer, as sole agent of this preservation, acts not only as the one who selects the object-as-image, but often as the one who constructs a vignette or tableau, juxtaposing disparate elements, shifting scales, fragmenting and redistributing parts into unexpected congruence. In some cases, the artifice of the composition is paramount. In others, there is a newly intensified sense of immediacy and, consequently, an augmented sense of poignancy and loss. The photographic *still,* single image extracted from an ongoing narrative, ironically, draws our attention to the idea of an absolute persistence, as in Keats's famous line "Thou still unravished bride of quietness". The endurance of the object—animate or inanimate—rubs up against the voracious rapidity of the shutter, and the invisible persona of the photographer comes to endow the images with the quixotic but powerful language of the secret, or the fetish. The ordinary, the grotesque, the tool, and the remnant, are at once removed from ritual context and ritualized as personal icon.

The world of objects is as diverse and contingent as the world of events; what we choose to see is part of a visual syntax that allows us insight into the fact, greatly enhanced by photography, that image and event have become nearly synonymous. The things of our daily lives are construed across an immense arc of intersecting shapes, recognizable as objects, but given significance by the individuated and singular act of perception. The photographic still life forces us to reconsider the importance of a genre.

ANN LAUTERBACH

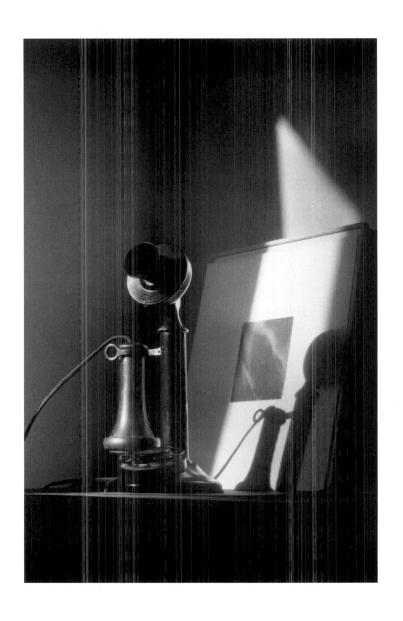

Dorothy Norman
An American Place: Phone, Shadow, and Alfred Stieglitz Equivalent in Background, c. 1940
Gelatin silver print
3 ¾ x 2 ¼ inches
Gift of the photographer, 1986
30.1986

17

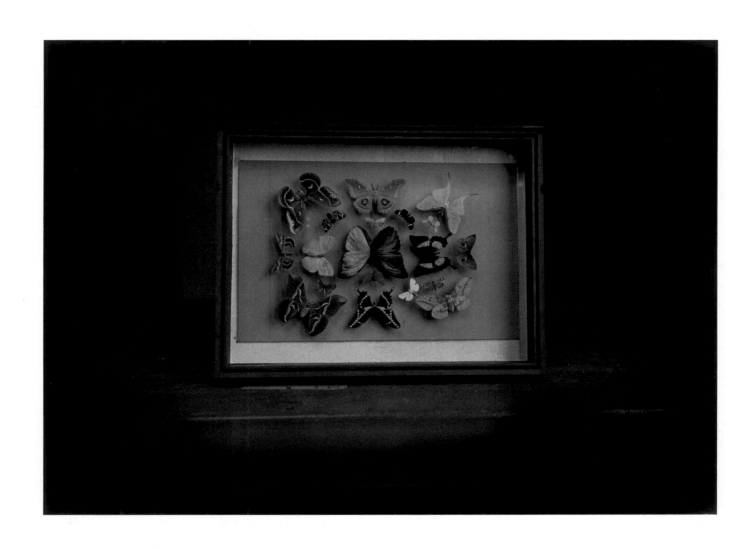

John B. Trevor
[Butterfly collection], 1920s

18 Autochrome
5 x 7 inches
Gift of Mr. John B. Trevor, Jr., 1976

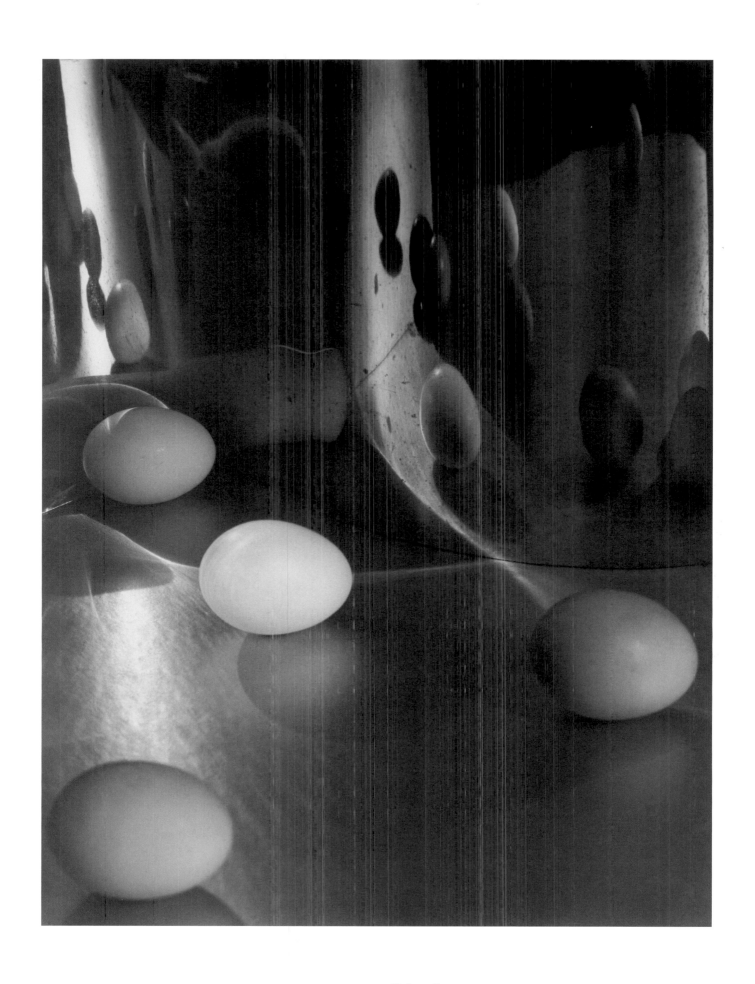

Carlotta Corpron
Eggs and Hand Sculpture #1, 1948
Gelatin silver print
13½ x 10½ inches
Gift of Mr. and Mrs. Herbert Lust, 1993
527.1993

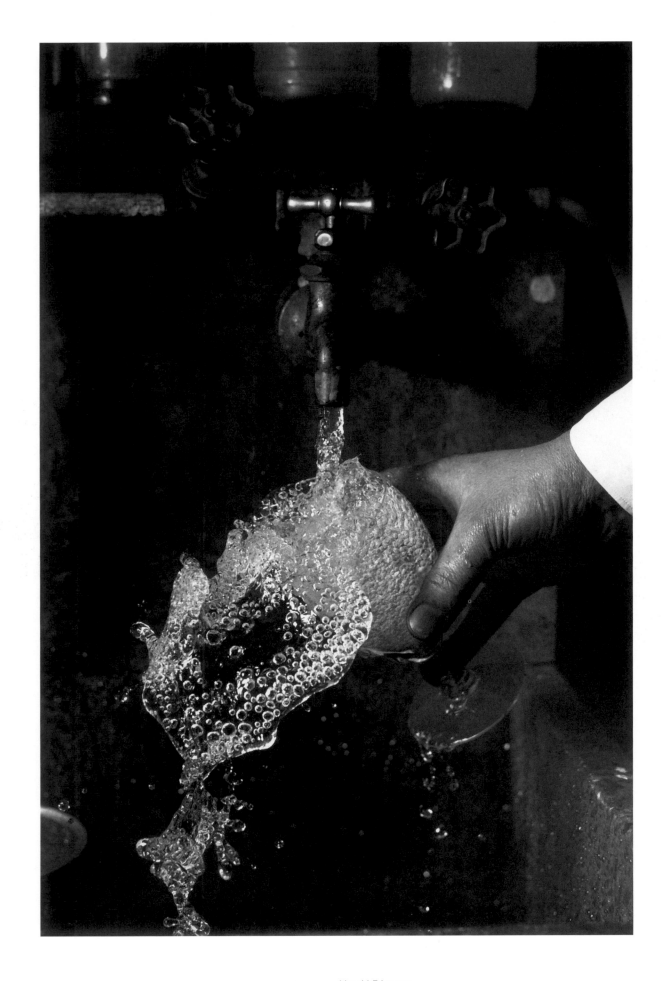

Harold Edgerton
Water into Goblet, 1934
Gelatin silver print
18⅝ x 12⅜ inches
Gift of Gus and Arlette Kayafas, 1987
106.1987

Andreas Feininger
Toy Engine, Dessau, 1928
Gelatin silver print
5¼ x 8¾ inches
Gift of the photographer, 1976
743.1976

21

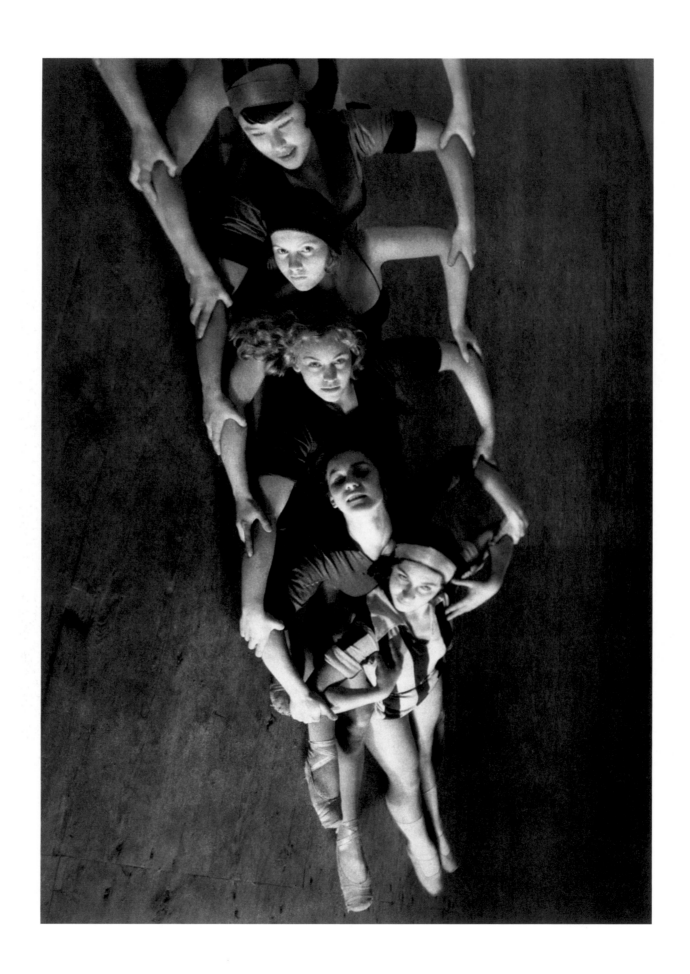

Margaret Bourke-White
Chain Belt Movement: Machine Dance, Moscow Ballet School, 1931
Photogravure
13 x 9⅛ inches
Gift of Mrs. Herman Seid, 1994
620.1994

22

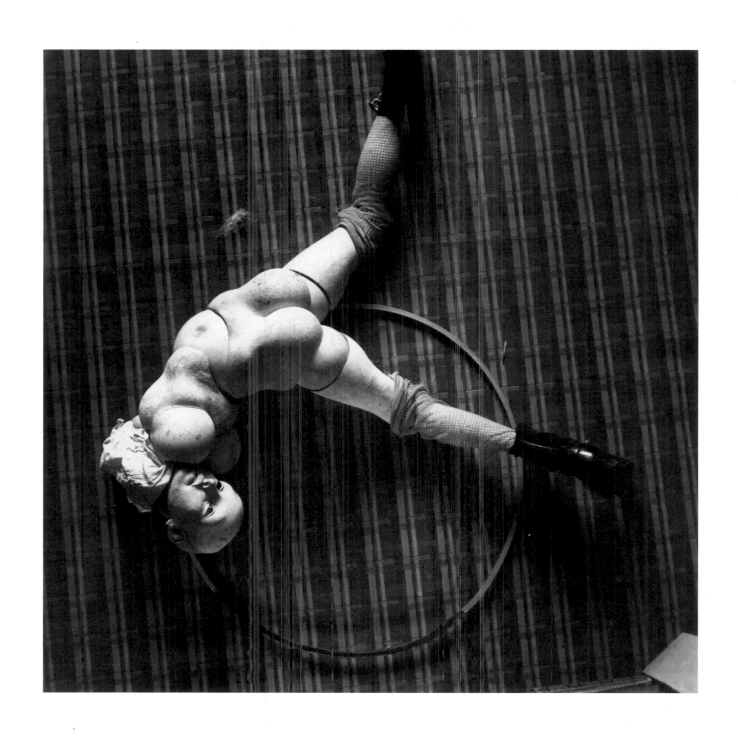

Hans Bellmer
La Poupée, 1935
From the portfolio "Hans Bellmer: Photographies," 1983
Gelatin silver print, 1983
10 x 10⅛ inches
Gift of Mr. Herbert Lust, 1987
203.1987

23

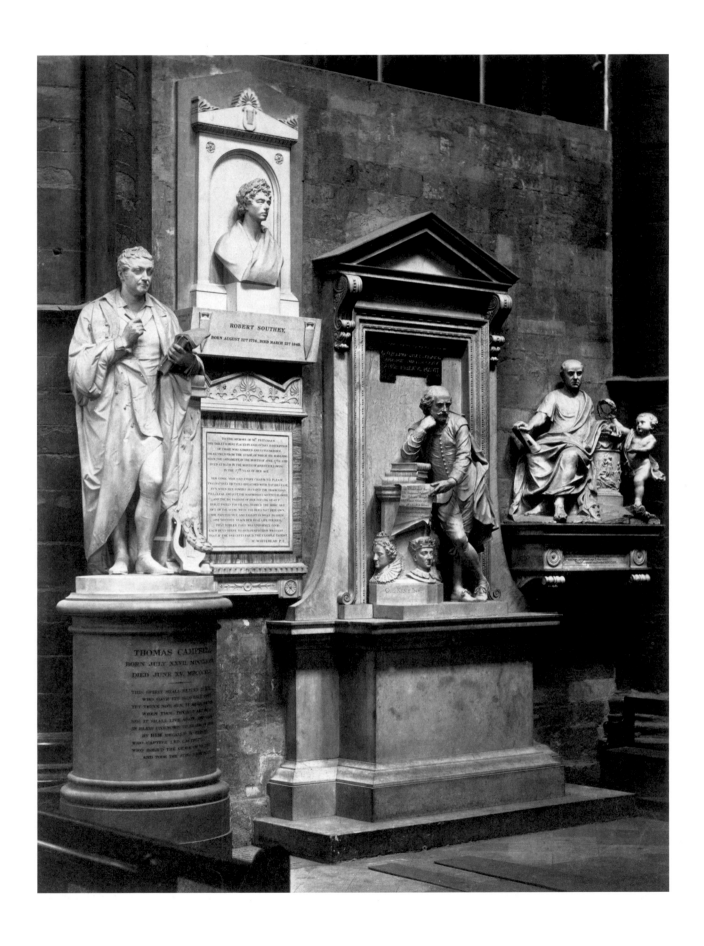

Francis Frith
Shakespeare, Southey, Campbell, Thomson, Poets' Corner,
Westminster Abbey, c. 1865

24 Albumen silver print from glass negative
8 x 6 inches
Gift of John Horne, 1980
70.1980

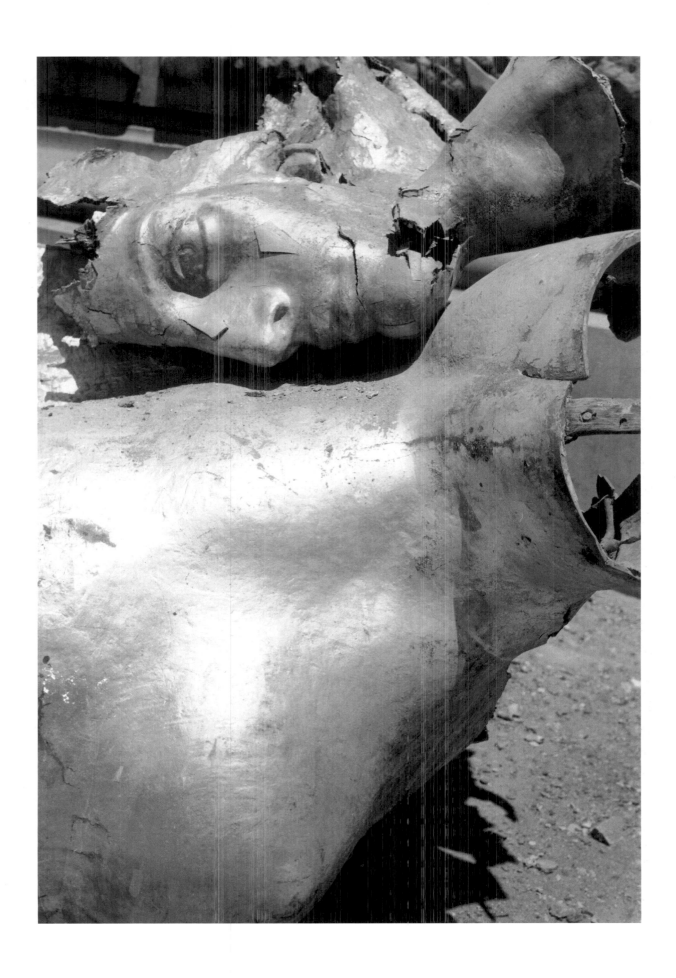

25

Manuel Alvarez Bravo
Angel del Temblor [Angel of the earthquake], 1957
Gelatin silver print, 1970s
9½ x 6½ inches
Gift of Mr. and Mrs. Harvey M. Krueger, 1980
171.1980i

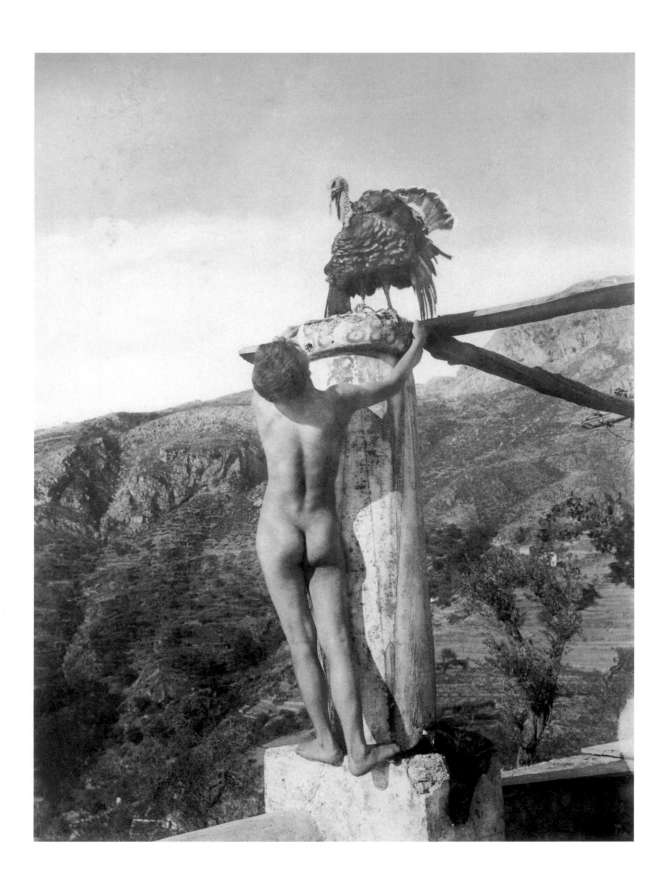

Wilhelm von Gloeden
[Boy with turkey], c. 1920
Albumen silver print from glass negative
8¾ x 6⅝ inches
Gift of Milton Radutzky, 1983
590.1983

26

Photographer Unknown
[Rooster], 1870s
Albumen silver print from glass negative
4½ x 6¼ inches
Gift of David Garfinkle, 1983
683.1983

27

Naomi Savage
Eskimo, 1972
Photo engraving on steel plate
18 x 14 inches
Gift of Robert Bruns, 1983
577.1983

28

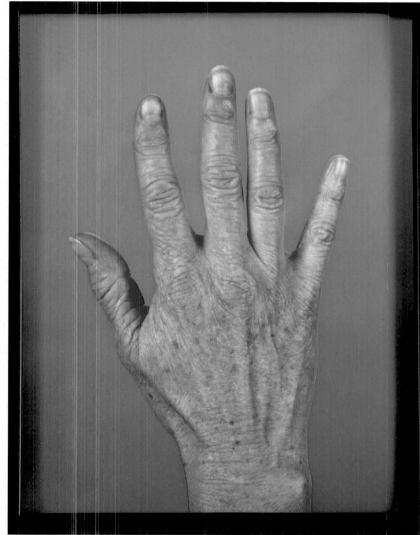

29

Neil Winokur
Front and Back of Tina Barney's Right Hand, 1995
Silver dye bleach prints
9⅝ x 7⅝ each
Gift of Anne and Joel Ehrenkranz, 1997
55.1997

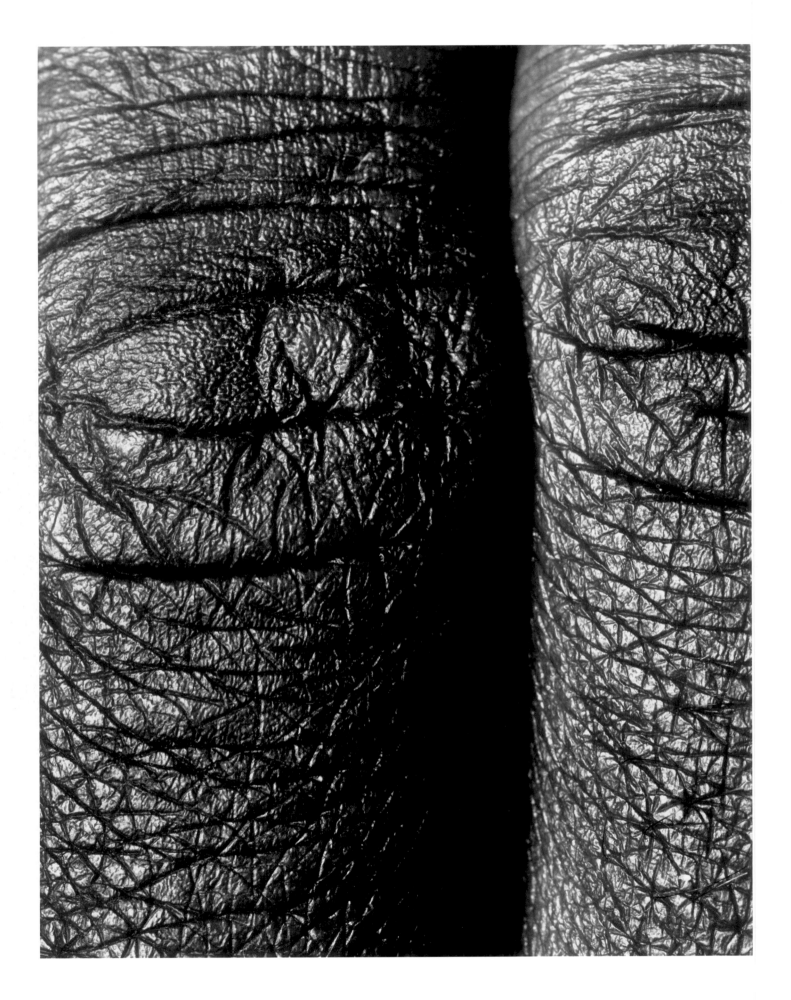

Udo Hesse
Fingers (Calvann), Berlin, 1985
Gelatin silver print
14¾ x 18¾ inches
ICP Purchase Fund, 1986
660.1986

30

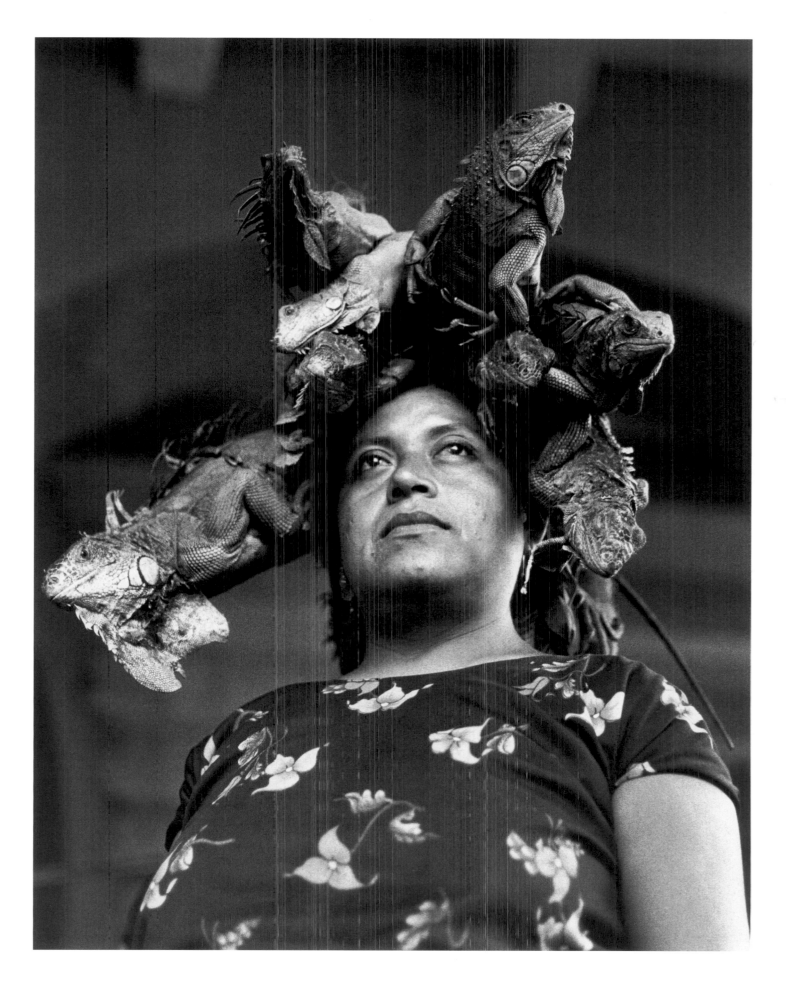

Graciela Iturbide
Nuestra Señora de las Iguanas, [Our Lady of the Iguanas], 1979
Gelatin silver print, 1990s
19 x 14¾ inches
Gift of the photographer to the W. Eugene Smith Legacy Collection
at the International Center of Photography, 1995
130.1995

31

32

Andres Serrano
Piss Christ, 1987
Silver dye bleach print
22⅝ x 15⅝ inches
Gift of Felix Gonzalez-Torres, in memory of Ross Laycock, 1991
13.1991

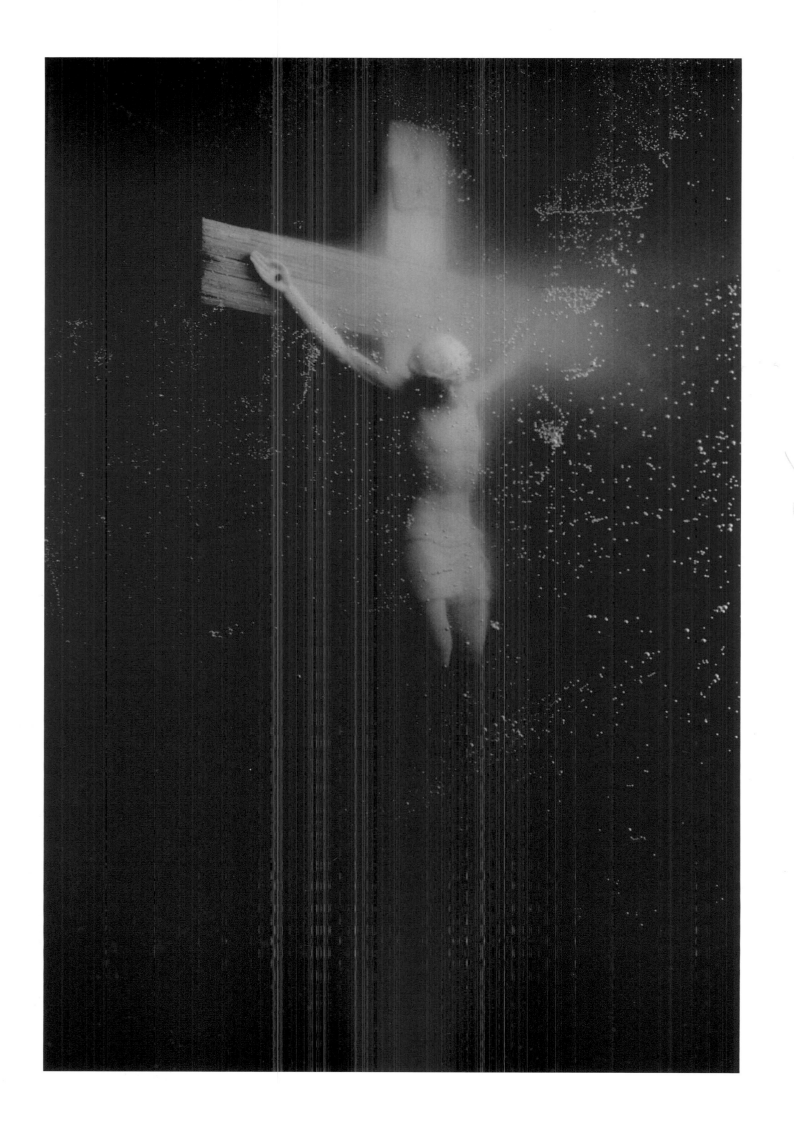

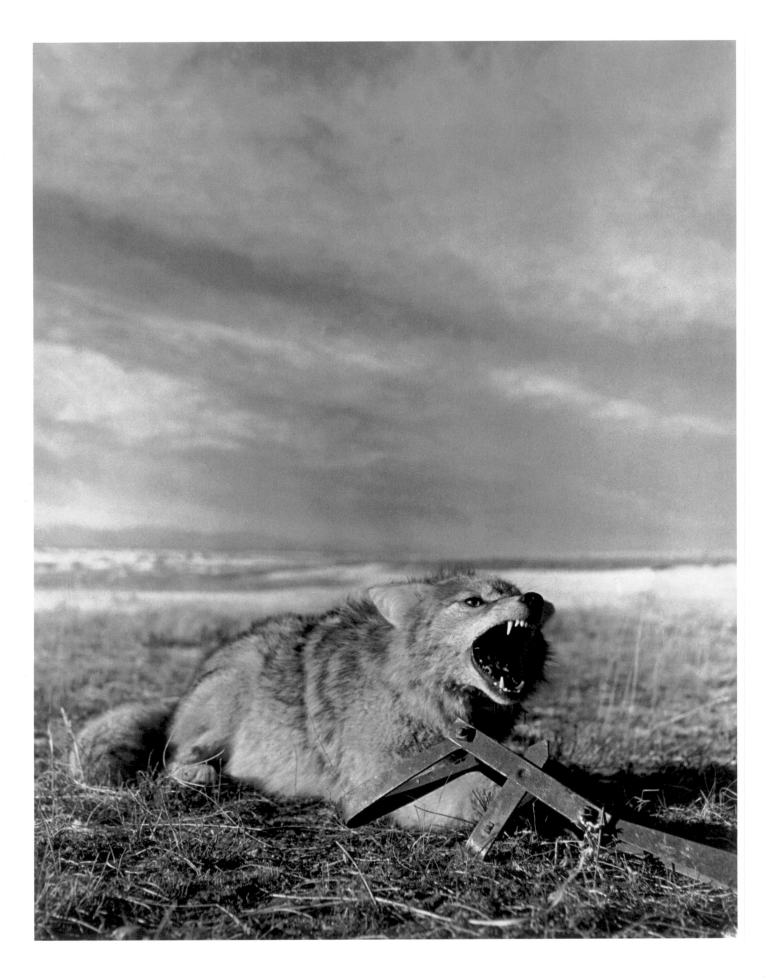

Hansel Mieth
Trapped Coyote, Montana, 1938
Gelatin silver print, 1980s
13⅜ x 10⅜ inches
Purchased, Director's Discretionary Fund and ICP Purchase Fund, 1993
388.1993

33

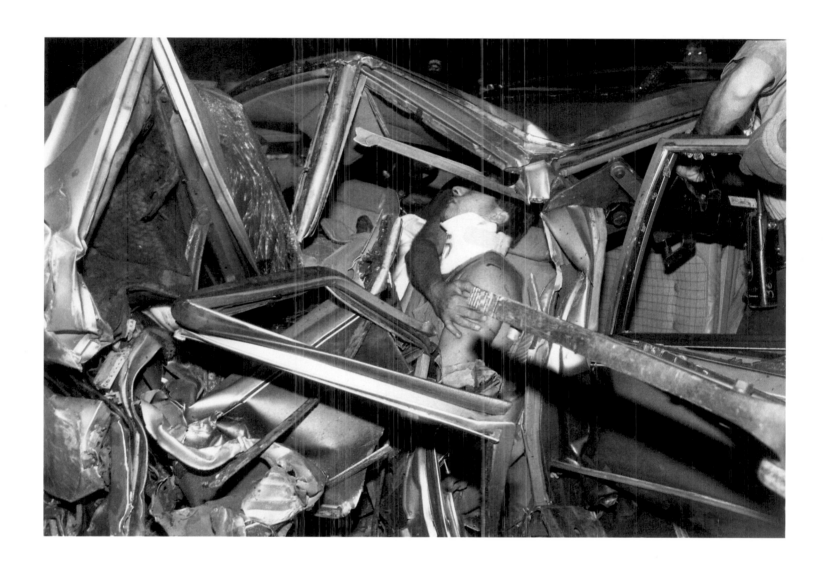

Andrew Savulich
Man Trapped in Car Wreck, 1989
Gelatin silver print
7 x 9½ inches
Gift of the photographer, 1994
403.1994

Ralph Eugene Meatyard
Untitled [Child with masks at waterfall], c. 1970
Gelatin silver print
6¼ x 6 inches
Gift of Mr. and Mrs. Charles Traub, 1980
157.1980

35

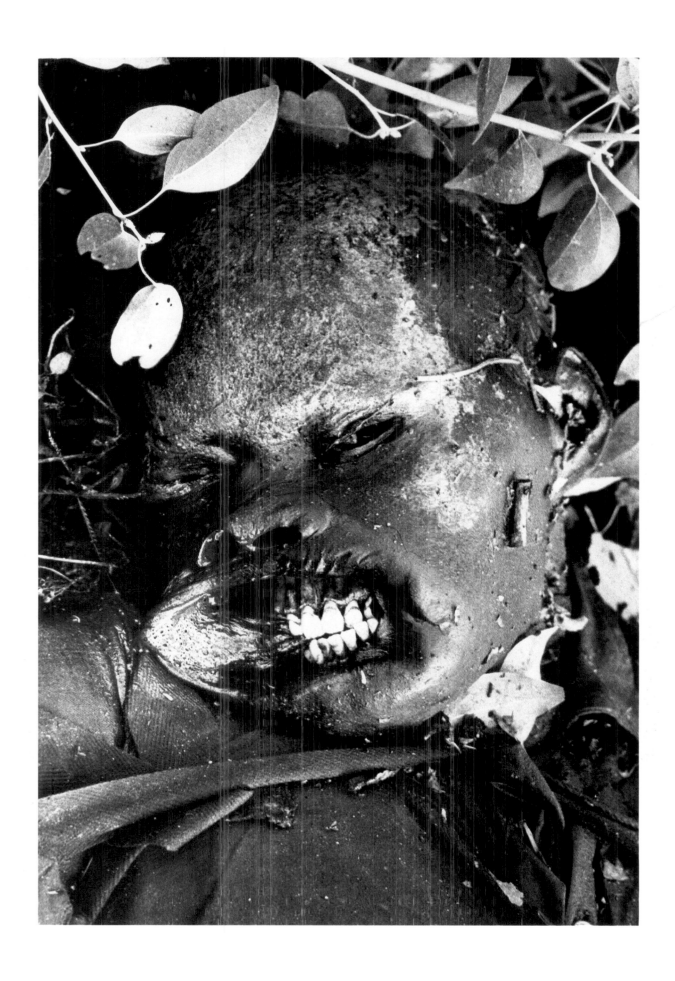

Donald McCullin
Decomposed Face of a Dead North Vietnamese Soldier, Hue, 1968
Gelatin silver print
10⅛ x 6⅞ inches
Purchased, International Fund for Concerned Photography, 1974

Victor Schrager
Untitled [Still life with Muybridge, Avedon and other images], 1978
Gelatin silver print
9 ¾ x 7 ¾ inches
Gift of Robert Freidus, 1981
252.1981

37

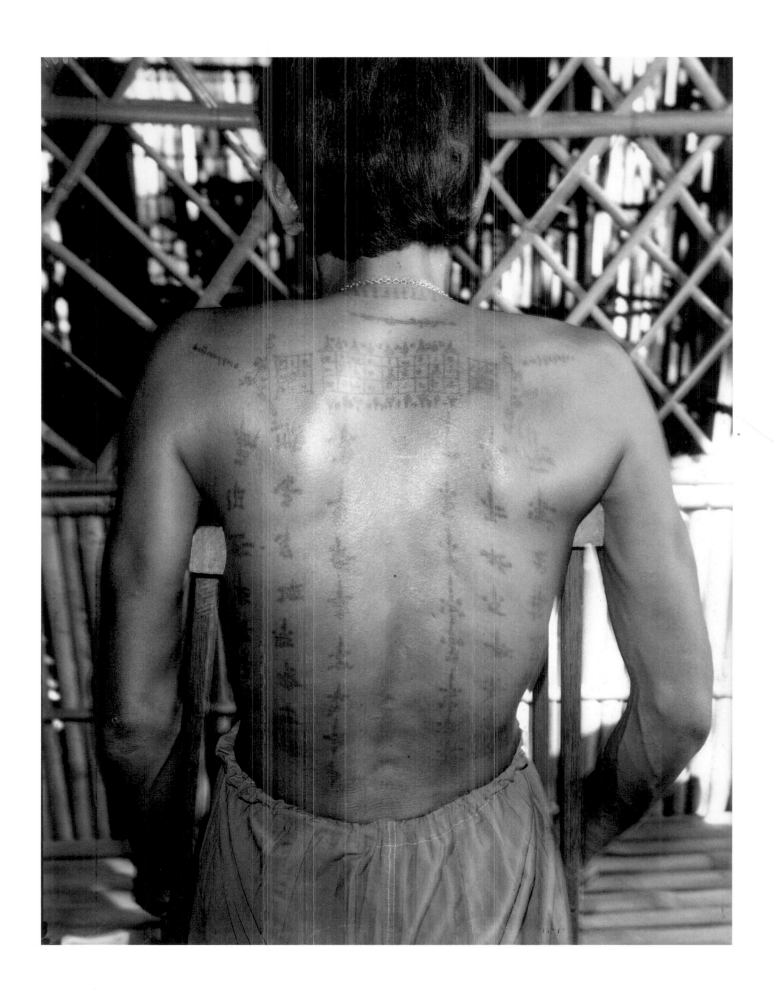

Bill Burke
Amputee with Protective Tattoos, Khao I Dang Camp, Thailand, 1984
Gelatin silver print
18½ x 14¼ inches
Purchased with funds from the Jerome Foundation, Inc., 1988
54.1988

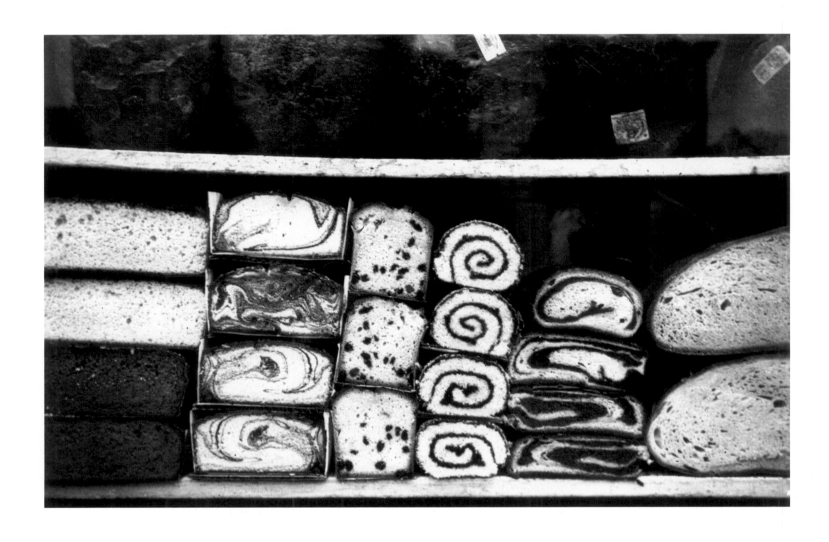

Nathan Lerner
Cakes in Window, New York, 1937
Gelatin silver print, c. 1980
6⅜ x 10⅜ inches
Gift of Mr. and Mrs. David C. Ruttenberg, 1986
547.1986

39

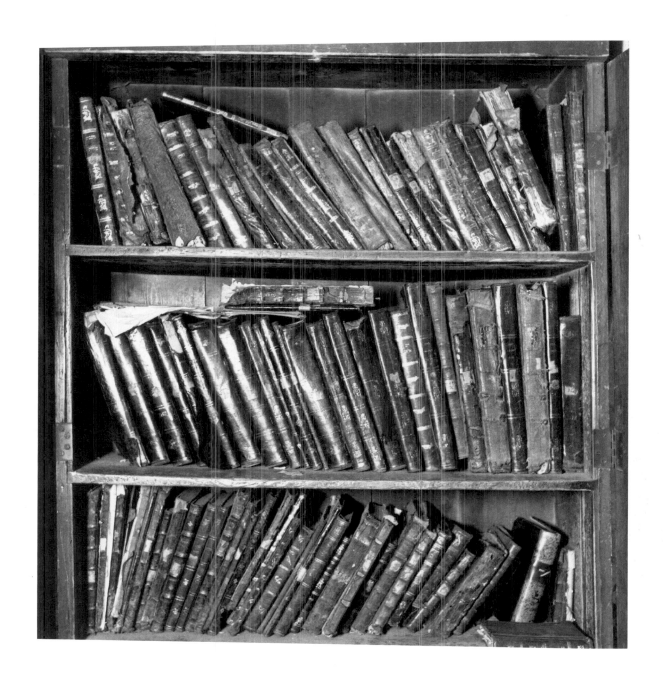

Roman Vishniac
The Books of Rabbi Hayyim Eleazar Shapira, Mukachevo, Czechoslovakia, 1938
Gelatin silver print, c. 1970
8 x 7¾ inches
Purchased, International Fund for Concerned Photography, 1974
148.1974

40

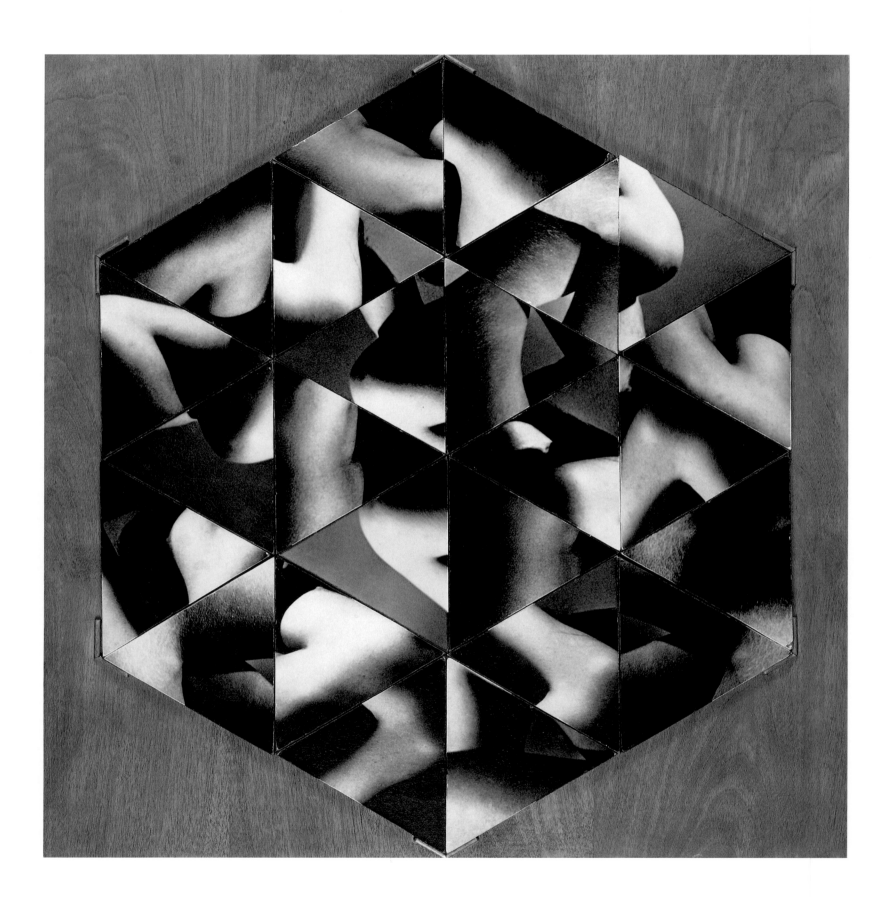

Robert Heinecken
Refractive Hexagon, 1965
24 gelatin silver prints mounted on composite board with
accompanying wooden base
17½ x 15¼ inches (six-sided)
Gift of Susan Unterberg, 1992
3428.1992

41

Marie Cosincas
Roses, Mexico. 1966
Dye transfer print
3½ x 4⅜ inches
Photography in the Fine Arts Collection. 1981

Robert Cumming
Four Corrugated Cubes from One, 1980
From the portfolio "Five Still Lifes," 1930
43 Instant color print
24 x 20½ inches
Gift of Joel and Anne Ehrenkranz, 1984
865.1984

Ferenc Berko
Rawalpindi, India, 1946
Gelatin silver print, 1990s
44 9⅞ x 8⅛ inches
Gift of the Cultural Program of Kodak Germany, 1994
458.1994

45 | Chuck Close
Sunflower, 1989
From the portfolio "The Indomitable Spirit," 1990
Instant color print
24¼ x 20¾ inches
Gift of Photographers + Friends United Against AIDS, 1998
1.1998b

46 | Sarah Charlesworth
Gold, 1986
Silver dye bleach print
40 x 30 inches
Gift of Anne and Joel Ehrenkranz, 1993
137.1993

Rimma Gerlovina, Valeriy Gerlovin, and Mark Berghash
Still-A-Life, 1988
Chromogenic print
16 x 69 inches
Purchased with funds from the Jerome Foundation, Inc., the National
Endowment for the Arts, and the ICP Purchase Fund, 1989
149.1989

Fashion and Style

The camera has created the style of this century more than any designer has. This is especially true of the style in dressed appearance, which is now wholly engendered by camera art. Such creative power was a feature of the camera's maturity, after the first quarter of this century—more than a hundred years before, during the early years of photography, painters and draftsmen were the ones who wielded the transforming power of style in figuration. Only artists could make clothed men and women look superior, deliciously appealing or strong and dignified, thin here and broad there, with perfect jaw-lines and smooth hands, skirts sweeping or collars sitting just so, ideal visions brought to life with breathing souls. The early camera was thought to be for rigid facts and opposed to such fluid dreams. Early photographers would nevertheless sometimes try for artistic prestige by borrowing the style of clad figures from earlier media, editing their clothed human subjects to resemble paintings by Ingres or etchings by Rembrandt, or the fantasy characters in works of contemporary Pre-Raphaelite painters and illustrators.

During the same period, fashion illustrators were ignoring both the camera and avant-garde art. They pursued their traditional stylizations at a much lower aesthetic level, so that fashion appeared worthy of transmission only in insipid, prettily tinted engravings, and thus unworthy altogether. It was only in the third decade of the twentieth century that Edward Steichen, known for compelling cityscapes, aerial photography, and portraits, began to make idealizing camera images specifically for fashion. These were beautifully suggestive and moody black-and-white visions that gave an unheard-of aesthetic dimension to the idea of fashion. Thereafter the camera showed itself supremely fitted for generating fashion magic—and in the hands of the best photographers, the ones who were laying direct claim to the status of artist. Graphic fashion illustration shifted into a higher status for fashion itself. But the camera had to win for clothes. That was partly because the look of being the truth endorsed all photographs—fanciful, baroque, and abstract, or documentary and prosaic, and especially the ones that were both at once. Camera style in the twentieth century came to render dull or grim facts as romantic, and to lend exhilarating actuality to fantasy visions, with more universal authority than classic painting ever had.

Style in dress itself could only profit from such amazing transformations. Pretty engravings became historical curiosities, and graphic fashion illustration stretched further and further toward caricature, where it remains. The ever-broadening scope of photography pointedly included fashion in a variety of ways, and very different photographers showed how vital clothed appearance is in the look of the world. This gave new directions to clothing itself—instructions, that is, as well as ways to go. Emotional tone came consciously to inhabit the look of dressed persons, as fashion photography seemed to say it should. A charged and transient mood, generated in a crisp image of chic perfection, could seem to make a drama happen and suggest that fine clothes create vital events. An elegantly clad woman posed with her head turned away from the charred ruins behind her proposed something different from an elegantly clad woman in a blur, shot in mid-stride on a teeming city street.

Designers of clothing itself began to design for the inventive, interpretive, imaginative eye of photographers. Following the artists of the camera, fashion was fragmented into widely separate social and emotive flavors. The look of pictures by photojournalists, war correspondents, or researchers in anthropology invested the character of fashionable clothing itself. All carefully clothed appearance, whether in tattered jeans or sleek gauze or rough wool, started to see itself through camera eyes—not just of the reporters' cameras on the runway, but of the collective camera eye that by the last third of this century had come to govern the visual perception of human beings.

ANNE HOLLANDER

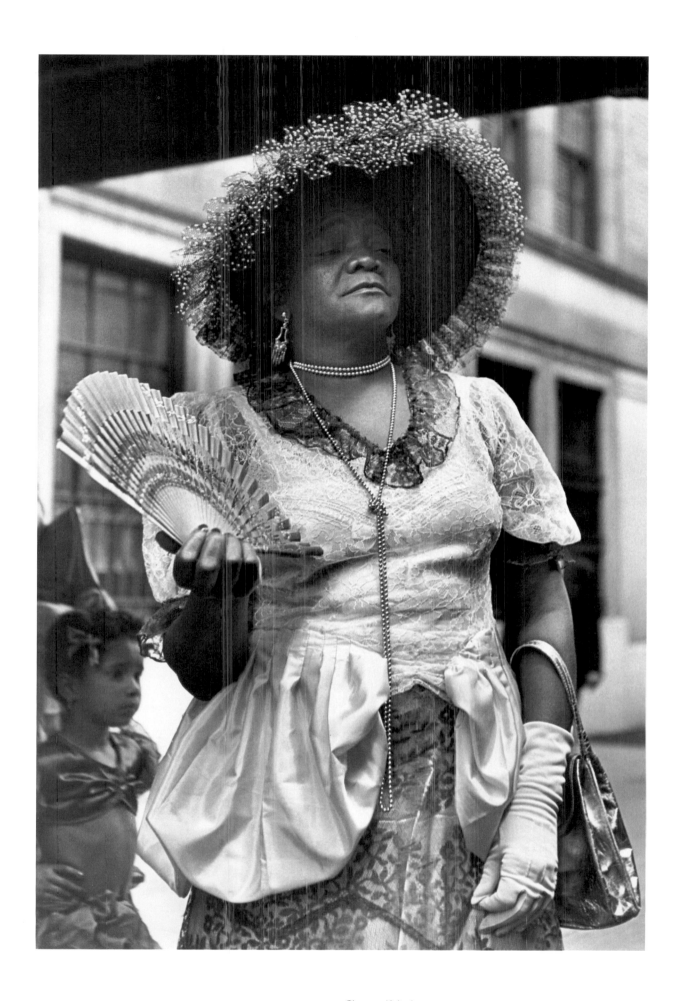

Clemens Kalischer
Cuban Lady, 1948
Gelatin silver print
13 x 8¾ inches
Photography in the Fine Arts Collection, 1981

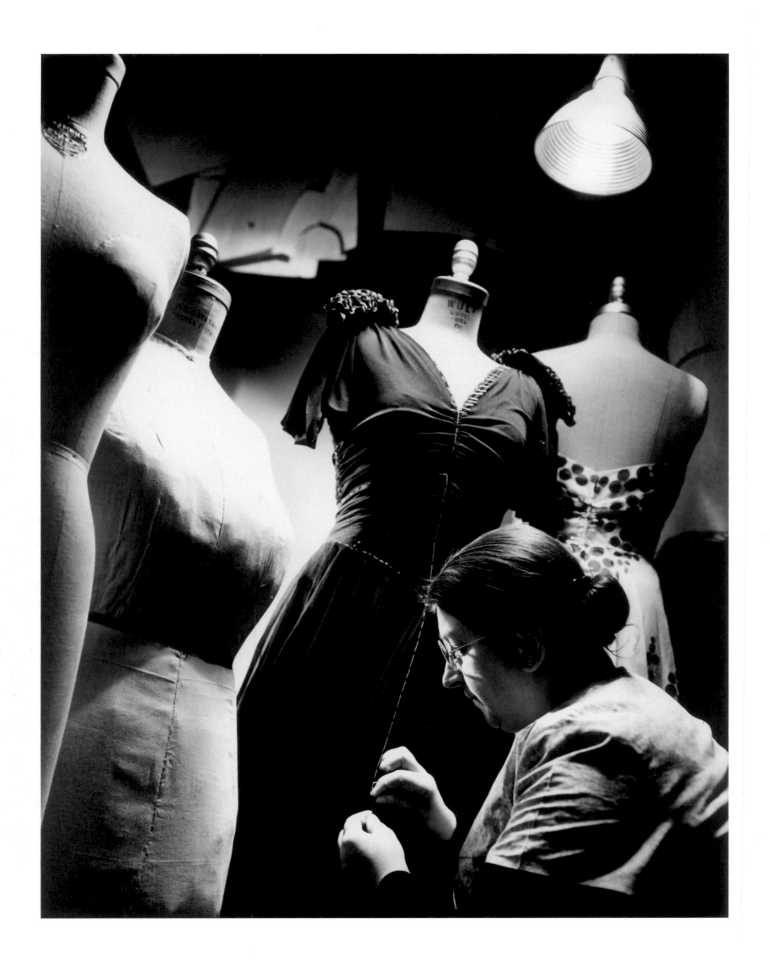

Anton Bruehl
Bergdorf Goodman Workshop, c. 1933
Gelatin silver print, c. 1980
13½ x 10¾ inches
Purchased, Vallarino Fashion Photography Fund, 1983
278.1983

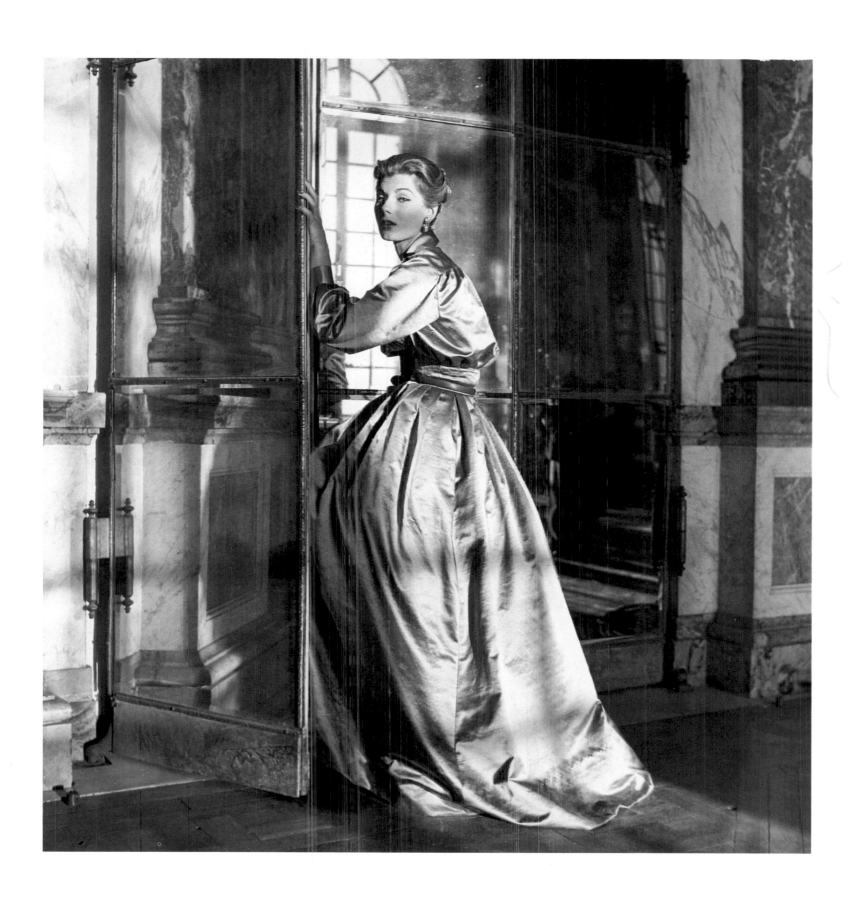

Frances McLaughlin-Gill
Tina Campbell at the Hall of Mirrors, Versailles, 1952
Gelatin silver print
15½ x 15 inches
ICP Purchase Fund, 1998
10.1998

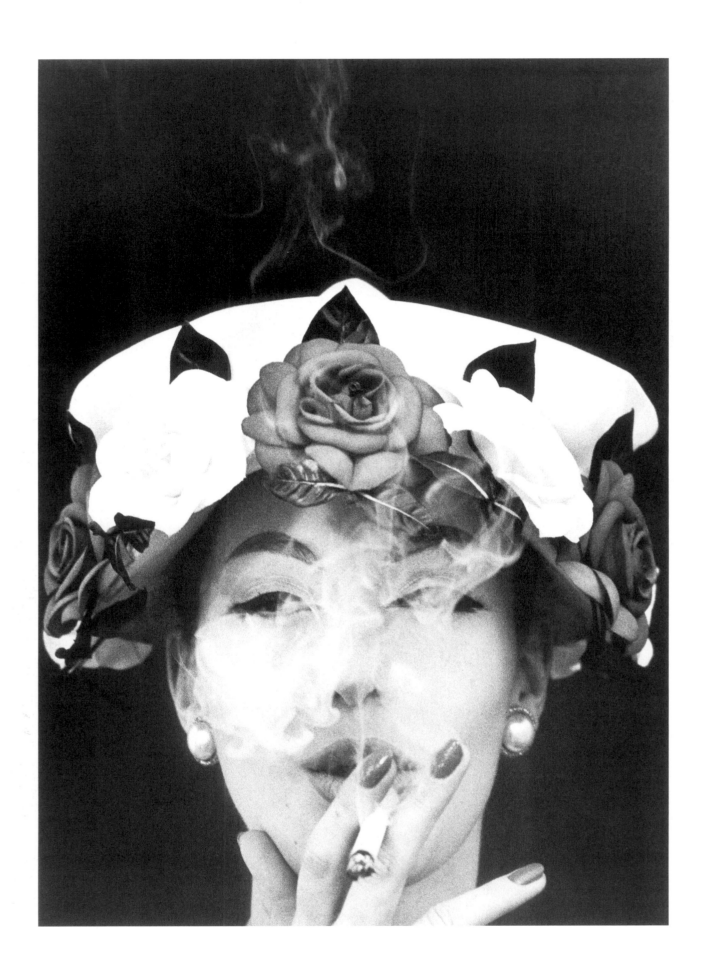

William Klein
Hat and Five Roses, 1956
Gelatin silver print
19⅜ x 15¼ inches
Photography in the Fine Arts Collection, 1981

51

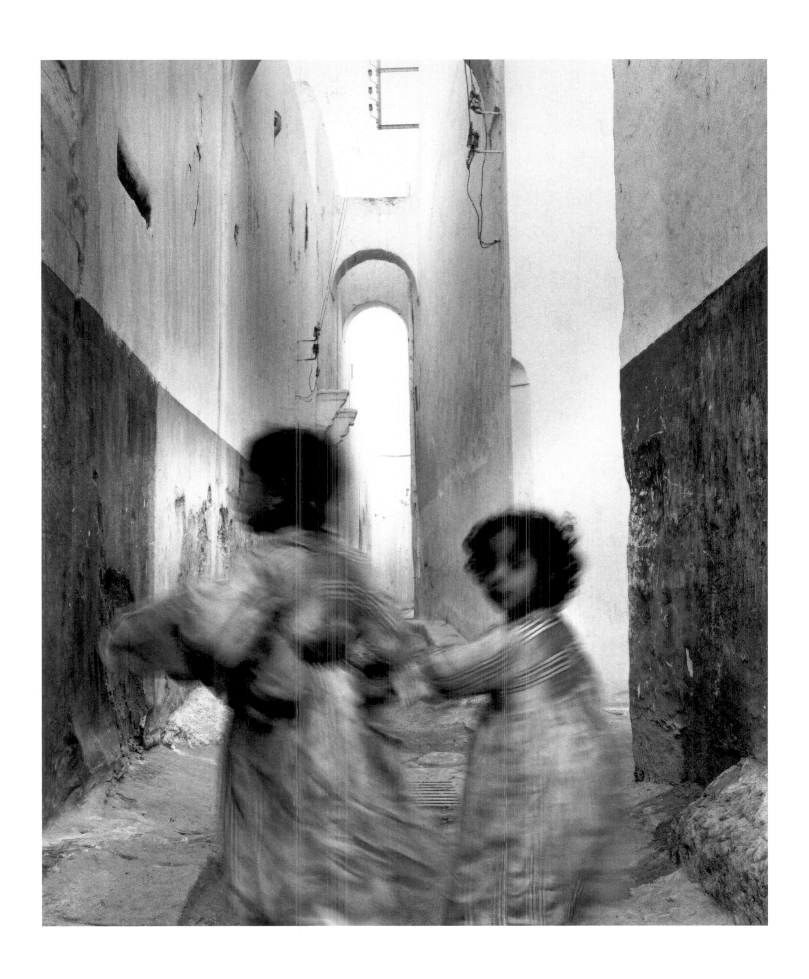

Irving Penn
Running Children, Morocco, 1951
Gelatin silver print, c. 1960
17¾ x 14⅞ inches
Photography in the Fine Arts Collection, 1981

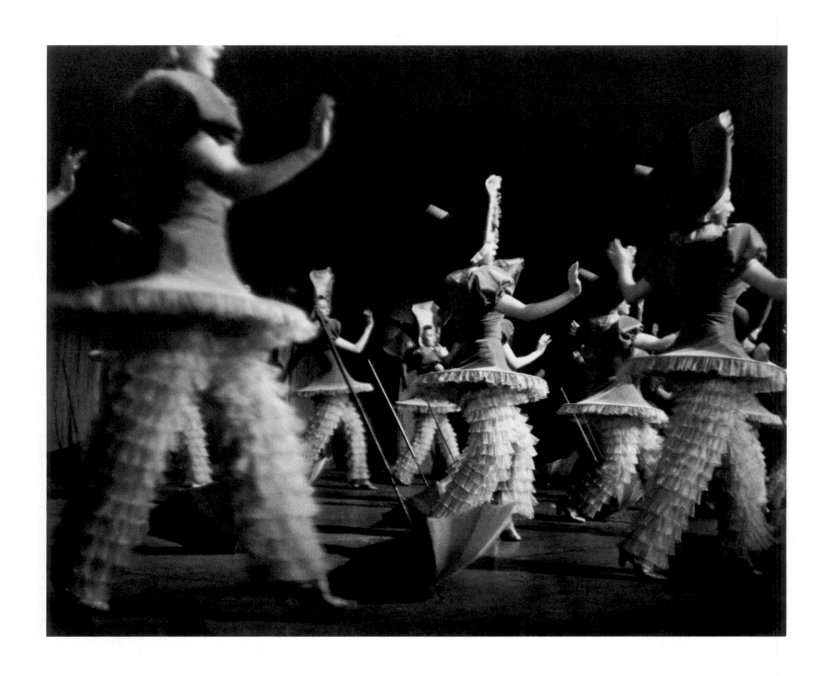

Jack Partington
Parasol Number, the Roxy Theater, New York, 1938
Gelatin silver print
8 x 9⅞ inches
Gift of Jeanne Partington, 1995
90.1995

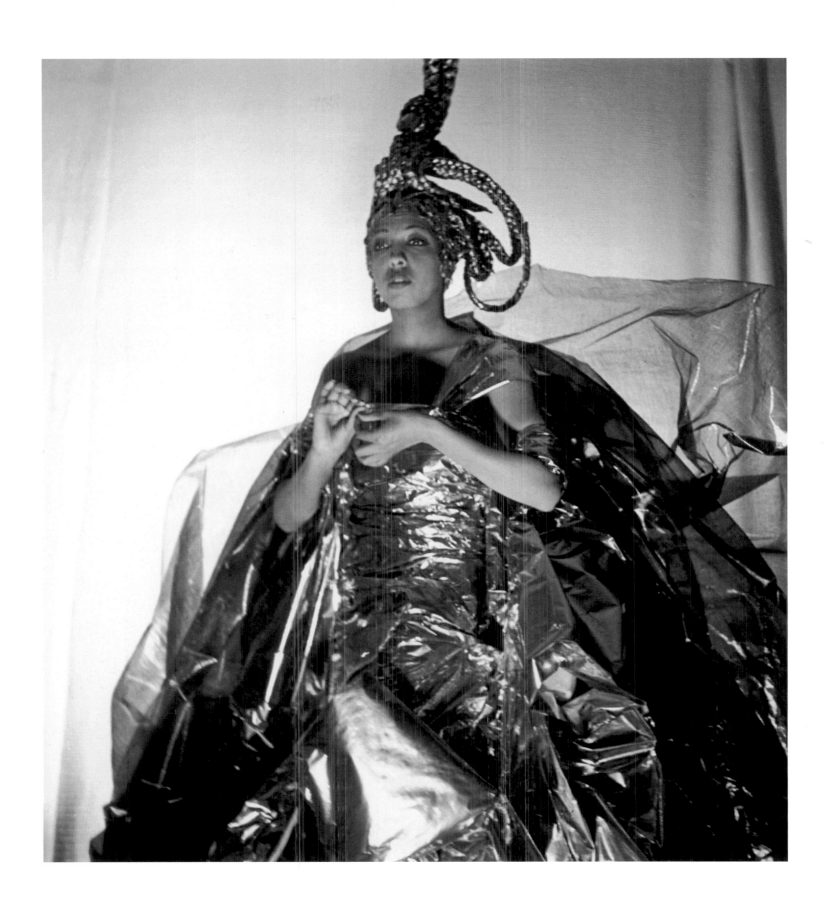

54

Louise Dahl-Wolfe
Josephine Baker, 1935
Gelatin silver print, c. 1980
11½ x 10⅝ inches
Gift of the photographer, 1982
71.1982

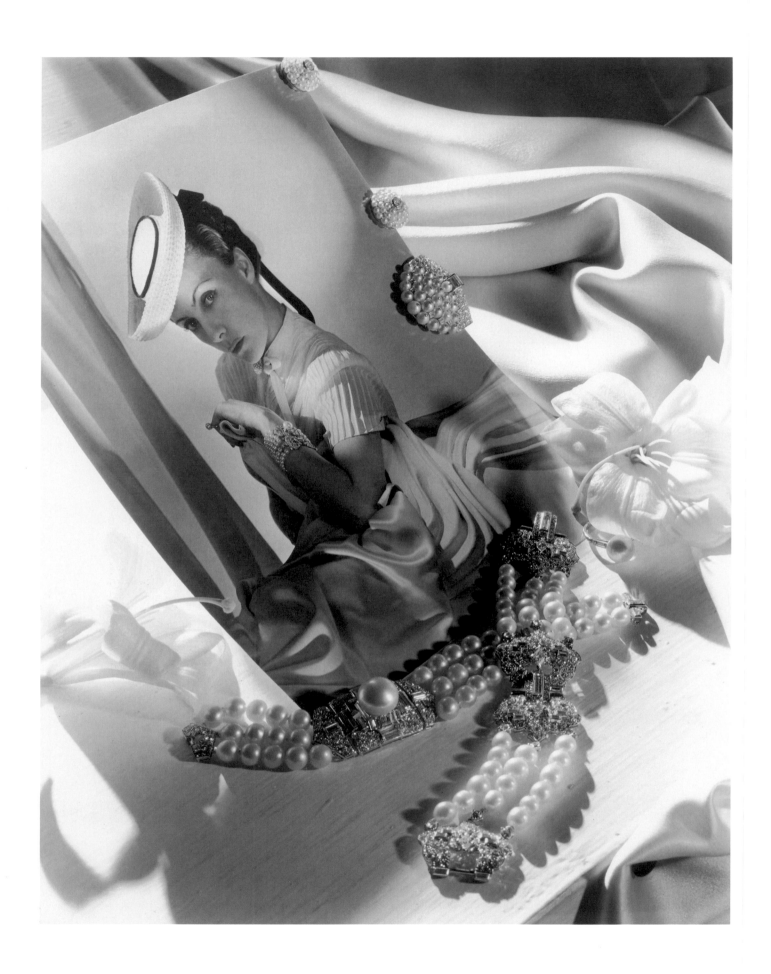

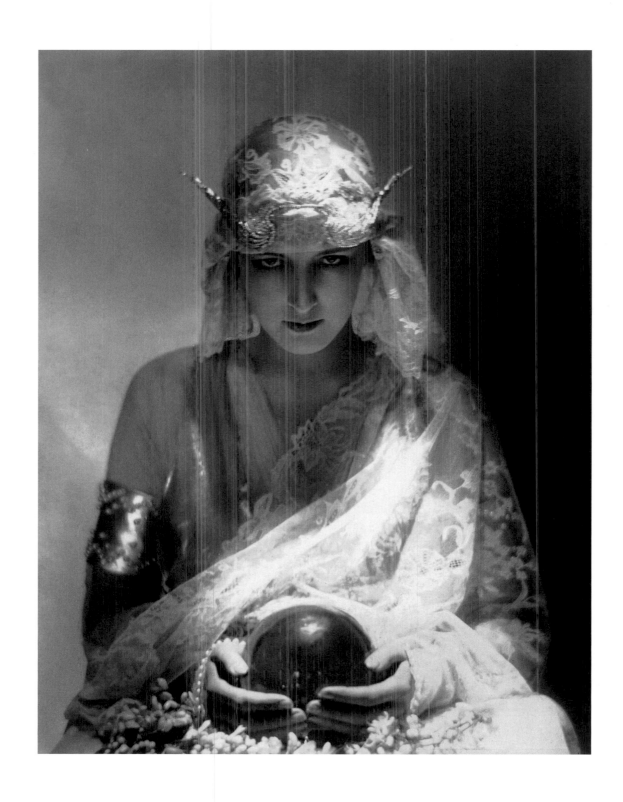

Baron Adolf de Meyer
Dolores Modeling, 1921
Gelatin silver print
9½ x 7⅜ inches
Purchased, Vallarino Fashion Photography Fund, 1982
386.1982

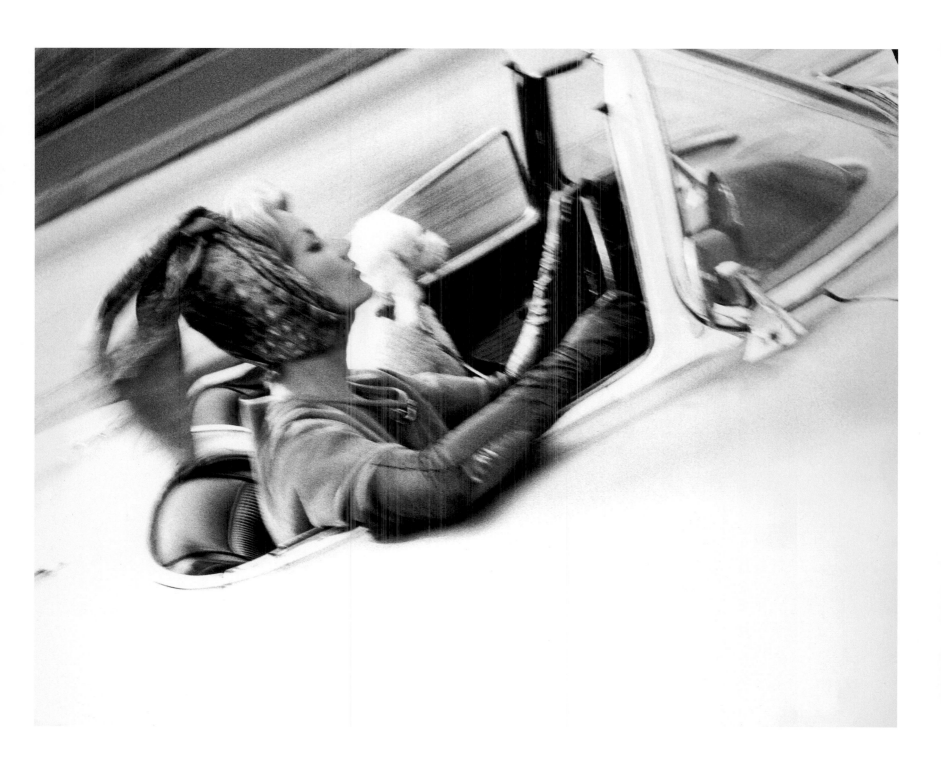

57

Lillian Bassmar
Lisa Fonssagrives, New York, 1961
Gelatin silver print
11 x 14 inches
ICP Purchase Fund, 1998
25.1998

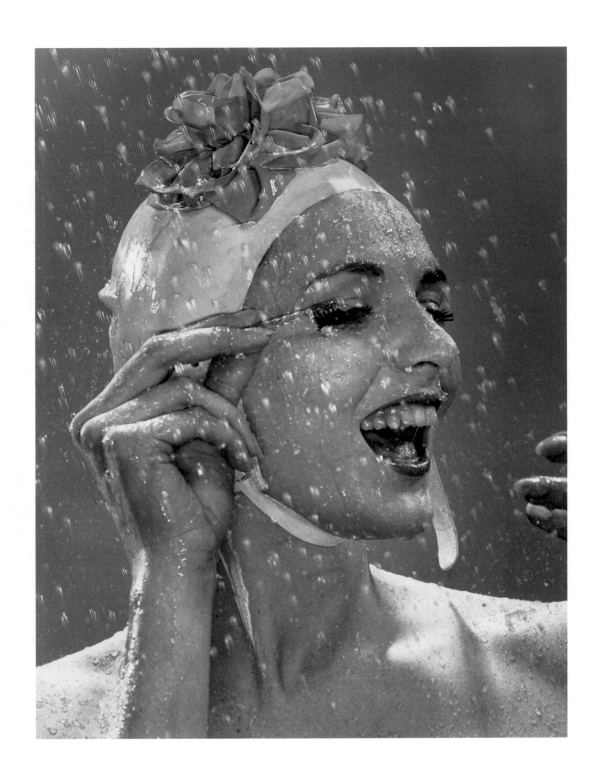

Gjon Mili
Fashion Advertisement for Saks Fifth Avenue, c. 1946
Gelatin silver print
13⅜ x 10¼ inches
ICP Purchase Fund, 1998
7.1998

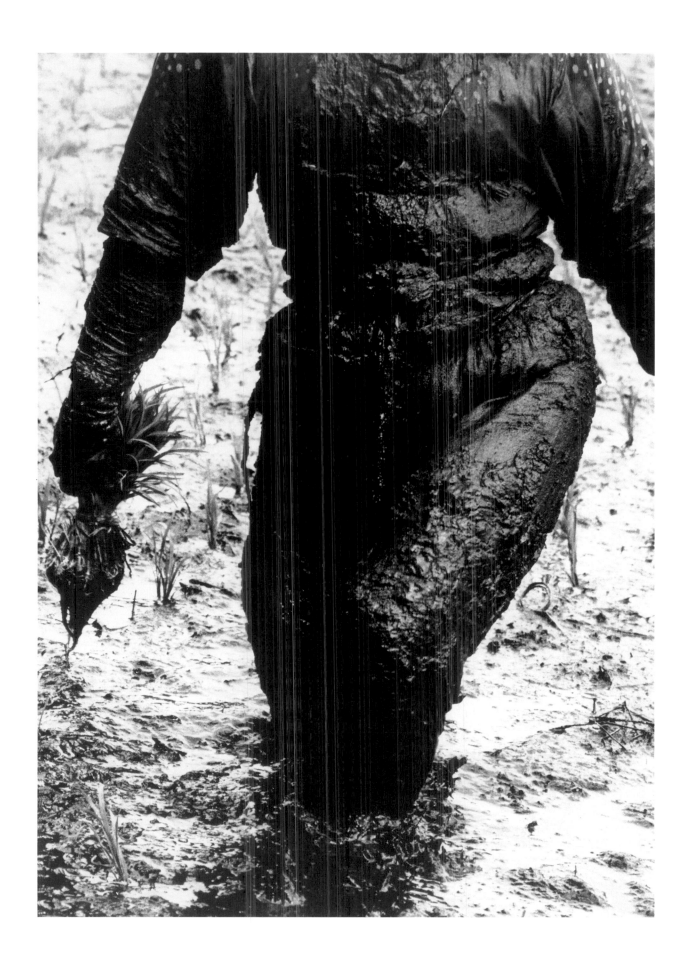

Hiroshi Hamaya
Planting Rice, Shirohiagi Nakashinkawa, Toyama, Japan, 1955
Gelatin silver print, c. 1975
10 x 7 inches
Purchased, International Fund for Concerned Photography, 1975
224.1975

59

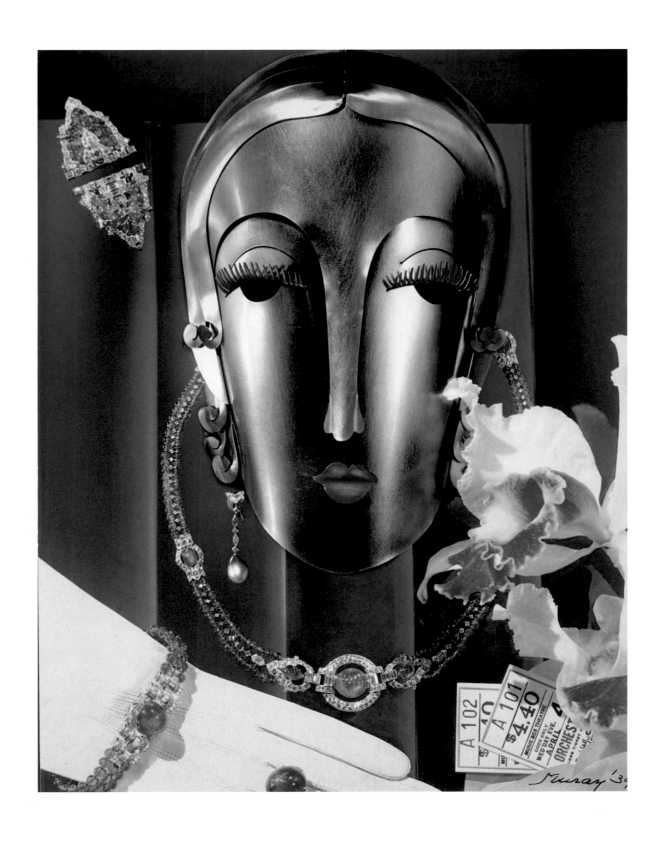

Nickolas Muray
[Still life with jewelry and mask], 1939
Carbro print
14 x 11 inches
Jacob Deschin Collection, 1982

Ruzzie Green
[Advertisement: Tippi Hedren], 1940s
Carbro print
15 x 12½ inches
Gift of Carol Jellinghaus, 1986
904.1986

61

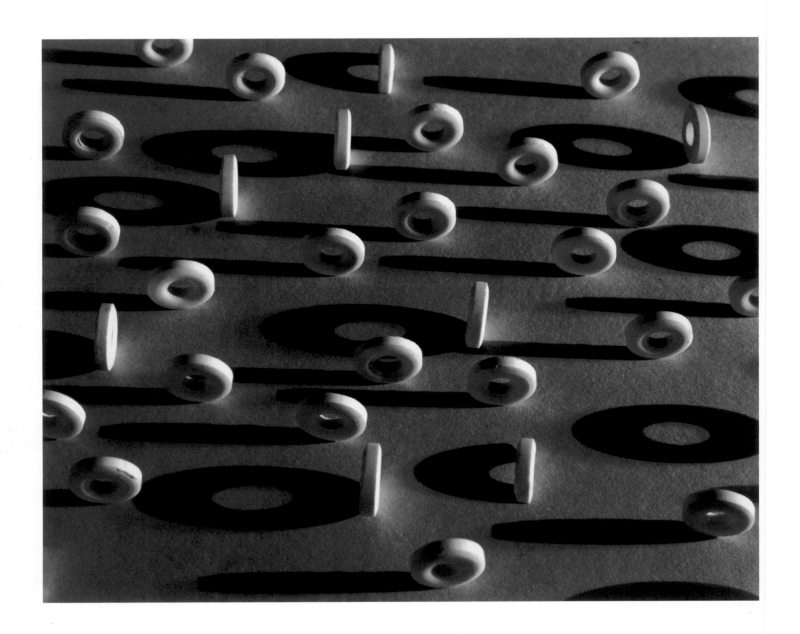

Ruth Bernhard
Lifesavers, New York, 1930
Gelatin silver print, 1970s
7 ⅜ x 9 ⅜ inches
Gift of the photographer, 1982
355.1982

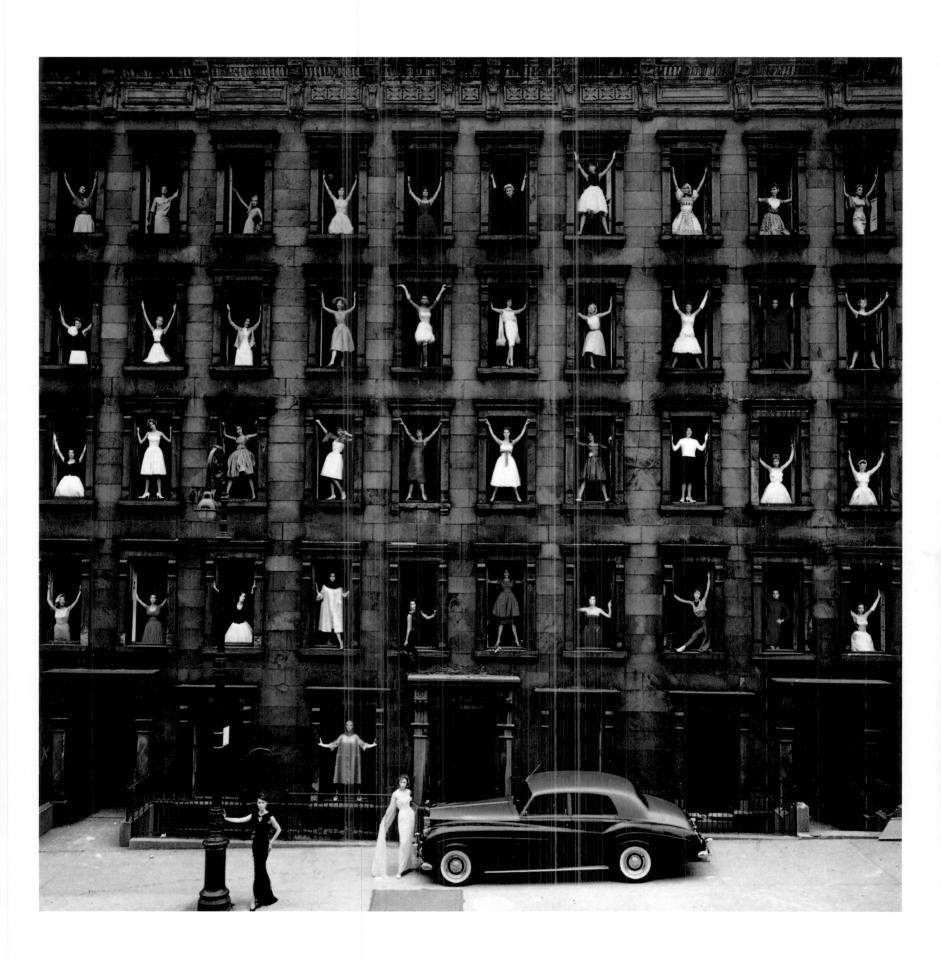

Ormond Gigli
Models in Window, New York, 1960
Dye transfer print
15¼ x 15½ inches
ICP Purchase Fund, 1998
12.1998

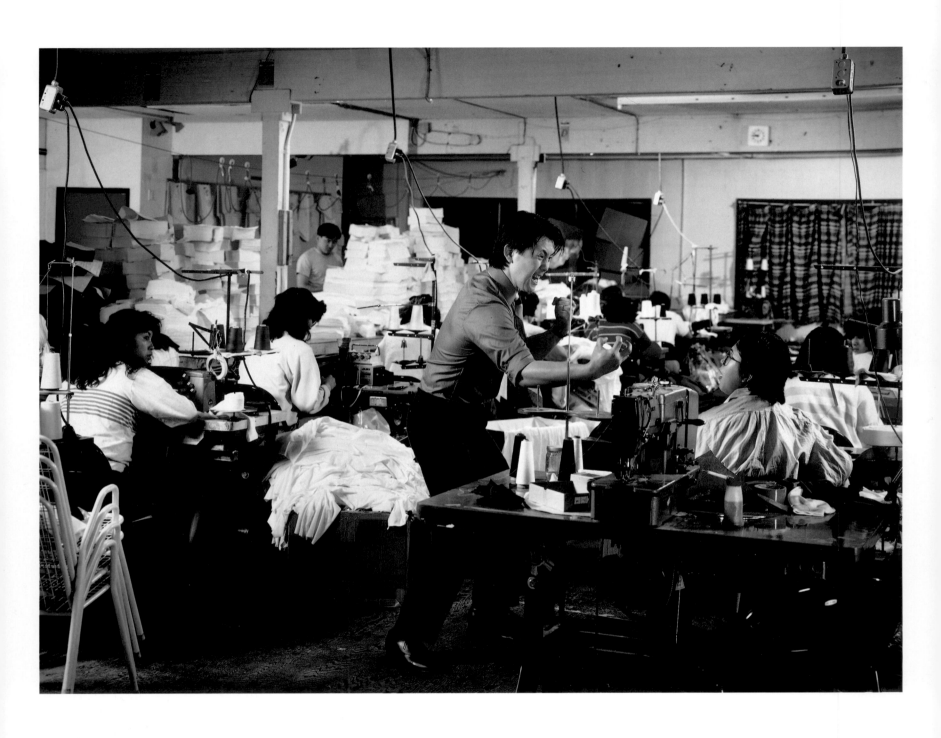

Jeff Wall
The Outburst, 1989
From the portfolio "In A Dream . . .", 1991
Silver dye bleach print
18 x 24 inches
Gift of Photographers + Friends United Against AIDS, 1998
2.1998i

64

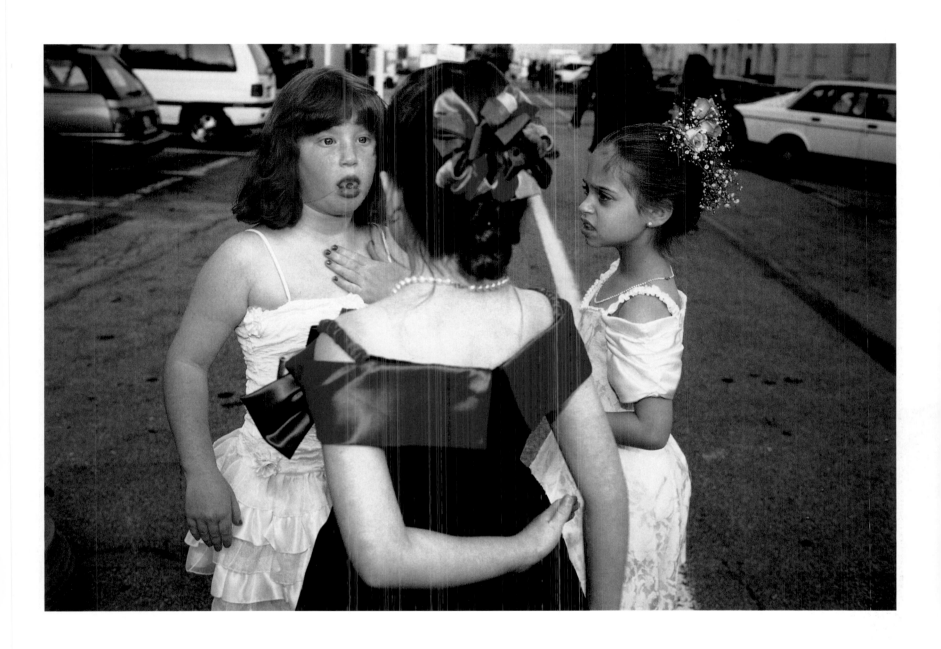

Lauren Greenfield
*A Bar Mitzvah Party at the 20th Century Fox Movie Studio Commissary,
West Los Angeles*, 1992
Silver dye bleach print
12¾ x 19⅜ inches
ICP Purchase Fund, 1997
62.1997

Interiors

The word confinement has only unpleasant associations: claustrophobia, prison, punishment. Photographs of interiors almost always begin by confining the viewer. This is done in many of the photographs on the following pages by describing the space with forceful vertical and horizontal elements forming rectangles, sometimes as tiny as a checkerboard pattern or a picture frame, sometimes broadly equivalent to the boundaries of the photograph. The human subjects are acted upon by the rectangles symbolizing and expressing confinement, and the effect is disturbing, even when the activities depicted are harmonious and collegial. People may be prisoners in their settings, as we sense from the vertical and horizontal lines around them as much as from their posture and expression.

A man fleeing up subway stairs in a photograph will never escape or arrive—a harsh square of light will block him—just as a man trying to exit the frame cannot transect the strong barrier of the doorjamb behind him, the visual limit of the picture. Emotionally charged moments captured by the camera are intensified by our sense that the subjects are doomed to forever reenact these moments, as scenes can be endlessly reenacted within the rectangle of a proscenium stage.

The photographs that least communicate the anxiety of confinement here are the portraits: perhaps because when the subject meets your gaze, you are reassured by his or her complicity, or perhaps because the confining rectangles are absent. What are the mysteriously inherent qualities of this form? Here we ask: are the rectangles present in all interior photography—a property of abiding principles of composition, of photographers, of the editor—the tic of an eye hungry for the neatness of enclosure?

Pictures capturing a moment of high drama in an interior effectively exclude us as viewers; we become voyeurs. But we ourselves can enter and inhabit an unpeopled interior. To this viewer, the popular magazines of interior decoration make a mistake when, in a photograph of a beautiful room, they include the owner. That person's propriety keeps us out. If the owner were not there, we could enter and make ourselves an imaginative home.

We ourselves might sit at that table, might write at that desk. Pictures of rooms with no one in them usually are welcoming, cozy, inviting squares, like pictures hung together at an exhibition, commenting on each other. Photographs of empty rooms allude to an exterior beyond themselves, suggested by the bright rectangles of windows—and televisions—encouraging expansion and escape. We are more comfortable in a room when we can see the exit.

In photographs, exterior landscapes—even with storms—are seldom emotionally charged but rather are calming. What people who are really outdoors may experience as bewildering largeness menacing their sense of identity and safety is almost always beautiful in photographs, or at any rate sublime. Human events in outdoor photographs are less disturbing than the same events photographed indoors. Imagine if E.J. Bellocq had photographed his Storyville women in porch chairs in gardens, for instance. Outdoors, their languorous postures and revealing garments would be less those of odalisques and more those of women on vacation—a more cheerful destiny than that we sense for them indoors.

DIANE JOHNSON

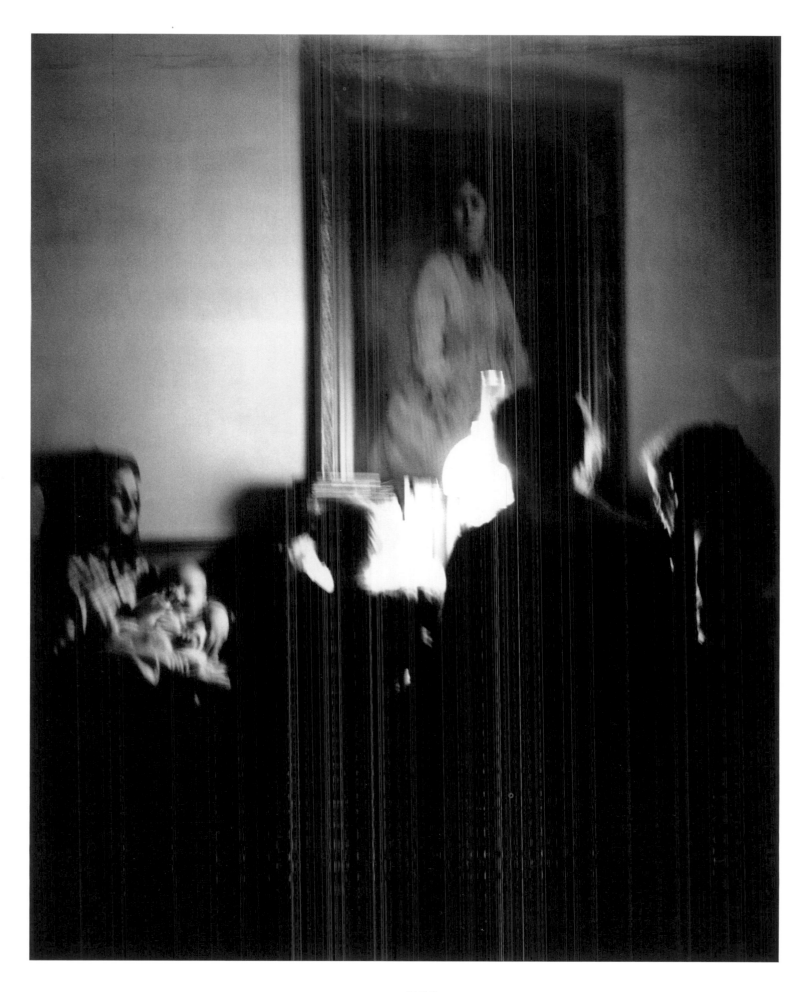

Nell Dorr
Family Ties, c. 1942
Gelatin silver print
19⅞ x 15⅞ inches
Gift of the photographer, 1982
34.1982

66

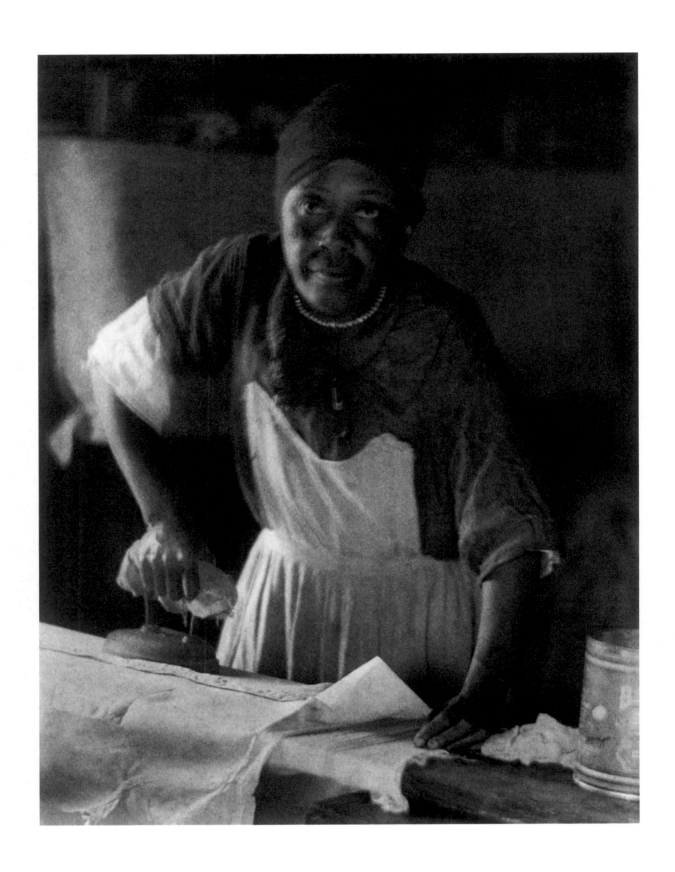

Doris Ulmann
Untitled [Woman ironing], c. 1933
Photogravure
8⅜ x 6½ inches
Gift of William Clift, 1983
598.1983

67

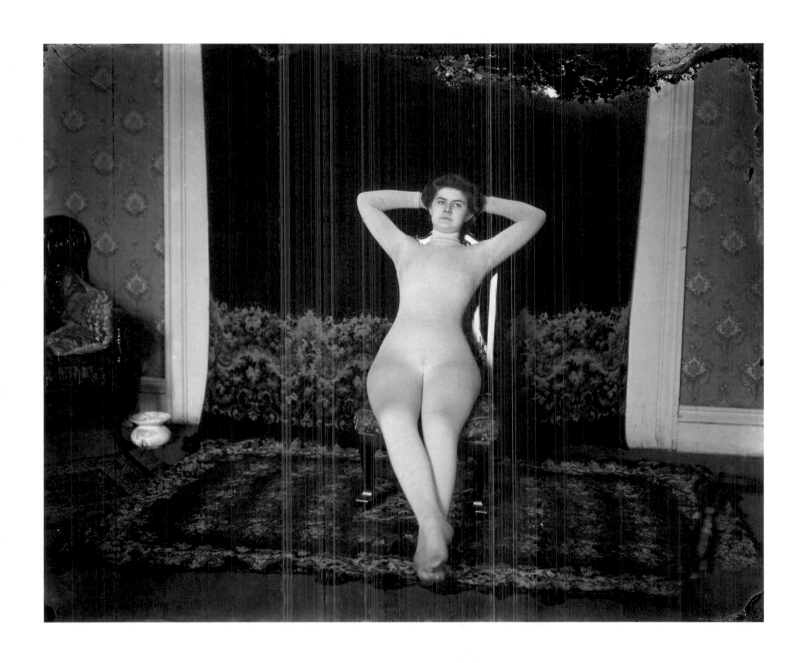

Ernest J. Bellocq
Storyville Portrait, New Orleans, 1911–1913
Gold toned printing-out paper from glass negative, c. 1970
Printed by Lee Friedlander
8 x 9⅞ inches
Gift of Arthur and Dolores Kiriacon, 1985
301.1985

68

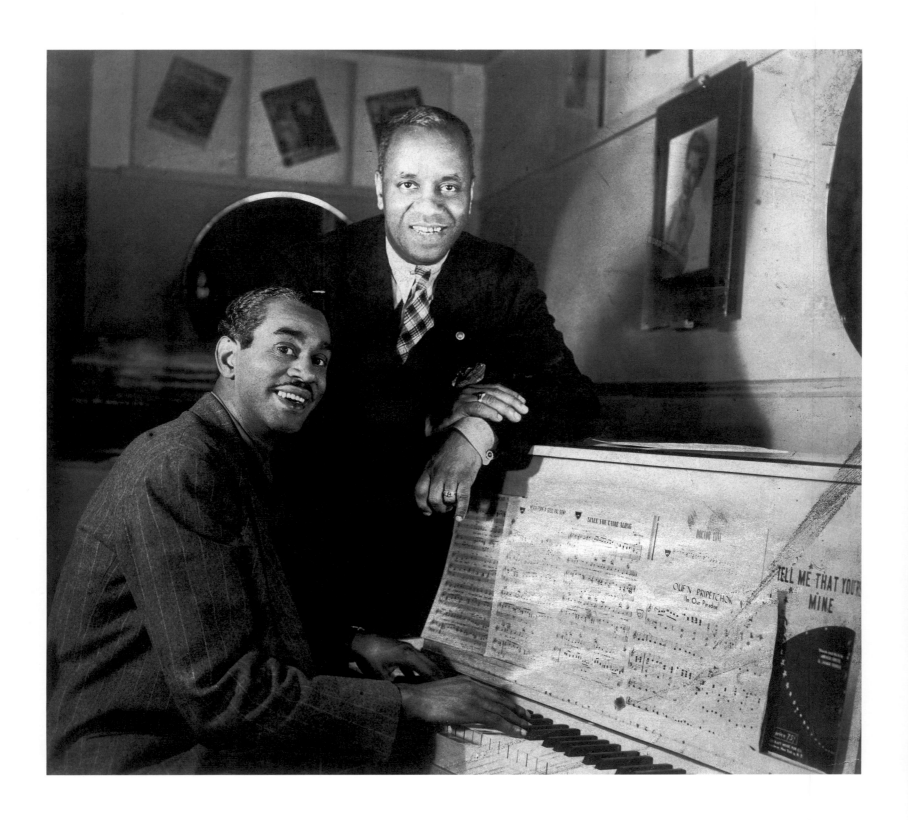

Photographer Unknown
[Two men at the piano], 1930s
Gelatin silver print
13⅜ x 15¼ inches
The Daniel Cowin Collection, gift of Daniel Cowin, 1992

69

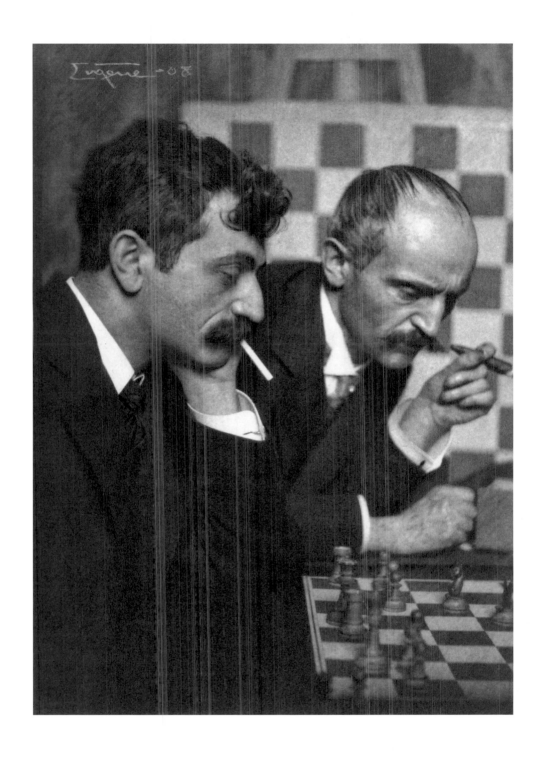

Frank Eugene
Dr. Emanuel Lasker and His Brother, 1908
From *Camera Work*, volume 31, July 1910
Photogravure
6⅞ x 4⅞ inches
Gift of Daniel Logan, Richard Logan, and Jonathan Logan, 1984
795.1984

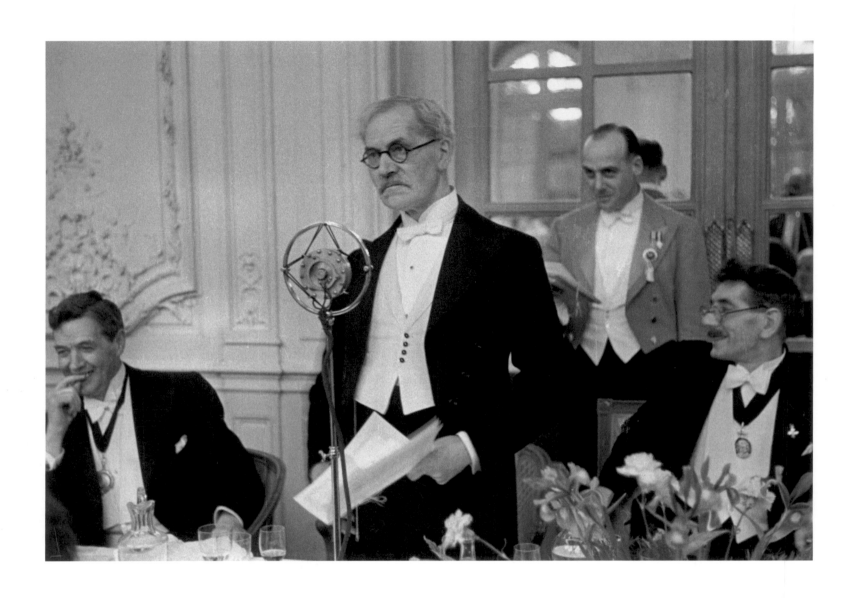

Erich Salomon
Prime Minister J. Ramsay MacDonald Speaking at Dinner of a Teachers'
Organization, London, 1935
Gelatin silver print, 1980s
9 x 13¼ inches
ICP Purchase Fund, 1986
125.1986

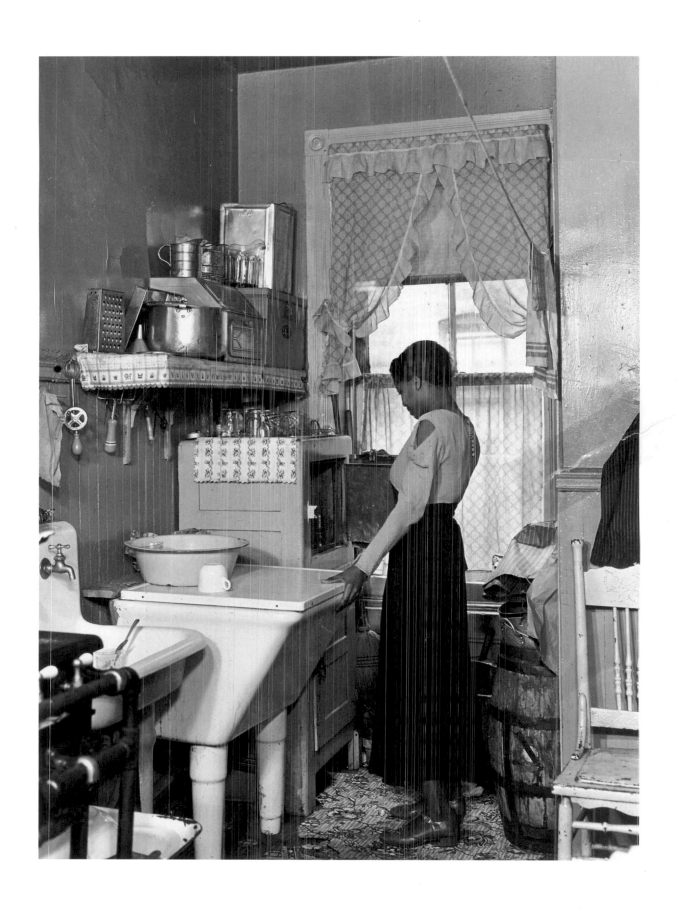

Aaron Siskind
[Woman looking into icebox], 1937–1939
Gelatin silver print, c. 1980
10½ x 7¾ inches
Gift of Emanuel M. Brotman, 1981
98.1981

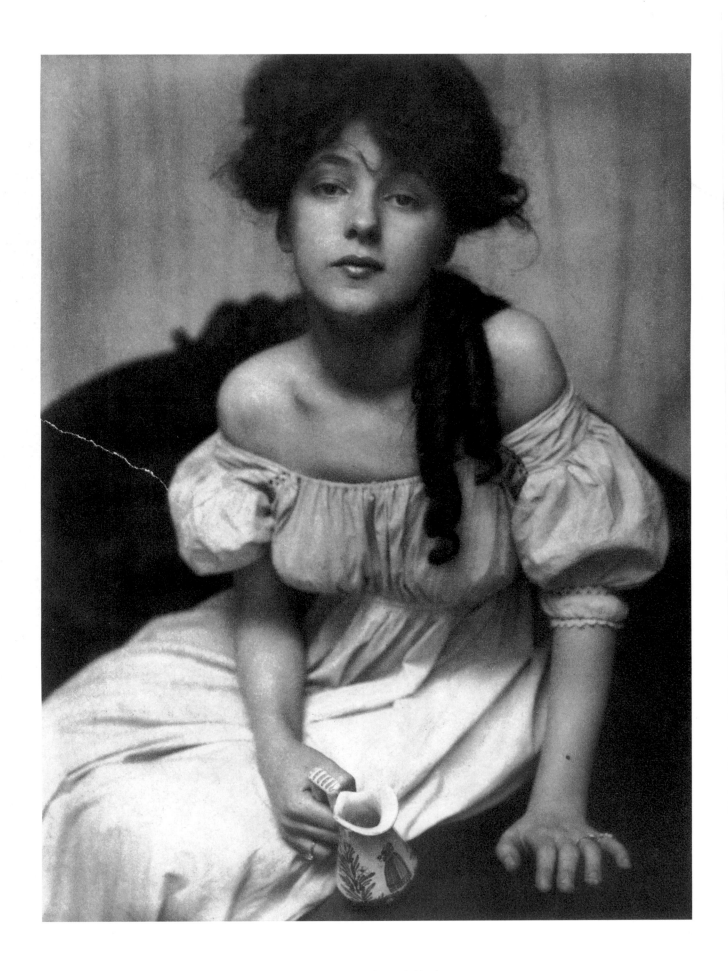

Gertrude Käsebier
Portrait (Miss N.), 1902
From *Camera Work*, volume 1, January 1903
73 Photogravure
7¾ x 5⅞ inches
Gift of Daniel Logan, Richard Logan, and Jonathan Logan, 1984
788.1984

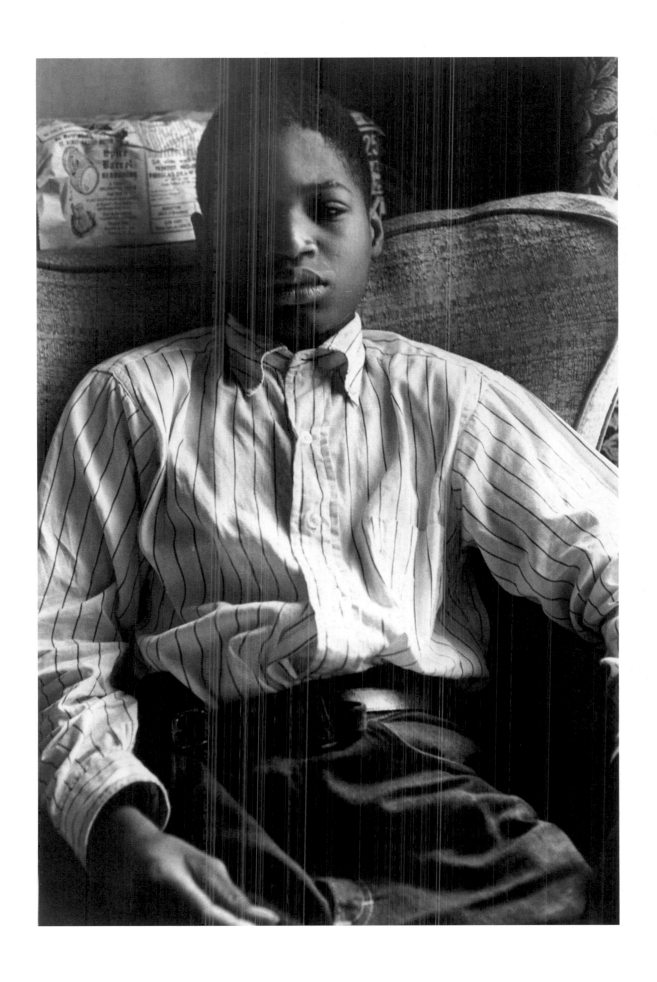

Sandra Weiner
George, 1968
Gelatin silver print
9½ x 6¼ inches
Jacob Deschin Collection, 1982

Roy DeCarava
Man on Subway Stairs, 1952
Gelatin silver print
18⅞ x 12¾ inches
Photography in the Fine Arts Collection, 1981

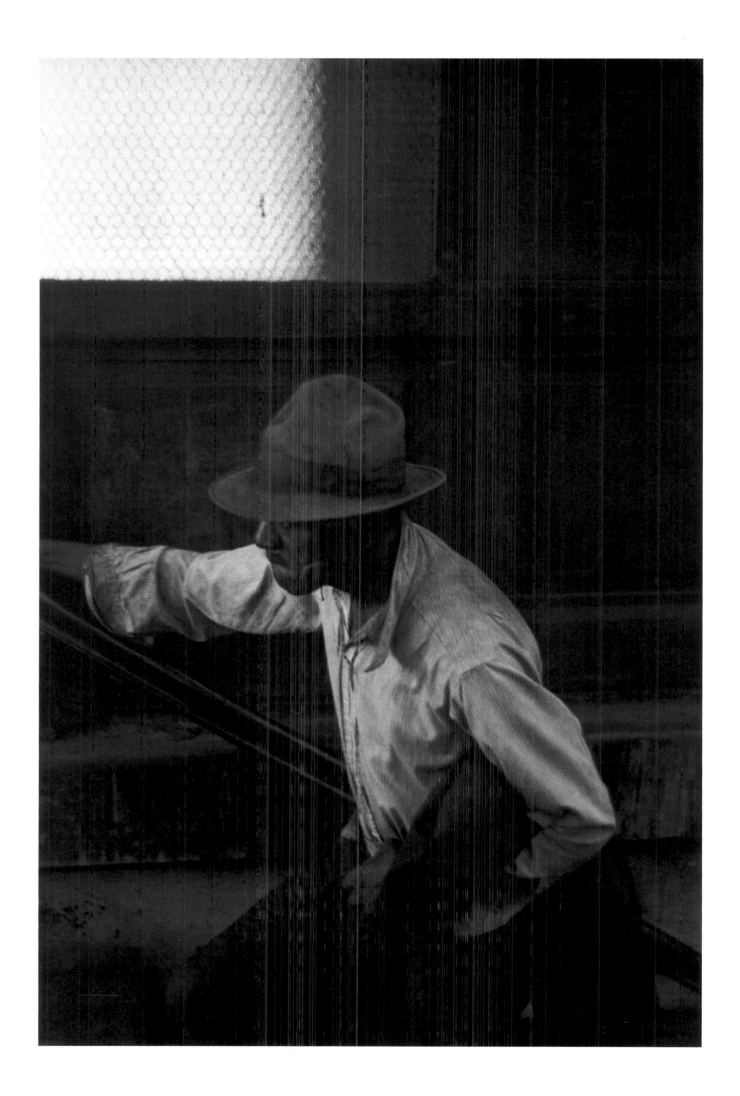

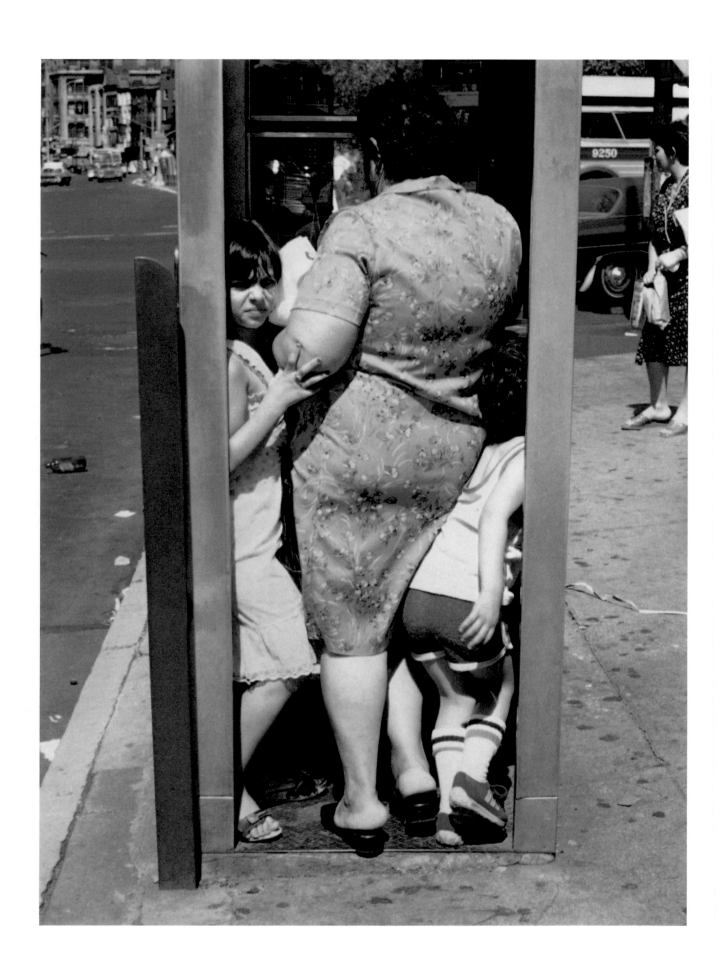

Helen Levitt
New York, 1988
Dye transfer print
12 x 8⅞ inches
ICP Purchase Fund, 1997
146.1997

76

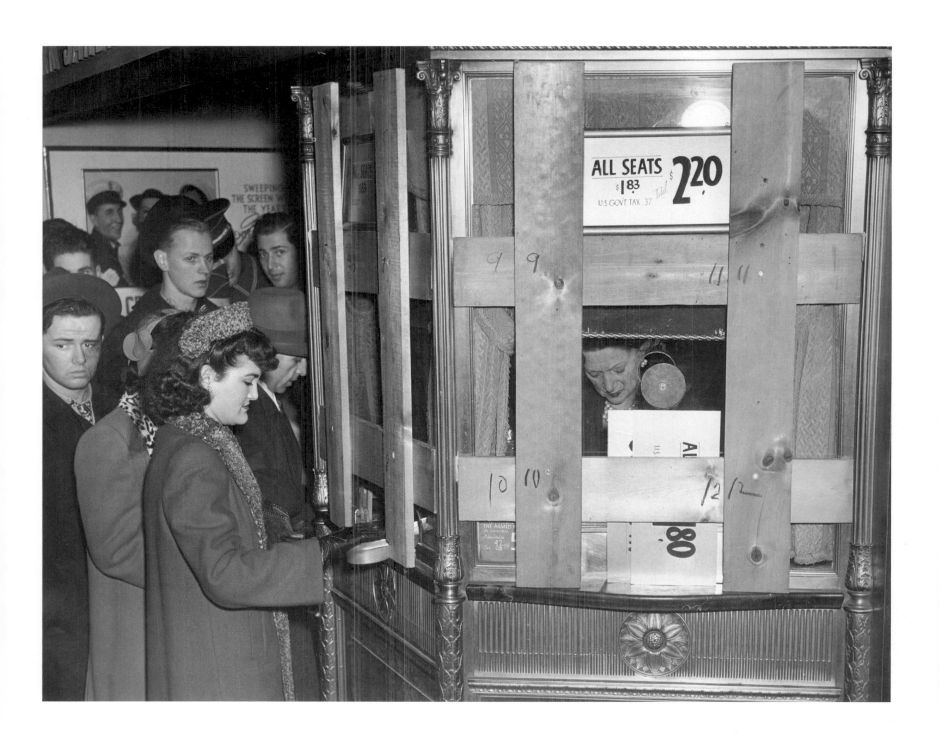

ALL SEATS $2.20
$1.83
U.S. GOV'T TAX .37

Weegee (Arthur Fellig)
[Ticket booth], 1940s
Gelatin silver print
10⅝ x 13¾ inches
Weegee Archive, Bequest of Wilma Wilcox, 1993
610.1993

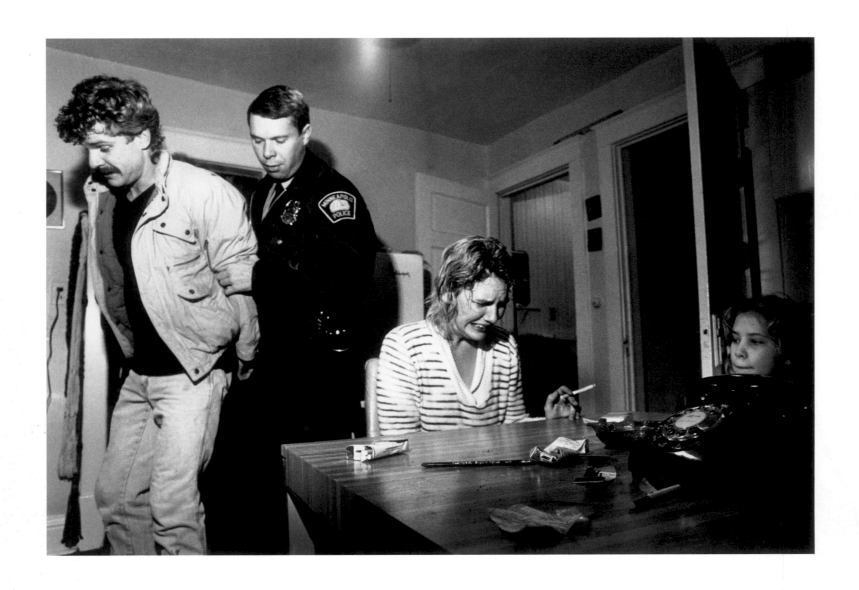

Donna Ferrato
Minneapolis, Minnesota, 1988
Gelatin silver print
13 x 19 inches
Gift of the photographer to the W. Eugene Smith Legacy Collection at the
International Center of Photography, 1994
546.1994

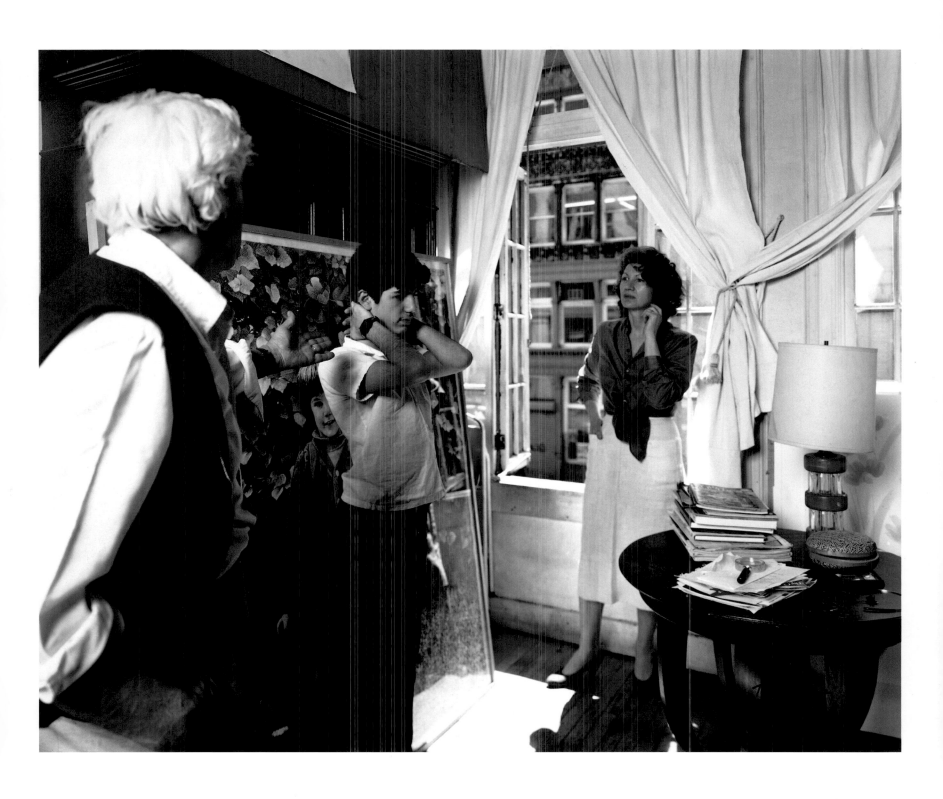

79

Tina Barney
The Son, 1990
From the portfolio "In A Dream . . .", 1991
Chromogenic print
19 x 23½ inches
Gift of Photographers + Friends United Against AIDS, 1998
2.1998a

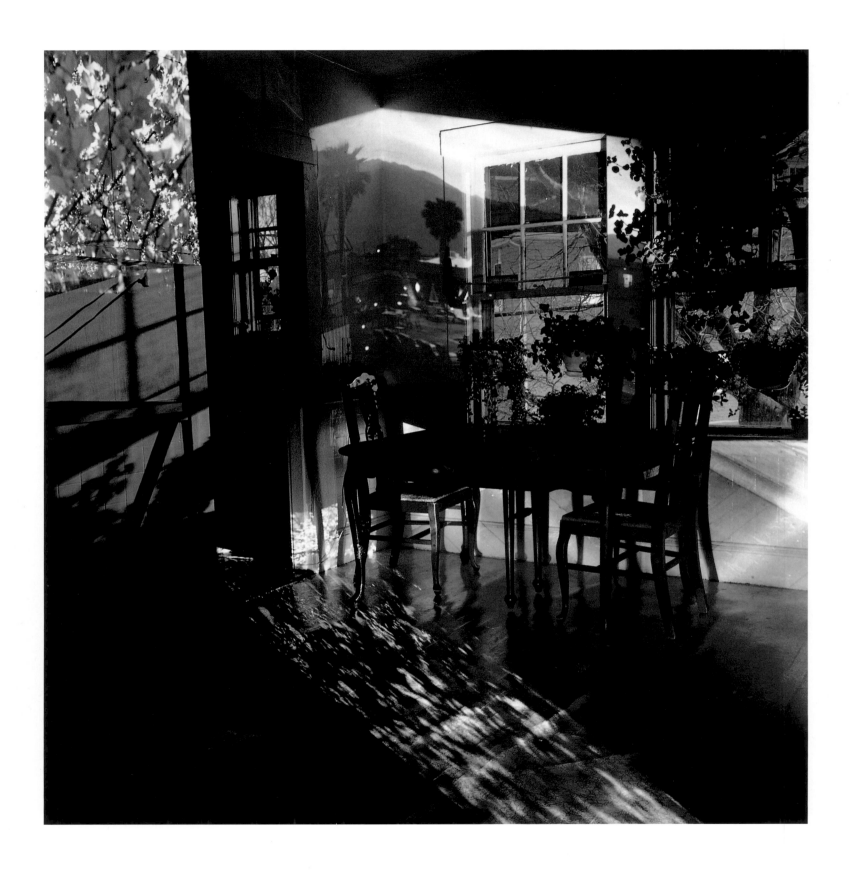

Lorie Novak
Untitled [Interior with color projections of trees], 1980
Chromogenic print
14½ x 14¼ inches
ICP Purchase Fund, 1986
276.1986

80

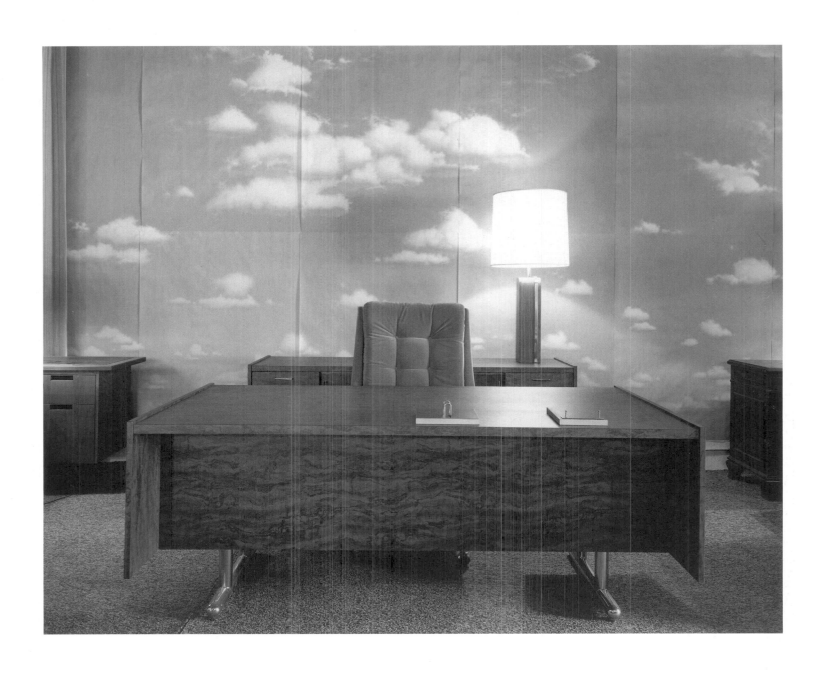

Lynne Cohen
Futuristic Furniture Supply, Ottawa, 1976
Gelatin silver print
7⅜ x 9½ inches
Gift of the photographer, 1984
300.1984

81

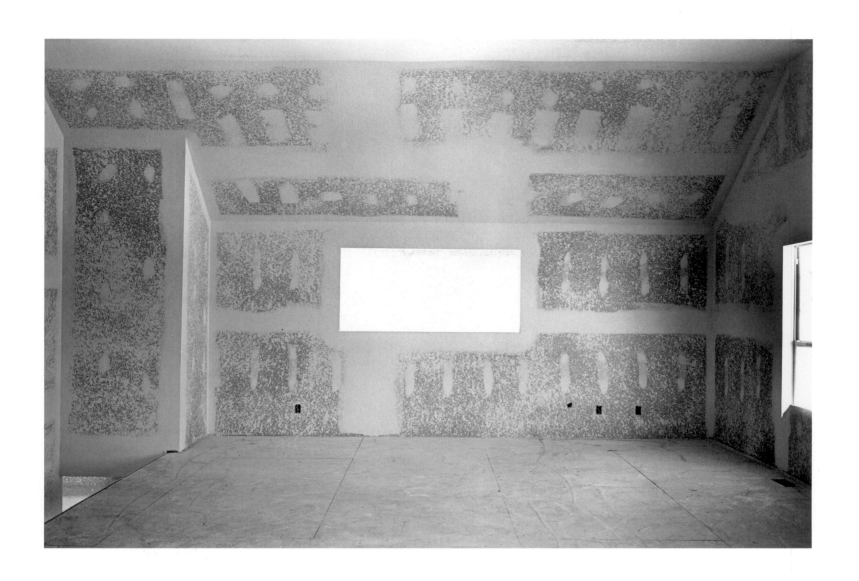

Lewis Baltz
Untitled, 1975
From the portfolio "Park City," 1979
82 Gelatin silver print
6⅜ x 9½ inches
Gift of Mr. Wayne R. Brandow, 1986
895.1986

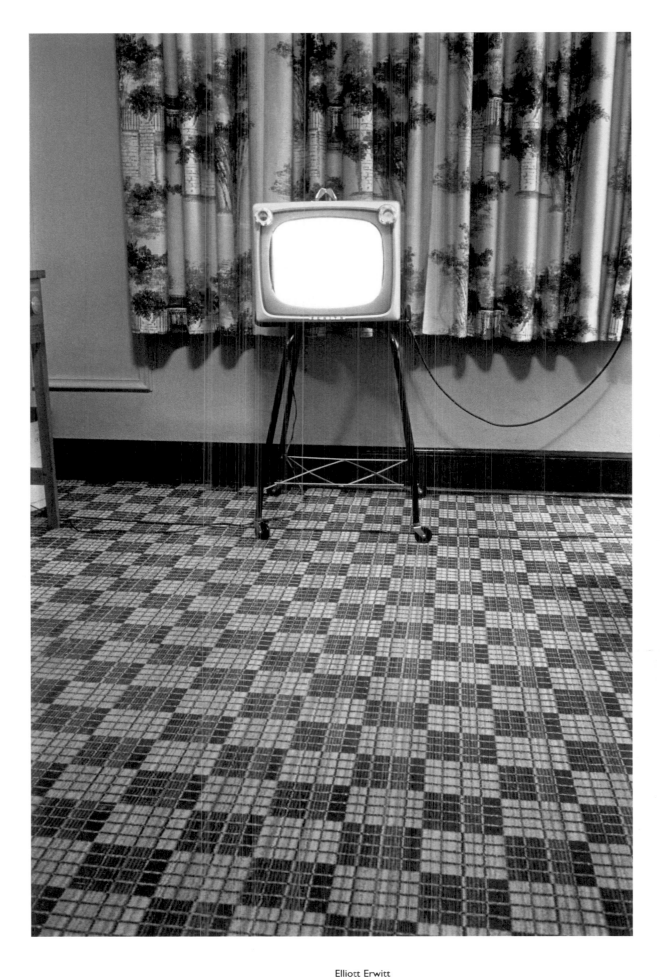

Elliott Erwitt
Texas, 1962
Gelatin silver print
15⅜ x 10⅝ inches
Gift of the Professional Photography Division,
Eastman Kodak Company, 1989
658.1989

83

Cities and Urban Encounters

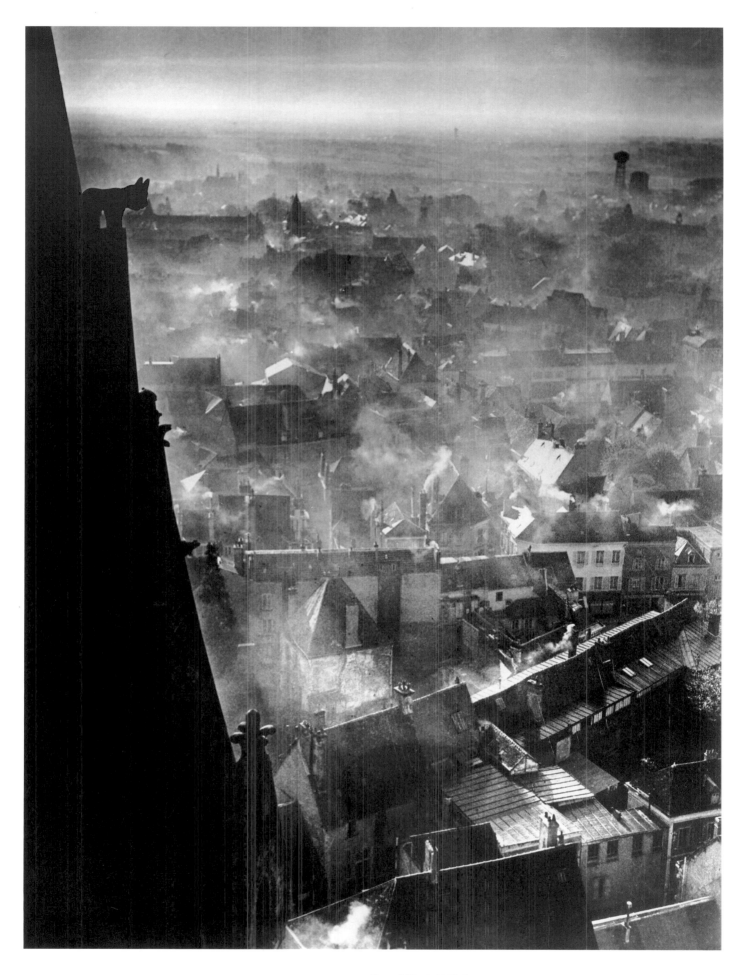

Brassaï (Gyula Halász)
Chartres en Hiver [Chartres in winter], 1946
Gelatin silver print, 1970s
12⅛ x 9¼ inches
Gift of Bryce Holcomb, 1981
275.1981

84

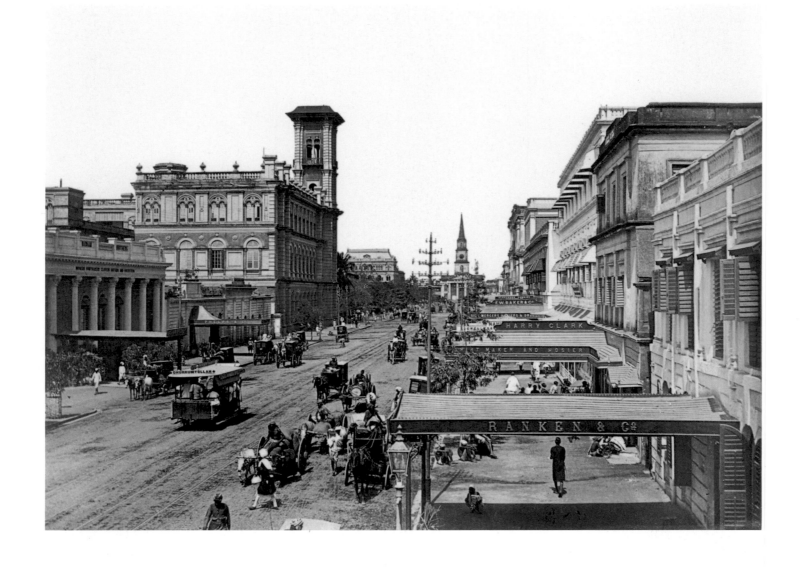

85

Photographer Unknown
Old Court House Street from Great Eastern Hotel, Calcutta, India, 1880s
Albumen silver print from glass negative
4½ x 6 inches
Gift of John Horne, 1980
45.1980

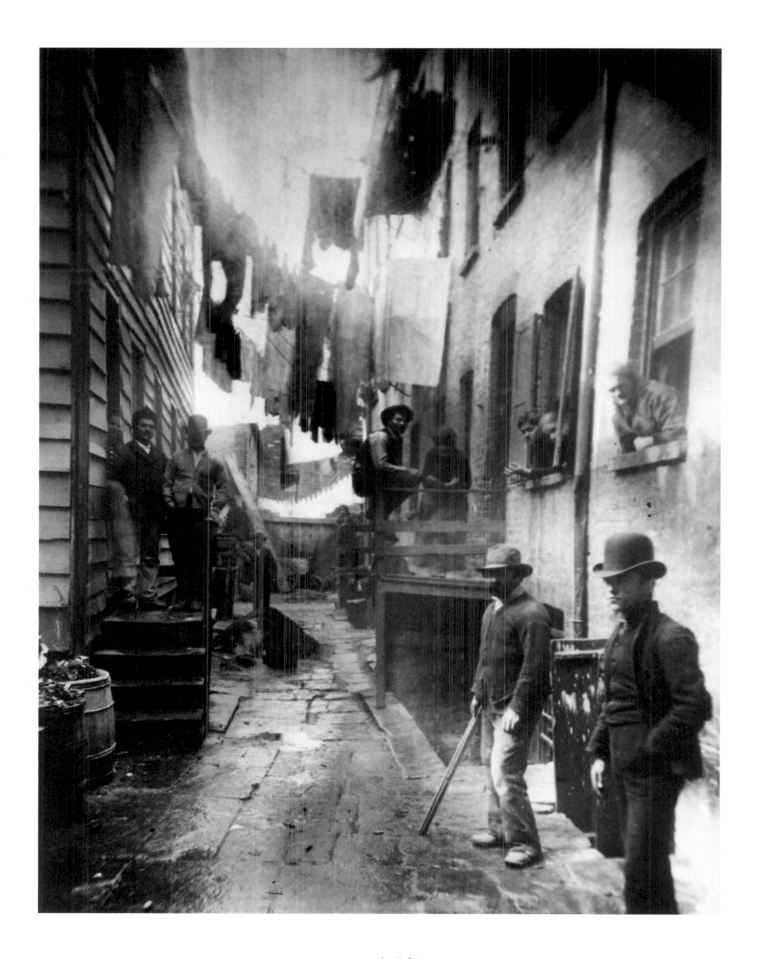

Jacob Riis
Bandits' Roost, 1888
Gelatin silver print from glass negative, 1940s
Printed by Alexander Alland, Sr.
13½ x 10⅜ inches
Purchased with funds from the Zenkel Foundation and partial gift of
Alexander Alland, Sr., 1982
235.1982

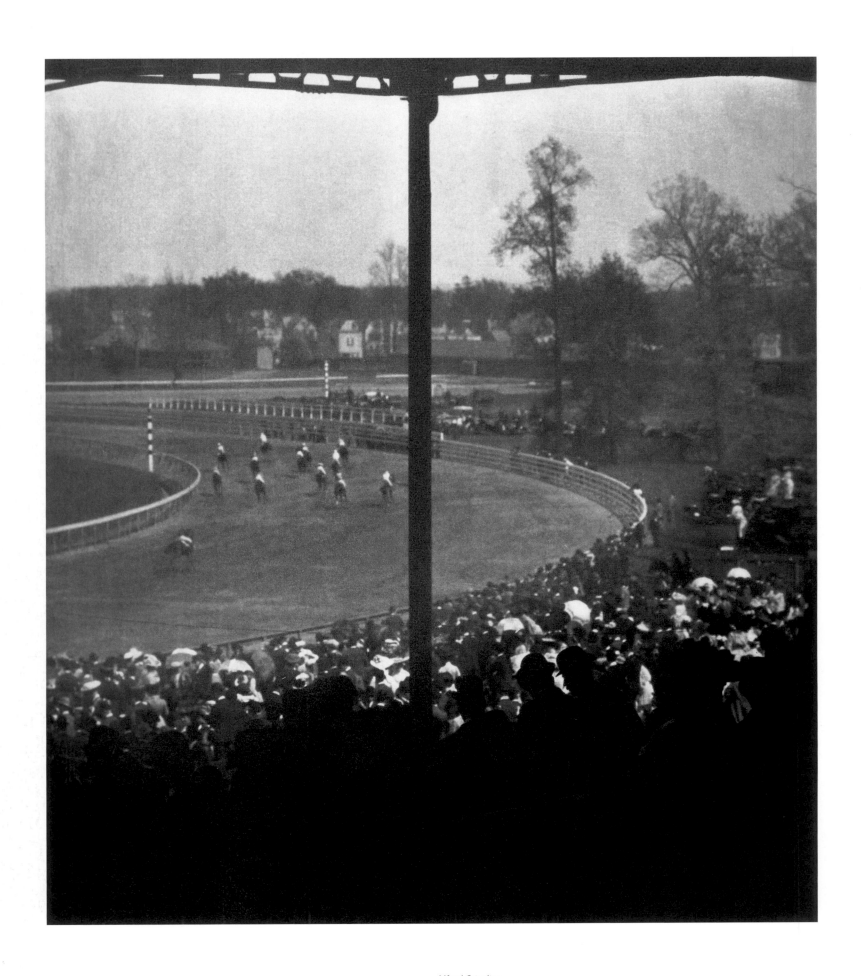

Alfred Stieglitz
Going to the Start, 1904
From *Camera Work*, volume 12, October 1905
Photogravure
8⅜ x 7½ inches
Gift of Daniel Logan, Richard Logan, and Jonathan Logan, 1984
790.1984

87

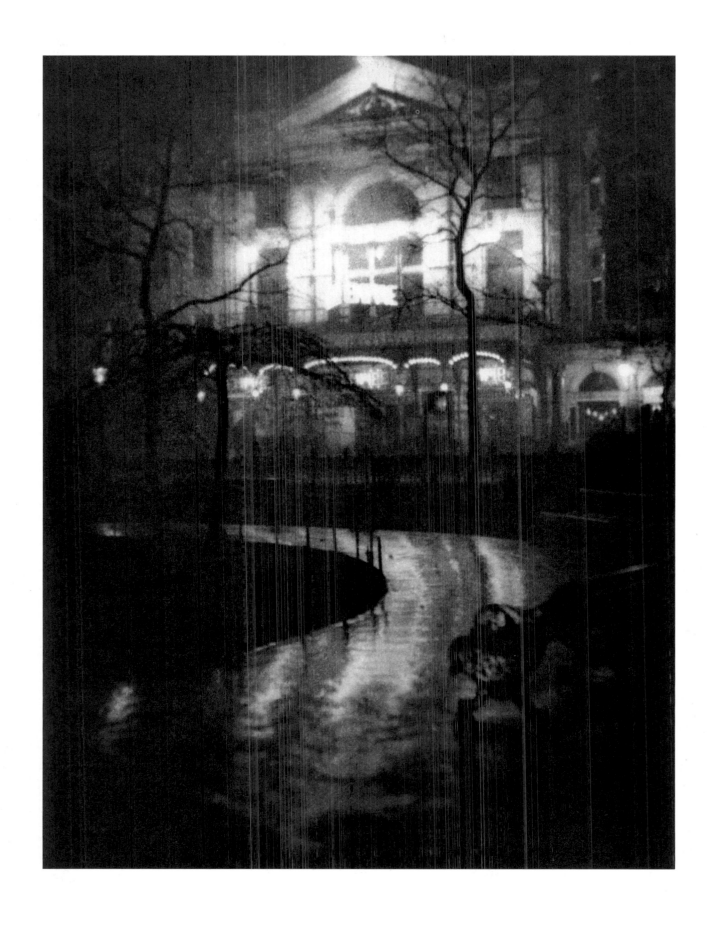

Alvin Langdon Coburn
Leicester Square, 1906
From *London*, 1909
Photogravure
7⅞ x 6⅛ inches
Gift of June Sidman, 1981
136.1981

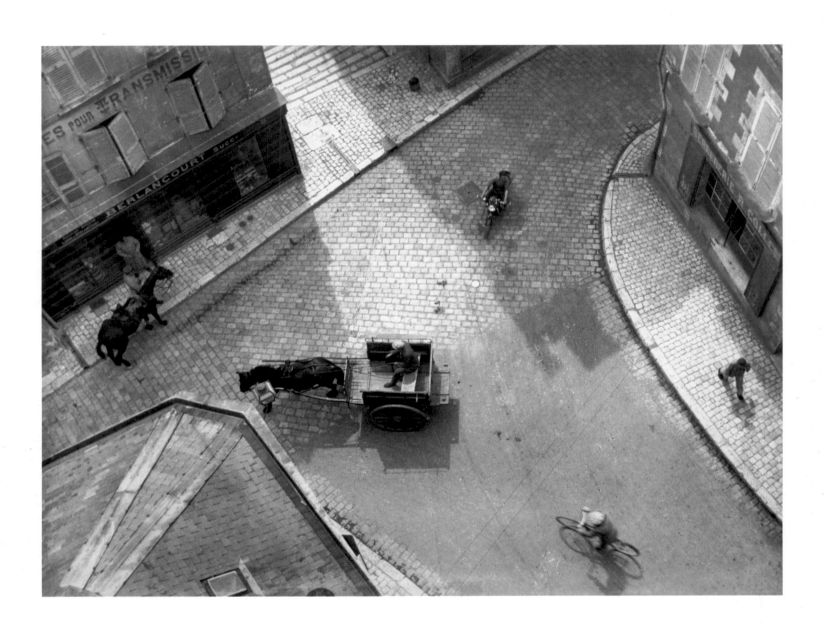

André Kertész
Carrefour [Crossroads], 1930
Gelatin silver print, 1980s
7⅜ x 9¾ inches
Gift of Igor Bakhtamian, 1986
914.1986

89

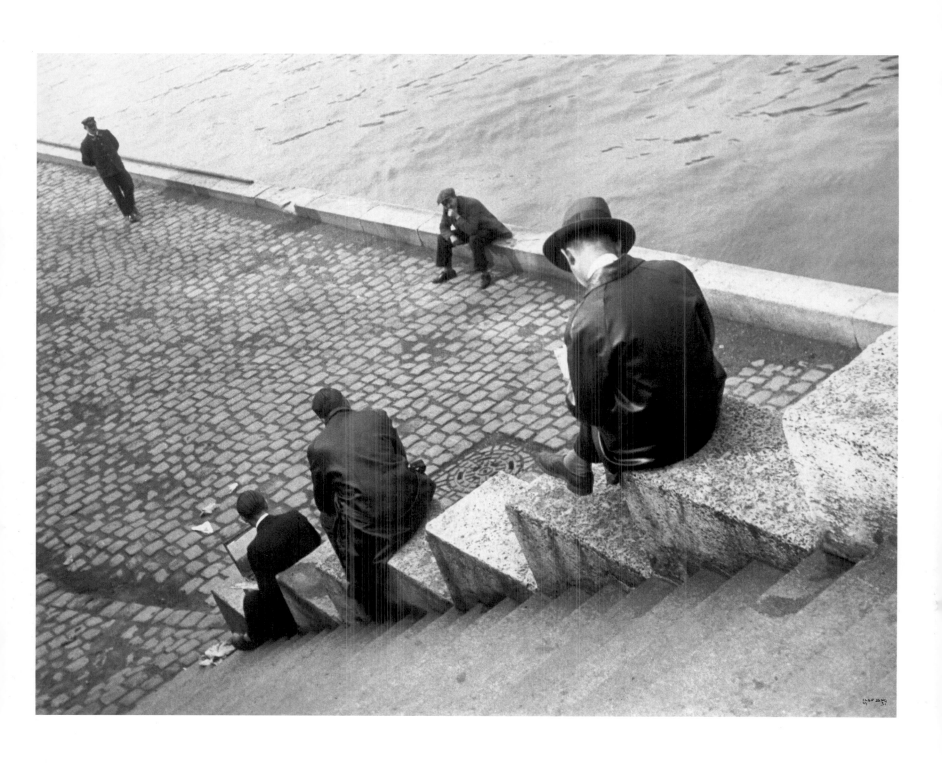

90

Ilse Bing
Three Men on Steps near the Seine, 1931
Gelatin silver pr nt, 1987
10¼ x 13⅜ inches
Gift of the photographer, 1991
16.1991

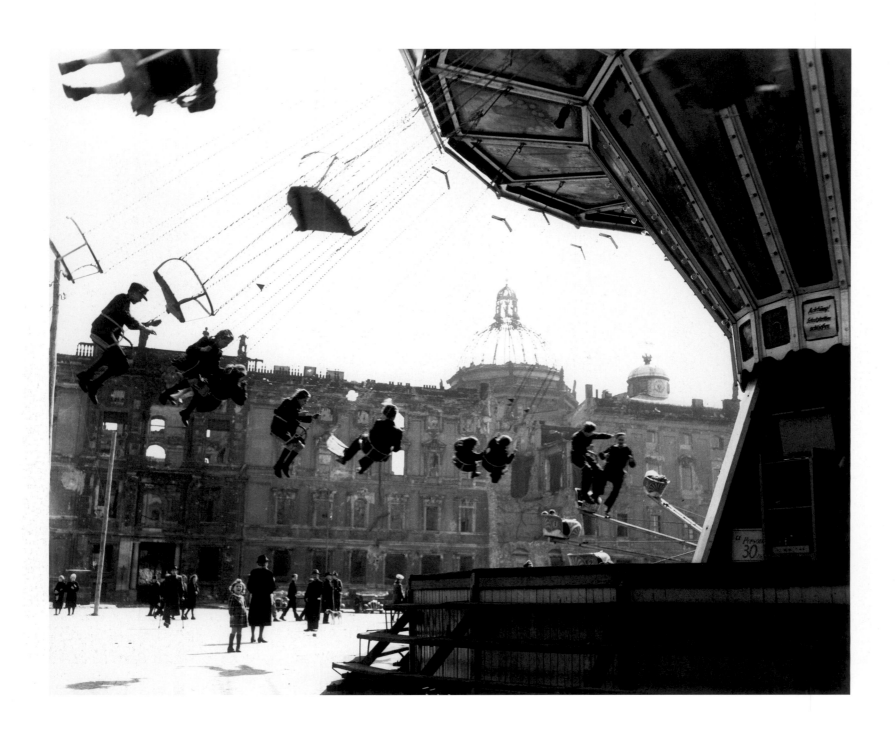

Henry Ries
Life Goes on in the Ruins of Berlin: In Front of the Reichstag, Former Seat of the German Parliament, 1947
Gelatin silver print, c. 1990
12 x 14¾ inches
Purchased with funds from the Senate of Berlin and the special assistance of Goethe House, New York, 1991
533.1991

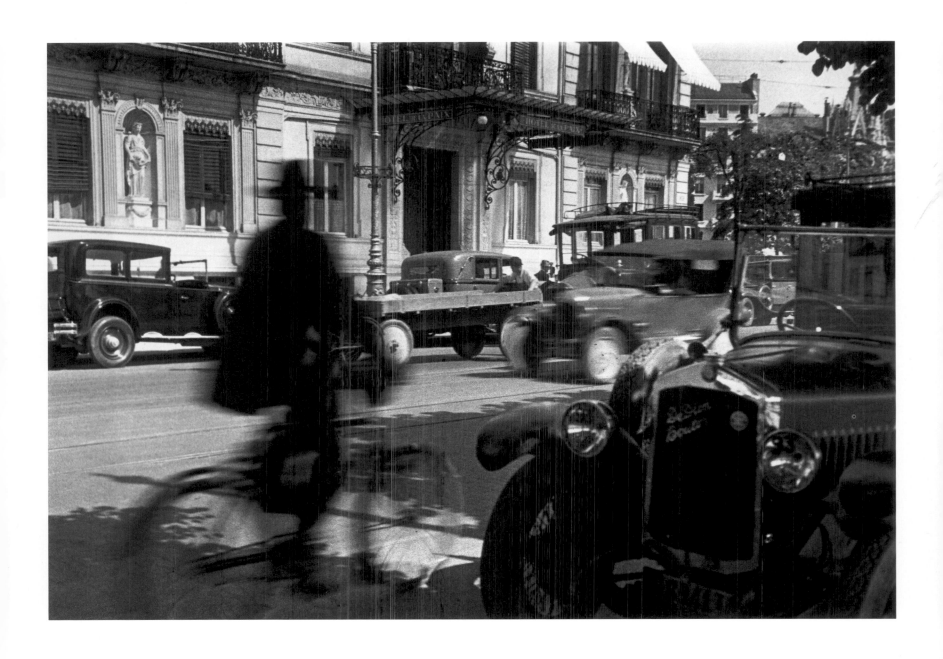

92

Lucien Aigner
Geneva Shadow, 1930s
Gelatin silver print, 1970s
9⅛ x 13⅜ inches
Purchased with funds from the Zenkel Foundation and an
anonymous gift, 1982
323.1982

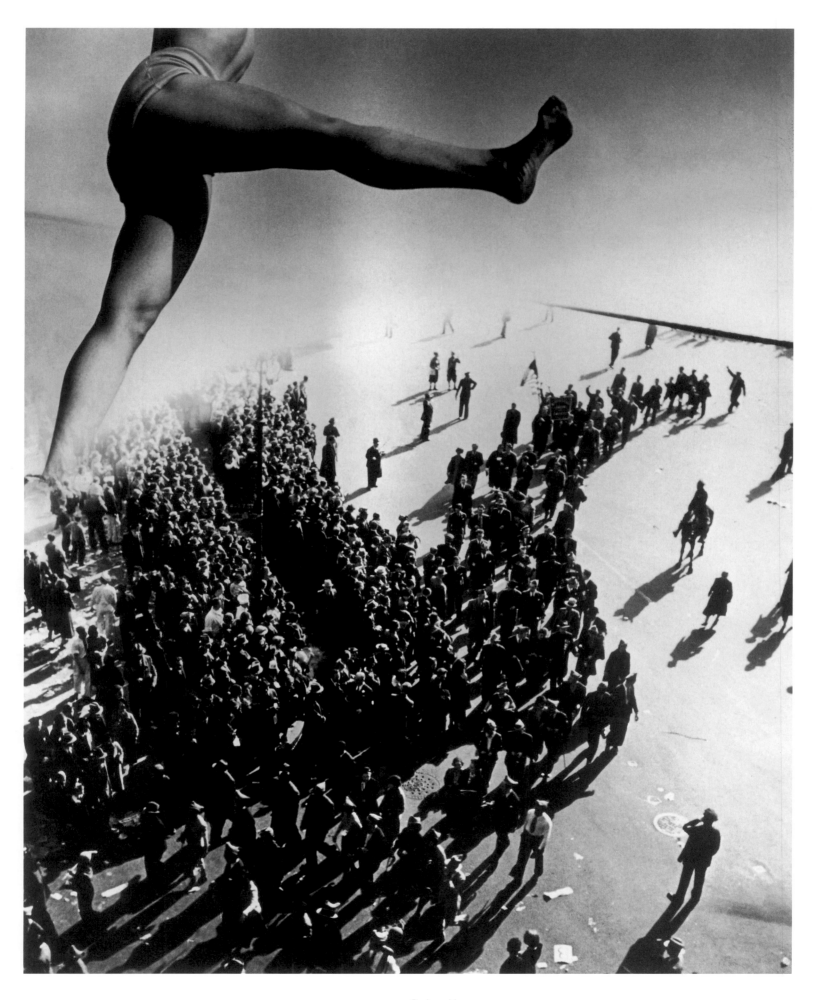

Barbara Morgan
Protest, New York City, 1940
Gelatin silver print, 1960s
13 x 10½ inches
Photography in the Fine Arts Collection, 1981

Lisette Model
Running Legs, New York City, 1940
Gelatin silver print, 1980
23 ¾ x 19 inches
Gift of the Lisette Model Foundation, in memory of Joseph G. Blum, 1993
84.1993

94

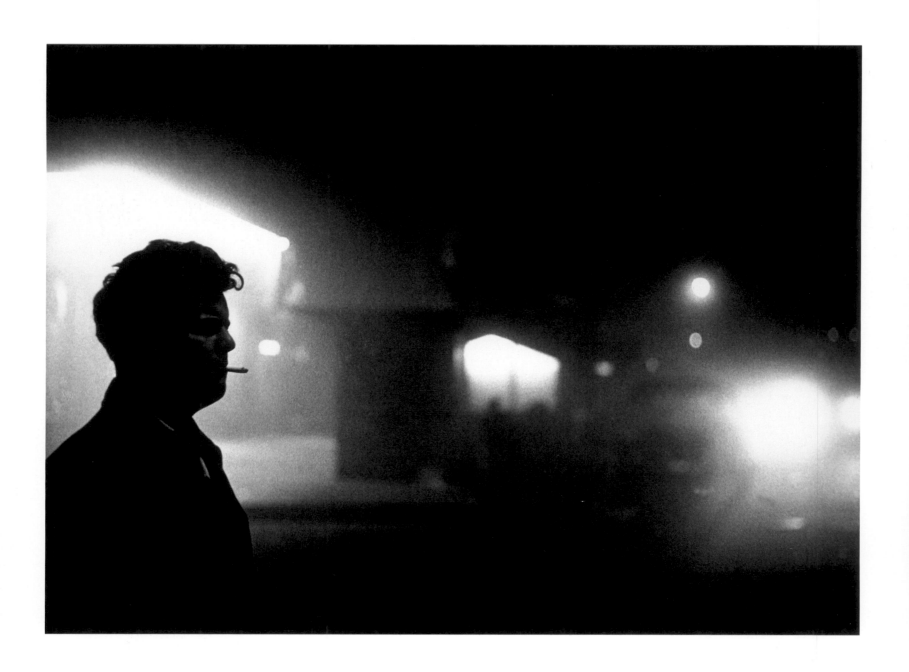

95

Benn Mitchell
Man in Night Fog, 1950
Gelatin silver print
10 x 13¾ inches
Jacob Deschin Collection, 1982

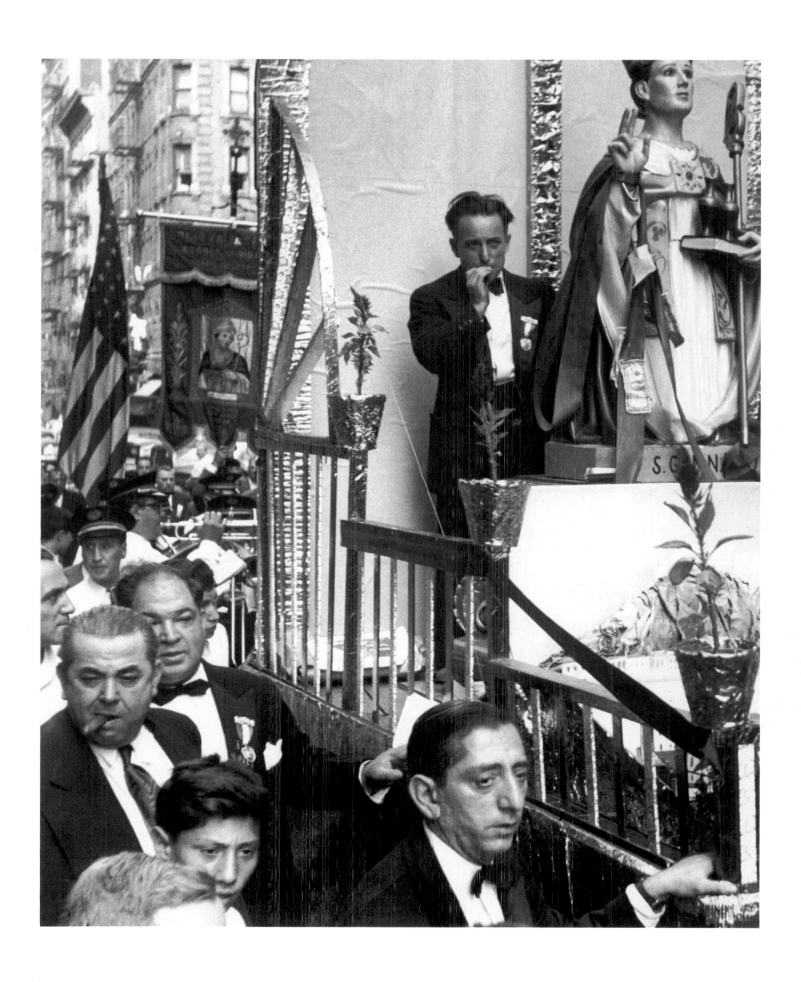

Daniel Weiner
San Gennaro Festival, New York City, 1952
Gelatin silver print
8⅜ x 7 inches
Purchased, International Fund for Concerned Photography, 1974
956.1974

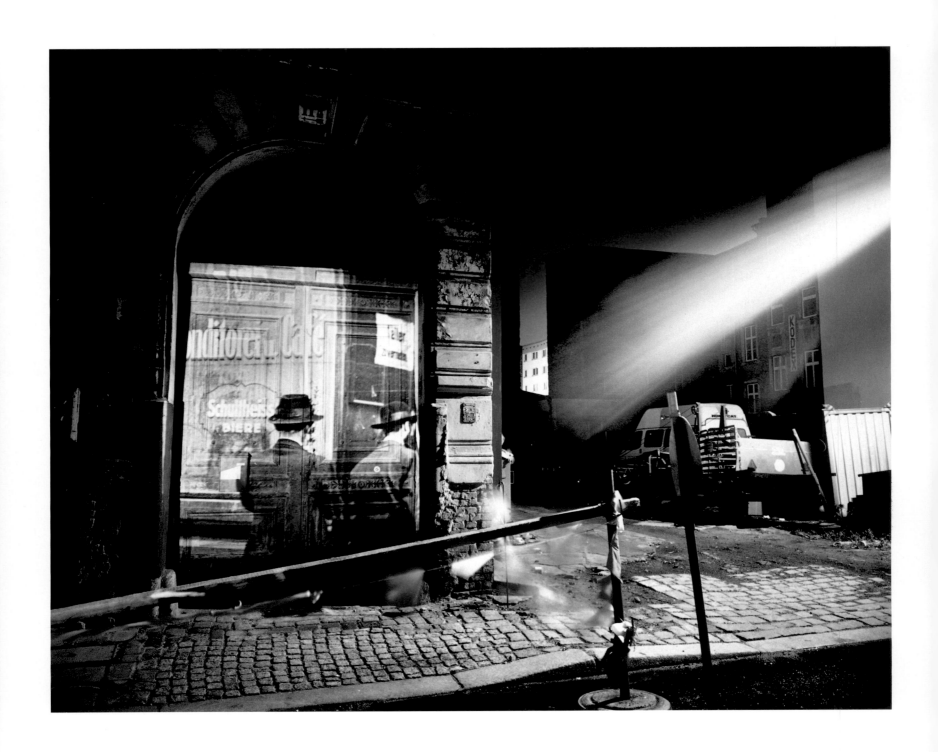

Shimon Attie
Untitled [Slide projection on derelict building: two men entering a café], 1992
Chromogenic print
19½ x 24 inches
Gift of the photographer, 1992
3560.1992

97

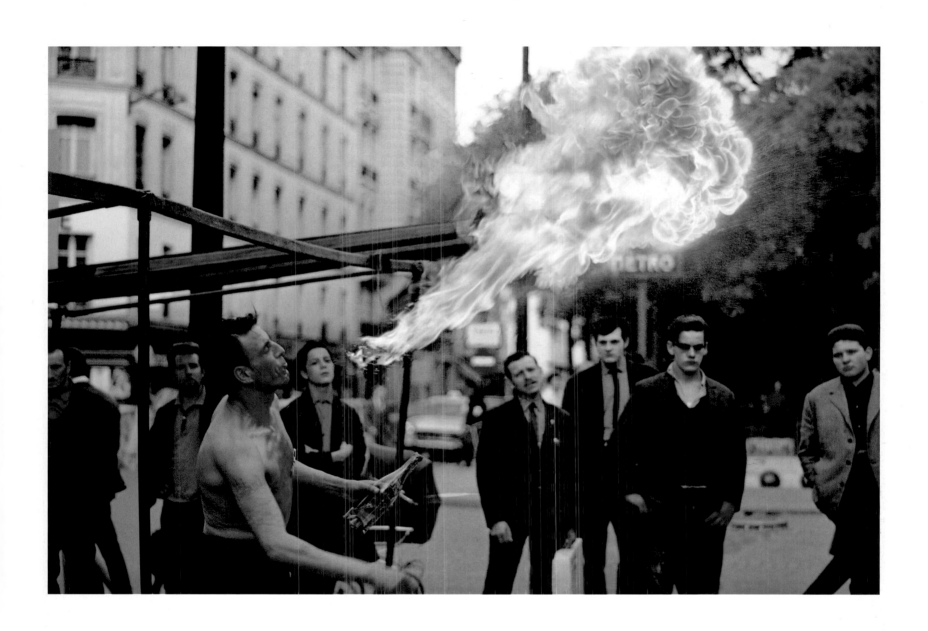

Joel Meyerowitz
Street Busker, Paris, 1967
Dye transfer print
11⅞ x 18 inches
Gift of Mr. and Mrs. Jeffrey Kay 1983
582.1983

98

Thomas Struth
Tour Totem, Beau Grenelle, Paris, 1981
Gelatin silver print
16 x 11⅜ inches
Gift of Henry S. Hacker, 1987
373.1987

99

Ruth Thorne-Thomsen
Glider, Illinois, 1979
Gelatin silver print from paper negative
3½ x 4½ inches
ICP Purchase Fund, 1985
209.1985

100

Landscapes

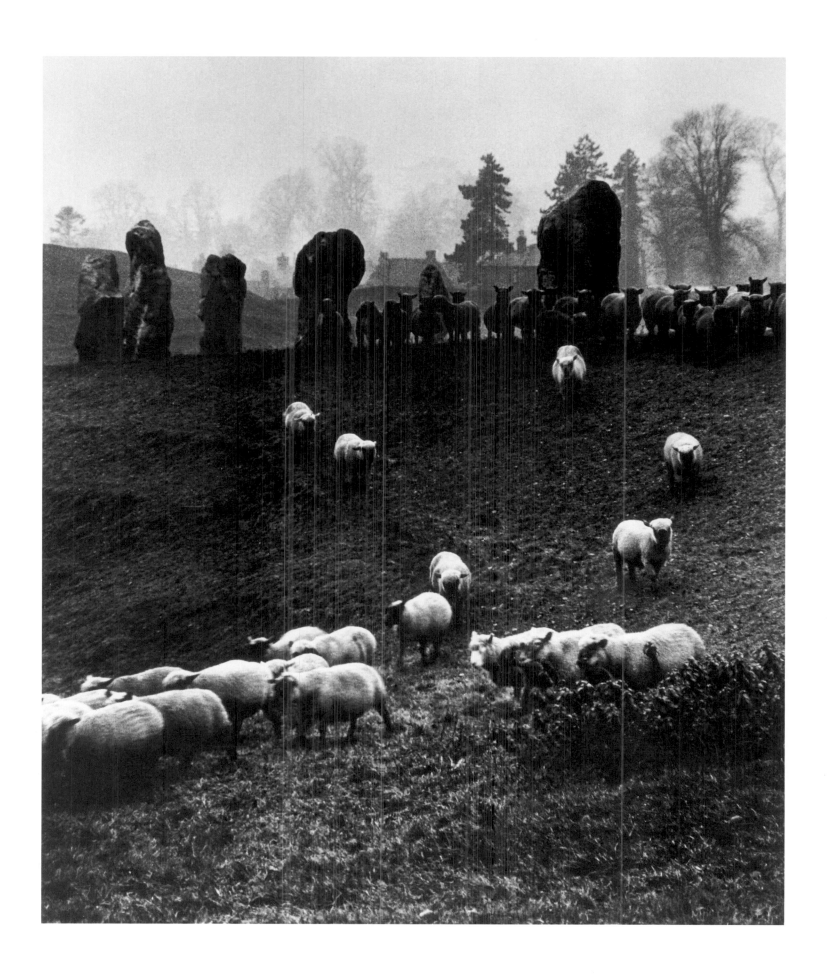

101

Bill Brandt
Avebury Stone Circle, Wiltshire, 1944
Gelatin silver print, 1970s
13¼ x 11¼ inches
Gift of June S dman, 1981
124.1981

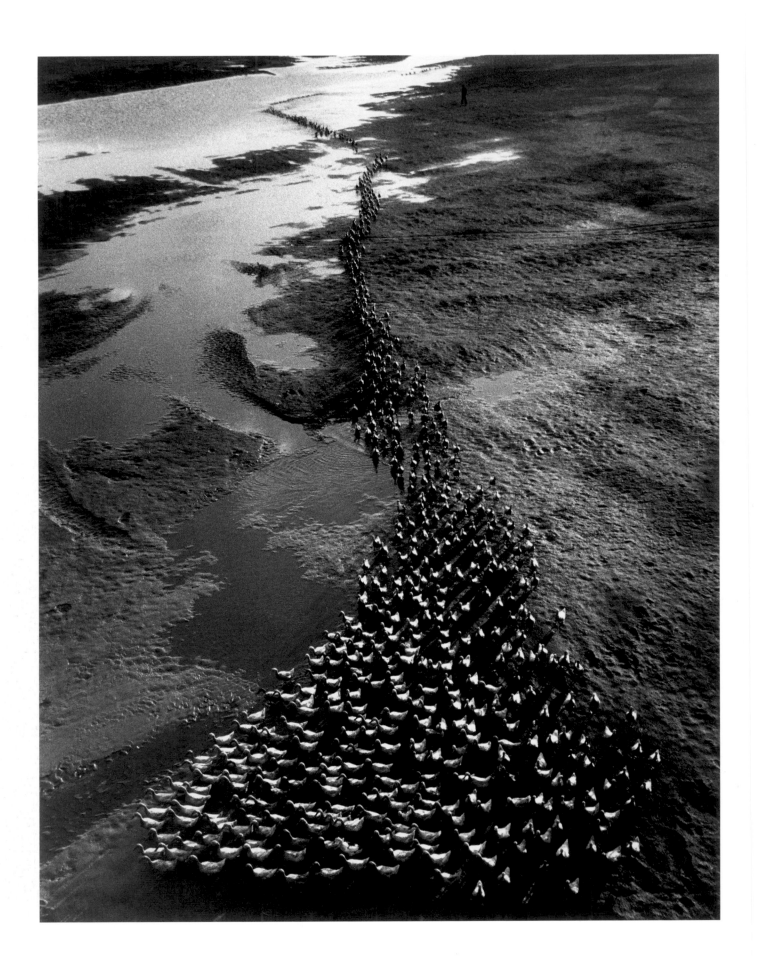

102

Shi-Ming Tsay
The Duck March, Taipei, Taiwan, c. 1966
Gelatin silver print
19¼ x 15⅛ inches
Photography in the Fine Arts Collection, 1981

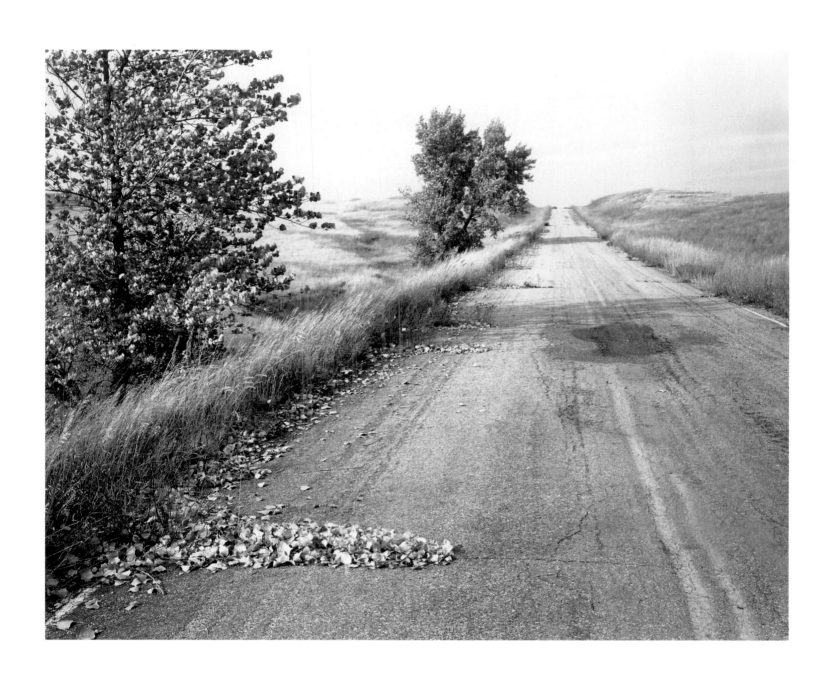

103

Robert Adams
Nebraska State Highway 2, Box Butte County, 1978
Gelatin silver print
9 x 11⅛ inches
Gift of Susan Unterberg, 1992
3425.1992

Nancy Goldring
Tunnel Vision: Maidens, 1995
Silver dye bleach print
16 x 20 inches
Gift of the artist, 1997
116.1997

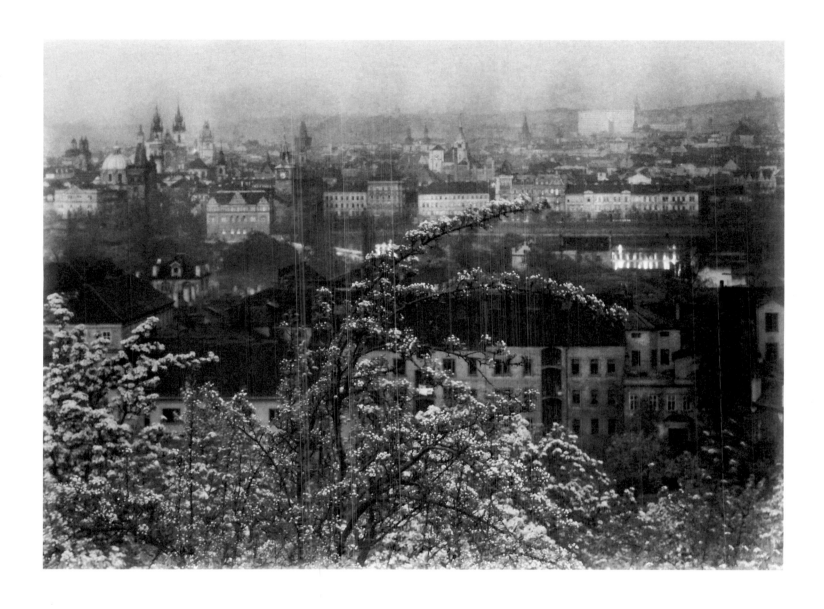

106

Josef Sudek
View of Prague, 1950s
Gelatin silver print, later print
5 x 7 inches
ICF Accession

George Tice
Tree #12, New York, 1965
Gelatin silver print
6¼ x 4⅜ inches
Jacob Deschin Collection, 1982

107

108

Thomas Ruff
Constellations, 1991
From the portfolio "'n A Dream . . .", 1991
Chromogenic print
18⅞ x 12½ inches
Gift of Photographers + Friends United Against AIDS, 1998
2.1998f

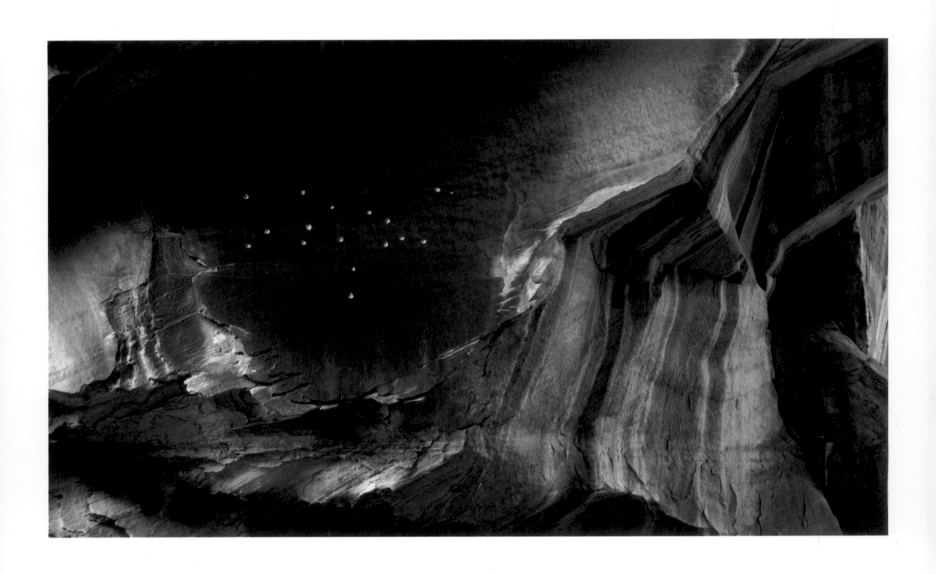

109

Minor White
Bullet Holes, Capitol Reef, Utah, 1961
Gelatin silver print
7¾ x 12⅞ inches
Photography in the Fine Arts Collection, 1981

Eliot Porter
Fox-Tail Grass, Lake City, Colorado, 1957
Dye transfer print
10⅜ x 8⅛ inches
Photography in the Fine Arts Collection, 1981

Frank Gohlke
Landscape with Birds Flying, near Fort Worth, Texas, 1978
Gelatin silver print
14⅜ x 17¼ inches
Gift of Roger R. Smith, 1983
554.1983

Mark Klett
Fallen Cactus, New Golf Course, Pinnacle Peak, Arizona, 1984
Gelatin silver print
16 x 20 inches
ICP Purchase Fund, 1985
273.1985

War and Disaster

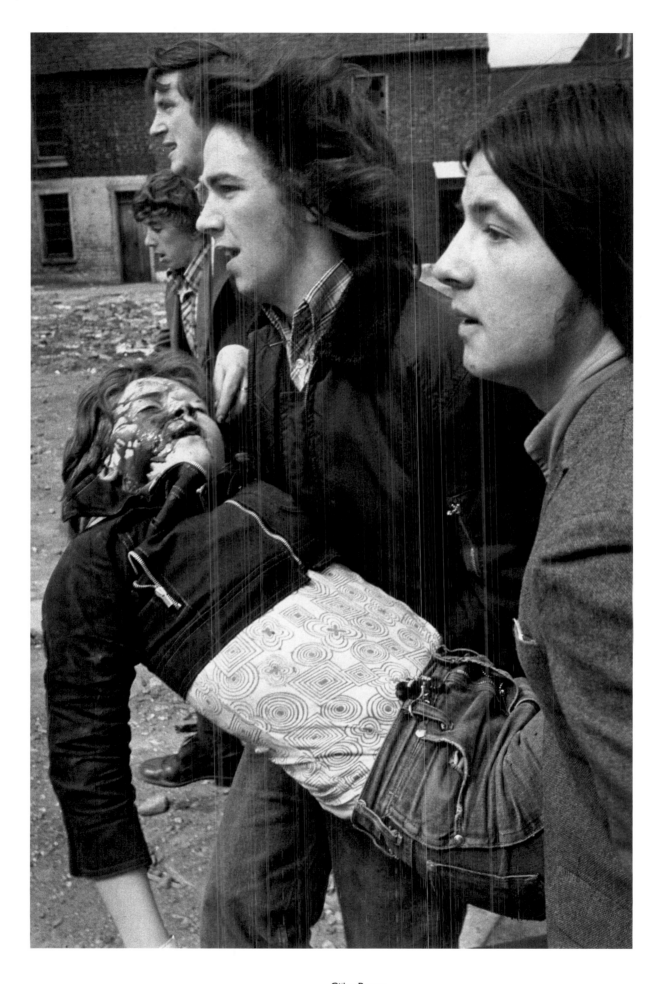

Gilles Peress
Lower Falls Road, Belfast, 1974
Gelatin silver print
18⅞ x 12½ inches
Gift of the photographer to the W. Eugene Smith Legacy Collection
at the International Center of Photography, 1994
539.1994

113

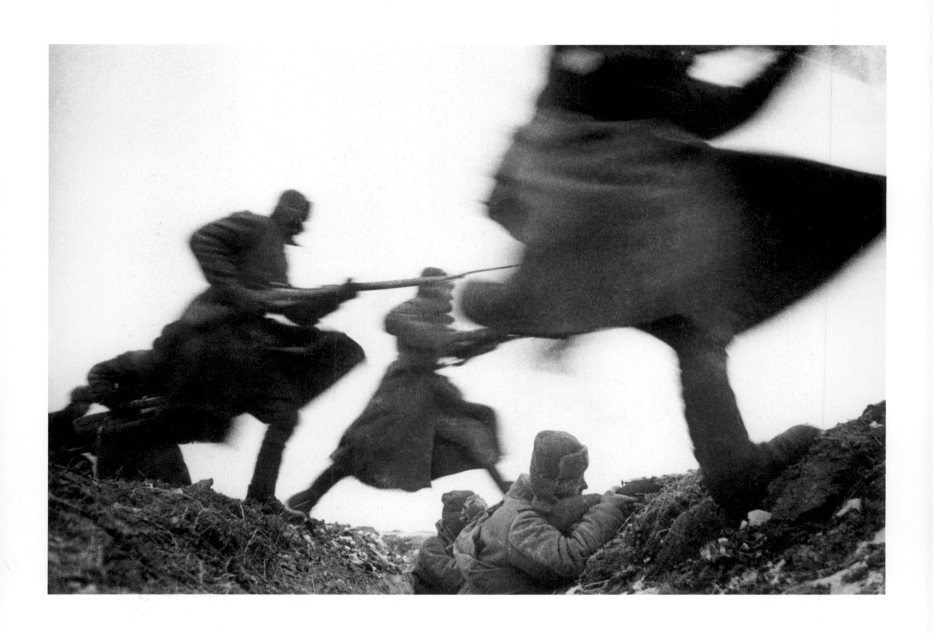

114

Dmitri Baltermants
Infantry Attack at Smolensk, 1942
Gelatin silver print, c. 1980
6¾ x 10⅛ inches
Gift of the photographer, 1983
380.1983

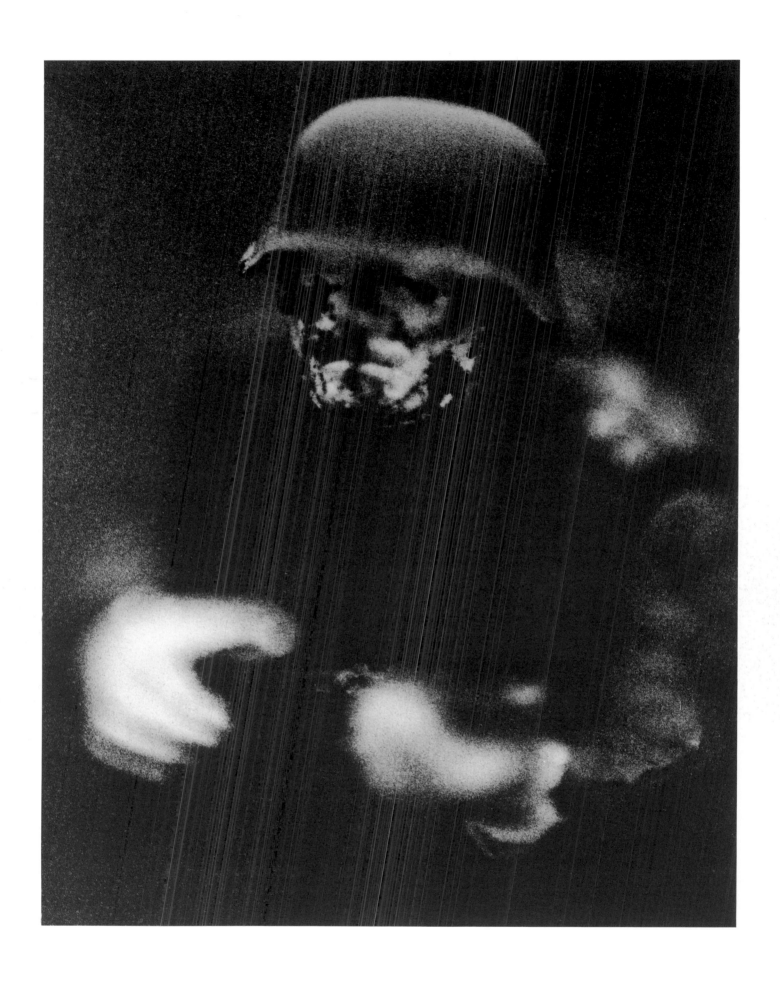

David Levinthal
Untitled [Toy soldier with gun], 1975
Gelatin silver print
9¼ x 7½ inches
Gift of Joel and Anne Ehrenkranz, 1995
116.1995

115

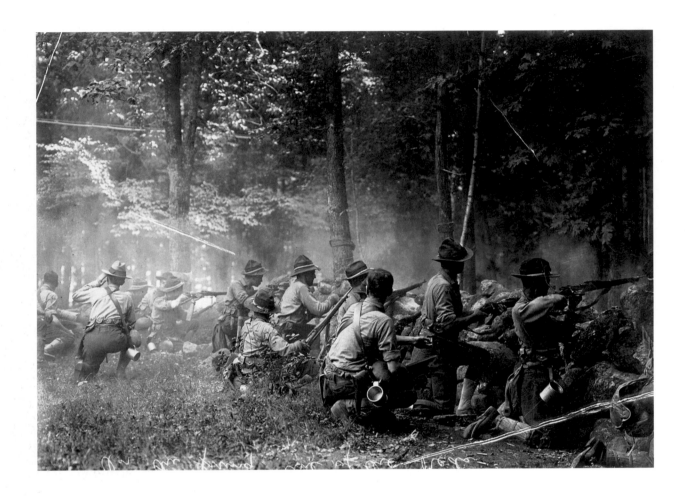

Photographer Unknown
Spanish-American War, 1898–1901
Gelatin silver print
4¾ x 6⅝ inches
Page Collection, Gift of Mr. and Mrs. Arthur Page, Jr., 1976

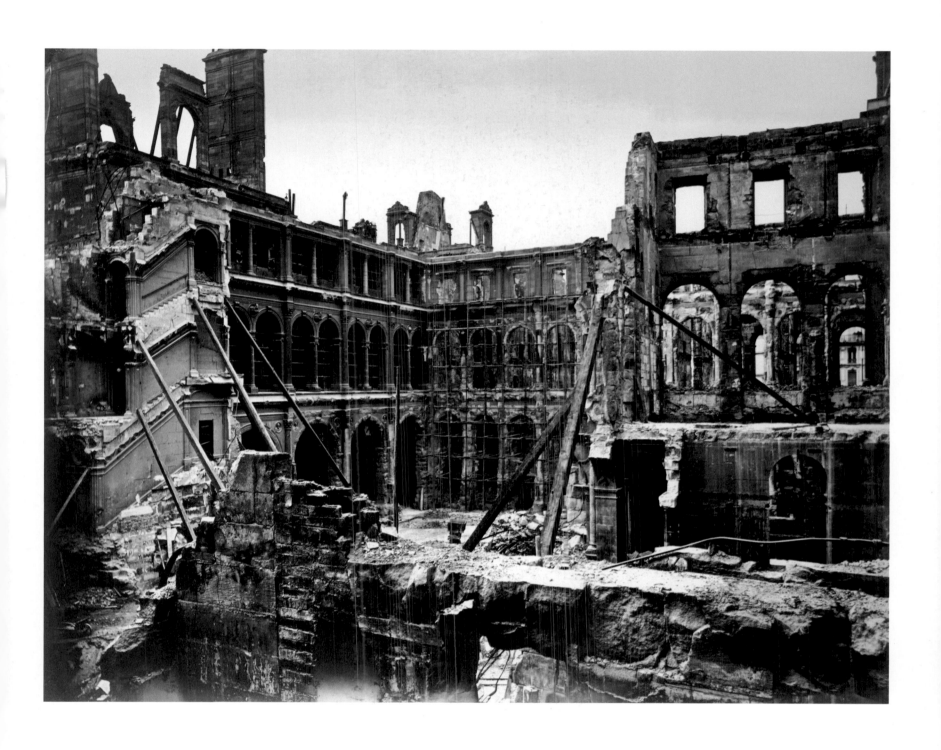

117

Alphonse J. Liebert
Hotel de Ville Incendie [City Hall after a fire], 1871
From *Les Ruines de Paris et Ses Environs*
[The ruins of Paris and its surroundings], 1870–71
Albumen silver print from glass negative from
a two volume work containing 100 prints
7⅜ x 10⅛ inches
Gift of the Shubert Foundation, 1990
229.1990

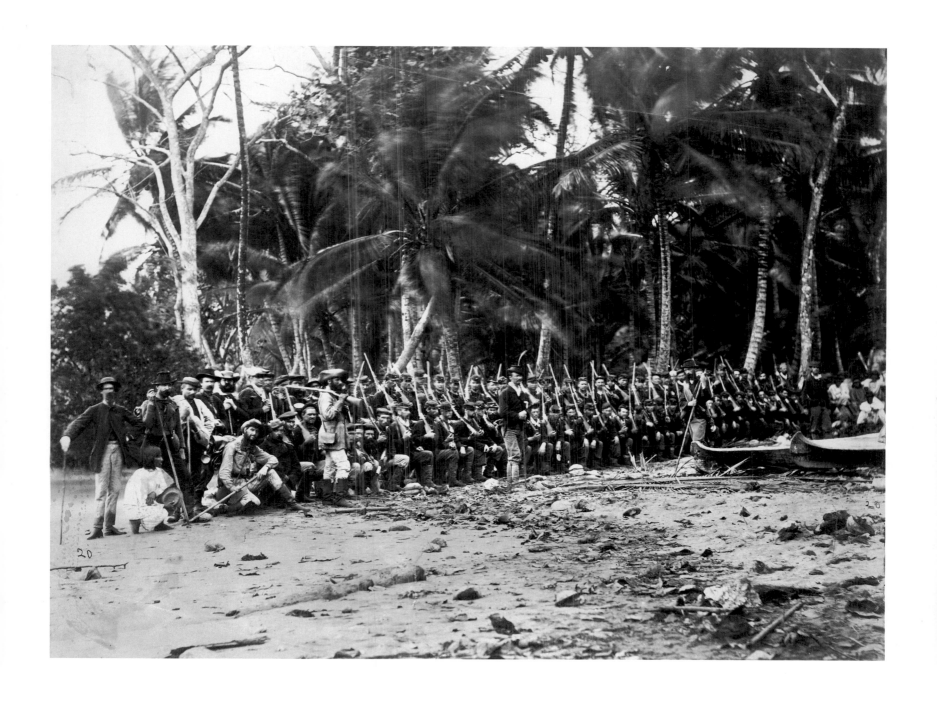

Timothy O'Sullivan
Return of Commander Selfridge and His Reconnaissance Party from an
Expedition into the Interior of Darién, 1870
Albumen silver print from glass negative
8¾ x 11½ inches
Gift of David Garfinkle, 1983
558.1983

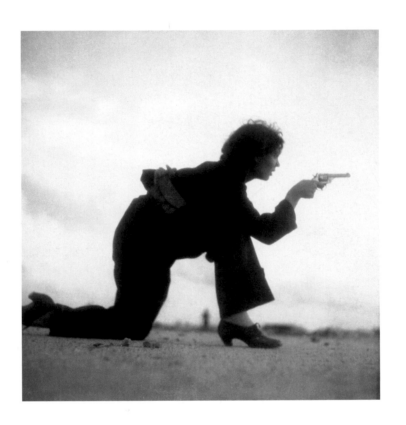

119

Gerda Taro
*Woman in Republican Militia during Small Arms Training at
Beach near Barcelona,* 1936
Gelatin silver print, 1940s
7⅜ x 7⅛ inches
Gift of Cornell Capa, 1986
452.1986

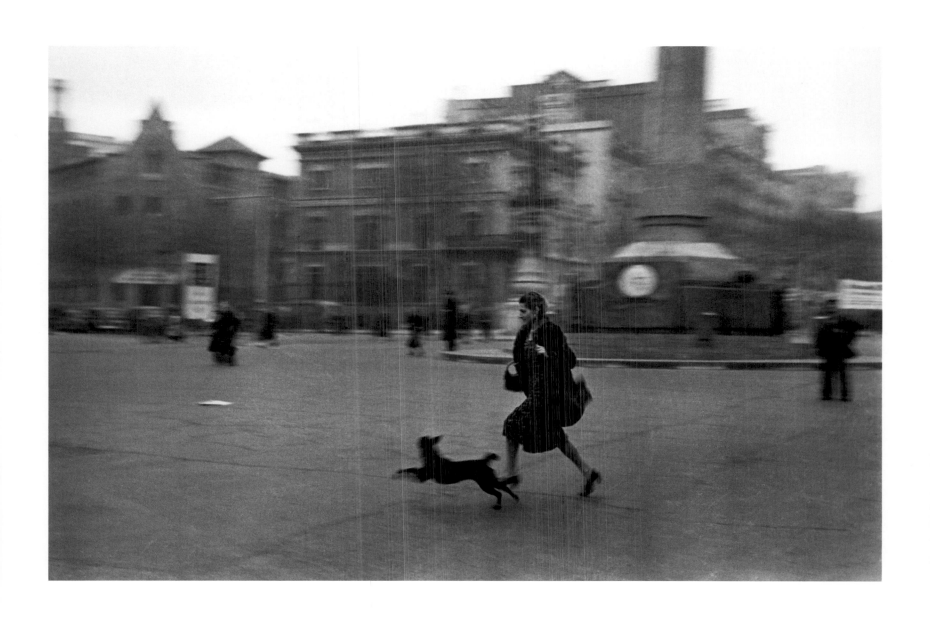

Robert Capa
Barcelona, 1939
Gelatin silver print, 1991
16 x 20 inches
Robert Capa Archive, Gift of Cornell and Edith Capa, 1992
2687.1992

120

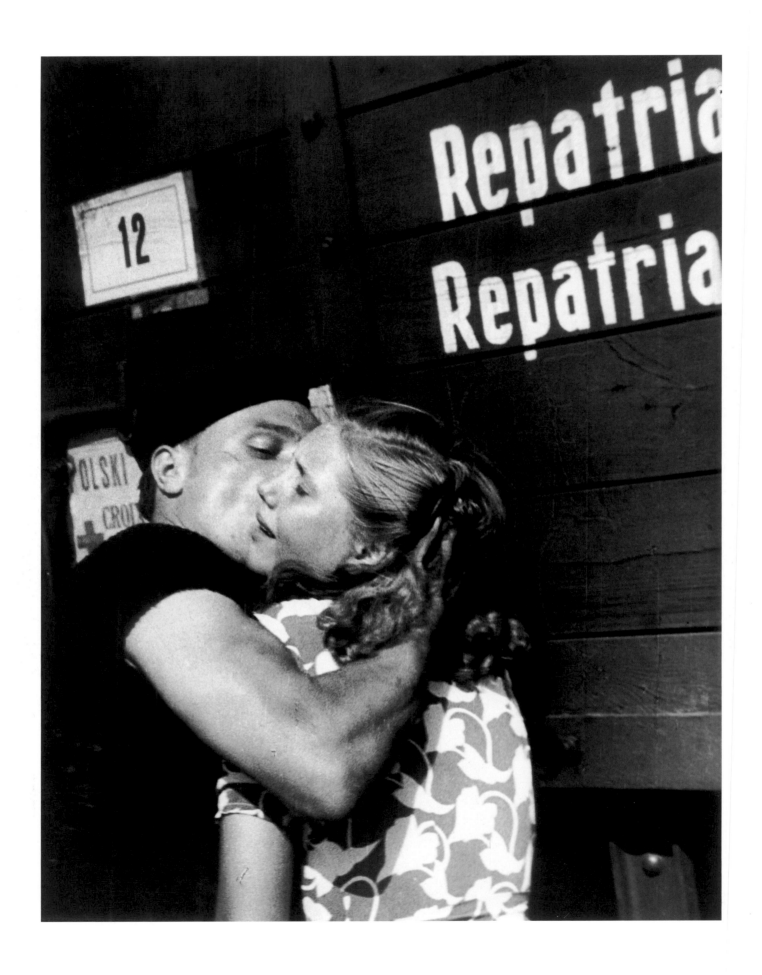

Julia Pirotte
Repatriation, France-Poland, 1947
Gelatin silver print
11½ x 9 inches
ICP Purchase Fund, 1984
845.1984

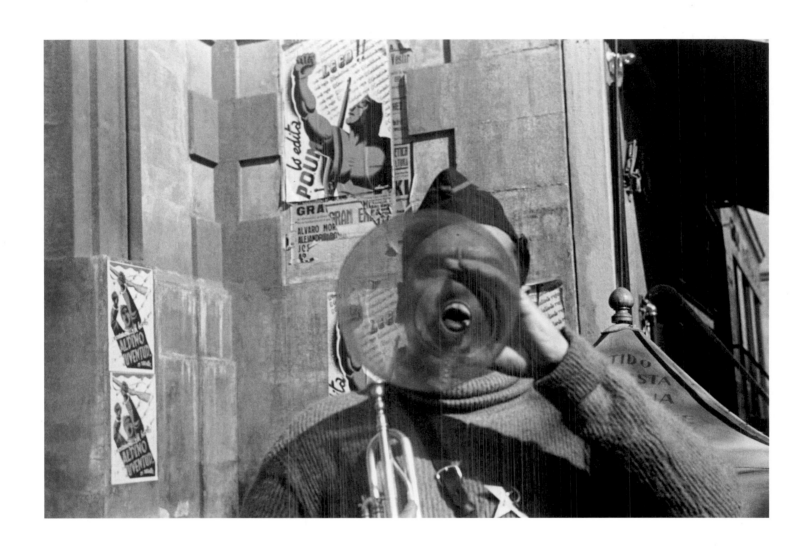

Hans Namuth
Propaganda (Man with Transparent Bullhorn), 1936
Gelatin silver print, 1980s
7 x 10⅛ inches
Gift of the photographer, 1987
155.1987

122

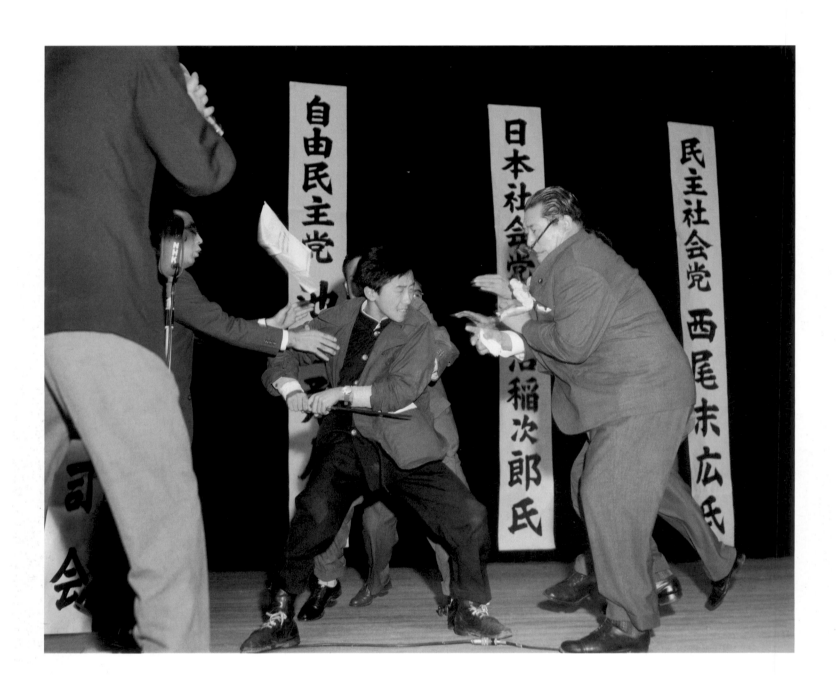

Yasushi Nagao
Assassination of Asanuma, 1960
Gelatin silver print
8⅝ x 10⅝ inches
Photography in the Fine Arts Collection, 1981

123

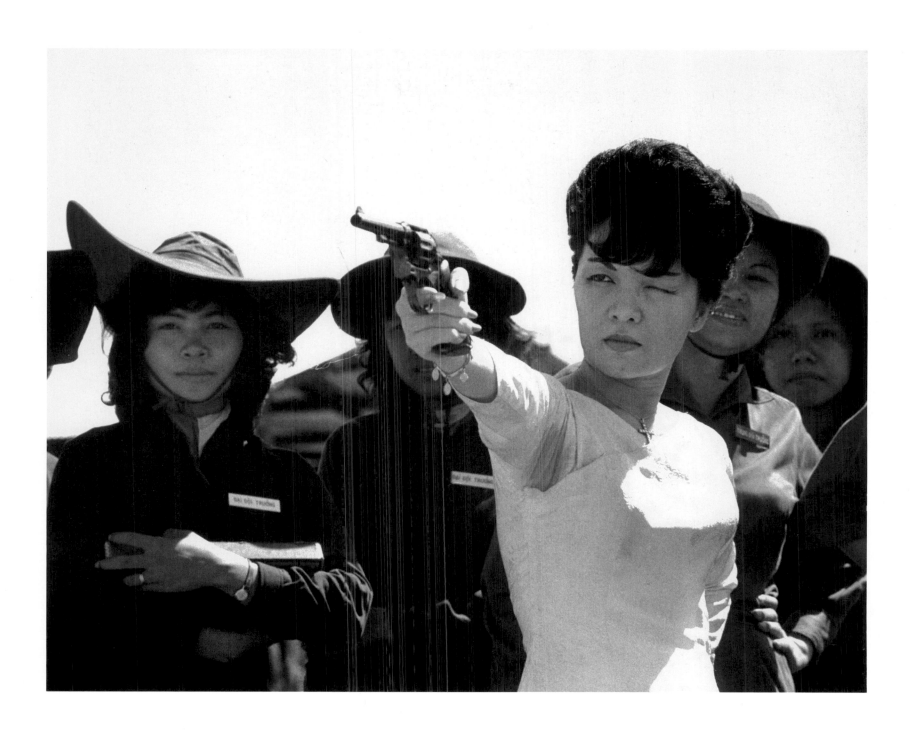

124

Larry Burrows
Madame Ngo Dinh Nhu Fires a .38 for the First Time, Tan Hoa Dong,
South Vietnam, 1962
Gelatin silver print
15¼ x 19¼ inches
Purchased with funds from the Acquisitions Committee, 1998
26 1998

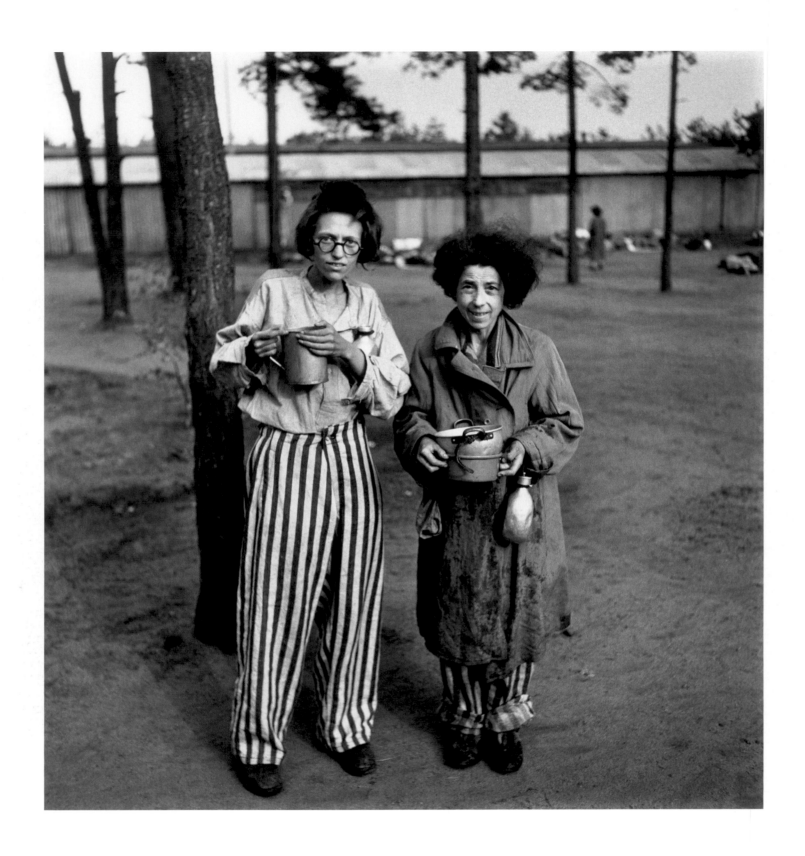

125

George Rodger
Inmates at Bergen-Belsen on Liberation, 1945
Gelatin silver print, 1980s
10¾ x 19¼ inches
Purchased with funds from the Professional Photography Division,
Eastman Kodak Company, 1989
414.1989

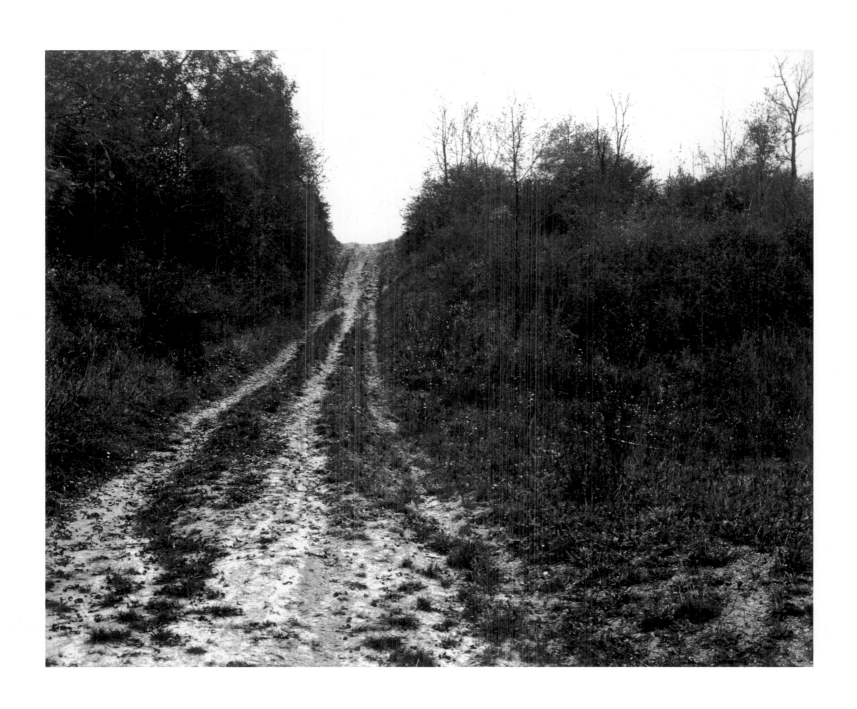

126

Mikael Levin
Nordlager Ohrdruf, 1995
Gelatin silver print
13⅞ x 17¼ inches
Gift of David W. Ruttenberg, 1997
86.1997

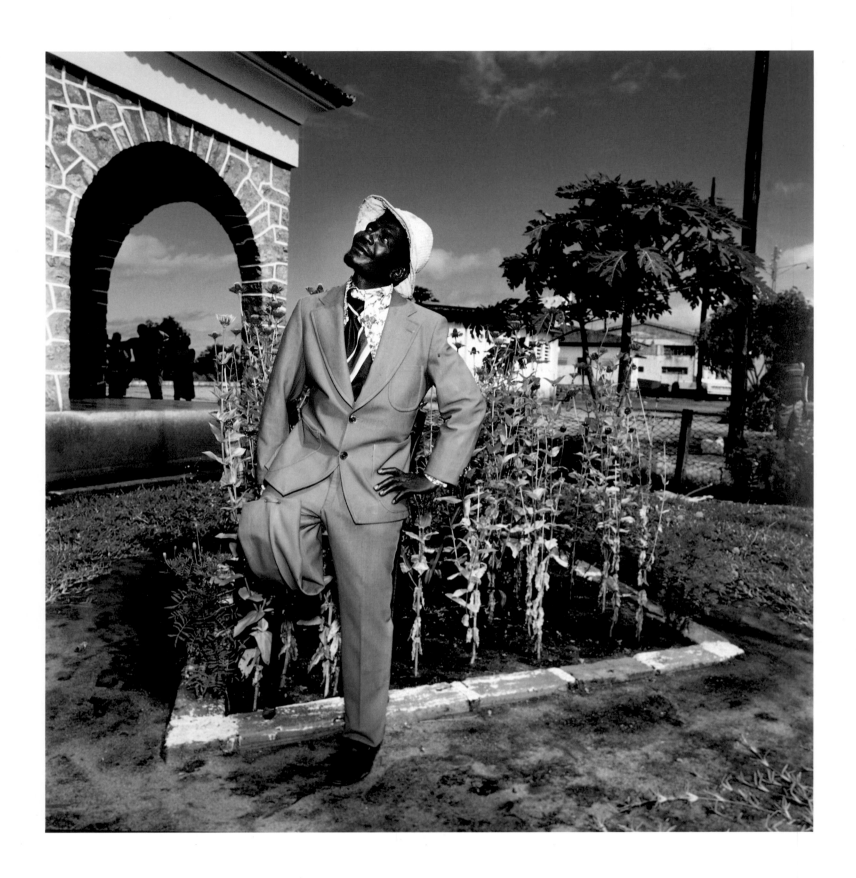

Bobby Neel Adams
Franco Dressed in Suit at Tica Railroad Station, Mozambique, 1994
Chromogenic print
28 x 28 inches
Gift of the photographer, 1996
130.1996

127

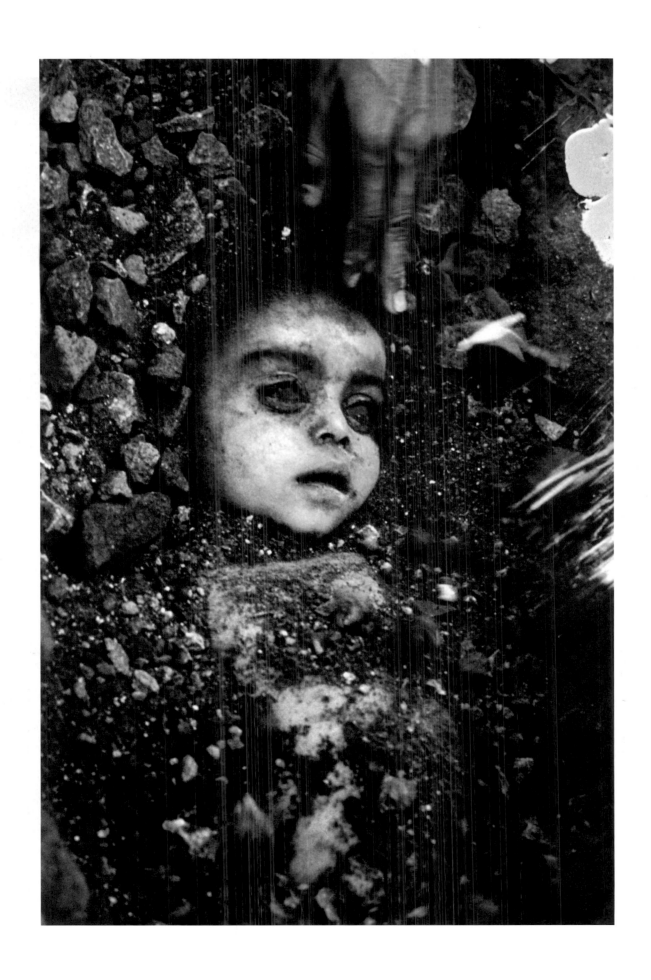

128

Pablo Bartholomew
Dead Baby, Bhopal, 1984
Silver dye bleach print
7⅜ x 11½ inches
Gift of the photographer, 1986
13.1986

Everyday Life

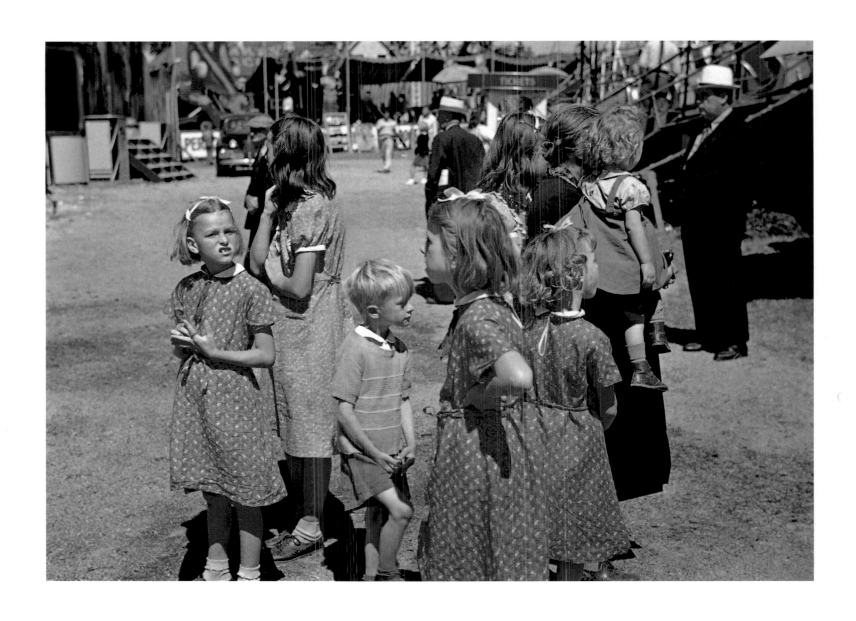

Jack Delano
At the Vermont State Fair Rutland, 1941
Dye transfer pr nt, c. 1980
7 x 10 inches
Gift of Tennyson ard Fern M. Schad, 1996
222.1996

129

130

August Sander
Jockey, Vienna, 1932
Gelatin silver print, 1970s
10¾ x 8¼ inches
Gift of Ann Sager, 1984
390.1984

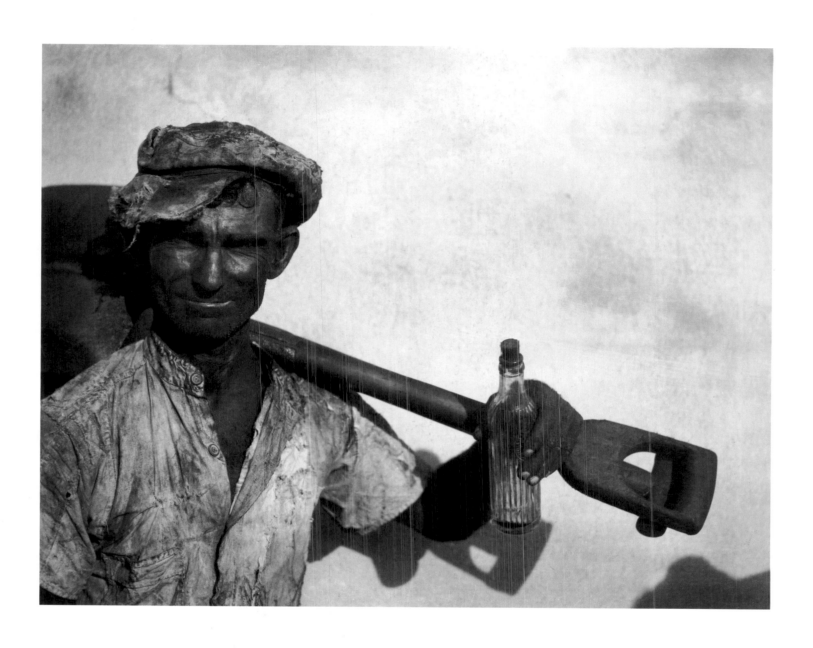

131

Walker Evans
Coal Dock Worker, Havana, 1933
Gelatin silver print
6⅛ x 7⅞ inches
Gift of June Sidman, 1981
130.1981

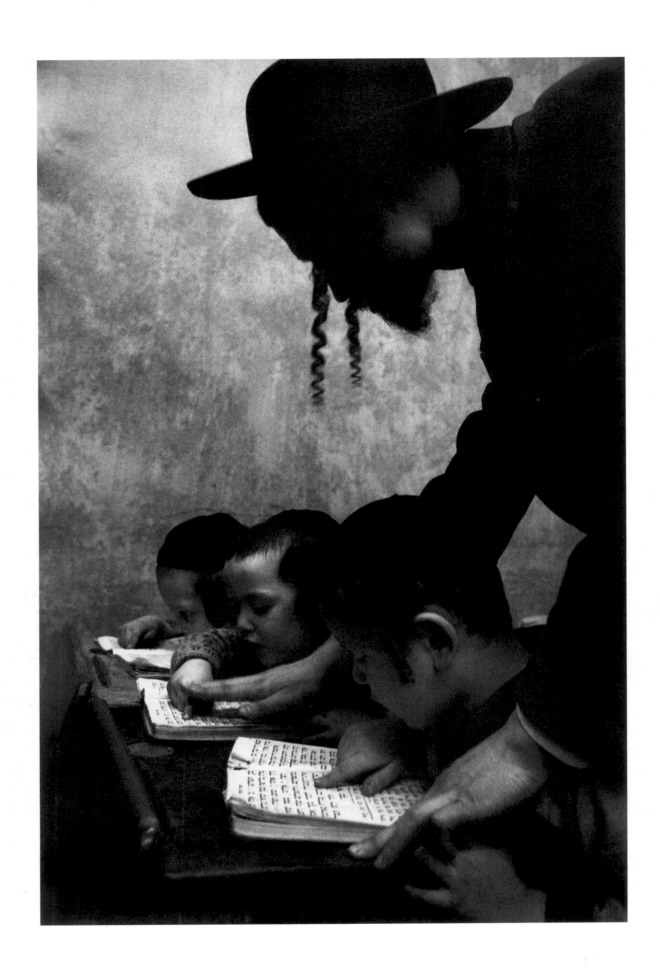

Cornell Capa
Talmudic Scholars, New York, 1956
Gelatin silver print
18⅝ x 12⅜ inches
Photography in the Fine Arts Collection, 1981

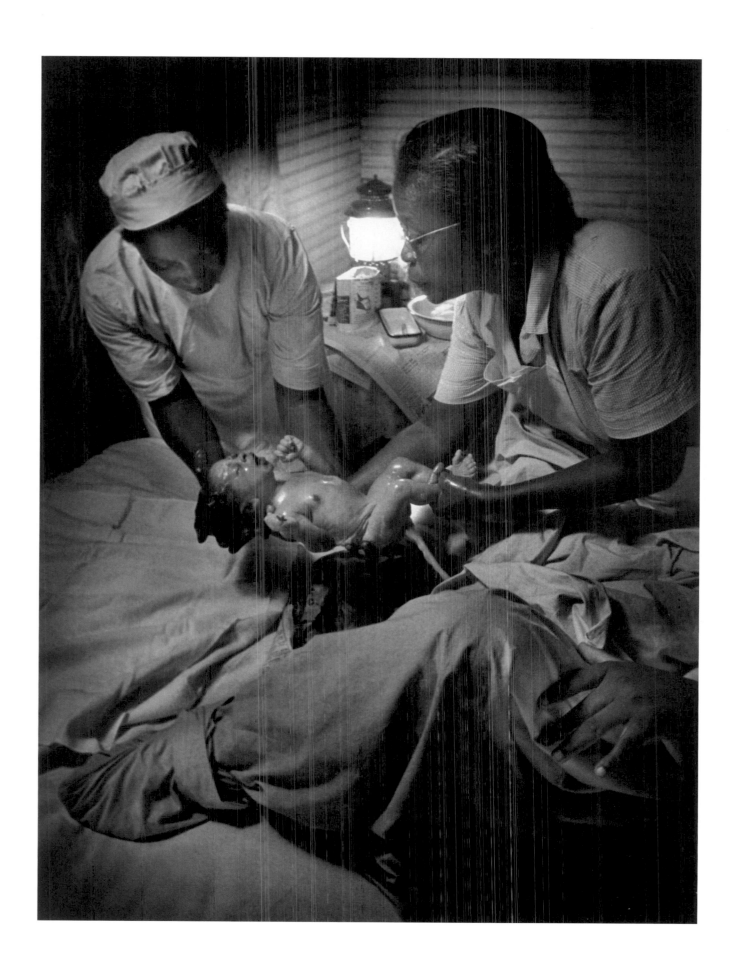

133

W. Eugene Smith
Maude Callen Delivers Baby, 1951
Gelatin silver print
13⅜ x 10⅛ inches
Purchased, International Fund for Concerned Photography

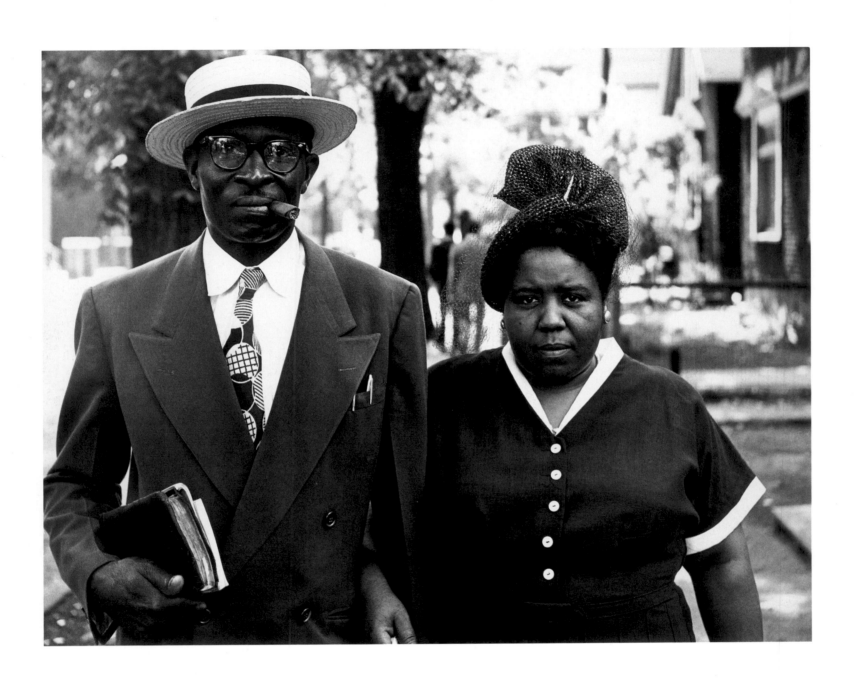

Gordon Parks
Husband and Wife, Sunday Morning, Fort Scott, Kansas, 1949
Gelatin silver print
9⅞ x 12⅝ inches
Purchased, International Fund for Concerned Photography, 1974

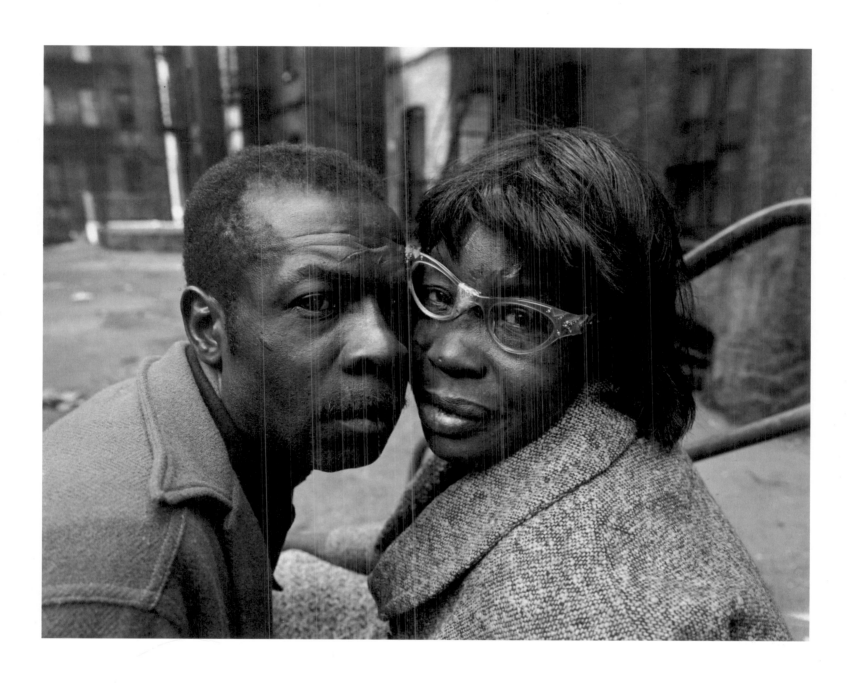

135

Bruce Davidson
[Couple: woman with broken glasses], c. 1970
Gelatin silver print
9 x 13⅜ inches
Purchased, International Fund for Concerned Photography, 1974

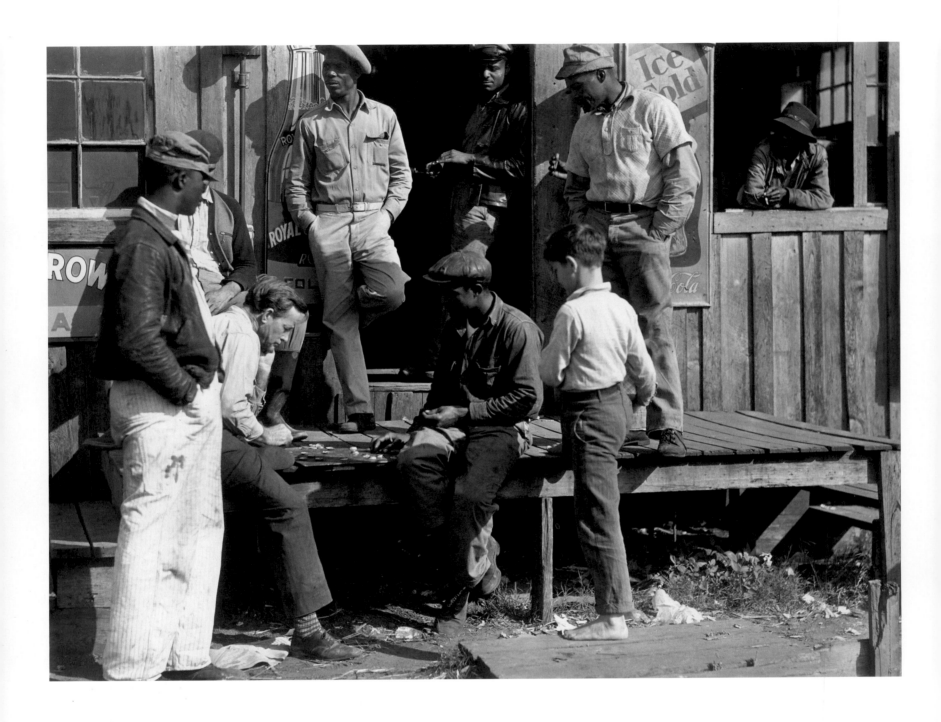

136

Marion Post Wolcott
Game of Checkers During "Freeze-Out," Homestead, Florida, 1939
Gelatin silver print
9¼ x 12⅜ inches
Gift of Mr. Leon Wolcott, 1991
419.1991

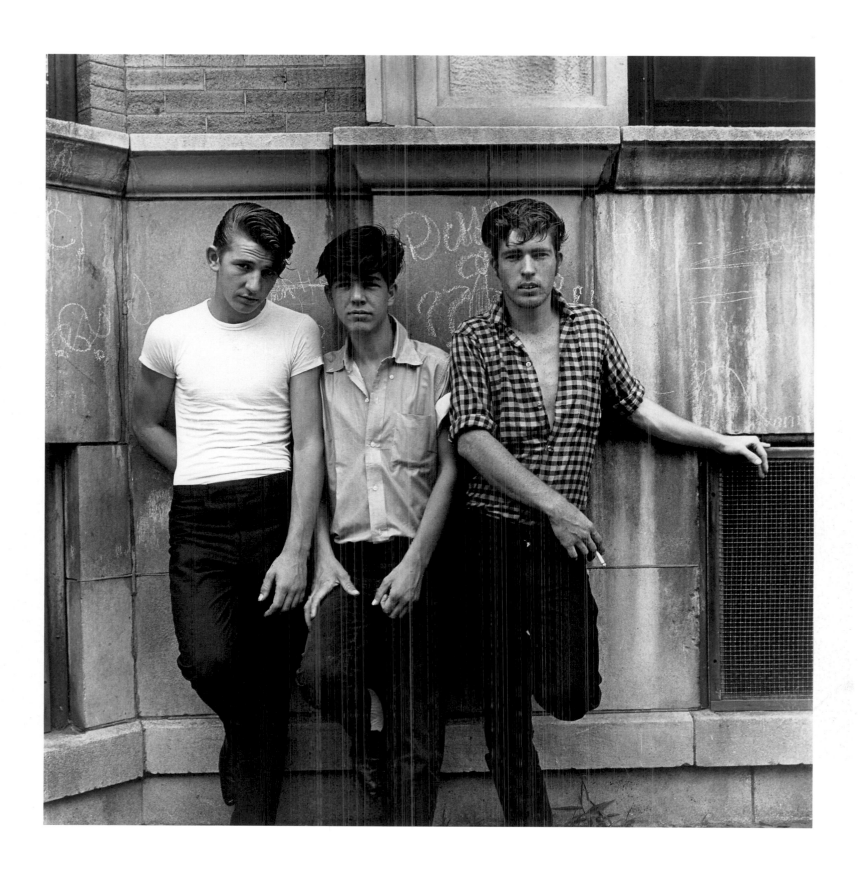

137

Danny Lyon
Uptown, Chicago, 1965
Gelatin silver print, 1970s
9⅝ x 9⅝ inches
Gift of Carol Lipis, 1980
41.1980

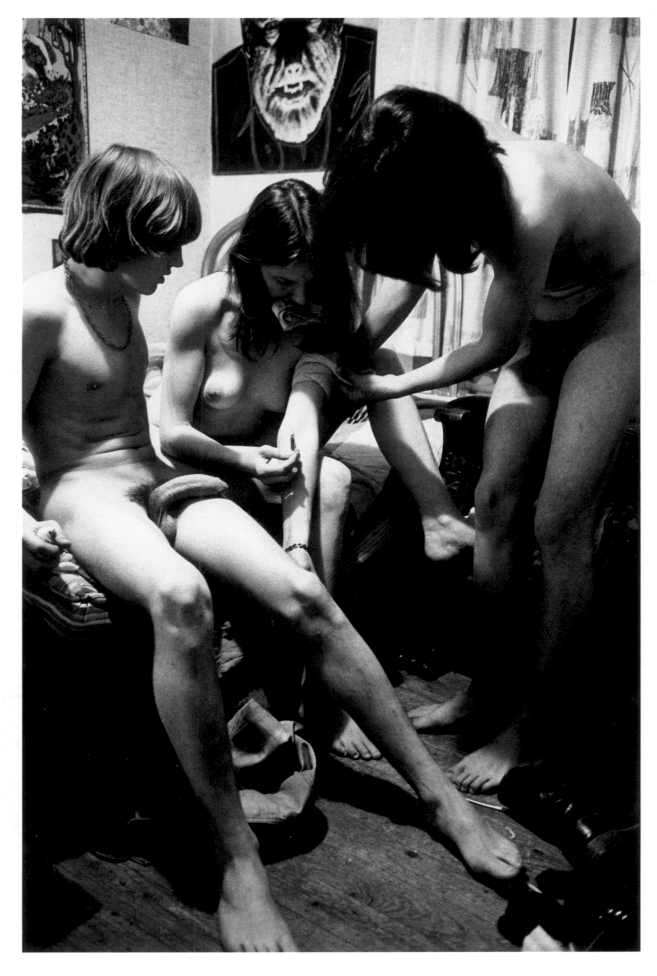

138

Larry Clark
[Naked teenagers injecting amphetamines], 1972
From the portfolio "Tulsa," 1980
Gelatin silver print
12 x 8 inches
Gift of Thomas D. Wright, 1991
406.1991

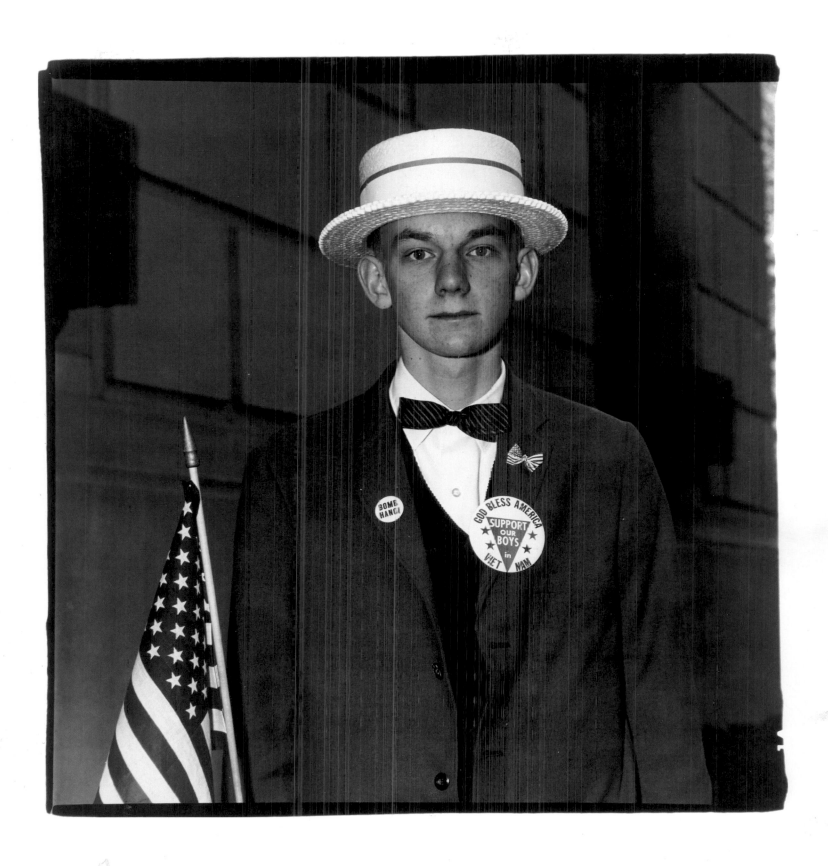

Diane Arbus
A Boy with Straw Hat and Flag About to March in a Pro-War Parade,
New York, 1967
139 | Gelatin silver print
14½ x 14½ inches
Gift of Cornell Capa, 1980
75.1980

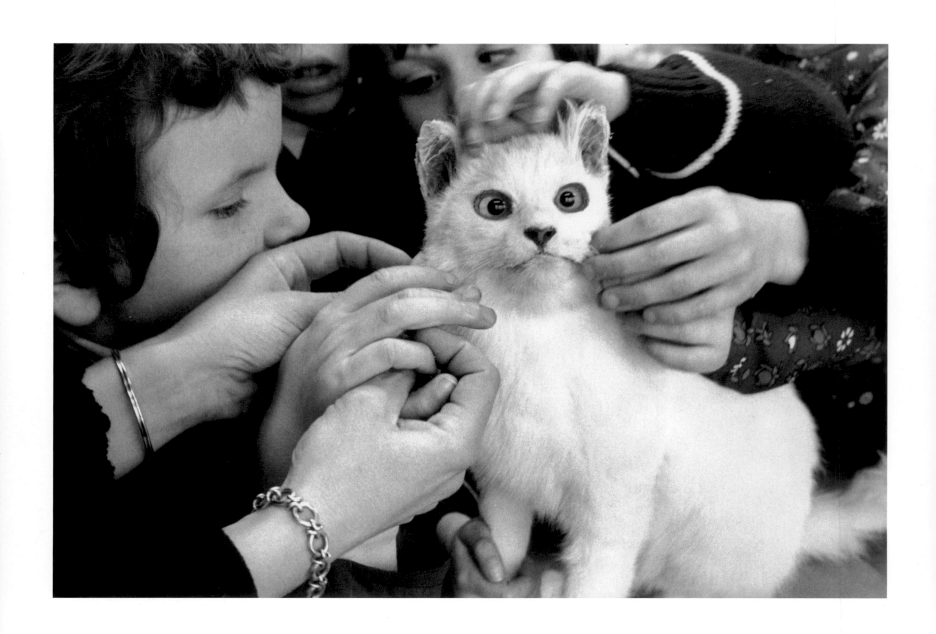

Jane Evelyn Atwood
Regional Institute for the Blind and Visually Impaired, Les Haut Thebaudières,
Vertou, France, 1981
Gelatin silver print
11⅜ x 17½ inches
Gift of the photographer to the W. Eugene Smith Legacy Collection at
the International Center of Photography, 1995
142.1995

140

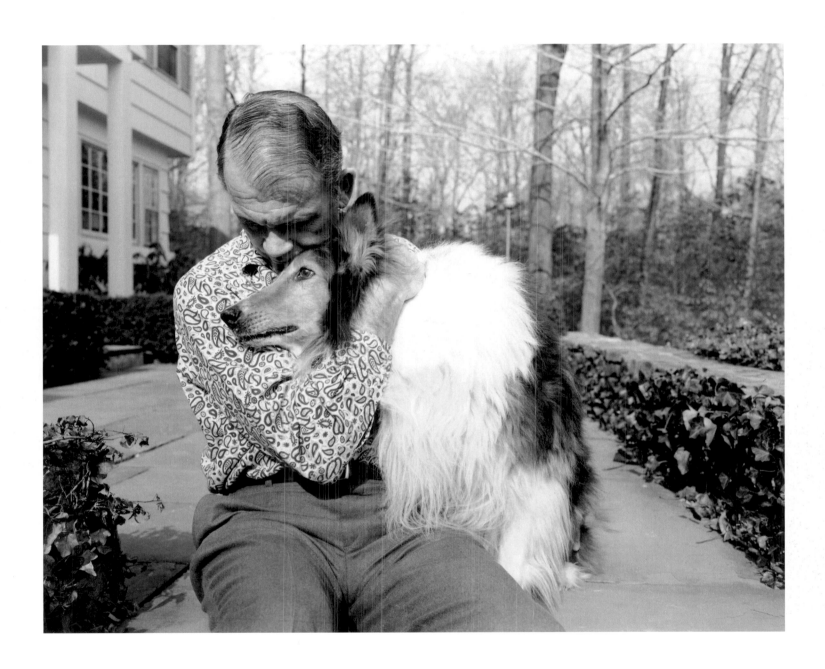

141

Nicholas Nixon
New Canaan, Connecticut, 1980
Gelatin silver print
7⅝ x 9⅝ inches
Gift of Tennyson and Fern M. Schad, 1996
231.1996

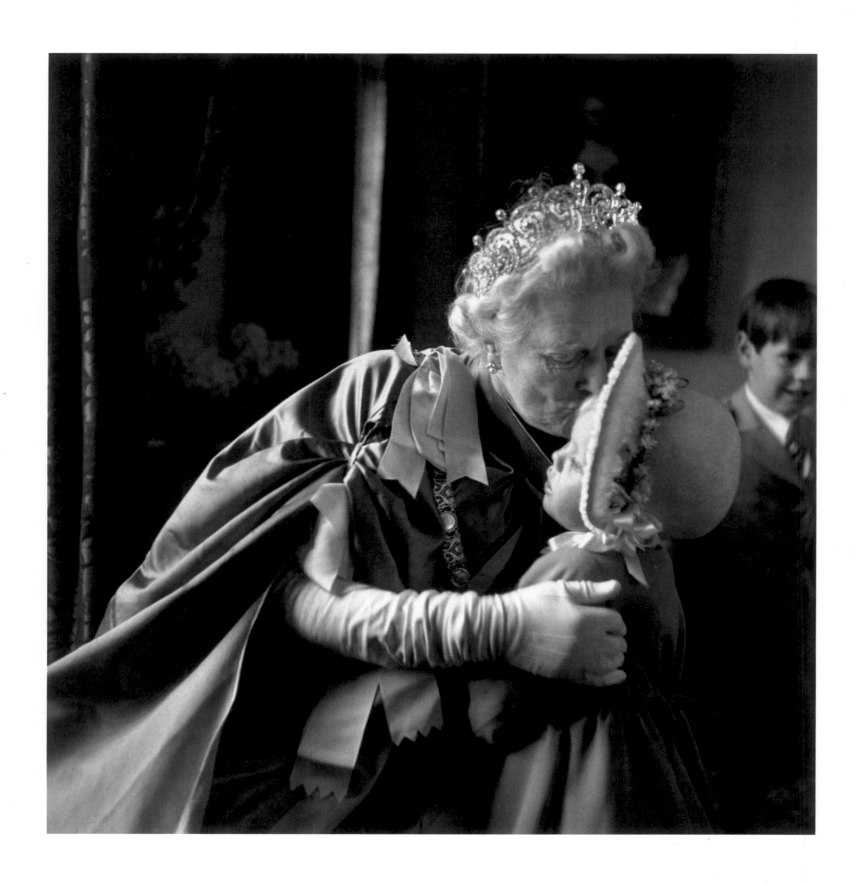

Toni Frissell
Lady Churchill and Her Granddaughter, 1953
Gelatin silver print, c. 1967
13¾ x 13¾ inches
Photography in the Fine Arts Collection, 1981

142

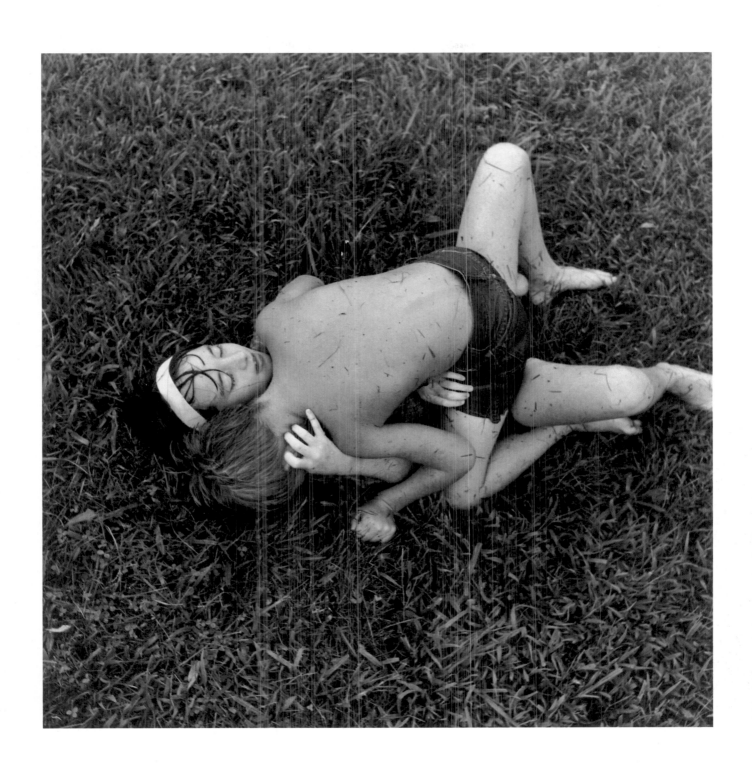

Emmet Gowin
Danville, Virginia, 1970
Gelatin silver print
6 ½ x 6 ½ inches
Gift of Tom Calicchio, 1982
383.1982

143

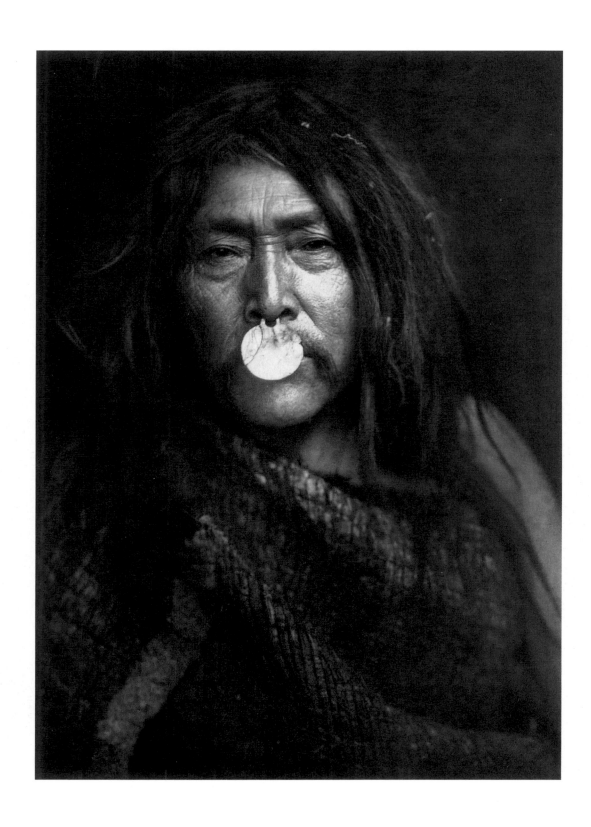

144

Edward S. Curtis
Naemahl Punkuma-Hahuamis, 1914
From "Kwakiutl" (1915) volume X, of *The North American Indian*,
1907–1930
Photogravure
7 ⅜ x 5 ½ inches
Gift of Daniel L. Gastel, in memory of Joseph and Bessie Vine, 1998
40.1998

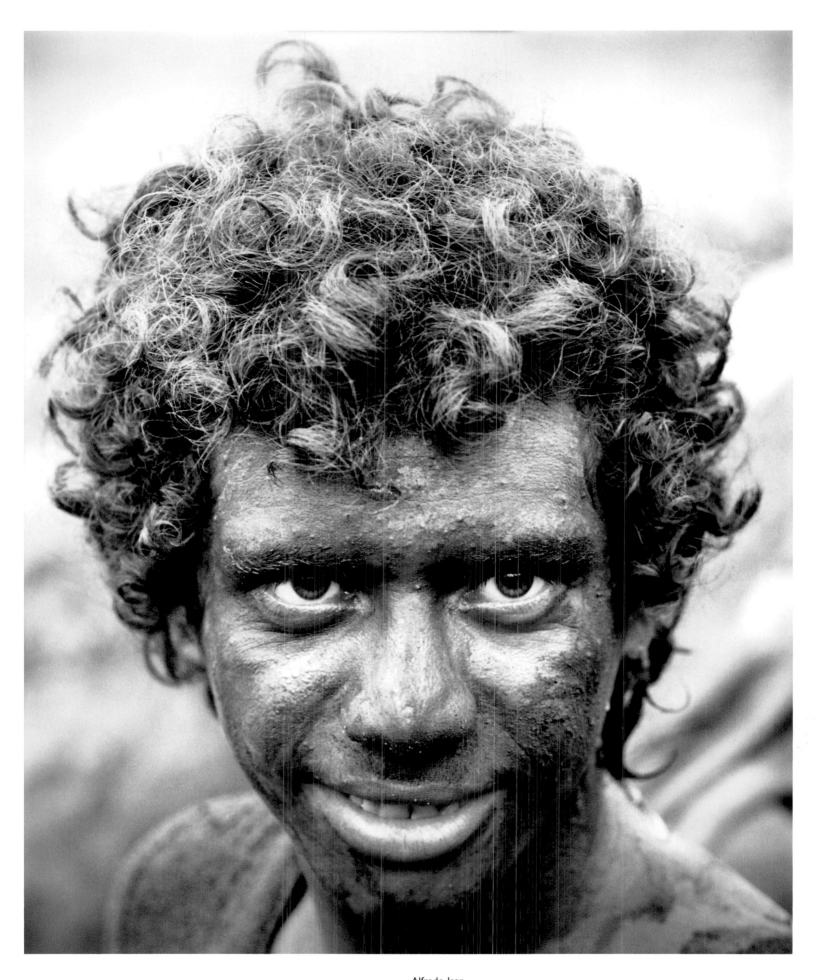

145

Alfredo Jaar
Untitled [Mud-covered laborer], 1991
From the portfolio "In a Dream . . .", 1991
Color transparency and lightbox
24 x 20 inches
Gift of Photographers + Friends United Against AIDS, 1998
2.1998c

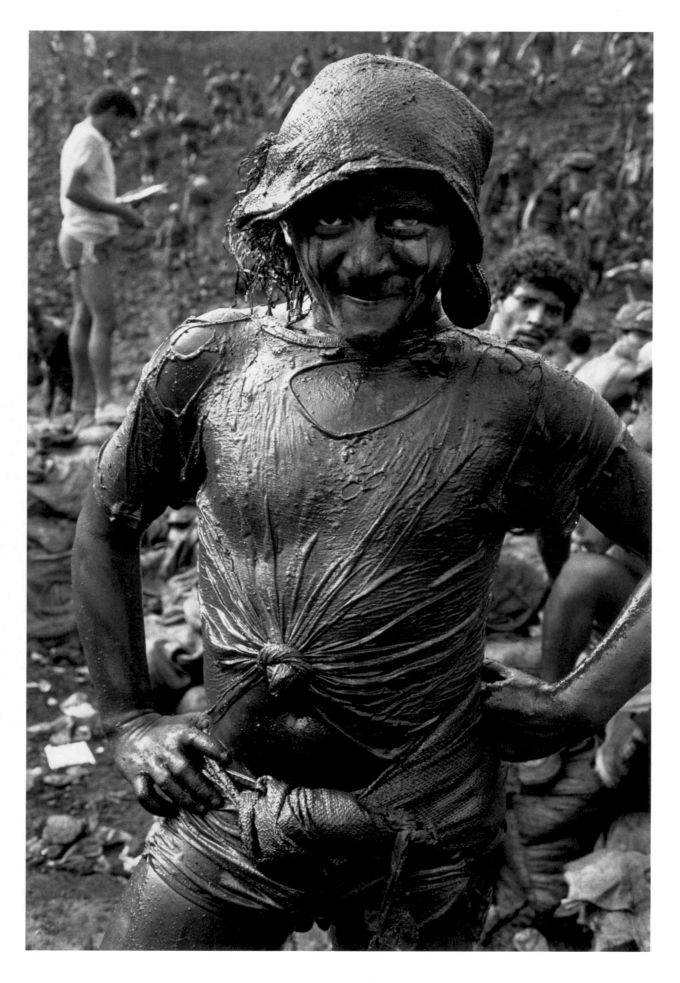

Sebastião Salgado
Serra Pelada, Brazil, 1986
Gelatin silver print
17⅝ x 11⅞ inches
ICP Purchase Fund, 1988
251.1988

146

Fazal Sheikh
Unaccompanied Minors, Sudanese Refugee Camp, Kakuma, Kenya, 1993
Gelatin silver print
20½ x 16¼ inches
Gift of the photographer, 1997
15.1997

Burt Glinn
Castro Speaks in Santa Clara, 1959
Gelatin silver print, 1990s
12¾ x 8½ inches
Gift of the photographer, 1996
337.1996

148

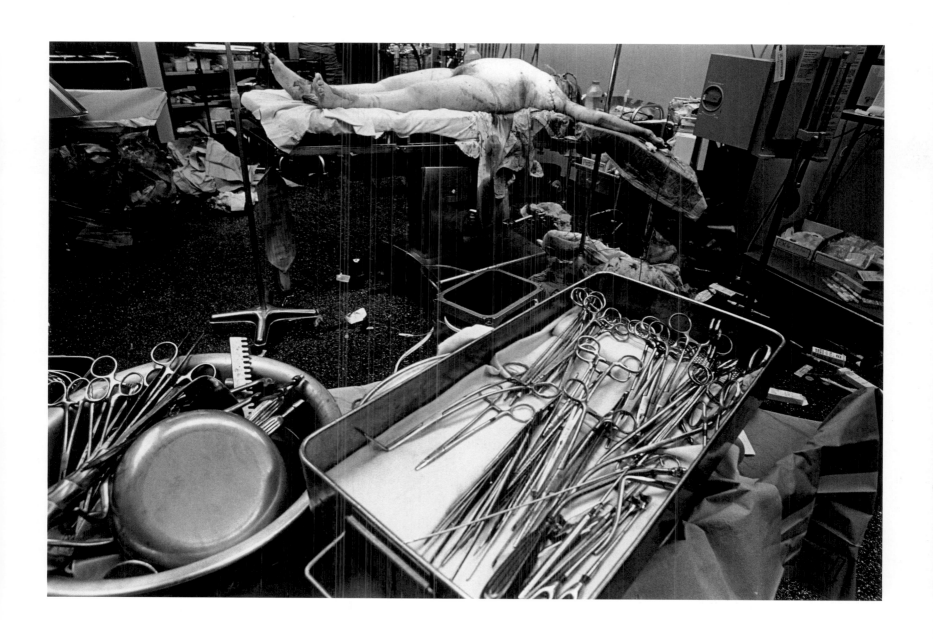

Eugene Richards
Dead from Gunshot, 1979–1987
Gelatin silver print
12¼ x 18⅝ inches
Gift of the photographer to the W. Eugene Smith Legacy Collection at the
International Center of Photography, 1995
25.1995

Verbal Image

An image made up entirely of words? That may sound like a magician's sleight-of-hand, and in many ways it is, except that even its cleverest practitioners do not know all its secrets. For instance, how many words are necessary to do the trick? It doesn't have to be many, but when they do their work, something or someone we have never met before suddenly materializes before us.

"His wife looks like a stork," we overhear someone say on the street, and we instantly start furnishing the rest. She is tall, thin-legged, wears short skirts, and keeps her head hanging low. And that's just the beginning. Once our imagination is cued up, it fills in the blanks. As both good writers and good gossips know, all one needs to do is plant a hint. Isaac Babel describes someone—I forget whom—as having "a soul as gentle and pitiless as the soul of a cat," and the face of a chubby little boy who likes to pluck the legs off flies pops into my head.

It's much harder if I'm the one who is trying to make a verbal image. I wish to nail with a quick phrase or two somebody's idiosyncrasy. I know that lengthy description of his physical appearance or quips about his psychological traits won't capture it. What I'm looking for is that fleeting moment when a facial expression, a gesture, a look in the eyes divulges something of the person's true character.

I remember my mother sitting one late October afternoon in the garden of a nursing home with a red shawl over her shoulders and a small book in her lap. I had come to pay her a visit, was told where she was, and stood by her side unobserved. It was very quiet. Once in a long while she looked up with the day's fading sunlight on her face, as if to ponder some serious matter she had just read and reread. The sky was clear and open to view because the leaves had already fallen and lay still around her thick-soled black shoes. I wrote a poem about it, but I had no confidence that I was conveying what I saw and felt. Though it was discernible to me, it was perhaps obscure to the reader. The alchemy of turning what is visible to us into what is visible to others is what all the arts are about.

Despite the heavy odds, it can be done. "He was a white man with greased black hair and a greased black look to his suit. He moved like a crow," is how Flannery O'Connor describes a steward seating people in the dining car of a train. "A young woman in slacks, whose face was as broad and innocent as a cabbage and was tied around with a green hand-kerchief that had two points on the top like rabbit's ears," she writes elsewhere. Our identities are secretive; they like to hide in plain view. The art of portraiture and the art of caricature are near cousins. Both zero in on some overlooked detail invisible until that very moment. A verbal image is the equivalent of a snapshot, except in this case the reader supplies the flash.

CHARLES SIMIC

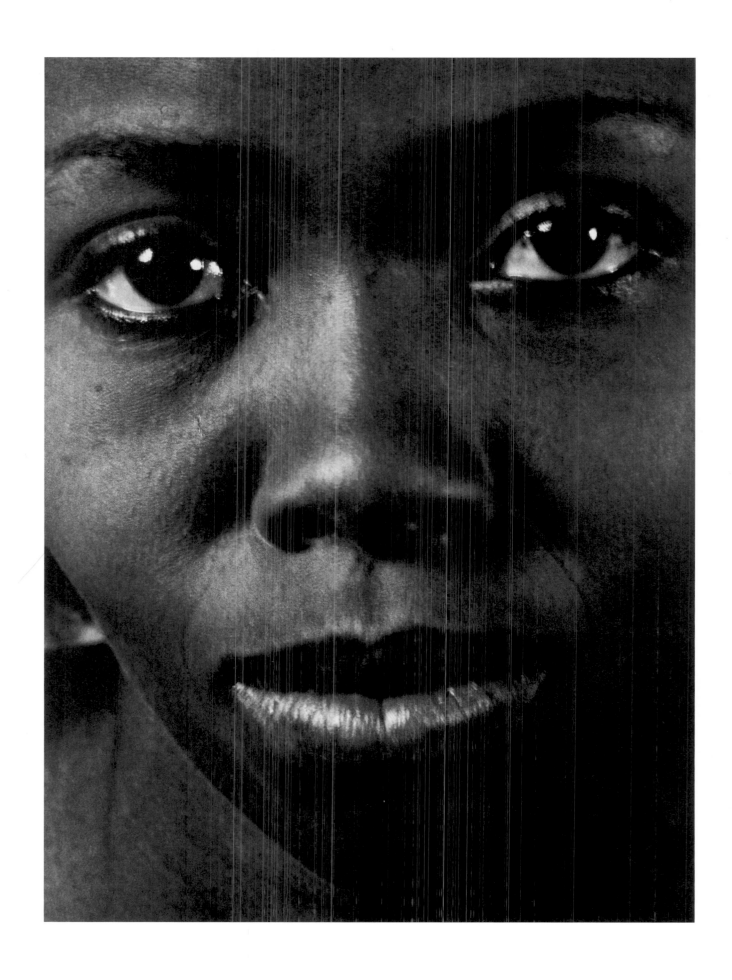

Consuelo Kanaga
Annie Mae Merriweather, 1935–1936
Gelatin silver print
7⅞ x 6 inches
Gift of Wallace Putnam, 1982
14.1982

150

151

Tessaro Studio
[Monk at Prayer *by Dieric Bouts, detail of a painting*], 1860s
Albumen silver print from glass negative
10¼ x 6⅞ inches
Brandwein Collection, Gift of Paul and Mary Brandwein, 1976

Julia Margaret Cameron
Charles Darwin, 1863
Carbon print
12 ½ x 9 ½ inches
Gift of Lee Sievan, 1983
323.1983

153

Sarah Sears
Mary, 1907 or before
From *Camera Work*, volume 18, April 1907
Photogravure
8⅛ x 6½ inches
Gift of Daniel Logan, Richard Logan, and Jonathan Logan, 1984
792.1984

Edward Steichen
Vitality—Yvette Guilbert, 1901
From *Camera Work*, volume 42/43, April–July 1913
Photogravure
9½ x 6⅝ inches
Gift of Daniel Logan, Richard Logan, and Jonathan Logan, 1984
798.1984

154

Photographers Unknown
[Two children], 1850s; *[Woman in white bonnet]*, 1850s
Daguerreotypes
3 ¼ x 2 ¾ inches; 3 ¼ x 2 ¾ inches
Brandwein Collection, Gift of Paul and Mary Brandwein, 1976

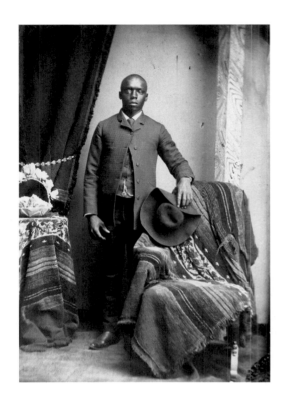

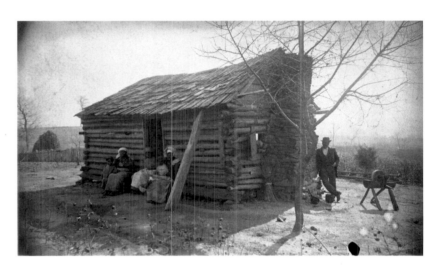

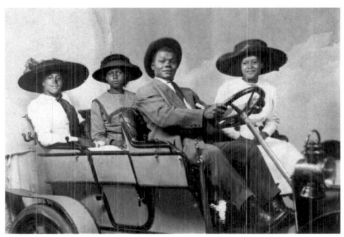

Photographers Unknown
[Standing man in suit], 1860s; *[Family in front of log cabin]*, 1870s;
[Family in open car], 1920s
Tintype; albumen silver print from glass negative;
gelatin silver print on postcard stock
3⅝ x 2⅜ inches; 4¾ x 8 inches; 2¾ x 3¼ inches
Daniel Cowin Collection, 1992

Photographers Unknown
[Landscape in winter]; [Two infants]; [Three children]; [Family portrait], c. 1905
Cyanotypes on postcard stock
Dimensions variable
Gift of Richard E. Kremer, 1993
609.1993-612.1993

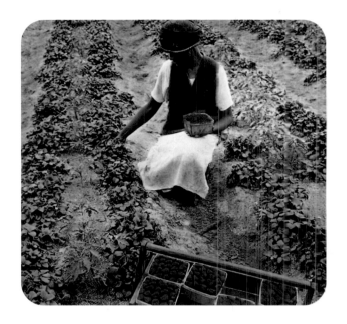

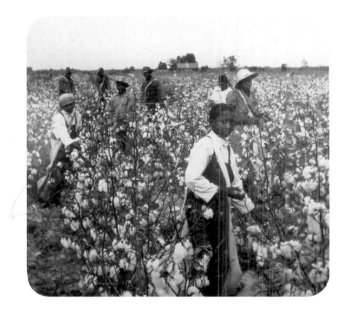

158

Photographers Unknown, published by Keystone View Company
Picking Strawberries in January; A Sugar Cane Field and Refinery; Picking Cotton;
Wheat Elevators at Fort Worth, Texas, 1920s–1930s
Glass lantern slides, two with applied color
3 x 4 inches each
ICP Accession

159

Clarence White
Alvin Langdon Coburn and His Mother, c. 1907
From *Camera Work*, volume 32, October 1910
Photogravure
8¼ x 5⅞ inches
Gift of Daniel Logan, Richard Logan, and Jonathan Logan, 1984
795.1984

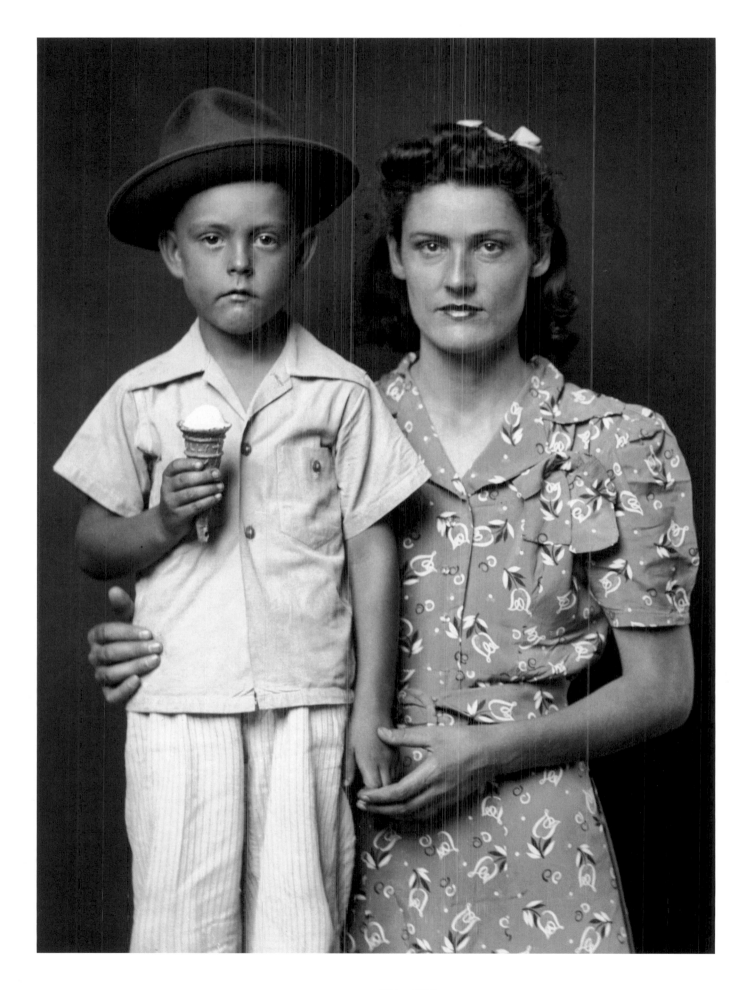

160

Michael Disfarmer
[Woman and child holding ice cream cone], 1939–1946
Gelatin silver print, 1970s
10¾ x 8 inches
Gift of Julia Scully, 1977
197.1977

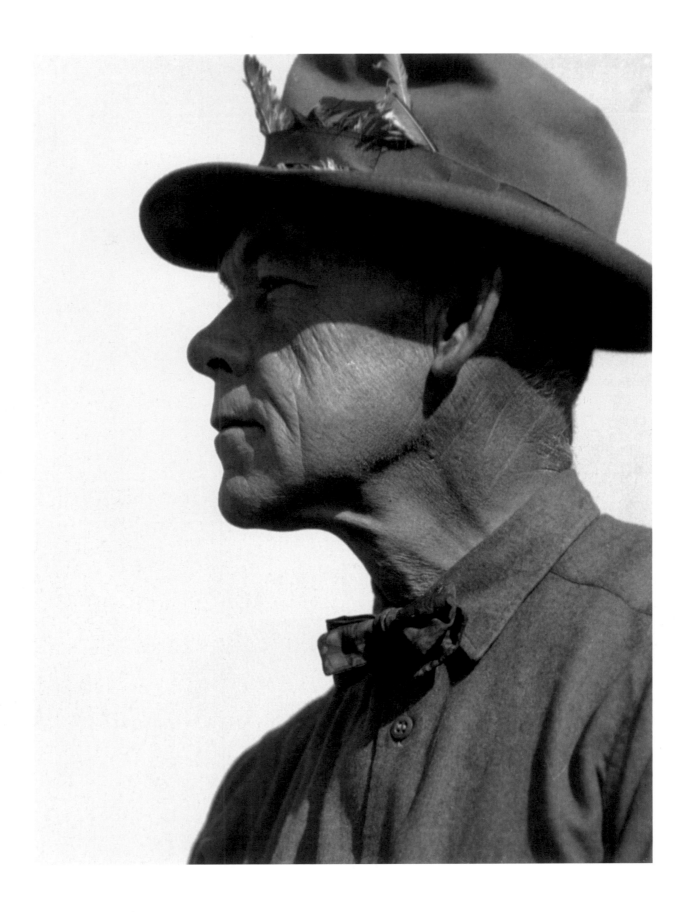

Ansel Adams
William Edward Colby, 1929
From the portfolio "The Sierra Club Outing," 1929
Gelatin silver print
7 ¼ x 5 ½ inches
Gift of Daniel Cowin, 1991
326.1991

161

Imogen Cunningham
Morris Graves, Painter, 1950
Gelatin silver print, c. 1967
9⅝ x 11⅞ inches
Photography in the Fine Arts Collection, 1981

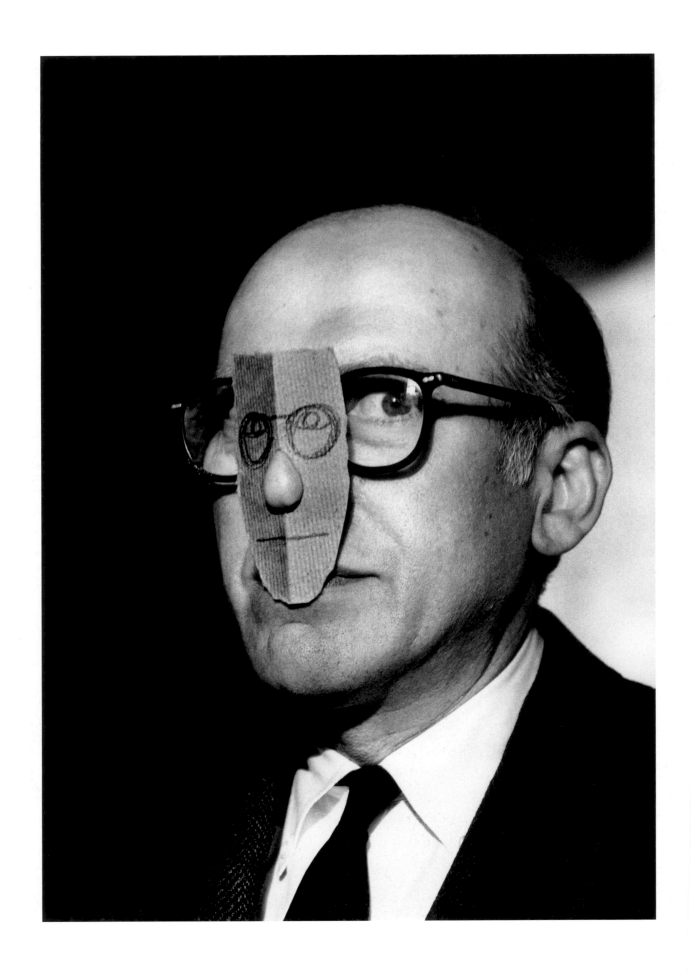

Inge Morath
Saul Steinberg, 1966
Gelatin silver print
10 x 7 inches
Gift of the photographer, 1975
202.1975

163

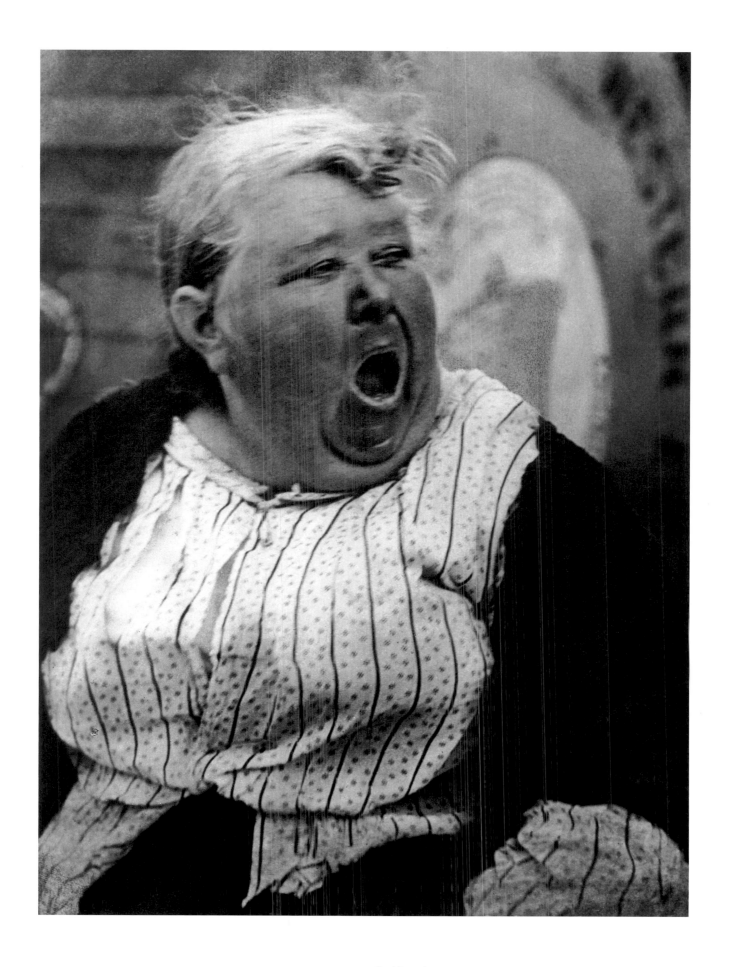

164

Paul Strand
Photograph — New York, 1916
From *Camera Work*, volume 49/50, June 1917
Photogravure
8½ x 6½ inches
Gift of Daniel Logan, Richard Logan, and Jonathan Logan, 1984
799.1984

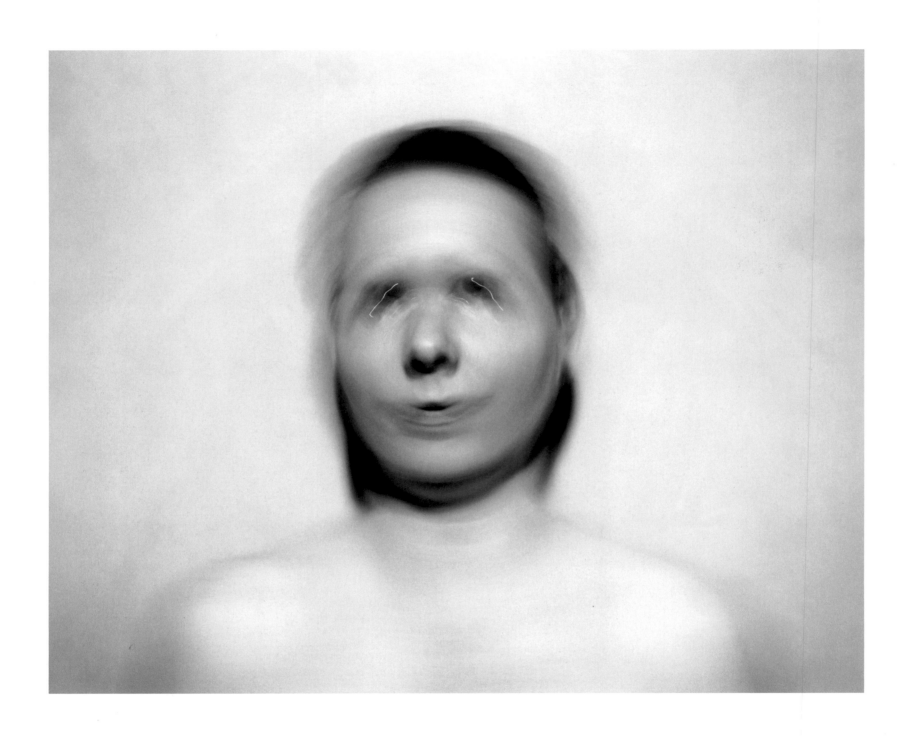

165

Blythe Bohnen
Self-Portrait: Pivotal Motion from Nose, Small, 1983
Gelatin silver print
14⅞ x 18½ inches
Gift of Herbert and Paula Molner, 1992
3523.1992

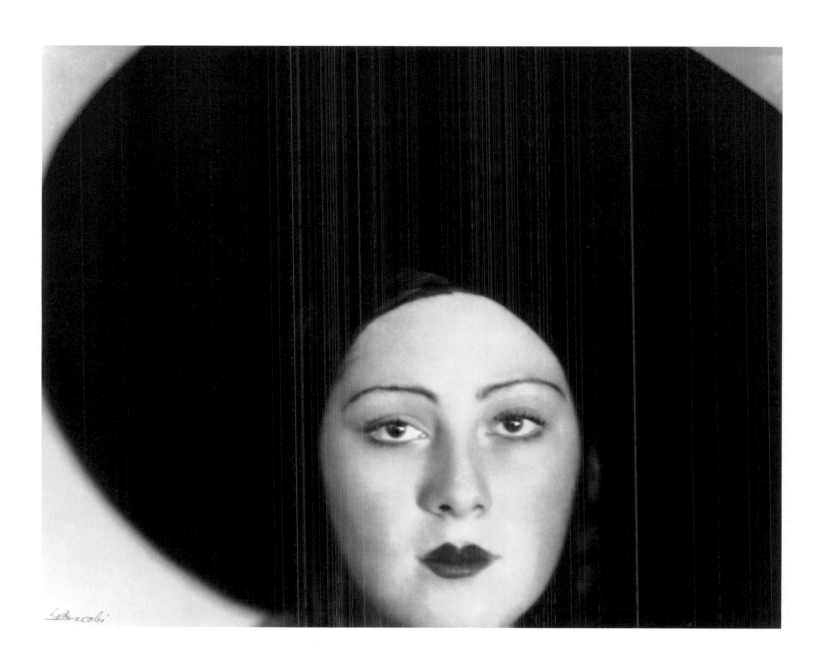

166

Lotte Jacobi
Niura Norskaya, Berlin, 1929
Gelatin silver print 1970s
7¾ x 9⅝ inches
Gift of Bernadette Hunter, 1986
34.1986

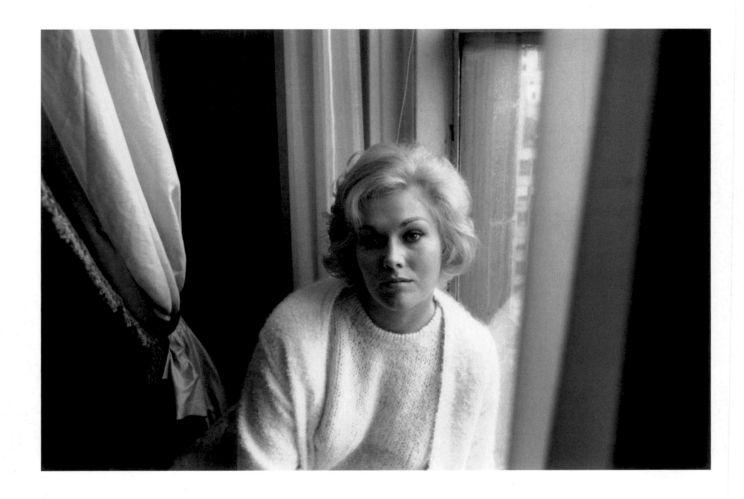

Duane Michals
Kim Novak, 1962
Gelatin silver print
4⅞ x 7⅞ inches
Purchased with funds from the Zenkel Foundation, 1981
144.1981

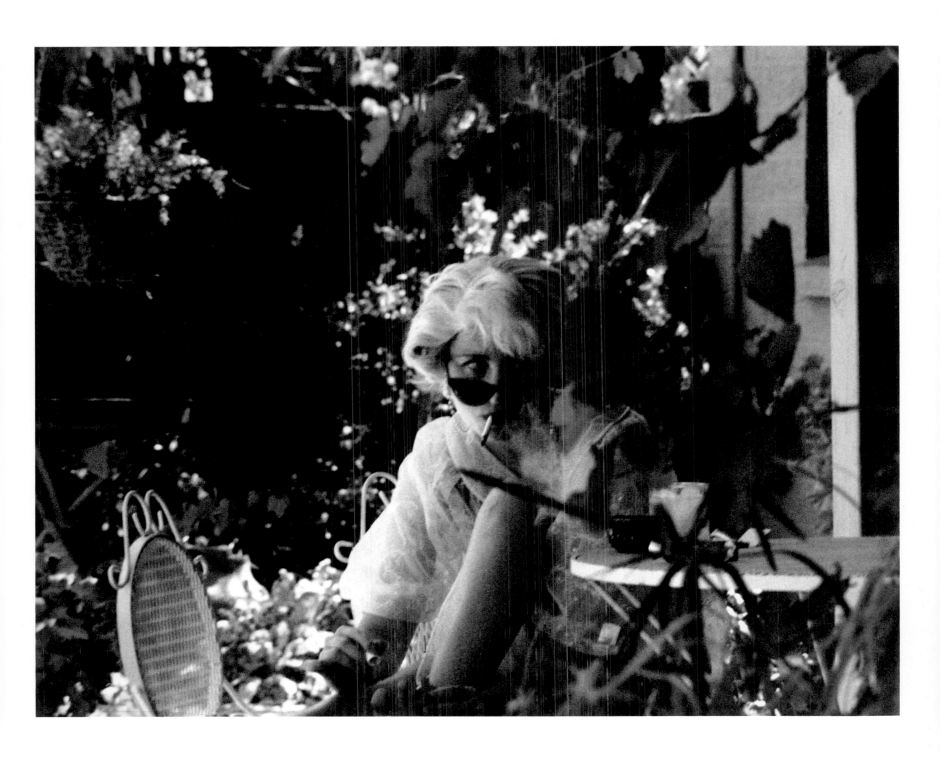

Cindy Sherman
Untitled [Woman applying toenail polish in a garden], 1979
From the portfolio "The Indomitable Spirit", 1990
Chromogenic print, 1989
18 x 23 ⅛ inches
Gift of Photographers – Friends United Against AIDS, 1998
1.1998h

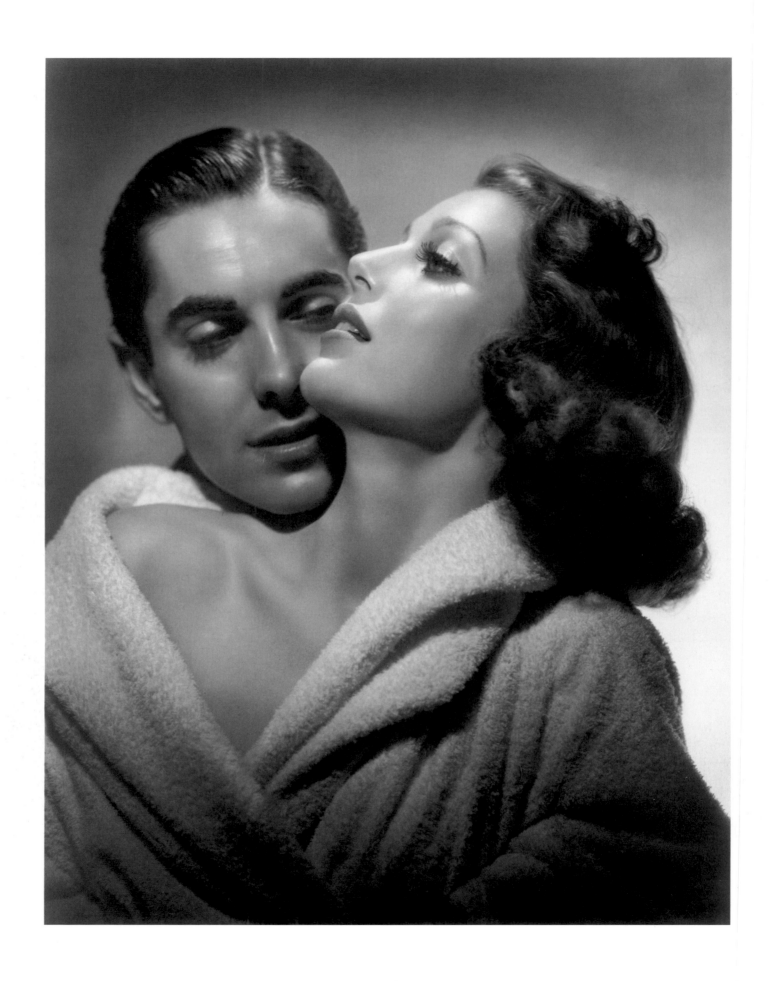

George Hurrell
Loretta Young and Tyrone Power, 1937
Gelatin silver print, 1970s
13¼ x 10½ inches
Gift of William C. Scott, 1981
299.1981

169

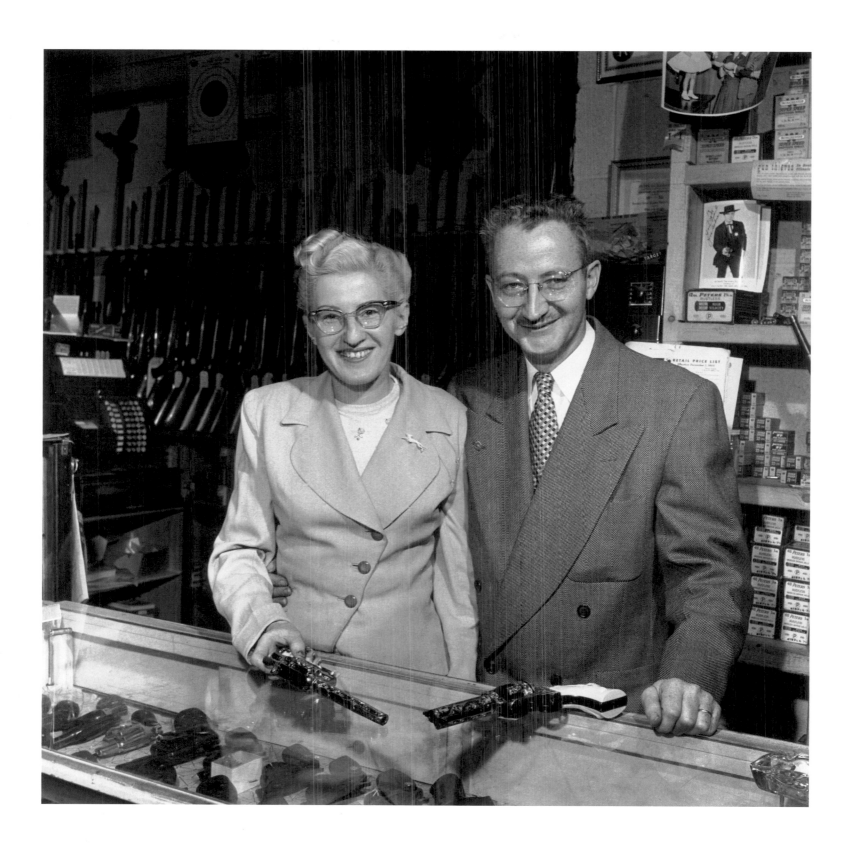

Mickey Pallas
Gun Shop Owners, 1956
Gelatin silver print, c. 1986
10⅜ x 10½ inches
Gift of the photographer, 1987
631.1987

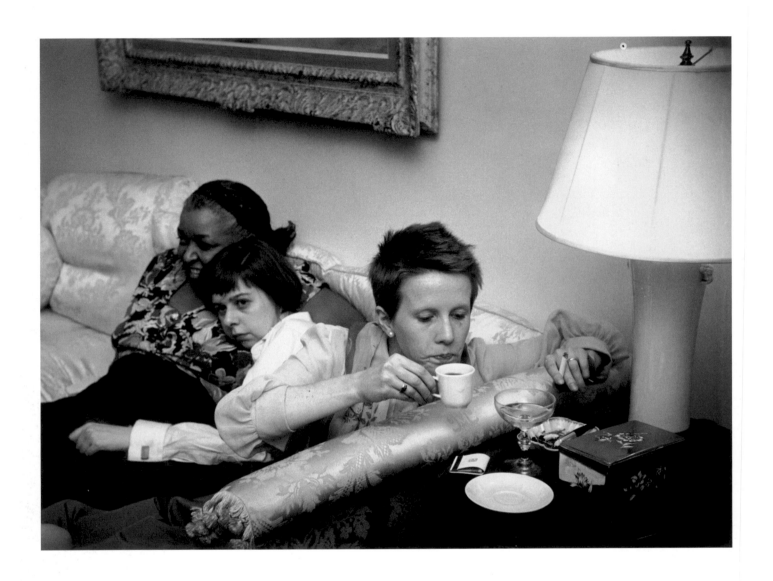

Ruth Orkin
Opening Night, The Member of the Wedding [Ethel Waters,
Carson McCullers, Julie Harris], 1950
Gelatin silver print, c. 1980
10 x 13½ inches
Purchased with funds from the National Endowment for the Arts
and the Zenkel Foundation, 1983
537.1983

171

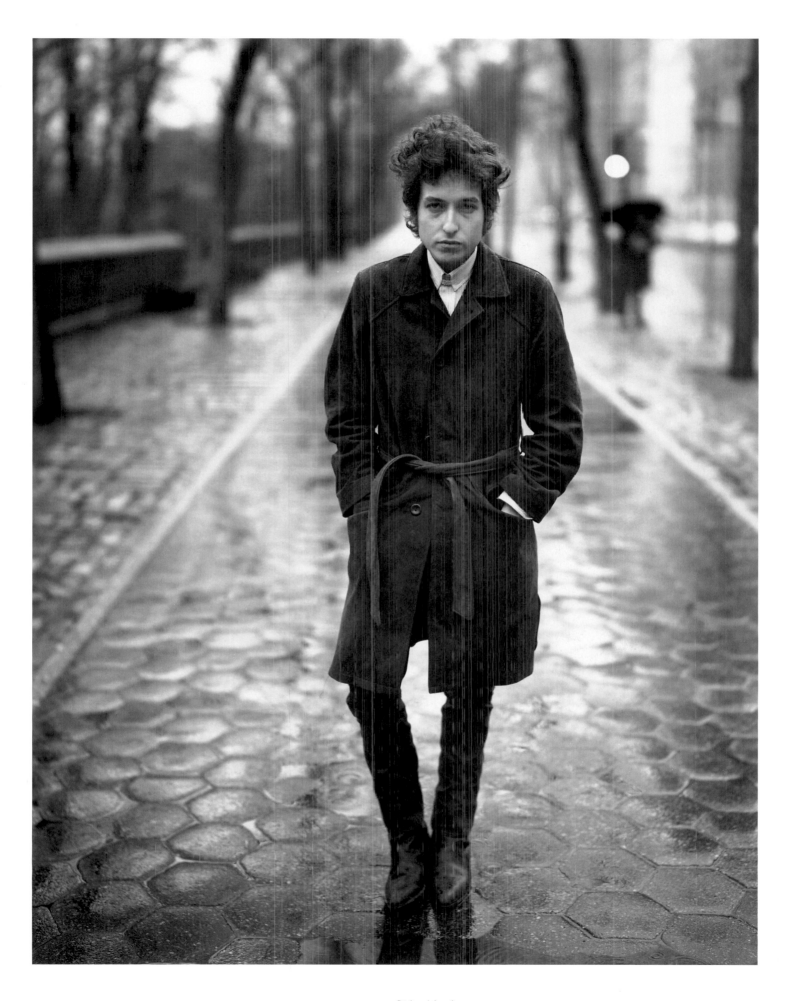

172

Richard Avedon
Bob Dylan, 1965
Gelatin silver print
19¼ x 15⅛ inches
Photography in the Fine Arts Collection, 1981

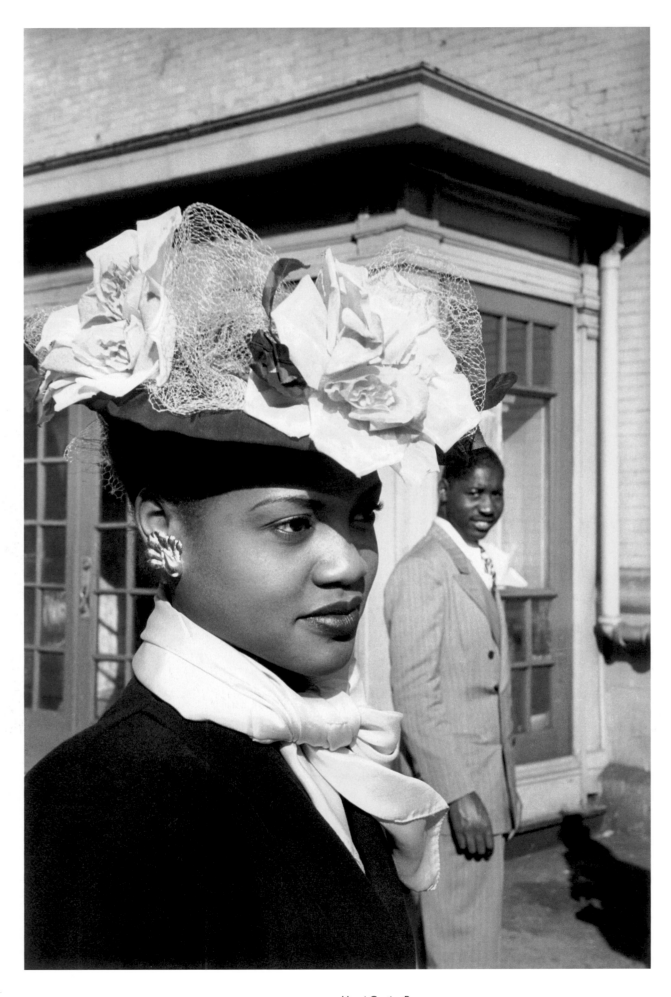

173

Henri Cartier-Bresson
Easter Parade, Harlem, 1947
Gelatin silver print, c. 1959
18¾ x 12½ inches
Photography in the Fine Arts Collection, 1981

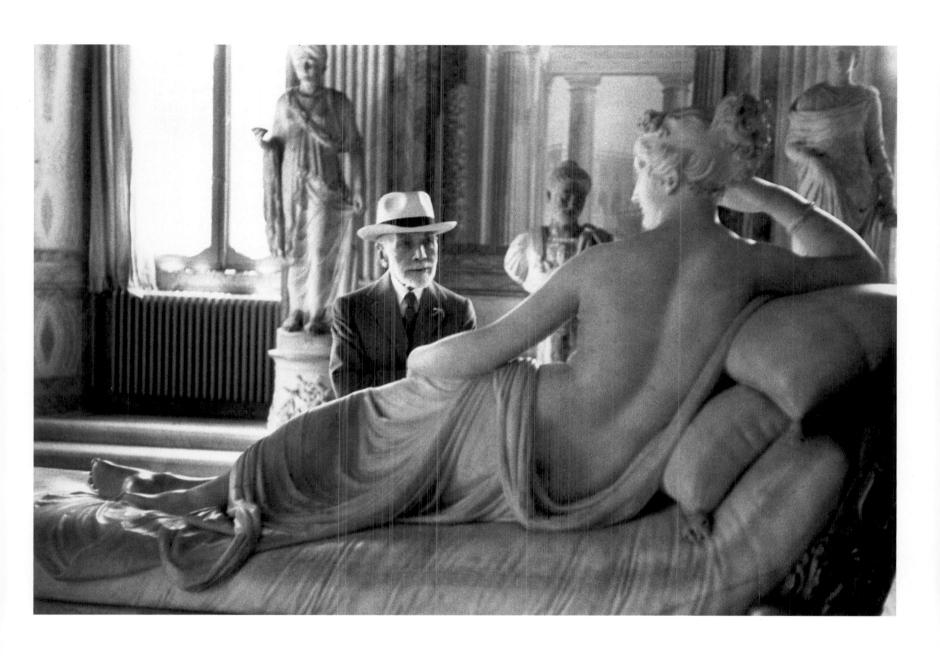

174

Chim (David Seymour)
Bernard Berenson at Ninety, Visiting the Borghese Gallery, Rome, 1955
Gelatin silver print, c. 1970
13 x 19¾ inches
Purchased, International Fund for Concerned Photography, 1974
768.1974

Biographies

These brief biographical entries for the photographers whose pictures are reproduced in this volume are the work of a team of researchers— Meredith Fisher, Cynthia Fredette, Lisa Hostetler, John McIntyre, and Lisa Soccio—whose individual contributions are identified by their initials. Each entry is necessarily selective; more complete information about many of these photographers is published and available elsewhere.

Berenice Abbott
(American, 1898–1991)
Born in Springfield, Ohio, Berenice Abbott spent the early part of her artistic career studying sculpture in New York, Berlin, and Paris, where she worked as Man Ray's studio assistant. This experience led her to photography, and in 1926 she established herself as an independent photographer whose portraits of well-known artists and writers rivaled those of Man Ray in excellence and renown. Through Man Ray, she met Eugène Atget, whose photographs of the transformation of Paris from the *ancien regime* through the mid-1920s impressed her with their methodical technique and intuitive inflections of artistry. Upon Atget's death, Abbott purchased his photographic oeuvre, and for more than forty years tirelessly promoted his work. It is largely through her efforts that this great photographer is still known today.

In 1929, Abbott returned to the United States, where she embarked on her best-known body of work—a documentation of New York City for which she developed her famous bird's-eye and worm's-eye points of view. She worked on the project independently through the early years of the Depression, and in 1935 secured funding from the Federal Art Project (a part of the Works Progress Administration). Her pictures were published as *Changing New York* (1939), which was both critically and commercially successful; it remains a classic text for historians of photography.

One of Abbott's later final projects was an illustration of scientific phenomenon, produced in the 1950s in collaboration with the Physical Sciences Study Committee based at the Massachusetts Institute of Technology. Although not as well known as her New York work, these pictures are exquisite examples of her acumen for technical experimentation and her natural instinct for combining factual photographic detail with stunning artistic accomplishment. With their clear visual demonstration of abstract scientific principles, the photographs were chosen to illustrate physics textbooks of the 1950s and 1960s. Abbott's work has been exhibited widely, and she was the recipient of numerous honors, including ICP's Master of Photography Infinity Award in 1989.—LH

Ansel Adams
(American, 1902–1984)
The influence of Ansel Adams on photography is immeasurable, and his long career as photographer, teacher, conservationist, and writer is legendary. His visionary belief in the redemptive beauty of wilderness was expressed in grand images that have popularized art photography among the American public. Adams was born in San Francisco, and trained as a musician; his interest in photography was catalyzed when he met Paul Strand in 1930. In 1932, with Imogen Cunningham, Edward Weston, and others, Adams founded the group *f/64*, which promoted use of large-format view cameras, small lens apertures, and contact printing. Adams developed this purist approach into the zone system, a controlled method of determining exposure and development. His deep respect for the grandeur of landscape motivated a lifelong involvement in conservation, which he advocated through photographic books and active membership in the Sierra Club.

In 1933, Adams met Alfred Stieglitz, who gave him a solo exhibition at his gallery An American Place in 1936; after this meeting, Adams opened his own gallery in San Francisco. He moved to Yosemite Valley in 1937 and lived there until 1962, teaching annual photography workshops from 1955 through 1984; in 1962 he moved to Carmel, California, where he spent the rest of his life. Adams assisted Beaumont Newhall and David McAlpin in forming the Department of Photography (the first in the country) at the Museum of Modern Art in 1940, and he founded the Department of Photography at the California School of Fine Arts in 1946. In 1967 he established the Friends of Photography in San Francisco. Adams received Guggenheim grants in 1946, 1948, and 1958. He published dozens of picture and technical books.—LS

Bobby Neel Adams
(American, born in 1953)
Bobby Neel Adams was born in Black Mountain, North Carolina, and received a BFA from Goddard College in Vermont in 1976. His photographs have appeared in several books published by Re/Search, including *The Industrial Culture Handbook* (1996) and *Modern Primitives* (1989); in photo-illustrated fiction by Charles Willeford and Octave Mirbeau; and in such periodicals as *LIFE*, *Artforum*, *Fortune*, *The New York Times*, *The Washington Post*, and *Wired*. Adams's best-known pictures are those made for the series "Beauties and Beasts," "Age Maps," and "Couples," in each of which he combined two individual portraits in the darkroom to create a single image. Adams's pictures have been shown publicly since 1988 at a number of venues, including the Greenville, North Carolina, County Art Museum and ICP. His recent portraits of landmine victims in Cambodia and Mozambique were published in book form as *Broken Wings* (1997), and selections from this series have been shown in traditional exhibitions and on the Internet (www.f8.com/FP/LMINES/LMint1.htm). Adams received a Grand Street Foundation Grant in 1998, the Aaron Siskind Award in 1997, and a Dorothea Lange/Paul Taylor Award in 1993.

Adams's composite photographs study similarities and differences among individuals' physical appearances from generation to generation, during the process of aging, and between genders. His portraits of landmine victims challenge preconceptions about the continuity and integrity of the body by calling attention to bodies that have been physically, rather than photographically, altered. Using both manipulated and straightforward photographic methods, Adams depicts the body as a malleable entity subject to disturbingly unmanageable elements. —LH

Robert Adams
(American, born in 1937)
Originally from Orange, New Jersey, Robert Adams came to photography in 1963 when earning a Ph.D. in English at the University of Southern California. While teaching English at Colorado College in 1967, he photographed residential areas around Colorado Springs at the request of the organizers of a conference on the western landscape. His interests shifted from the primarily rural landscape to urban and suburban landscapes, and in photographing the latter, he concentrated on the man-made incursions on the natural landscape. This work was published in *The New West: Landscapes Along the Front Range* (1974) and *Denver: A Photographic Survey of the Metropolitan Area* (1977). More recently, Adams has reincorporated the rural landscape into his work, in such books as *Our Lives & Our Children: Photographs Taken Near the Rocky Flats Nuclear Weapons Plant* (1984) and *Cottonwoods* (1994). He has earned many distinctions, including a MacArthur Foundation Fellowship, two National Endowment for the Arts Fellowships (in 1973 and 1978), and a Guggenheim Fellowship (1973). He was included in the 1975 exhibition "New Topographics: Photographs of a Man-Altered Landscape" at the George Eastman House, which associated his work with that of Lewis Baltz and Stephen Shore, among others.

Adams's documentation of contemporary western landscapes reveals the environmental damage caused by the suburbanization of such cities as Denver, Portland, Seattle, and Salt Lake City, as well as by the proliferation of nuclear weapons technology in those areas. Adams describes his photography as an attempt to "reconcile" his disappointment with the behavior of people toward nature with his heartfelt respect for the unique landscape of the West. In accomplishing this aim, he draws on the tradition of black-and-white western landscape photography as practiced by Timothy O'Sullivan and Ansel Adams.—LH

Lucien Aigner
(American, 1901–1999)
Hungarian-born Lucien Aigner arrived at photography through his initial pursuit of a career in journalism. After earning a law degree in 1924, he worked as a reporter for the *Az Est* newspaper in Budapest; he learned photography only in order to enhance his ability to describe details and atmosphere in his reports. From 1927 to 1939 he was Paris bureau chief for the newspaper, and during that time he explored other avenues in photography and writing: he was an assistant to the photographer James Abbe, and editor in chief of Aral Press, and Paris correspondent for the London General Press. In addition, he did freelance photojournalism for *Vu*, *L'Illustration*, *Picture Post* (London), *Berliner Illustrierte Zeitung*, *Münchner Illustrierte*, and *LIFE*, to which he was under contract from 1936 to 1937. Feeling restless and constrained in Paris, he immigrated to the United States in 1939 and continued freelancing as a photojournalist for *The Christian Science Monitor*,

Look, The New York Times, and other periodicals. By 1948 he had produced the bulk of his photographic work; he turned his attention to duties as announcer, scriptwriter, and producer/director for Voice of America radio programs. Aigner retired from broadcasting in 1953 and moved to Massachusetts, where he opened a portrait studio.

An elegant writer as well as photographer, Lucien Aigner is most often associated with his coverage of political events and personalities that led up to World War II in Europe. In that capacity, he was a pioneer of the small camera, along with others of his generation such as Henri Cartier-Bresson and Erich Salomon; his work is exemplary of traditional European photojournalism. Aigner's personal work evokes the atmosphere of everyday life in prewar Europe.
—LH

Manuel Alvarez Bravo
(Mexican, born in 1902)
Born in Mexico City, Manuel Alvarez Bravo worked for the Mexican Treasury Ministry and studied literature before entering the Academia Nacional de Bellas Artes de San Carlos in 1918. He bought his first camera in 1924, and in 1927 met Tina Modotti, who encouraged him in his work and urged him to send a portfolio of his prints to Edward Weston for review. Modotti introduced him to the Mexican muralists Diego Rivera, David Siqueiros, and José Orozco in 1930, and with their encouragement and Weston's, Alvarez Bravo turned to photography full-time in 1931. In 1938 he met André Breton, who familiarized him with the aesthetics of Surrealism and included him in a Surrealist exhibition in Mexico City that year. From 1939 to 1942, Alvarez Bravo operated a commercial photography studio in Mexico City, while continuing to produce personal work. He cofounded the Fondo Editorial de la Plástica Mexicana in 1959 to promote and publish indigenous Mexican art, and opened the Museum of Mexican Photography in 1986. His work has been exhibited at the Instituto Nacional de Bellas Artes in Mexico City, the Musée d'Art Moderne de la Ville de Paris, the Museum of Modern Art, ICP, and elsewhere. He has been recognized with many honors, including a Guggenheim Fellowship in 1975, a Lifetime Achievement Award from the College Art Association in 1996, and ICP's Master of Photography Infinity Award in 1987.

Although his work is often associated with Surrealism, Alvarez Bravo was not a member of the movement. His photography is deeply rooted in the indigenous culture of Mexico, and his knowledge of Surrealist aesthetics has served mainly to reinforce the exploration of death, earth, and violence typical of his native culture. Alvarez Bravo's incisive formal sensibility has reinforced his portrayal of the universal through images of individual people, objects, and places.—LH

Diane Arbus
(American, 1923–1971)
Diane Arbus was born in New York City, where she studied at the Ethical Culture and Fieldston schools until 1940. Working with

her photographer husband, Alan Arbus, as a stylist on fashion assignments, she developed an interest in photography that led her to take classes with Lisette Model from 1955 to 1957. Model encouraged her to pursue her own projects, and in 1961, Arbus published her photographs for the first time, in an *Esquire* feature entitled "The Vertical Journey," which began her successful career. Her work appeared in *Harper's Bazaar, Show, The New York Times Magazine*, and many other publications, attracting attention very quickly. Arbus won Guggenheim grants in 1963 and 1966, and was included in John Szarkowski's important "New Documents" exhibition at the Museum of Modern Art in 1967, grouped with Lee Friedlander and Garry Winogrand as a documentarian of the "social landscape." She taught at Parsons School of Design, Cooper Union, and Rhode Island School of Design. Her work was shown posthumously at the 1972 Venice Biennale, the first time an American photographer was represented at that event; the Museum of Modern Art held a retrospective of her work the same year. *Diane Arbus: An Aperture Monograph* (1972), published in conjunction with that exhibition, remains one of the best-selling photography books in history.

Arbus's photographs possess a disarming psychological frankness. Her work is considered by some to be exploitative, and it has been the subject of much controversy since its first appearance. Nevertheless, her often sensitive photographs remain widely influential on the development of contemporary photography.—LH

Shimon Attie
(American, born in 1957)
A native of Los Angeles, Shimon Attie earned an M.A. in psychology from Antioch University in 1982 and an MFA in 1991 from San Francisco State University. In his first major project, "The Writing on the Walls," produced in Berlin, he projected slides of old photographs of life in the city's Jewish quarter before the Holocaust onto the sites where the Jews had lived—and from which they had been removed. His subsequent projects included "Trains I" and "Trains II" in Hamburg and Dresden, and "Sites Unseen," a series of site-specific public installations in Krakow, Copenhagen, and Cologne. Attie's documentary photographs of these public projects have been exhibited at the Neue Gesellschaft für Bildende Kunst and the Museum for German History, both in Berlin; the Institute of Contemporary Art in Boston; and elsewhere. He has received a number of awards for his work, including a Visual Artist Fellowship from the German Ministry of Culture in 1996 and a National Endowment for the Arts Fellowship in 1993. Attie has published three books: *Shimon Attie: Finstere Medine* (Disreputable Quarter, 1992), *The Writing on the Wall: Projections in Berlin's Jewish Quarter* (1993), and *Sites Unseen: Shimon Attie—European Projects* (1998).

Attie's most recent projects, *Between Dreams and Memory* and *Untitled Memory (Projection of. . .)*, are rooted, like his previous ones, in the recovery of memory and its incorporation into the present. Unlike

his earlier projects, however, which were based in large part on the Holocaust, the new works have assumed a more personal approach and extend his study of memory into more varied cultural environments. In finding a method of imaging memory for examination in the present, Attie reminds us that accepting and processing our personal and cultural past are vital to confronting the future.—LH

Jane Evelyn Atwood
(American, born in 1947)
Jane Evelyn Atwood was born in New York City, and educated in Tennessee, Illinois, and Massachusetts; she graduated from Bard College in 1970. She bought her first camera in 1975 and learned photography in the city, where she has lived since 1971. Her first documentary project involved photographing prostitutes in the city, and her career has continued to concentrate on people living on the edges of society. This work has been published in book form in Germany and France as *Nacht'licher Alltag* (1980) and *Dialogues de Nuit* (1981). Atwood received the first W. Eugene Smith Grant for humanistic photography in 1980 to continue a project begun in 1977 concerning the lives of blind children, and her 1987 photo essay "Jean-Louis: Living and Dying with AIDS" earned her a World Press Photo Foundation prize. For the past decade, Atwood has been conducting a study of women in prison around the world, to be published in book form. She has received numerous grants and honors, including the Ernst Haas Award, a Hasselblad Foundation grant, the Oscar Barnack Award, the Prix Paris-Match, and the Alfred Eisenstaedt Award. Atwood's photographs have appeared in *LIFE, Géo, Stern, Paris-Match, The New York Times Magazine*, and other periodicals. "Documents," her first retrospective exhibition, premiered in Paris as part of the Mois de la Photo (Month of Photography) in 1990.

Atwood gives her subjects the rare opportunity to speak for themselves about the realities of their lives. For most of her projects, she conducts intimate interviews with the people she photographs, and publishes their words with her pictures. By combining her imagery with their stories, Atwood expands upon the tradition of documentary photography focused on people living on the margins of mainstream culture.—CF

Richard Avedon
(American, born in 1923)
Born in New York, Richard Avedon attended city public schools and Columbia University, and served in the photographic section of the merchant marine. He studied under Alexey Brodovitch at the New School for Social Research from 1944 to 1950, and became the elder designer's protégé. Avedon was a staff photographer for *Junior Bazaar* and then *Harper's Bazaar* for some twenty years, and became a staff photographer at *Vogue* in 1966. In 1994 he was the first staff photographer hired by *The New Yorker*. For a photographer whose roots are in publication work, Avedon has been exceptionally successful in museums as well. He was included in the 1955 landmark exhibition "The

Family of Man," at the Museum of Modern Art, and has received solo exhibitions at the Smithsonian Institution in Washington, D.C., the Museum of Modern Art, the Metropolitan Museum of Art, and many other institutions. Most recently, the Whitney Museum of American Art presented "Evidence: 1944–1994," a career retrospective of his work. In 1993, Avedon received the Master of Photography Infinity Award from ICP.

Since the late 1940s—when Avedon's blurred black-and-white portrait heads were acclaimed for capturing the raw dynamism of youth—his photography has changed to reflect the style, energy, and dynamism of the moment. He helped set the standard for sleek, urbane elegance in mid-twentieth-century fashion photography, and his gift for highlighting the allure and drama of his subjects has made him one of the most iconic photographers of the late twentieth century. Avedon maintains that "a photographic portrait is a picture of someone who knows he's being photographed, and what he does with this knowledge is as much a part of the photograph as what he's wearing or how he looks."—MF

Dmitri Baltermants
(Russian, 1912–1990)
Born in Warsaw (then part of the Russian empire), Dmitri Baltermants moved to Moscow with his mother when he was two, and left secondary school in the mid-1920s in order to work. After stints as a metal grinder, copy editor, and cinema mechanic, he was hired as an apprentice printer at the Izvestia printing house, which sent him to study at Moscow State University. He earned a degree in mechanical mathematics and was assigned to teach at a military academy in 1939; shortly thereafter, the paper *Izvestia* called him to cover the Soviet invasion of Poland. Having taught himself photography while a student, Baltermants had been making pictures since 1936, and his photographs from the Polish invasion led to a career in photojournalism. As a photographer with the Red Army, he covered major events of World War II, including battles outside Moscow in November 1941 and in the eastern Crimea during the winter of 1942. It was then that he made his most famous photograph, *Grief*, which depicts family members mourning soldiers massacred during a German retreat. Because the Soviet press wanted only positive pictures of war, which suggested impending victory for the Soviet Union, this photograph, and others—including *An Attack*—were not seen until more than twenty years later. After the war, and until his death in 1990, Baltermants worked as a staff photographer in Moscow for the illustrated magazine *Ogonyok*.

Although famous as a war correspondent, Baltermants was an avowed pacifist. His photographs often reveal the disastrous and sorrowful effects of war rather than individual feats of heroism. His images capturing the reality and immediacy of historical events provide insight into the quality and character of Soviet photojournalism during this century.—LH

Lewis Baltz
(American, born in 1945)

Lewis Baltz, born in Newport Beach, California, studied at the San Francisco Art Institute and received an MFA from the Claremont Graduate School in 1971. He worked as a freelance photographer in California and taught photography at various institutions, including the California Institute of the Arts, the University of California (Riverside and Santa Cruz), Yale, the École Nationale Superieure des Beaux-Arts, Paris, and the Art Academy of Helsinki. His work has been included in major exhibitions, including "New Topographics" at the George Eastman House in 1975 and "Mirrors and Windows" at the Museum of Modern Art in 1978. Baltz, who received National Endowment for the Arts grants in 1973 and 1977 and a Guggenheim Fellowship in 1977, has produced many projects on commission, among them "The Nation's Capital in Photographs" for the Corcoran Gallery of Art and "Near Reno" for the Nevada State Arts Commission. He has been based in Europe since the mid-1980s and travels extensively.

Lewis Baltz produces photographs in series focused on a particular theme or geographic area and usually publishes them in book form, as in *The New Industrial Parks Near Irvine, California* (1975), *Nevada* (1978), and *Park City* (1981). His work, like that of others associated with the New Topographics, challenges the nineteenth-century tradition of western landscape photography represented by Timothy O'Sullivan, Carleton Watkins, and William Henry Jackson through its less innocent view of the landscape. Baltz's perception of the landscape necessarily reveals the effects of twentieth-century culture and suburban development on the nation's topography. His recent books *Rule Without Exception* (1991), *Lewis Baltz: Politics of Bacteria*, and *Docile Bodies, Ronde de Nuit* (1998) reproduce color work dealing with Europe's urban landscapes.—LH

Tina Barney
(American, born in 1945)

Born in New York City, Tina Barney became interested in photography when she took a course at the Center for Arts and Humanities in Sun Valley, Idaho, in the mid-1970s. Her early photographs were black-and-white snapshots made with a 35-millimeter camera at her family's summer home. By 1981, she had changed to color film and a 4x5 view camera and was producing the large tableaux of friends and family in domestic settings for which she has become known. The inclusion of one such work, her forty-eight-by-sixty-inch print *Sunday New York Times*, in the Museum of Modern Art's 1983 "Big Pictures" exhibition brought her critical and popular attention and led to inclusion in such exhibitions as the 1987 Whitney Biennial and solo shows at the Museum of Modern Art and the George Eastman House. In the mid-1980s, Barney changed to an 8x10 view camera and expanded her range of subject matter beyond friends and relatives in their homes to strangers at public places. She has published two photographic books, *Friends and Relations: Photographs by Tina Barney* (1991) and *Photographs: Theater of Manners* (1997).

Barney's large-scale photographs of her upper-middle-class family and friends in the 1980s concerned a milieu that had been largely undocumented. These pictures were striking for their sense of familiarity and self-absorption, which prevented an easy identification between the viewer and the affluent subjects of the photographs. Her more recent work, which depicts nude figures in place of family and friends and incorporates direct references to art history, incites an even higher level of psychological tension by inserting jarring elements into mundane environments. The result is a body of photographs that move beyond voyeuristic curiosity to suggest the complex relationships embedded in common situations.—LH

Pablo Bartholomew
(Indian, born in 1955)

Born in New Delhi, Pablo Bartholomew learned the basics of photography from his father and began to experiment on his own at age sixteen. In 1975 he won the Press Institute of India Award for an early photo essay on the life of a morphine addict, for which he received the World Press Photo Award in 1976. After working for the Red Cross and the United Nations in the 1980s, he joined the Gamma-Liaison agency. Bartholomew has been published in *Time*, *Newsweek*, *The New York Times*, the London *Sunday Times Magazine*, *Paris-Match*, *Stern*, *National Geographic*, and other periodicals. He was a still photographer for Satyajit Ray's *The Chess Players* (1975) and Richard Attenborough's *Gandhi* (1982), among other films, and has done advertising work for multinational corporations. He was awarded a fellowship by the Asian Cultural Council in New York in 1987 to produce a series of photographs on Indian émigrés in the United States, some of which were published on the Internet (www.m-web.com/pablo.html). He also received funding in 1991 and 1995 from *The Times of India* and Norway's Institute of Comparative Studies in Human Culture to photograph tribes in northeastern India. Bartholomew's work has been exhibited in Bombay, London, and elsewhere.

Bartholomew combines an interest in documentation with a penchant for unsettling, Surrealist-inspired juxtapositions. In his attempt to portray an India free of picturesque clichés, he presents the positive and the negative aspects of modernization in his country while neither endorsing nor condemning them. Bartholomew offers his work to a wider audience through digital imaging and the Internet, thus exploring new possibilities for his individual vision.—LH

Lillian Bassman
(American, born in 1917)

A New York City native, Lillian Bassman studied textile design in high school and modeled for the Art Students League. She joined the Works Progress Administration as a painting assistant in 1934, and when it was discontinued in 1939, studied fashion illustration at Pratt Institute and worked as a textile designer. Alexey Brodovitch, the art director at *Harper's Bazaar*, offered her a scholarship to study with him at the New School for Social Research in 1940, and encouraged her to pursue graphic design. She became his first salaried assistant at *Harper's Bazaar* and in 1945 was appointed co-art director at *Junior Bazaar*, a short-lived Hearst publication. During her tenure there, she provided many emerging photographers—Robert Frank and Richard Avedon among them—with their first opportunities to work in fashion. Bassman began making her own photographs while at *Junior Bazaar*, and when the magazine ceased production in 1947, she became a freelance fashion and advertising photographer, specializing in lingerie, fabrics, cosmetics, and liquor, and working chiefly for *Harper's Bazaar* and commercial clients. Bassman's editorial work for *Bazaar* lessened in the later 1960s, and she retired from commercial photography in 1970. In the 1970s and 1980s, she exhibited large-format color photographs of fruits and vegetables, abstractions, and "musclemen," among other subjects; she has recently been reinterpreting the negatives of her 1940s and 1950s fashion photography, in addition to executing new fashion assignments.

Bassman's photography is notable for her unusual printing techniques and innovative graphic effects, which involve experimentation with gauze and tissue in the darkroom. This experimentation, combined with the close rapport she establishes with her models, has resulted in pictures memorable for their emotional atmosphere, impressionistic mood, and subtlety of intimate gestures.—LH

Hans Bellmer
(French, born in Germany, 1902–1975)

In often violently erotic photographs and drawings, Hans Bellmer developed the Surrealist theme of mannequins and dolls as metaphors of sexuality with a singularly obsessive focus. He explored the usually pubescent female figure as fetish object. Bellmer's series *Die Puppe* (The Doll) debuted in the 1934 issue of the Surrealist publication *Le Minotaure*, and the photographs were described as "variations on the assemblage of an articulated minor." The doll consisted of a wood-and-metal skeleton covered with a realistic body of plaster and papier mâché; a system of ball joints allowed it to be shaped into endless disturbing configurations, appearing dismembered and monstrous.

Born in Katowice, Silesia, Bellmer worked in coal mines before entering the Berlin Technische Hochschule to study engineering in 1923. While there, he studied perspective with George Grosz and established contact with Dada artists. From 1924 to 1936 he worked variously as a typographer and draftsman. He first made contact with the Surrealists in 1924 on a trip to Paris. In 1932 he was inspired by the opera *The Tales of Hoffmann*, and the next year collaborated on a production of Hoffmann's *The Sandman*: both works feature female automatons. At around this time, in opposition to the rise of Nazism, he stopped all work that supported the state. Bellmer began constructing his first "artificial girl" in 1934, with his wife, Margarete. Photographs of the doll were hand-colored by Bellmer for the first edition of his book *Die Puppe*. The second series of dolls, even more disarticulated than the first, were created in 1936–1938. Bellmer left Berlin in 1938 and settled in Paris, where he was part of Surrealist circles. With the outbreak of the war, he was interned as a German citizen in a prison camp in 1940–1941. Bellmer's work appeared in numerous exhibitions, including the 1947 International Surrealist Exposition in Paris.—LS

Ernest James Bellocq
(American, 1873–1949)

E. J. Bellocq is a mysterious figure in the history of photography. His photographs did not become well-recognized until nineteen years after his death, and little is known about his life or his creative intentions. Active as a commercial photographer in the 1910s, he made at least eighty-nine portraits of prostitutes in a brothel in Storyville, the fabled red-light district of New Orleans. It is unclear whether these were commissioned as advertisements for the brothel's potential clients or—probably more likely—intended for Bellocq's own pleasure. His portraits are remarkable for the relaxed demeanor of the women, unusual for photographs produced with the glass plates and relatively long exposure times Bellocq used. The qualities of familiarity and casual intimacy of these portraits intrigued Lee Friedlander, who purchased Bellocq's negatives from an antique-book dealer in New Orleans in 1966. After Friedlander's prints from the negatives were exhibited at the Museum of Modern Art in 1970, Bellocq's pictures won wide public exposure and he came to be included in standard histories of photography. There are two publications of Bellocq's photographs: *E. J. Bellocq: Storyville Portraits* (1970) and *Bellocq: Photographs from Storyville, the Red Light District of New Orleans* (1996), an enlarged reprint. Bellocq is said to have made photographs on commission for the Foundation Company, a shipbuilding concern, and to have documented the opium dens of New Orleans's Chinatown, but none of these images seems to have survived.—LH

Ferenc Berko
(American, born in Hungary in 1916)

Born in Nagyvárad, Ferenc Berko moved to Germany with his family shortly after World War I. As a teenager he discovered photography and was exposed to the ideas of many prominent artists and photographers, including László Moholy-Nagy and Walter Gropius. From 1933 to 1947 he lived in London, Paris, and Bombay, where he established himself as a filmmaker and photographer. His photojournalistic and documentary work, as well as his nude studies, were reproduced regularly in *Lilliput*, *Minicam*, *U.S. Camera*, *Popular Photography*, and other magazines, although he earned his living primarily by making portraits. At the invitation of Moholy-Nagy, Berko came to the United States in 1947 to teach at the Chicago School of Design (now called the Institute of Design), and he pursued his avid interests in color photography. Walter Paepcke, a supporter of the school and president of the Container Corporation of America, in 1949 persuaded him to settle in

Aspen and work as a publicity, advertising, and portrait photographer for his company. Since 1951, Berko has been a filmmaker and advertising and documentary photographer in Aspen. Exhibitions of his work have been featured at the Cincinnati Museum of Art, the Amon Carter Museum in Fort Worth, the Center for Creative Photography in Tucson, the Fotografie Forum in Frankfurt, ICP, and elsewhere.

Berko's photographs reveal a diversity of technique and a range of subject matter, which the photographer approaches with gentle, perceptive humor. The pictures he made in India with a Leica demonstrate a lively, small-format aesthetic and a fine eye for street photography. His color photographs from the late 1940s—close-up images of crumbling walls, reflections, peeling posters, barn doors, windows—are striking for their exploration of abstract uses of color, an interest shared with his contemporaries Harry Callahan and Arthur Siegel.—CF

Ruth Bernhard
(American, born in Germany in 1905)
Ruth Bernhard was the daughter of Lucien Bernhard, a graphic designer known as "the father of the German poster." After studying for two years at the Berlin Academy of Art, she came to New York in 1927 and worked briefly in Ralph Steiner's studio; she bought her first camera the next year. Her first serious photograph, *Lifesavers*, interested *Vogue*'s art director, Dr. M. F. Agha, and he arranged for its publication in *Advertising Art* in 1931; many photography assignments in advertising and industrial design photography followed. In 1934 she photographed the Museum of Modern Art's "Machine Art" exhibition, and began the photographs of nudes for which she is best known. She met Edward Weston in California and was compelled enough by his ideas to move to California in 1935. The focus of her work expanded to include pictures such as *Doll's Head*, often considered a prototype of Surrealist photography. Bernhard moved back to New York for eight years beginning in 1939, during which time she met Alfred Stieglitz and was the subject of an issue of *U.S. Camera*. When she returned to California, she joined Ansel Adams, Wynn Bullock, and Imogen Cunningham as a leading photographer on the West Coast. She began a long and successful teaching career in 1967 and received the Dorothea Lange Award from the Oakland Art Museum in 1971. Two portfolios of her work—*The Eternal Body* and *The Gift of the Commonplace*—appeared in 1976, and a collection of her work, *Collecting Light*, was published in 1979.

Bernhard treats all of her subjects, whether they are nudes, shells, or advertising products, as objects worthy of detailed observation. The close-up rendering lends a psychological element that aligns her work both with Surrealism and with the formalist tenets of 1930s modernist photography. In combining graphic elegance with sensual subject matter, Bernhard achieves a delicate balance between compositional precision and evocative sensuality.—LH

Ilse Bing
(American, born in Germany, 1899–1998)
Ilse Bing became interested in photography while creating illustrations for her dissertation at the University of Frankfurt on the eighteenth-century German architect Friedrich Gilly. As her enthusiasm for the new medium increased, she gave up her art history career to devote herself full-time to photography. Her friendship with figures associated with the Bauhaus, including the architect Martin Stam and the photographer Florence Henri, as well as her acquaintance with André Kertész in Paris, encouraged her tendency toward the formalist techniques of modernist photography. Like László Moholy-Nagy, the self-taught Bing turned her photographs upside down and sideways to assess their compositional relationships; like Kurt Schwitters, she was attracted to the banal details of urban living—torn tram tickets, gate latches, and other apparently minor objects. Bing worked with a Leica (she purchased hers in 1929, three years after it was introduced) very early in her career and by 1932 had established a reputation in Paris as "queen of the Leica." Although most of her work was done on a freelance basis for the burgeoning German and French illustrated magazine industry, she was known also for her personal photographs in a style dubbed "documentary humanism" by Lincoln Kirstein, who favorably compared her successful communication of natural spontaneity to that of Henri Cartier-Bresson. Bing was included in important photography exhibitions, such as Julien Levy's "Modern European Photography" and the Museum of Modern Art's "Photography 1839–1937." ICP held a retrospective exhibition of her work in 1936.

Bing's photographic activity subsided when she moved to the United States in 1941, but continued until 1959, when she decided she "had said all that she had to say with photography." She devoted her time thereafter to poetry and drawing, but her major contributions remain in photography, where she was among the first to use solarization, the electronic flash, and the 35-millimeter camera, and to take photographs at night.—LH

Werner Bischof
(Swiss, 1916–1954)
Werner Bischof's photographs of post–World War II European and Asian cultures were integral to the development of photojournalism since 1945. Trained in graphic design and photography at the Zurich School of Arts and Crafts, Bischof adhered early to the style of New Objectivity, and an interest in avant-garde art and photography led him to move to Paris in 1939. The war began shortly after his arrival, and he returned to Switzerland, where he was conscripted. His experiences with refugees and his observation of the desperate conditions of war as a soldier at the Swiss border—as well as his later employment at the Zurich magazine *Du*, where he was encouraged toward photojournalism—resulted in a dramatic change in his photographic approach between 1942 and 1944. By 1945 he was producing the socially conscious photographs and essays for which he became

best known, and had begun traveling extensively for *LIFE*. In 1949 he joined Magnum, a cooperative picture agency founded by Henri Cartier-Bresson, Robert Capa, Chim (David Seymour), and George Rodger, with the hope of resolving the conflict between his artistic intentions and the often sensationalist journalism that commercial picture editors preferred. Eventually he produced his own projects in book form: in 1954 he published *Japan*, with photographs from a year spent living there. That same year, while in South America gathering documentation for a project on the continent's many cultures, he died in a car accident in Peru.

In the 1960s, as video journalism replaced picture magazines, the Fund for Concerned Photography (later the International Center of Photography) was established to preserve and recognize the contributions of photographers whose social dedication and acute humanity changed people's understanding of their own and foreign cultures. Bischof's achievements were duly recognized, as he was one of the first photographers whose work the Fund collected.—LH

Blythe Bohnen
(American, born in 1940)
Blythe Bohnen was born in Evanston, Illinois, and she graduated from Smith College and Boston University with degrees in art. She completed an MFA at Hunter College in New York in 1972, and was one of the founding members of A.I.R. Gallery, a women's cooperative arts organization. Bohnen began her artistic career as a painter, and in her paintings and drawings of 1968–1973 she explored the effects of physical gesture and examined how bodily motion—the pressure exerted by the arm while drawing, for instance—affects artistic production. She first used a camera in 1974 to photograph her hand and arm in motion, in the process of making art. Her photographic self-portrait series from the early 1970s expands on themes of motion and identity. The first exhibition of her photography in New York came in 1984; her works in other media were shown in the 1970s at the Whitney Museum of American Art and the Museum of Modern Art, and at the 1977 Documenta in Kassel, Germany.

While she does not identify herself exclusively as a photographer, Bohnen has used the medium for one important series to explore her interest in motion. Her photographic self-portraits from the early 1970s were intentionally distorted and blurred through the use of three-to-four-second exposures. Approximately life-size, these gelatin silver prints of the artist's face encourage an intimacy between subject and viewer, while simultaneously emphasizing the disorientation that divides the two. Most of Bohnen's work is characterized by its combination of sensual and intuitive imagery and precisely calculated execution.—MF

Margaret Bourke-White
(American, 1904–1971)
Margaret Bourke-White was born in New York City and attended the Clarence H. White School of Photography in 1921–1922.

After graduating from college in 1927, she pursued a career in photography and opened a photography studio in Cleveland. The industrial photography she did there brought her work to the attention of Henry Luce, the publisher of *Fortune*, who hired her in 1929 and the next year sent her to the Soviet Union, where she was the first foreign photographer to make pictures of Soviet industry. She photographed the Dust Bowl for *Fortune* in 1934; this project led to the publication of *You Have Seen Their Faces* (1937), which documented the human aspects of the Depression and featured text by Erskine Caldwell. In the fall of 1936, Henry Luce again offered Bourke-White a job, this time as a staff photographer for his newly conceived *LIFE* magazine. Bourke-White was one of the first four photographers hired, and her photograph *Fort Peck Dam* was reproduced on the first cover. Over the next several years and throughout World War II, Bourke-White produced a number of photo essays on the turmoil in Europe. She was the only Western photographer to witness the German invasion of Moscow in 1941, she was the first woman to accompany Air Corps crews on bombing missions in 1942, and she traveled with Patton's army through Germany in 1945 as it liberated several concentration camps. During the next twelve years, she photographed major international events and stories, including Gandhi's fight for Indian independence, unrest in South Africa, and the Korean War. Bourke-White contracted Parkinson's disease in 1953 and made her last photo essay for *LIFE*, "Megalopolis," in 1957.

Margaret Bourke-White's photojournalism demonstrated her singular ability to communicate the intensity of major world events while respecting formal relationships and aesthetic considerations. She was one of the most respected photojournalists in the country during the 1930s and 1940s, and her documentary work was among the most popular of its day.—LH

Bill Brandt
(British, born in Germany, 1904–1983)
Born in Hamburg, Bill Brandt was Man Ray's studio assistant in Paris in 1929 before settling in England in 1931. He worked as a freelance documentary photographer for *Weekly Illustrated*, *Picture Post*, *Lilliput*, and other British periodicals. During World War II, he photographed air raid shelters for the Ministry of Information and documented endangered buildings for the National Buildings Record. In 1943 he accepted portrait and fashion assignments from *Harper's Bazaar*, thus producing fewer documentary surveys. Brandt published several books of photographs throughout his career, beginning with *The English at Home* (1936), *A Night in London* (1938), and *Camera in London* (1948). In the postwar years, his work became increasingly abstract, as he experimented with a wide-angle lens and made Surrealist-inspired photographs of nudes outdoors. Brandt was included in many exhibitions during his lifetime, at, among others, the Museum of Modern Art, the George Eastman House, the National Centre of Photography in England, and ICP.

Testimony to Bill Brandt's skill and versatility is his ability to maintain his status as a major photographer despite frequent changes in style. His nudes of the 1950s and 1960s have become as widely recognized as his documentary work from the 1930s. Toward the end of his career, Brandt encouraged the perception of his photographs as a single aesthetic investigation: the prints he made for his 1966 book *Shadow of Light*, for instance, showed such a high degree of contrast that even his early documentary images approached abstract patterns of black and white, as if to suggest that his photography had always pursued the same formal principles.—LH

Brassaï
(French, born in Hungary, 1899–1984)
Brassaï, born Gyula Halász in the town of Brasso, was known for depicting the eclectic nightlife of Paris in the 1920s and 1930s. Originally intending to become painter, he studied at the Academy of Fine Arts in Budapest in 1918 and the Akademische Hochschule in Berlin in 1921 before moving to Paris in 1924. While working as a journalist there, he met André Kertész, who encouraged him to try photography. Realizing that it was not the impersonal, mechanical operation he had assumed it to be, Brassaï embraced it as the most appropriate means for recording his observations of Parisian nightclubs and cafés, where he photographed prostitutes, transvestites, entertainers, and their audiences, as well as lamplighters and street cleaners, among many other subjects. His first book, *Paris de Nuit* (Paris by Night), was both critically and popularly acclaimed when issued in 1932, and it was followed by *The Secret Paris of the 30s* (1976), *Les Sculptures de Picasso* (1948), *The Artists of My Life* (1982), and others. Brassaï cultivated friendships with artists and writers, and although he was not a Surrealist, his photographs were popular among the Surrealists, whose journal *Le Minotaure* published his work frequently. Brassaï was also a sculptor, and by the 1960s his photographic output had declined in favor of this medium.

Brassaï's photographs are often considered virtual illustrations of Paris life in the 1920s and 1930s. They do more than simply depict the typical details of the city at that time, however, for they emphasize each element's and each person's unique vulnerability.—LH

Anton Bruehl
(American, born in Australia, 1900–1982)
Anton Bruehl studied engineering at the Christian Brothers School in Melbourne before immigrating to the United States in 1919 to accept a job with Western Electric. An exhibition of photographs at the Clarence H. White School in New York inspired him to give up engineering for photography. He enrolled in White's school in 1924–1925, and soon became a teaching assistant for White in New York and New Canaan, Connecticut. After *Vogue* published his photographs in 1926, Bruehl dedicated himself to freelance commercial photography by establishing a New York studio,

which was active from 1927 through 1966. His photographs appeared in *Vogue*, *Vanity Fair*, and other prominent publications, and his work was shown in major international exhibitions, such as "Film und Foto" at the Deutscher Werkbund in Stuttgart (1929) and "Photography 1839–1937" at the Museum of Modern Art. His best-known body of work produced outside the studio was published as *Mexico* (1933), a book of black-and-white photographs of life and people in Mexican towns.

Bruehl is noted for the color photography he produced in the 1930s for Condé Nast, which at that time had a virtual monopoly on the color printing process. Fernand Bourges, a color technician at Condé Nast Engravers, developed a four-color separation transparency process in 1932 that allowed the company to print color images in its publications on a regular basis. This collaboration—Bruehl's color photographs, Bourges's color transparencies, Condé Nast's printing—accounted for the majority of color images that appeared in print in the mid-1930s. Besides his innovative color photography, Bruehl was recognized for his stylish advertising still lifes, and for the celebrity portraiture and fashion photography he did for *Vogue* during the 1930s.—LH

Bill Burke
(American, born in 1943)
Born in Derby, Connecticut, Bill Burke received a B.A. in art history from Middlebury College in 1966, and studied photography with Harry Callahan at the Rhode Island School of Design, receiving a BFA in 1968 and an MFA in 1970. Since 1971 he has taught at the School of the Museum of Fine Arts in Boston. While he has contributed to *The Christian Science Monitor* and published his work in *Fortune* and *Esquire*, Burke prefers to present personal travelogue images in series in books and exhibitions. His monographs include *They Shall Cast Out Demons* (1983), *Bill Burke Portraits* (1987), *I Want to Take Picture* (1987), and *Mine Fields* (1994). He has exhibited alone and in groups at ICP and elsewhere.

Burke, who failed his draft physical, was spared the experience of many of his contemporaries who fought in the Vietnam War. Since the 1970s he has photographed his travels through Asia not to document military atrocities, but to record his personal reactions. His work reflects a fascination with historical events and sites, yet his interest is broader than the topical documentation of photojournalism. The independent spirit of works such as Robert Frank's *The Americans* (1959) informs Burke's approach to his subjects: he recognizes his outsider status, and the black-and-white photographs of his many trips to Cambodia are as much about the personal impact and experience of being a witness as they are about the cultures he visits. This visitor status is important: Burke makes no pretense trying to develop a photo essay with political overtones, in the tradition of American documentary photography of the 1930s.—MF

Larry Burrows
(British, 1926–1971)
Born in London, Larry Burrows began working in the city's press in 1942, first in the art department of the *Daily Express*; he soon learned photography and moved on to the darkrooms of the Keystone photography agency and *LIFE*. By 1961, Burrows had established himself as a staff photographer for *LIFE* and was covering the Vietnam War. Although he was a war correspondent for several international conflicts, including those in Lebanon, Iraq, Congo, and Cyprus, he is best known for his coverage of the war in Vietnam. Burrows did what he could to experience the war as a soldier: he flew combat missions with air crews, lived in military camps, and stayed at the front lines with the GIs during enemy fire. Such dedication eventually cost him his life, when his helicopter was shot down over Laos. *LIFE* ran Burrows's photographs from Vietnam frequently between 1962 and 1971, devoting many pages to his dramatic color images. Among his most important photo essays were "The Air War" (September 9, 1966) and "One Ride with Yankee Papa 13" (April 16, 1965). During his lifetime, his work was exhibited at the Royal Photographic Society in London, in 1971, and the Rochester Institute of Technology sponsored a traveling exhibition of his photography in 1972. He won many honors, including two Robert Capa Awards, the 1967 Magazine Photographer of the Year Award, and the 1967 British Press Picture of the Year Award.

Burrows's method of photojournalism was deliberate and meticulous, not dependent on chance and instinct. He carefully planned his photographs, dictating their scenario, setting, and composition on the basis of his observations of the battlefront, and often spending several days on a single image. Although his method may seem counter-intuitive for war photography, he captured many of the most effective and memorable images of the war in Vietnam.—LH

Harry Callahan
(American, 1912–1999)
Harry Callahan was born in Detroit, studied engineering at Michigan State University, and worked for Chrysler before taking up photography as a hobby in 1938. Callahan cited a visit by Ansel Adams to his local camera club in 1941 as the time he began to view the medium seriously. Self-taught as a photographer, he found work in the General Motors Photographic Laboratories. In 1946, shortly after meeting László Moholy-Nagy, he was asked to join the faculty of the New Bauhaus (later known as the Institute of Design) in Chicago, where he became chairman of the photography department in 1949. He left Chicago in 1961 to head the photography department at the Rhode Island School of Design, where he remained until 1973. He won many awards for his photography, including a Guggenheim Fellowship in 1972 and the Photographer and Educator Award from the Society for Photographic Education in 1976; he was designated Honored Photographer of the Rencontres Internationales de la Photographie in Arles, France, in 1977, and

received ICP's Master of Photography Infinity Award in 1991. Among the major exhibitions of his work were "Photographs of Harry Callahan and Robert Frank" (1962), one of the last shows curated by Edward Steichen at the Museum of Modern Art, and retrospectives at the Museum of Modern Art (1976) and the National Gallery in Washington, D.C. (1996).

Callahan was widely respected in the photography community for his open mind and experimental attitude, qualities reinforced by his association with Moholy-Nagy and the principles of Bauhaus design. He produced work in both formalist and more documentary modes, and worked in both black-and-white and color. He used a 35-millimeter and an 8x10 camera, and worked with multiple exposures as well as straight images. Such versatility contributed to his success as a teacher, his students ranging widely in style—among them Ray K. Metzker, Emmet Gowin, Kenneth Josephson, and Bill Burke. —LH

Julia Margaret Cameron
(British, 1815–1879)
Born to a prosperous family stationed in Calcutta, Julia Margaret Pattle was educated in England and France. She was married in 1838 to Charles Hay Cameron and had six children. The family settled in 1860 on the Isle of Wight, neighboring the estate of their friend the poet laureate Alfred, Lord Tennyson. Cameron's practice of photography began relatively late in her life, at age forty-eight, when her daughter gave her a sliding wooden box camera. Her "very first success in photography" came in January 1864, with a portrait of Annie, the daughter of a neighbor.

Cameron used the wet collodion process, making prints with albumen printing-out paper, and worked with large negatives in order to avoid having to enlarge. In 1864 she began to register her work at the British Copyright Office, became a member of the Photographic Society of London and of Scotland, and prepared photographs for exhibition and sale through the London print dealers P. and D. Colnaghi. Most of her work was made between 1864 and 1875, before she left for family coffee plantations in Ceylon. She exhibited frequently in London, Dublin, Berlin, Paris, Philadelphia, and the Netherlands, and won numerous medals and awards.

Cameron's oeuvre, some 3,000 photographs, falls into two categories: portraits, and religious and allegorical tableaux vivants. They share a stylistic consistency, characterized by soft focus, dramatic chiaroscuro lighting reminiscent of Rembrandt, and technical imperfections. This idealizing aesthetic bespeaks the influence of the painter George Frederic Watts; Cameron shared with Pre-Raphaelite associates such as Dante Gabriel Rossetti a predilection for the Italian Old Masters. Cameron's portraits have received the most praise of all her photographs, and are distinctive because of their closeness of framing and strength of composition. Her sitters were often drawn from her circle of prominent acquaintances, including Tennyson, Sir John Herschel,

Charles Darwin, and Thomas Carlyle. While her portraits were usually of influential men, those of women and children were often intended as allegorical figures. In 1874, Cameron made photographic illustrations for Tennyson's *Idylls of the King* at his request, and began *Annals of My Glass House*, an unfinished account of her career, which was published posthumously in 1889.—LS

Cornell Capa

(American, born in Hungary in 1918)
Cornell Capa (originally Cornell Friedmann) was born in Budapest and moved to Paris in 1936 to join his brother, Robert, who had escaped from the increasingly anti-Semitic climate of Hungary in 1930. Although he had intended to study medicine, Cornell was drawn to photography through his brother and began making prints for him, as well as for Henri Cartier-Bresson and Chim (David Seymour). This experience encouraged him to become a professional photojournalist, and in 1937 he moved to New York to pursue a career. After he had worked in the darkrooms of the Pix agency and *LIFE* for a few years, his first photo story was published in *Picture Post* in 1939. During World War II, Capa worked for the U.S. Army Air Corps Photo-Intelligence Unit and the Army Air Corps's public relations department. In 1946 he became a staff photographer at *LIFE*, based mainly in the American Midwest, and covered some three hundred assignments over the next three years. He was the magazine's resident photographer in England for two years, after which he returned to the United States, to produce some of his best-known photo essays, on subjects such as Adlai Stevenson's presidential campaign and the education of mentally retarded children. Upon Robert's death in 1954, Capa left *LIFE* to continue his brother's work at Magnum, the international cooperative photography agency cofounded in 1947 by Robert, Henri Cartier-Bresson, Chim (David Seymour), and George Rodger. Over the next twenty years, Capa photographed many important stories for Magnum, including the activities of the Perinternational cooperative photography agency co-founded in 1947 by Robert, Henri Cartier-Bresson, Chim (David Seymour), and George Rodger. Over the next twenty years, Capa photographed many important stories for Magnum, including the activities of the Perón government in Argentina; the Democratic National Conventions of 1956, 1960, and 1968; and John F. Kennedy's first hundred days in office.

Capa's photographic production slowed in the mid-1970s as he devoted himself more to the care and promotion of other photographers' work through his International Fund for Concerned Photography. In 1964 he organized the exhibition "The Concerned Photographer," which led to the establishment of the International Center of Photography, an organization dedicated to the support of photography as a means of communication and creative expression, and to the preservation of photographic archives as a vital component of twentieth-century history. Capa received ICP's Lifetime Achievement Infinity Award in 1995, and he remains ICP's director emeritus.
—LH

Robert Capa

(American, born in Hungary, 1913–1954)
Born André Friedmann in Budapest, Robert Capa left Hungary in 1930 for Berlin, enrolled in the Deutsche Hochschule für Politik as a student of journalism and political science, and served as a darkroom assistant at the Deutsche Photodienst agency. With the rise of the Nazis in 1933, Capa left Germany for Paris, where he shared a darkroom with Henri Cartier-Bresson and Chim (David Seymour). He worked regularly as a photojournalist and between 1936 and 1939 made several trips to Spain with his companion, Gerda Taro, to document the civil war. His photographs from this conflict, including his most famous image, *Death of a Loyalist Soldier* (1936), were heralded almost immediately for their stunning impact; *Picture Post* termed him "the greatest war photographer in the world" in 1938. When World War II began, he moved to the United States and worked freelance for *LIFE*, *Time*, and other publications. From 1941 to 1946 he was a war correspondent for *LIFE* and *Collier's*, traveling with the U.S. Army and documenting Allied victories in North Africa, the Allied landing at Normandy, and the Allied capture of Leipzig, Nuremberg, and Berlin. After the war, Capa joined Henri Cartier-Bresson, Chim (David Seymour), and George Rodger in founding Magnum, a cooperative photography agency providing pictures to international publications. In 1948–1950 he photographed the turmoil surrounding Israel's declaration of independence. He traveled to Hanoi in 1954 to cover the French war in Indochina for *LIFE*; shortly after his arrival, he stepped on a landmine and was killed.

Robert Capa made photographs that achieved their exceptionally powerful effect through his strong connection to and affection for people. This attitude, and his use of the small 35-millimeter camera, allowed him to approach his subjects and throw himself into the action as no one else. The result was a breakthrough in the history of photojournalism.
—LH

Henri Cartier-Bresson

(French, born in 1908)
Henri Cartier-Bresson has intuitively chronicled decisive moments of human life around the world with poetic documentary style. His photographs impart spontaneous instances with meaning, mystery, and humor in terms of precise visual organization, and his work, although tremendously difficult to imitate, has influenced many other photographers. His photographs may be summed up through a phrase of his own: "the decisive moment," the magical instant when the world falls into apparent order and meaning, and may be apprehended by a gifted photographer.

Cartier-Bresson was born in Chanteloup, and studied literature at Cambridge University in 1928–1929. He began photographing in 1931 and purchased a Leica in 1933. He joined an ethnographic expedition to Mexico the next year, and in 1935 studied cinematography with Paul Strand. He assisted the film director Jean Renoir in 1936 and 1939,

and made his own documentary, *Return to Life*, in 1937. He was drafted into the film and photo unit of the French army in 1940 and was taken prisoner by the Germans that same year. After three years of imprisonment he escaped and began working for the French underground. In 1943 he made a series of portraits of artists, including Matisse, Bonnard, and Braque. Through 1944 and 1945, Cartier-Bresson photographed the occupation of France and its liberation. In 1947 he cofounded the Magnum agency with Robert Capa, Chim (David Seymour), and George Rodger, and he spent the next twenty years traveling around the world. He received the Overseas Press Club Award four times, the American Society of Magazine Photographers Award in 1953, and the Prix de la Société Française de Photographie in 1959, among other honors. In 1966 he left Magnum, which remains his agent, and has devoted himself to drawing. Cartier-Bresson's extensive publications include *From One China to Another* (1954), *The Europeans*, and *People of Moscow* (1955), *The Face of Asia* (1972), and *The Decisive Moment* (1973).—LS

Sarah Charlesworth

(American, born in 1947)
"Art is made of ideas," says Charlesworth, who considers herself a conceptual artist rather than a photographer. She studied with the conceptual artist Douglas Huebler and was influenced by the artist Joseph Kosuth. Charlesworth appropriates images from the media, along with reproduced icons of natural and cultural history, redeploying their force as secular talismans. After exhaustive visual research, she selects images that are symbolically over-determined. Formally simple, her compositions are minimal and dense, with a multiplicity of allusions. Charlesworth is interested in seeking out "the most primary questions of visual language," which in contemporary culture involve the unmaking and remaking of meaning in the visual realm of popular culture. For all their conceptual complexity, her prints, often more than forty inches high, function as consciously seductive objects of desire. Her work juxtaposes isolated images on fields of highly saturated color that function symbolically. Charlesworth selects reproduced images from her files and attaches them to colored boards, sending the camera-ready work to a commercial lab that makes the 4x5-inch transparencies from which her prints are made. Like advertisements, the laminated prints are highly reflective.

Charlesworth studied with Lisette Model in 1970, and was a freelance photographer during the 1970s before developing her distinctive style. Her first iconic series, "Objects of Desire," interrogated sexuality and gender as constructed in consumer culture. By 1989 her work had become more introspective, and her productions of 1991, which used images from Renaissance paintings, addressed her own emotions and relationships. In 1993 she began photographing herself doing magic tricks. This work addresses the illusionism of art and the assumed veracity of photography.

Charlesworth, who teaches at the School of Visual Arts in New York, has received three National Endowment for the Arts grants. SITE Santa Fe presented a retrospective of her work in 1997.—LS

Chim (David Seymour)

(American, born in Poland, 1911–1956)
Born in Warsaw, David Szymin (who changed his name to Seymour in 1942 and used his sobriquet professionally) studied graphic arts in Leipzig, Germany, and went to Paris in 1932 to continue his studies at the Sorbonne. Despite his lack of training, upon his arrival he found a job at the Rap picture agency, where he befriended Robert Capa and Henri Cartier-Bresson. By 1934, Szymin was signing his prints "Chim" and had published his first picture in *Regards*, a French weekly with which he was closely associated until 1939. He became known for his photographs of the Popular Front in Paris and the Spanish Civil War. In 1939, on assignment for *Paris-Match*, Chim documented the journey of some 150,000 Spanish Loyalists to the exiled Spanish Republican government in Mexico. At the onset of World War II in Europe, he moved to New York, and in 1942 served as an interpreter of reconnaissance photographs for the U.S. military. In 1947, he joined Henri Cartier-Bresson, Robert Capa, and George Rodger in founding the Magnum photo agency, and the next year was commissioned by UNICEF to photograph the war's effect on European children. This series, "Children of Europe," became his best-known project and was widely celebrated when it was published by *LIFE* in 1948 and in book form in 1949. Subsequently, Chim accepted portrait and reportage assignments for major international periodicals. Upon Robert Capa's death in 1954 he became president of Magnum. Chim was killed by Egyptian sniper fire while on assignment in the Suez in 1956.

Chim's training in the graphic arts gave him a visual acuity that balanced his empathetic eye and complemented his practical approach to reportage. His talent was apparent particularly in his photographs of children, which honestly render painful circumstances without resorting to sentimentality. Chim's intelligence, dedication, and wit set a high standard for photojournalism that has seldom been surpassed.—LH

Larry Clark

(American, born in 1943)
Larry Clark, born in Tulsa, worked in his family's commercial photographic portrait business before studying photography with Walter Sheffer at the Layton School of Art in Milwaukee from 1961 to 1963. He served in the military during the Vietnam War and has been a freelance photographer based in New York since 1966. During the 1960s, Clark documented the culture of drug use and illicit activity of his friends in Tulsa, and his photographs from those years were published as *Tulsa* (1971). Considered shocking for its graphic portrayal of the intimate details of its subjects' risky lives, the book

launched Clark's career. After *Tulsa*, he produced *Teenage Lust* (1983), a series of photographs depicting adolescent sexuality, *Larry Clark* (1992), and *The Perfect Childhood* (1993). His work has been included in group and solo exhibitions since the early 1970s, and he was the recipient of a National Endowment for the Arts Photographers' Fellowship in 1973 and a Creative Arts Public Service photographers' grant in 1980. Clark has also produced films: *Kids* (1994), based on his experiences with New York City teenagers and their culture of drugs, alcohol, and sex, and *Another Day in Paradise* (1999).

Larry Clark's photographs in *Tulsa* are unflinching portrayals of difficult and often unsightly circumstances viewed through a participant's eyes. Their firsthand intensity recalls the work of Danny Lyon and Bruce Davidson, but Clark's raw voyeurism and insistent exposure of detail results in a somberness that differentiates his production from that of others in the early 1970s. His recent photography addresses similar subjects, but with the distance of an observer and a more prominent formal sensibility. —LH

Chuck Close
(American, born in 1940)
Chuck Close is known for his monumental portrait paintings transformed from photographs. His first large figurative painting from 1965, *Big Nude*, measured ten by twenty-two feet. Close has concentrated on facial portraits, of himself, friends, and family, and has throughout his career declined commissions. The confrontational scale of his colossal paintings, often as much as nine feet high, forces viewers to attend to these enlarged imperfections and idiosyncrasies that individualize his subjects. The photographic realism of his paintings operates in productive tension with an emotional impact and intimacy nevertheless conveyed. Close has applied his characteristic rendering—a frontal view in close proximity—to occasional works varying from his formula, such as photocollages and photographic flower portraits from the late 1980s. His interest in working with both photography and painting has been in the process of transformation, which he describes as an "invention of means." Accordingly, because of continual experimentation, his work has never become formulaic. He has employed varying degrees of abstraction with his use of a pictorial grid, and his later work is more colorful, discontinuous, and gestural. His earlier photographs employed a 4x5 view camera and negative film; more recently he has worked with a 20x24-inch Polaroid camera. In 1984 he was invited by the Museum of Fine Arts in Boston to use its room-size Museum camera to produce eighty-by-forty-inch prints.

Close was born in Monroe, Washington, and received a B.A. in 1962 from the University of Washington, Seattle, and a BFA (1963) and an MFA (1964) from Yale. His honors have included a Fulbright grant for travel to Vienna, a National Endowment for the Arts grant, and the International Center of Photography Infinity Award for Art. He has taught throughout the country, and has

had numerous exhibitions at, among others, the Museum of Modern Art, the Whitney Museum of American Art, the Art Institute of Chicago, the Walker Art Center, and the Staatliche Kunsthalle Baden-Baden.—LS

Alvin Langdon Coburn
(British, born in the United States, 1882–1966)
Alvin Langdon Coburn's work traces photography's transition from Pictorialism to modernism at the turn of the century. Born in Boston, he was given his first camera at the age of eight, but did not photograph seriously until he met F. Holland Day in 1898. Day encouraged Coburn to pursue photography and asked his help in preparing the exhibition "The New School of American Pictorial Photography" at London's Royal Photographic Society in 1900. Upon his return to New York, Coburn opened a photography studio and became involved with the artists and intellectuals surrounding Alfred Stieglitz, who invited him to be a founding member of the Photo-Secession and published his photographs in *Camera Work*. Coburn's affiliation with avant-garde photography was confirmed in Britain when he was elected to the Linked Ring Brotherhood, an association of Pictorialist photographers, in 1903. He was commissioned to do portraits of British literati for a London magazine and afterward traveled throughout Europe and America. In 1912 he took his last photographs in the United States, from the tops of New York City skyscrapers. He pointed the camera directly at the street, eliminating the horizon line and flattening perspective to emphasize abstraction. These photographs marked a distinct change in Coburn's style.

Coburn moved to London, where his concentration turned to abstraction. His close association with the Vorticists Wyndham Lewis and Ezra Pound inspired experiments that led to his construction of the Vortoscope in 1916. This device, consisting of a kaleidoscopic arrangement of mirrors, allowed him to produce what many considered the first entirely abstract photographs. In the 1920s, Coburn became increasingly interested in mysticism, and his photographic production waned significantly by 1924. He became a British citizen in 1932 and settled in northern Wales.—LH

Lynne Cohen
(Canadian, born in the United States in 1944)
Lynne Cohen was born in Racine, Wisconsin, and studied art at University College in London in 1964–1965. Having chosen painting as her medium, she received a B.S. in fine arts and arts education from the University of Wisconsin and an M.S. in fine arts from Eastern Michigan University. By 1973 she had moved to Ottawa where she taught photography at Algonquin College, and had had her first solo exhibition of photographs. Since then, she has been included in a number of exhibitions, including a one-person show at ICP and group shows at the Walker Art Center, the Museum of Modern Art, the Corcoran Gallery of Art, and the

Galerie Nationale du Jeu de Paume in Paris. Cohen, who has received numerous awards and grants in Canada for her work, has taught at the University of Ottawa since 1974; her most recent book is *Lost and Found* (1993).

In the photographs for her book *Occupied Territory* (1988), Cohen aimed her large-format view camera at the unpopulated interiors of classrooms, training centers, restaurants, retirement homes, and office and retail environments. Although these spaces might be familiar, Cohen's generic depiction of them highlights their impersonal design, rendering them awkward and eerie, and revealing how our behavior and aesthetic sensibility may be conditioned by corporate culture.—LH

Carlotta Corpron
(American, 1901–1987)
Carlotta Corpron was born in Blue Earth, Minnesota, but spent fifteen years of her youth in India. She returned to the United States in 1920 to earn degrees in art education at Michigan State Normal College and Columbia University, and was first introduced to photography in 1933. Her interest grew out of her desire to create close-up images of natural forms for use in art and design courses, and her vision was influenced by László Moholy-Nagy, and further shaped by her friendship with Gyorgy Kepes, who included her in his book *The Language of Vision* (1944). Of particular note are Corpron's early light drawings, made by tracking moving light at amusement parks—radiant images of wild edges and rhythmic lines—and her "space compositions," which employed eggs and shells, although their real subject is the constructed space in which they exist. This space, achieved by the use of light-reflecting surfaces, often seems to reproduce the perceptual distortions of underwater realms. Corpron also made "fluid light designs" examining reflections on plastic materials; "light follows form" studies of sculpture; abstractions of light flowing through glass; and solarizations of flowers and portraits. She retired from teaching in 1968 but continued printing her earlier work. Corpron's photographs were shown at the Museum of Modern Art and the Art Institute of Chicago, and were included in the 1979 ICP exhibition "Recollections: Ten Women in Photography."

Corpron's experiments with light are among the most intriguing abstract photographic works from her day, sharing as they do the concerns of her predecessors Moholy-Nagy, Man Ray, and Alvin Langdon Coburn. Her work is significant for its inventive and resolutely independent exploration of the aesthetic possibilities of light and space. Wrought from simple materials and the free play of imagination, Corpron's light abstractions are increasingly admired.—CF

Marie Cosindas
(American, born in 1925)
Marie Cosindas, a Boston native, attended a fashion design school in the 1950s after studying painting at the Boston Museum School. She studied photography briefly with Ansel Adams in 1961. Expecting that

her landscape photographs would be used as source material for future paintings, Cosindas brought a 35-millimeter camera on a trip to Greece, and was so satisfied with photography's ability to capture color and light that she soon abandoned painting. In 1962 the Polaroid Corporation invited her to experiment with its new instant film, which provided her with an unprecedented degree of control in color photography. She found that color tones could be adjusted by altering camera filters, the temperature in the room where the picture was being taken, exposure time, and in-camera developing time. The resulting photographs often looked like paintings. The Museum of Modern Art exhibited her work in 1966 and 1978, and in the latter year a monograph, *Marie Cosindas: Color Photographs*, was published. Retrospectives of her work have been held at the Santa Barbara Museum of Art and the Fitchburg Art Museum in Massachusetts. Cosindas has received many honors, including a Rockefeller grant and an honorary degree from Moore College of Art in Philadelphia.

Cosindas was a leading figure of the 1960s wave of experimental color photography. At a time when aesthetic tastes favored street photography and experimental uses of the medium, romance and the opulence of Victorian portraiture and still life painting were reclaimed in her work through meticulous arrangement of props, flowers, patterned fabrics, and highly posed models. Cosindas's prints are distinctive in their balance of intricate material detail and emotional warmth and intimacy.—MF

Robert Cumming
(American, born in 1943)
Robert Cumming's photographic work is only one component of his production as a conceptual artist. His photographs are characterized by cerebral concepts that are nonetheless materially incorporated in oddly useful constructions. His interest in "perceptual glitches," magic tricks, paradoxes, and puns recalls the whimsical irony of Marcel Duchamp, and of his contemporaries Robert Heinecken and William Wegman. Cumming explores the relationships between text and images, and employs visual and linguistic humor in an ongoing investigation of everyday objects according to an "objective" sensibility. He has applied his often satirical and sometimes absurd engineering to fantasy machines and landscapes; his slightly romantic appreciation of industrial-era mechanics is part of a long-standing interest in technology and its relationship to society and perception.

Unlike other conceptual artists who have used photography instrumentally, Cumming pays careful attention to the craft of the medium. He often builds functional constructions in order to photograph them, and both structure and image demonstrate a concern for careful execution. The influence of his training under Art Sinsabaugh is evidenced by his use of an 8x10 view camera in his early work; he later moved to a medium format. Cumming is interested in demystifying artistic conventions in photography. He calls attention to the artifice of images, extending the photograph beyond

the illusion of the scene to include props, tools, and lighting devices, and simultaneously questions and confuses the boundaries between real life and fiction. Cumming, who has taught at art schools and universities around the country, has won numerous awards, including four National Endowment for the Arts Fellowships, and a Guggenheim Fellowship for 1980–1981. He has had major retrospective exhibitions at the Whitney Museum of American Art, the Hirshhorn Museum, and the Museum of Contemporary Art in San Diego.—LS

Imogen Cunningham
(American, 1883–1976)

Inspired by Gertrude Käsebier's photographs, Imogen Cunningham learned to use a 4x5 view camera via correspondence school. She studied chemistry at the University of Washington and, after graduating, worked in the studio of Edward S. Curtis making commercial platinum prints. Her early work was Pictorialist in style, depicting allegorical figures in soft-focus tableaux. Cunningham met Edward Weston in 1923, and was influenced by the stylistic shift evolving in his work and that of his partner, Margrethe Mather. This change indicated a broader reaction in art photography against the romanticism of the Photo-Secession and in favor of such modernist approaches as New Objectivity, of which Cunningham was a pioneer among Americans. She nevertheless retained a subtle romanticism and sensuality in her work. Her widely reproduced series of close-up plant photographs, reminiscent of those by Albert Renger-Patzsch and Karl Blossfeldt, was first shown in the landmark "Film und Foto" exhibit in Stuttgart in 1929.

The precisionism of American West Coast straight photography reached its zenith in 1932–1935 with the f/64 group, an informal association that included Cunningham, Weston, and Ansel Adams, whose members advocated the use of large-format view cameras, small lens apertures, and contact printing. The clarity of vision and strong, uncluttered compositions of Cunningham's photographs of people and plants exemplify this aesthetic, even after she began to use a smaller-format camera in 1945. Her work is characterized by a potent formalism and an interest in design and structure, tempered by a humanizing capacity obvious in her memorable and sympathetic portraits. Cunningham opened a successful studio in Seattle in 1910, and made a living with portrait commissions; her sitters included Martha Graham, Alfred Stieglitz, Frida Kahlo, Herbert Hoover, Gertrude Stein, Edward Weston, Morris Graves, Merce Cunningham, Man Ray, August Sander, and Minor White. Cunningham's work is in major collections; she has been the subject of numerous individual exhibitions and several monographs. She taught and lectured widely, especially in the San Francisco Bay area, and continued to photograph until late in her life.—LS

Edward S. Curtis
(American, 1868–1952)

Born near White Water, Wisconsin, Edward Sheriff Curtis taught himself photography at a young age. He moved to Seattle in the mid-1880s and developed a reputation for romantic Pictorialist landscapes and portraits. Although he made his first portrait of a Native American in 1896, it was not until after his return from documenting an 1899 expedition in Alaska that Curtis became interested in a large-scale photoethnographic study of Native American culture. President Theodore Roosevelt saw Curtis's early Native American images and introduced the photographer to the banker J. P. Morgan, who agreed to commit $75,000 to support Curtis's completion and publication of his comprehensive study. The resulting twenty-volume work, *The North American Indian*, featuring some 1,500 photographs, appeared in installments between 1907 and 1930. Over the course of Curtis's career, he made more than 40,000 platinum prints, photogravures, and drawings of Native Americans across the United States and British Columbia. Curtis's images enjoyed a brief period of popularity after the turn of the century, because of the nostalgic interest in the vanishing Native American cultures, but by the time of his death, his work had been forgotten. Numerous monographs have been published on his work since its rediscovery in the late 1960s.

Curtis intended to document disappearing Native American cultures and communities, but his work partakes as much of the romance and idealism of Pictorialism as of the scientific records of documentary photography. Surrounded by soft, hazy light, his subjects often wore inappropriate costumes or held props provided by the artist, reflecting Curtis's common cultural assumptions about what it meant to be "Indian." When automobiles or other material signs of modern life were captured in a frame, Curtis would scratch them out of his negatives. He recorded a highly subjective impression of Native American life rather than its full complexity, and his encyclopedic work reveals as much about American tastes for exotic images in the late nineteenth and early twentieth centuries as it does about Native American life.—MF

Louise Dahl-Wolfe
(American, 1895–1989)

Born in Alameda, California, Dahl-Wolfe studied at the San Francisco Institute of Art. In 1921, while working as a sign painter, she discovered the photographs of Anne Brigman, a Pictorialist based in California and associated with the Stieglitz circle in New York. Although greatly impressed by Brigman's work, Dahl-Wolfe did not take up photography herself until the early 1930s. Travel with the photographer Consuelo Kanaga in Europe in 1927–1928 piqued her interest in photography once again. In 1932, when she was living with her husband near the Great Smoky Mountains, she made her first published photograph, *Tennessee Mountain Woman*. After it was published in *Vanity Fair* in 1933, she moved to New York City and opened a photography studio, which she maintained until 1960. After a few years producing advertising and fashion photographs for *The Woman's Home Companion*, Saks Fifth Avenue, and Bonwit Teller, she was hired by Carmel Snow as a staff fashion photographer for *Harper's Bazaar* in 1936. Dahl-Wolfe remained with the magazine until 1958, after which time she accepted freelance assignments from *Vogue* and *Sports Illustrated* until her retirement in 1960.

Dahl-Wolfe was especially well known during the infancy of color fashion photography for her exacting standards in reproducing her images. Her insistence on precision in the color transparencies made from her negatives resulted in stunning prints whose subtle hues and unusual gradations in color set the standard for elegance in the 1940s and 1950s. In addition, she pioneered the active yet sophisticated image of the "New Woman" through her incorporation of art historical themes and concepts into her photographs.—LH

Bruce Davidson
(American, born in 1933)

Born in Oak Park, Illinois, Bruce Davidson has been interested in photography since age ten. While attending the Rochester Institute of Technology and Yale University, he continued studying photography and was particularly inspired by the work of Henri Cartier-Bresson and W. Eugene Smith. After military service he worked for *LIFE* in 1957 before joining Magnum, the cooperative photo agency founded in 1947 by Henri Cartier-Bresson, Robert Capa, George Rodger, and Chim (David Seymour). In his early work, Davidson typically selected subjects who were unusual or isolated from society, including a widow living in a Paris garret, a dwarf clown, and a teenage Brooklyn gang. He received a Guggenheim Fellowship to photograph events and figures of the civil rights movement, and in 1967 received the first photography grant awarded by the National Endowment for the Arts. He spent the next two years photographing one city block in New York City's East Harlem, publishing this work as *East 100th Street* (1970), one of his many books. In the early 1980s, Davidson made an extensive color photographic survey of New York's subways; more recently he has worked in Central Park. His work has appeared in *The New York Times Magazine*, *LIFE*, *Vogue*, *Esquire*, and other publications worldwide, and his work has been shown at the Museum of Modern Art, the Walker Art Center, the National Museum of American Art, ICP, and other museums.

Bruce Davidson documents the lives of his subjects with sensitivity and sympathy. His photographs express his own desire to observe, understand, and reveal the complexity of people and their communities. He transforms intimately observed details and events into stories about individuals' lives that reflect concerns and emotions common to all.—CF

Roy DeCarava
(American, born in 1919)

Roy DeCarava was born in New York City in 1919. He attended Cooper Union from 1938 to 1940, and then, because of his growing frustration with racial prejudice, transferred to the Harlem Community Art Center. He began taking photographs in the late 1940s, and Harlem—its sense of community, its rich and varied cultural traditions and talents—was at the heart of his work. In 1952, DeCarava became the first African-American photographer to receive a Guggenheim Fellowship, on the basis of his proposal to create a photographic portrait of Harlem paired with poetry by Langston Hughes. Their 1955 collaboration, *The Sweet Flypaper of Life*, was a critical and popular success. That same year, DeCarava's work was included in the "Family of Man" exhibition at the Museum of Modern Art. He also founded A Photographer's Gallery in New York (1955–1957) to present his own work as well as that of Ralph Eugene Meatyard, Harry Callahan, and others. DeCarava is perhaps best known for the photographs he took of jazz performers in the mid-1950s. Since 1975 he has taught photography at Hunter College in New York. Monographs on him and his work include *Roy DeCarava: Photographs* and *Roy DeCarava: A Retrospective*, released in 1996 to coincide with a major exhibition at the Museum of Modern Art. In 1998 he was awarded ICP's Master of Photography Infinity Award.

DeCarava's photography embodies passion and joy, his need for community, and his understanding of urban alienation. His work teems with an awareness of life, expressed both through his portraits of friends, family, and musicians, and in his desolate city views where human presence is only implied. His printing is characterized by warm dark tones with little contrast.—MF

Jack Delano
(American, born in 1914)

Jack Delano immigrated to the United States with his family from Ukraine in 1923 and attended the Settlement Music School in Philadelphia as a scholarship student beginning in 1925. After graduating from high school, he took classes at the Pennsylvania Academy of Fine Arts, until 1937; he became interested in photography while traveling in Europe in 1936–1937. He worked for the photography projects of the Works Progress Administration, the United Fund, and the Farm Security Administration, and inspired by his experiences with the FSA in Puerto Rico, he settled there in 1946 and was the official photographer for the government of Puerto Rico. Delano has been there since, holding positions in the Puerto Rican media and remaining active as a book illustrator, graphics consultant, music teacher, and animator. He has received a National Endowment for the Arts grant and a Guggenheim Fellowship, among other honors.

Delano's photographs elevate the ordinary individual to heroic status. In the 1940s he often played with scale to underline the strength of character in his subjects, and he enlarged some of his prints beyond the usual proportions to dramatize the subjects' presence. Delano documents a region through not only its people and landscape, but also its cultural and social patterns; this attitude differentiated his work from that of most other FSA photographers. His early exploration of color photography in the 1940s produced unconventional but beautiful photographs demonstrating his mastery.—LH

Adolf (Gayne) de Meyer
(French, possibly born in Germany, 1868–1946)

The facts of Baron Adolf de Meyer's early life have been obscured by contradictory accounts from various sources (including himself); he was born in Paris or Germany, spent his childhood in both France and Germany, and entered the international photographic community in 1894–1895. He moved to London in 1896, where by 1899 his Pictorialist photographs had earned him membership in the Linked Ring Brotherhood, a society of Pictorialist photographers in Britain. In about 1900, he assumed the title of baron; de Meyer's wife, Olga, claimed to be the illegitimate daughter of the Prince of Wales (later Edward VII). In 1903, de Meyer contacted Alfred Stieglitz and became associated with the Photo-Secession. He traveled to the United States in 1912; he was hired as *Vogue*'s first full-time photographer in 1914, and produced fashion layouts and photographed celebrities there until 1921, when he accepted a position at *Harper's Bazaar* that allowed him to return to Paris. Although de Meyer had set a standard for elegance and style, his Pictorialist-inspired fashion photographs were seen as outmoded by the 1930s, and he was forced to leave *Harper's Bazaar* in 1932. Unrest in Europe brought him back to the United States in 1939, and he spent his remaining years in Hollywood, where he died, virtually unknown and unappreciated, in 1946.

De Meyer was the preeminent photographer of Vaslav Nijinsky and the Ballets Russes, and a dedicated and skilled pioneer in the use of the autochrome process of color photography. A master of fashion photography and society portraiture, he captured an elegant and leisured world which vanished with World War II. His sophisticated photographs, although once out of favor, have become models for many contemporary fashion photographers.—LH

Michael Disfarmer
(American, 1884–1959)

Michael Disfarmer was a small-town portrait photographer whose negatives came to national attention in 1973, when Julia Scully published them in *Modern Photography*. Scully had learned of them from Peter Miller, an Arkansas newspaper editor, who had received a few of Disfarmer's glass-plate negatives in response to a call for old photographs. What drew Miller and Scully to the images was the directness and unaffected quality of the portraits, which revealed the character of their subjects most perceptively. This sensibility may have stemmed from the fact that in Heber Springs, where Disfarmer lived and worked, everybody knew the photographer. Whatever the case, Disfarmer's portraits are among the most moving documents of rural life in the American South between 1930 and 1959.

Disfarmer was not a particularly social individual, and little is known about his life. He was born Mike Meyer in Indiana and moved to Arkansas with his parents in the late 1800s. After his father died, in 1914, he moved with his mother to Heber Springs, where he constructed a photography studio

on the back porch of their house. Around 1930, when a tornado killed his mother and destroyed his house, he built a new studio on Main Street and established himself as the town photographer. He tended to keep to himself, and was considered strange
and eccentric by many townspeople. He changed his name to Disfarmer after his mother's death because he believed that a tornado had taken him from his real place of birth and deposited him with the Meyer family. Disfarmer used 5x7 inch glass plates early in his career and 3¼x5½-inch plates later, and he always made contact prints.
—LH

Nell Dorr
(American, 1893 or 1895–1988)

Ohio-born Nell Dorr grew up surrounded by photography; her father, John Jacob Becker, cofounded one of the largest and most respected photography studios of the late nineteenth century. She was interested in her father's business at a young age but did not become a professional photographer until after she had moved to Florida with her husband and children in 1923. Dorr opened a portrait photography studio in Miami and worked on her own photographic projects. She was particularly interested in photomurals, and the International Gallery in New York City showed her pioneering efforts in this medium in 1932. In New York, Dorr met Edward Steichen and Alfred Stieglitz, as well as her second husband, John Van Nostrand Dorr, a chemical engineer, metallurgist, and inventor. She published books of her photographs, including *In a Blue Moon* (1939), *Mother and Child* (1934), and *Of Night and Day* (1968). After the death of her youngest daughter in 1954, Dorr devoted herself to photographing mothers and children.

Dorr believed that terror and misery were already abundantly documented in American culture and thus committed herself to eliciting beauty in her photographs. Her images evoke the dreamy atmosphere of reminiscence. Dorr also made color sound films, and experimented with such photographic techniques as light abstraction, negative manipulation, and alternative printing processes. Dorr's work appeared in the 1979 ICP exhibition "Recollections: Ten Women in Photography."—LH

Arnold Eagle
(American, born in Hungary, 1909–1992)

Arnold Eagle immigrated to the United States with his parents in 1929. He learned photography in the early 1930s, worked as a photo retoucher, and bought his first camera in 1932. He cultivated a passion for documentary photography through his membership in the Film and Photo League, and in 1936 joined several others in establishing an independent Photo League devoted exclusively to still photography. Throughout the 1930s and 1940s, Eagle produced extended documentary projects, including a portrait of the Orthodox Jewish community on Manhattan's Lower East Side; "One Third of a Nation," a Works Progress Administration series depicting slum conditions in New York City; and a documenta-

tion of the vanishing elevated subway trains. He contributed photographs to *Fortune* and *The Saturday Evening Post* throughout the 1940s and worked with Roy Stryker for Standard Oil of New Jersey. Among his best-known bodies of work are his photographs for the Martha Graham Dance Company, a decade-long endeavor begun in 1944. Eagle, who was cinematographer for Hans Richter's *Dreams That Money Can Buy* and Robert Flaherty's *Louisiana Story*, taught filmmaking for more than three decades at the New School for Social Research.

Eagle's socially concerned documentary photographs of the 1930s and 1940s were dedicated not only to divulging the social problems of contemporary society, but to elucidating its positive aspects as well. He was devoted to preserving aspects of urban culture that were in danger of disappearance, and in this respect, his work is invaluable to our historical understanding of New York in the 1930s and 1940s. His work has been shown infrequently; a notable exhibition was held at ICP in 1990.—LH

Harold Edgerton
(American, 1903–1990)

Harold Edgerton was born in Fremont, Nebraska, and studied electrical engineering at the University of Nebraska. After completing a master's degree in the subject at the Massachusetts Institute of Technology in 1927, he joined the university faculty; he was awarded a Ph.D. in 1931. Between 1933 and 1966, Edgerton applied for forty-five patents for various strobe and electrical engineering devices. He obtained a patent for the stroboscope—a high-powered repeatable flash device—in 1949. His books include *Flash! Seeing the Unseen by Ultra High-Speed Photography* (1939), *Electronic Flash, Strobe* (1969), *Moments of Vision: The Stroboscopic Revolution in Photography* (1979), and *Sonar Images* (1986). His photographs were exhibited for the first time in 1933, at the Royal Photographic Society in London, and Beaumont Newhall included his work in the first exhibition of photography at the Museum of Modern Art in 1937. Edgerton was awarded the U.S. National Medal of Science in 1973. His work was the subject of a retrospective at the International Center of Photography, and he was given ICP's Infinity Award for Lifetime Achievement in 1987.

Edgerton revolutionized photography, science, military surveillance, Hollywood filmmaking, and the media through his invention of the strobe light in the early 1930s. The photographs that resulted from his scientific experiments were championed in the 1930s as representative of New Objectivity, the American counterpart to the German Neue Sachlichkeit. Edgerton's photography of split-second motion may be seen as an expansion beyond the nineteenth-century locomotion studies of Eadweard Muybridge and Étienne-Jules Marey.—MF

Alfred Eisenstaedt
(American, born in Germany, 1898–1995)

Born in Dirschau (now Poland), Alfred Eisenstaedt studied at the University of Berlin and served in the German army during World War I. After the war, while employed as a button and belt salesman in Berlin, he taught himself photography and worked as a freelance photojournalist. In 1929 he received his first assignment, which would launch his professional career—the Nobel Prize ceremony in Stockholm. From 1929 to 1935 he was a full-time photojournalist for the Pacific and Atlantic Picture Agency, later part of Associated Press, and contributed to *Berliner Illustrierte Zeitung* and other picture magazines in Berlin and Paris. In 1935 he came to the United States, where he freelanced for *Harper's Bazaar*, *Vogue*, *Town & Country*, and other publications. In 1936, Henry Luce hired him, along with Margaret Bourke-White, Peter Stackpole, and Thomas McAvoy, as one of four staff photographers for his new publication, *LIFE*. Eisenstaedt remained at the magazine for the next forty years and was active as a photojournalist into his eighties. In 1988 he was honored with ICP's Infinity Master of Photography Award.

Eisenstaedt was among those Europeans who pioneered the use of the 35-millimeter camera in photojournalism as they brought their knowledge to American publications after World War I. He was also among the earliest devotees of available-light photography. Unlike many photojournalists in the postwar period, he was not associated with a particular kind of event or geographic area: he was a generalist. As such, he was a favorite among editors, not only for his quick eye, but also for his ability in making good photographs of any situation or event. His nonjudgmental but acutely perceptive eye and his facility with composition have made his photographs memorable documents of his era both historically and aesthetically.—LH

Elliott Erwitt
(American, born in France in 1928)

Elliot Erwitt was educated in Milan, Paris, and New York before moving with his parents to Los Angeles in 1942. After attending Los Angeles City College, he moved to New York and studied film at the New School for Social Research in 1948–1950. His success as a freelance magazine photographer came in 1953, after military service and employment as a staff photographer for Roy Stryker at the Standard Oil Company of New Jersey. Throughout the 1950s and 1960s, Erwitt's documentary photographs appeared in major U.S. magazines. He has also published work through Magnum, the agency founded by Henri Cartier-Bresson, Robert Capa, George Rodger, and Chim (David Seymour). He has been active in the organization as both photographer and officer, serving as president in 1966. Among Erwitt's most famous photographs are those made during the "kitchen debate" between Richard Nixon and Nikita Khruschev in Moscow in 1959; he is well known for his humorous pictures of people and dogs, which invoke visual puns to ironic effect.

His work has been the subject of numerous exhibitions, at the Museum of Modern Art, ICP, the Royal Photographic Society in Bath, and elsewhere. Since the early 1970s, Erwitt has produced films, including *Dustin Hoffman*, *Beauty Knows No Pain*, and *Red, White and Bluegrass*.

Although frequently noted for offbeat humor, Erwitt's photography is based on a graphic sensibility that instinctively organizes the formal elements of a scene to create a personalized comment on the subject. This sensibility pervades all of Erwitt's photographs, whether they are photojournalistic documents, advertising assignments, or personal pictures, and has had a substantial impact on contemporary photography. In addition, through his insistence that the maker, rather than the publisher, of an image hold the copyright, he has affected the entire magazine photography industry.—LH

Frank Eugene
(German, born in the United States, 1865–1936)
Born in New York, Frank Eugene spent most of his life in Germany, where he was an important figure in avant-garde photography and photographic education. He traveled to Germany for the first time in 1886 to attend the Bavarian Academy of Graphic Arts in Munich, and upon his return to New York in 1894, he studied photography and worked as a stage designer and portraitist. His strong painting background, combined with his expertise in etching and his affinity for Jugendstil, resulted in photographs with heavily manipulated surfaces and a handmade sensibility. His Pictorialist works warranted his election to the Linked Ring Brotherhood in London in 1900 and recommended his work to Alfred Stieglitz, who in 1902 invited Eugene to be a founder-member of the Photo-Secession. Eugene established himself in Munich that same year, and was active in avant-garde photography organizations. In 1905 he joined the International Association of Art Photographers and three years later resigned from the Linked Ring. Eugene devoted the majority of his time to serving as a photographic educator in Germany, first in Munich and then in Leipzig.

Frank Eugene was significant in the Pictorialist movement of the early 1900s; his pictures helped fortify the connection between painting and photography that led to the acceptance of photography as a fine art. His facility with painting, etching, and such photographic techniques as the gum bichromate and autochrome processes have distinguished him as an accomplished practitioner of early-twentieth-century photography.—LH

Walker Evans
(American, 1903–1975)
Walker Evans is one of the leading photographers in the history of American documentary photography. Born in St. Louis, he studied at Williams College and the Sorbonne in Paris. He returned to the United States in 1928, and within five years, though self-taught in photography, he was the subject of a solo exhibition at the Museum of Modern Art, and had had his photographs

published in an edition of Hart Crane's *The Bridge* (1930) and in Lincoln Kirstein's *Hound & Horn* (1931). Evans worked for the Farm Security Administration from 1935 to 1937, during which time he made many of the photographs for *Walker Evans: American Photographs*, an exhibition and publication organized by the Museum of Modern Art in 1938. In 1936 he took a leave from the FSA in order to document the living conditions of Alabama sharecropper families as part of a collaborative project with the writer James Agee. The results were published in 1941 as *Let Us Now Praise Famous Men*, with text by Agee and photographs by Evans. Another of Evans's many photographic series was "Many Are Called," comprising images taken with a hidden camera in the New York City subway system between 1938 and 1945. Evans received three Guggenheim Fellowships and was a member of the National Institute of Arts and Letters. Between 1943 and 1965 he worked as a staff photographer for *Time* and *Fortune*. After retiring from professional photography in 1965, he taught graphic arts at Yale.

Walker Evans's photographs were prototypes both for the American documentary movement of the 1930s and for street photographers of the 1940s and 1950s. His precisely composed, intricately detailed, spare photographs insisted on their subject matter, and his impartial acceptance of his subjects made his work seem true and aesthetically pure—qualities that have been the goal of documentary photography ever since. Later in his career he often photographed with the new Polaroid camera, which he used to depict street graffiti and various detritus of the contemporary world.—LH

Andreas Feininger
(American, born in France, 1906–1999)
One of the world's most prolific photographers, Feininger was a pioneer both visually and technically. Born in Paris, son of the painter Lyonel Feininger, Andreas was educated in German public schools and at the Weimar Bauhaus. His interest in photography developed while he was studying architecture, and he worked as both architect and photographer in Germany for four years, until political circumstances made it impossible. He moved to Paris, where he worked in Le Corbusier's studio, and later to Stockholm. There he established his own photographic firm specializing in architectural and industrial photography. With the outbreak of war in 1939, Feininger moved to New York, where he was a freelance photographer for the Black Star agency and then for the U.S. Office of War Information. After working on a retainer basis, he was a staff photographer at *LIFE* from 1943 to 1962, and there established his reputation. He subsequently concentrated on personal work, exhibiting and publishing extensively. Feininger was renowned as a teacher via his publications that combine practical experience with clarity of presentation.

Feininger's purpose in photography was documentation of the unity of natural things, their interdependence, and their similarity to constructed forms. His images emphasize design, deploying the principles of simplicity, clarity, and organization. In

addition to natural forms, Feininger's subject matter included the city, machines, and sculpture. He built four customized telephoto lenses and three close-up cameras, which allowed him to represent landscapes and city scenes in a distortion-free monumental perspective, and to show small subjects in startling sizes, thereby revealing unknown aspects. He preferred black-and-white photography for the graphic control it allowed. Feininger received numerous awards; his photographic archive is held at the Center for Creative Photography in Tucson.—LS

Harold Feinstein
(American, born in 1931)
Coney Island native Harold Feinstein embarked on his career in photography at the age of fifteen, and by the time he was nineteen, the Museum of Modern Art was collecting and exhibiting his work. Self-taught, he worked closely with W. Eugene Smith during the early 1950s and learned from him the value of photography in reorienting one's thinking. From the 1950s through the 1970s, a wide variety of periodicals published his work, including *LIFE*, *Audubon*, *Newsday*, *The New York Times*, *Aperture*, *Newsweek*, *Camera 35*, and *Ladies' Home Journal*. Since the late 1950s, Feinstein has been influential as a teacher, at the University of Pennsylvania, the School of Visual Arts in New York, the Maryland Institute of Art, and elsewhere, and in private workshops. Exhibitions of his work have been held at ICP, the Musée d'Art Moderne in Paris, and the George Eastman House.

Feinstein is best known for photographs he made at Coney Island in the 1950s. Not merely lighthearted studies of people having fun, they brought viewers close enough to his subjects and their typical activities—sunning themselves, riding the roller coaster, talking, and laughing—to feel as though they were sharing in those experiences. Engaging and magnetic, these images skirted the edges of intrusiveness, thrilling viewers. Feinstein has also produced photographic series on New York street life, flowers, seashells, backs, and rippling water. His street photography echoes the excitement of urban life while recognizing its potential for alienation and loneliness.—LH

Donna Ferrato
(American, born in 1949)
Born in Lorain, Ohio, Donna Ferrato is a self-taught photographer who became a freelance photojournalist in 1976. She was based in Paris and Belgium until 1978 and traveled extensively in Europe and the United States throughout the late 1970s. In 1982 she was hired by Japanese *Playboy* to photograph couples who epitomized the wealthy American lifestyle of the early 1980s. After witnessing the husband of one of those couples brutally beat his wife, she embarked on an independent documentation of domestic violence in the United States. She spent several years visiting women's shelters, emergency rooms, and

prisons, and traveling with police to make contact with people involved in domestic violence. Her photographs on this subject were published in *LIFE*, *The New York Times Magazine*, *Time*, *USA Today*, *U.S. News & World Report*, and the *Los Angeles Times*, among other publications, and were aired on television programs such as *Dateline* and *Eye on America*. Ferrato has received numerous honors for this reportage, including a W. Eugene Smith Grant in 1985 and a Kodak Crystal Eagle Award in 1990. The culmination of her domestic violence project came in 1991 with the publication of her book *Living with the Enemy* and the founding of the Domestic Abuse Awareness Project, which produces photographic exhibitions on domestic violence to raise money for women's shelters.

Ferrato's photographs heightened public awareness of domestic violence. She uses only black-and-white film, and thus avoids exploiting the victims' suffering through the sensationalizing effects of color. Hers is an important and effective body of work that continues to insist on photojournalism's potential for social change.—LH

Robert Frank
(American, born in Switzerland in 1924)
Robert Frank began studying photography in 1941 and spent the next six years working for commercial photography and graphic design studios in Zurich, Geneva, and Basel. In 1947 he traveled to the United States, where Alexey Brodovitch hired him to make fashion photographs at *Harper's Bazaar*. Although a few magazines accepted Frank's unconventional use of the 35-millimeter Leica for fashion work, he disliked the limitations of fashion photography and resigned a few months after he was hired. Between 1950 and 1955 he worked freelance, producing photojournalism and advertising photographs for *LIFE*, *Look*, *Charm*, *Vogue*, and others. He also garnered support for his independently produced street photographs from important figures in the New York art world, including Edward Steichen, Willem de Kooning, Franz Kline, and Walker Evans, who became an important American advocate of Frank's photography. It was Evans who suggested that he apply for the Guggenheim Fellowship that freed him to travel throughout the country in 1955 and 1956 and make the photographs that would result in his most famous book, *The Americans*, first published in France in 1957, as *Les Américains*. After its publication in the United States in 1959, he devoted an increasing amount of time to making films, including *Pull My Daisy* and *Cocksucker Blues*, both of which exemplify avant-garde filmmaking of the era. Since 1970, Frank has divided his time between Nova Scotia and New York; he continues to produce still photographs in addition to films. He has received numerous honors, including ICP's Infinity Award for Publication for *New York to Nova Scotia* (1987).

The Americans was one of the most revolutionary volumes in the history of photography, and it was a source of controversy when it was published in the United States. Frank's cutting perspective on American culture, combined with his carefree attitude

toward traditional photographic technique, shocked most Americans who saw it at the time. During the next decade, however, these qualities of his photography became touchstones for a new generation of American photographers; indeed, Frank's work continues to shape contemporary photography.—LH

Lee Friedlander
(American, born in 1934)
Lee Friedlander was born in Aberdeen, Washington, and became interested in photography at age fourteen. He studied photography at the Art Center School in Los Angeles from 1953 to 1955 and then began freelancing. His work appeared in *Esquire*, *Art in America*, *Sports Illustrated*, and other periodicals, and he had his first solo exhibition at the George Eastman House in 1963. Subsequent exhibitions of his work include "Toward a Social Landscape" at the George Eastman House in 1966 and "New Documents" at the Museum of Modern Art in 1967, both of which identified his photographs with those of other "social landscape" photographers such as Garry Winogrand, Bruce Davidson, Danny Lyon, and Diane Arbus. Friedlander has published books regularly: *Work from the Same House* (with Jim Dine, 1969), *Self-Portrait* (1970), *Flowers and Trees* (1981), *Lee Friedlander: Portraits* (1985), and *Cray at Chippewa Falls* (1987); more recently he has produced the book *Nudes* (1991) and *The Jazz People of New Orleans* (1992). He has received a number of awards for his photography, including three Guggenheim Fellowships; five National Endowment for the Arts Fellowships; and a MacArthur Foundation Award. Friedlander is responsible for printing the negatives of the turn-of-the-century New Orleans photographer E. J. Bellocq, whom he rescued from oblivion.

Friedlander's photography follows in the tradition of documentary photography as practiced by Walker Evans and Robert Frank. It is unusual for street photography in that it possesses a constant awareness of the photographer's relationship to the picture plane and places at least as much importance on it as on the image's ostensible subject—usually something like an empty street, a store window, or an unremarkable piece of town statuary. Friedlander's photographs also often contain his shadow and/or reflection, which lends an odd, uncomfortable edge to his observations.—LH

Toni Frissell
(American, 1907–1988)
A native of New York City, Toni Frissell trained as an actress and worked in advertising before devoting herself to photography in the early 1930s. Her introduction to photographic representation came through her brother Varick, a documentary filmmaker, whose death while filming off the coast of Labrador in 1929 inspired her to pursue the medium seriously. Mainly self-taught, she found work first as a caption writer and then as a fashion photographer for *Vogue*. During World War II, she was the official photographer for the American Red Cross and for the Women's Army Corps of the U.S. Office of War Information. From 1941 through 1950, she worked for *Harper's Bazaar*, but her experiences as a war observer encouraged her toward photojournalism, and she produced little fashion work after 1950. Instead, she did location photography on a freelance basis for *Life*, *Look*, *Vogue*, and *Sports Illustrated* until her retirement in 1967. Since the resurgence of interest in fashion photography, Frissell's work has been included in solo exhibitions at the Philadelphia Museum of Art and ICP, group shows at the George Eastman House, and many other exhibitions.

Frissell's major contribution to fashion photography was her development of the realistic (as opposed to staged) fashion photograph in the 1930s and 1940s. Like Martin Munkacsi, she mastered the appearance of unself-conscious spontaneity in fashion pictures by working outside and on location with her models. She had a tendency to use uncommon perspectives, which she achieved by placing her camera on a dramatic diagonal axis, and/or using a low point of view and a wide-angle lens against a neutral background, thus creating the illusion of elongated human form. With her preference for close-ups and straightforward, unembellished images of winsome, sportswear-clad models, Frissell's action-fashion photographs are landmarks in the development of postwar fashion imagery.—LH

Francis Frith
(British, 1822–1898)
Born in Chesterfield, England, Francis Frith apprenticed to a cutlery house and was a partner in a successful wholesale grocery business before he became interested in photography in the early 1850s. He co-founded the Liverpool Photographic Society in 1853, and three years later embarked on his first photographic excursion to Egypt, where he made pictures of ancient monuments. Frith overcame the adverse climatic conditions, producing his striking photographs in a portable wicker darkroom with wet-plate collodion on glass negatives and the albumen printing process. His striking images from this journey proved so popular that he was able to return to the Middle East twice during the next three years. Frith's journeys resulted in a total of nine publications, including *Egypt and Palestine Photographed and Described by Francis Frith*, a subscription series issued between 1858 and 1860, and *Cairo, Sinai, Jerusalem, and the Pyramids of Egypt* (1860). By 1859, Frith had earned enough to establish F. Frith & Co., which specialized in postcards of landscape and architectural views in Britain and the Middle East. After 1861, as he became more involved in the management of the company, Frith hired other photographers to provide views of Great Britain, continental Europe, and the United States. F. Frith & Co. remained in business until 1968, long after his death.

Francis Frith was a successful entrepreneur and photographer whose topographical views responded to the high demand in mid-nineteenth-century England for pictorial evidence of Middle Eastern subjects. Although his use of three negative formats for each view—8x10, 16x20, and stereoscopic pairs—points to the commercial nature of his enterprise, those negatives also reveal his experimentation with exposure times and vantage points in order to discern the most pleasing composition for each site. Underscoring his comprehension of the artistic possibilities of photography were the many articles he wrote about the subject, in which he argued for the ability of photographs to communicate divine truth and aesthetic awareness to the general population.—LH

Valeriy Gerlovin
(American, born in Russia in 1945),
Rimma Gerlovina
(American, born in Russia in 1951), and
Mark Berghash
(American, born in 1935)
Born in Vladivostok and Moscow, respectively, Valeriy Gerlovin and Rimma Gerlovina immigrated in 1980 to the United States, where they met Mark Berghash, who became their collaborator. Valeriy studied painting and sculpture, and Rimma received a degree in linguistics and philosophy from the University of Moscow; their first collaboration was in 1971. In the Soviet Union, the Gerlovins (who are husband and wife) were proponents of the underground *samizdat*, or self-publishing, art movement that sought to circumvent official censorship. Since their immigration, they have been involved in introducing contemporary Russian art to the West, yet have continued to draw upon *samizdat* techniques of using text to illustrate the primacy of language in society, exploring this theme through what they refer to as "the magnifying eye of photography."

For the "still performances" which become their "photoglyphs," the Gerlovins photograph their own faces and bodies marked with words and symbols, and produce larger-than-life color prints that are witty, intriguing, and seductive. Their body decoration deploys a primitive and direct form of human expression: skin becomes "human parchment" for their "organic formulas." These theatrical portraits present the artists as literal "figures of speech," and are more cosmic than worldly in spite of the fleshy realism of the photographs. Their images create a visual anthropomorphic poetry that is simultaneously humorous and serious. With titles such as *To Be*, *Absolute-Relative*, *A-head*, and *Still-a-Life*, the work entails multiple layers of punning, metaphor, and analogy operating at visual and textual levels. The works' dense references span languages, religions, cultures, and history, and draw equally on mysticism, mythology, mathematics, linguistics, and philosophy. The Gerlovins pursue their fascination with riddle and paradox through words and images that pose the duality of a concept and its opposite in order to move beyond mere rationality; their partnership is founded upon the dynamic symmetry of masculinity and femininity.

The Gerlovins have collaborated with the graphic designer and portrait photographer Mark Berghash, whom they met in New York in 1985. The trio produced a series of work titled "Photems" that combines the concepts of photography and totem; an exhibition of this project was shown at the Art Institute of Chicago in 1989.—LS

Ormond Gigli
(American, born in 1925)
Born in New York City, Ormond Gigli graduated from the School of Modern Photography in 1942 and served in the Navy during World War II. While he was working for the Rapho photo agency in 1952, a LIFE editor enlisted him to do celebrity profiles in place of the photojournalist Robert Capa, who was interested in other assignments. That same year, LIFE assigned Gigli to the Paris fashion shows; a photograph of his published in the center spread of the magazine initiated his career as one of the most sought-after magazine photographers of the next two decades. His work was published in major international periodicals, including *Time*, *Paris-Match*, *LIFE*, and *Collier's*; in 1954 he opened a Manhattan studio on East Sixty-fifth Street, where he photographed leading stars of the day and covered Broadway shows for *Time* and *LIFE*. As fashion photography lost its innocence in the 1970s and 1980s, he increasingly worked for a roster of corporate clients. His work has been shown in galleries around the world and has appeared in various photographic anthologies.

Ormond Gigli is best known for his 1960 color photograph *Girls in the Window*, in which models in an assortment of poses and outfits stand in the windows of three New York brownstones across the street from his studio. Gigli conceived of this image independently, rather than on assignment, and when he showed it to editors at LIFE and *Ladies' Home Journal*, they published it immediately. It has since been the inspiration for subsequent commercial image-makers.—LH

Burt Glinn
(American, born in 1925)
Burt Glinn, a Pittsburgh native, began working in photography after serving in the Army and enrolling at Harvard. He was the photographer and photography editor for the Harvard *Crimson*, and his work there attracted the attention of a talent scout for LIFE, who hired him as a photographer in 1949. By 1950, Glinn had advanced to staff photographer, but he maintained his freelance status, which allowed him to work for many publications, including *Holiday*, *Esquire*, *Fortune*, *Travel & Leisure*, *Paris-Match*, and *Newsweek*. Some of his best-known works were the color travel essays he produced for *Holiday* in the 1960s, among them entire issues devoted to such places as the South Seas, Japan, Mexico, Russia, and California. Two of these essays grew into books, *A Portrait of All the Russias* (1967) and *A Portrait of Japan* (1968). In addition to his magazine photography, Glinn made many advertising and annual report photographs for numerous corporate clients. Since 1952, Glinn has been an active member of Magnum, the cooperative photography agency founded by Henri Cartier-Bresson, Robert Capa, George Rodger, and Chim (David Seymour), and he served as its president in 1972–1974 and 1987–1988, as well as its vice-president in 1994–1998.

From 1974 to 1977, he was one of the original contributing editors to *New York* magazine. In addition to many other honors, he received an Overseas Press Club Award in 1967.

Burt Glinn has been one of the most prolific photographers of the postwar period. His wide range of political and cultural interests and his consistent ability to obtain excellent photographs for any assignment have earned him the moniker "editor's photographer." Although Glinn claims to be much less fond of technique than he is of good subject matter, his vibrant color work proves that his formal acuity is equal to his obvious versatility.—LH

Frank Gohlke
(American, born in 1942)
Born in Wichita Falls, Texas, Gohlke received a B.A. in English from the University of Texas at Austin in 1964, and an M.A. in English from Yale in 1967. He studied photography with Paul Caponigro in 1967–1968. Soon after, he himself began teaching at a number of institutions. He has also worked as a freelance photographer since 1967. Among his notable works are a series documenting volcanic activity and its aftermath at Mount Saint Helens, Washington. Gohlke has been honored with a Minnesota State Arts Council Artist's Fellowship, a Guggenheim Fellowship, two National Endowment for the Arts Fellowships, and a Bush Foundation grant. In 1980, he was commissioned to make a series of mural photographs for the Tulsa International Airport. His work has been shown at the George Eastman House, the Art Institute of Chicago, the Amon Carter Museum, and the Museum of Modern Art. It was included in the "New Topographics" exhibition in 1975, and a fifteen-year retrospective of his work, "Landscapes from the Middle of the World" was shown at the Museum of Contemporary Photography in Chicago in 1988; a catalogue accompanied the exhibition.

Gohlke is perhaps best known as a photographer of midwestern icons, the most compelling of which are the grain elevators he has visually defined as "measures of emptiness." Consideration of distance and place are central to his work, which he characterizes as essentially lyrical, or concerned with describing the interaction between inner and outer realities, and the often elegiac relationship of loss and longing among person, place, and time.—LS

Nancy Goldring
(American, born in 1945)
Born in Oak Ridge, Tennessee and reared in St. Louis, Nancy Goldring graduated from Smith College in 1967. She spent a year in Italy on a Fulbright fellowship, and later enrolled in the MFA program at New York University. Then a sculptor and printmaker, she was a cofounder of SITE, or Sculpture in the Environment, an organization of artists interested in developing public art projects; when the group's interests became increasingly commercial, Goldring redirected her energies. She is head of drawing and contemporary art at Montclair State University. Goldring's interest in the power of location and memory manifests itself in the technique

she calls "foto-projection." A ceaseless photographer of her travels and a collector of other images with personal relevance, Goldring makes shallow-relief paper models based on her drawings. Multiple layers of transparencies related to her travels and memories are projected onto the front and back of the paper, which is suspended upright. The layered composition is visually flattened by the artist when the collage of images is rephotographed to create a final document. Goldring's work was included in a 1939 exhibition at the National Museum of American Art, "The Photography of Invention: American Pictures of the 1980s," and a mid-career retrospective and accompanying monograph will be produced by the Southeast Museum of Photography in 2000.

Goldring's work is unique in its incorporation of drawing, models, photography, and slide projection. The Surrealist concept of the persistence of memory lingers in her color photographs, where multiple images glow simultaneously, bright and frozen, impermanent and translucent, intangible. Images of windows, doors, and other framing devices are often included in her photographs, inspiring in viewers a desire to move through and beyond the portal. Her work is a reminder of the vastness of our world.—MF

Emmet Gowin
(American, born in 1941)
Emmet Gowin was born in Danville, Virginia, and grew up in a close-knit religious family whose values formed the foundation for much of his photographic work. Although inspired by an Ansel Adams photograph reproduced in *Popular Photography* in 1957, he did not pursue the medium seriously until he enrolled in the graphic design program at the Richmond Professional Institute in 1961. In 1965 he studied with Harry Callahan at the Rhode Island School of Design, and he began to concentrate on his family as his primary subject matter. Two years later, Gowin met Frederick Sommer, whose work and friendship would profoundly affect his creative development. He joined the faculty at Princeton University in 1973 and teaches there today. Gowin began photographing European landscapes in the early 1970s; he photographed Mount Saint Helens after its eruption in the 1980s, and his current work includes aerial views of sites of buried nuclear waste in the American West. Since his first solo exhibition at the Dayton Art Institute in 1968, Gowin's work has been shown at the George Eastman House, the Corcoran Gallery of Art, the Philadelphia Museum of Art, and elsewhere. He has received a Guggenheim Fellowship and two National Endowment for the Arts Fellowships.

From his family photographs of the late 1960s through his recent aerial views, Emmet Gowin has devoted himself to analyzing intimacy among individuals and in their relationship to nature. Drawing on his continuous study of philosophy, physics, and spirituality, as well as his deep appreciation for the symbolic power of photography,

Gowin's work consistently reminds us that we need connections—both physical and emotional—in order to survive. His virtuosity in printing enriches the expressive power of his images and contributes to his ranking as one of the most accomplished photographers working today.—LH

Ruzzie Green
(American, 1892–1956)
Born in New York, Kneeland L. Green adopted his nickname while attending the Art Students League. Upon his graduation in 1917, he worked as a freelance illustrator and layout specialist for commercial clients until he was employed as chief illustrator, and later art director, for the Stehle Silk corporation, a leading textile design firm of the 1920s. While traveling to Europe in 1926, Green met Edward Steichen, with whom he soon collaborated on a series of photographs for Stehle Silk. Green was art director for this project, while Steichen photographed arrangements of common items—matches, carpet tacks, thread, buttons, rice, coffee—that were reproduced as textile designs. Steichen later credited Green as the catalyst for this series, which Steichen considered important in his artistic development away from Pictorialism to the new modernist aesthetic of the 1920s and 1930s. Because of the Depression, Green had to leave Stehle Silk; he was hired as art director for *Harper's Bazaar*, where he remained until he turned to commercial photography in 1932. By the next year he was a specialist in the carbro color printing process, an expensive and complicated technique that was highly prized among commercial media throughout the 1930s. Green's commercial work appeared in such magazines as *Harper's Bazaar*, *Ladies' Home Journal*, and *McCall's* from the 1930s through the 1950s, and he produced photographs for some of the most famous advertising campaigns by Camel, Modess, and other clients.

Despite his relative obscurity today, Ruzzie Green was one of the best-known commercial photographers of his era. Noted for striking color images epitomizing modern glamour and elegance, his work blurred the boundary between editorial fashion photography and commercial illustration, as did that of Nickolas Muray and Ruth Bernhard. Although much research remains to be done on his life and career, it is clear that Green was among the most accomplished photographers of his generation.—LH

Lauren Greenfield
(American, born in 1966)
Lauren Greenfield was born in Boston, grew up in Los Angeles, and graduated from Harvard with a B.A. in visual and environmental studies in 1987. She worked as a photojournalist based in Los Angeles and London, and published work in *National Geographic*, *Time*, *Newsweek*, *The New York Times Magazine*, the London *Sunday Times Magazine*, *Fortune*, *Vanity Fair*, *LIFE*, and other magazines. Her early projects included the photographic series "Survivors of the French Revolution" and a film, *Once You're*

In . . ., which documented the lives of young Irish illegal immigrants in Boston. Her best-known work to date is *Fast Forward: Growing Up in the Shadow of Hollywood*, a book of color photographs that were also exhibited at ICP, the Maylight Festival in Bologna, the Fotofestival Naarden in Holland, and the Visa pour l'Image in Perpignan, France. Greenfield has received many honors for her photographs, notably ICP's Young Photographer Infinity Award, the National Geographic Society Documentary Grant, and a National Foundation for Advancement in the Arts Award.

Greenfield's color photographs (and excerpts of interviews with her subjects) in *Fast Forward* portray the life-styles of preteens and teenagers living in the most media-saturated area of the country. Through photographs as suffused with lush color as the lives of her subjects are with the power of money, popular culture, and celebrity, Greenfield demonstrates the surprising and often disturbing face of youth in late-twentieth-century America. Her work not only enhances our understanding of contemporary media culture's effect on the young, but also represents a dramatic change from the way children have traditionally been depicted in documentary photography.—LH

Ernst Haas
(Austrian, 1921–1986)
Ernst Haas was born in Vienna and began studying photography at the Graphische Lehr-und Versuchsanstalt in Vienna six years before acquiring his first camera in 1946. After several photography-related jobs, he was offered a position at *LIFE*, and his first feature article, "Returning Prisoners of War," was published in both *Heute* and *LIFE* in 1949. This prompted Robert Capa to invite Haas to join the Magnum agency, the international cooperative founded by Capa, Henri Cartier-Bresson, George Rodger, and Chim (David Seymour). Also in 1949, Haas purchased a Leica and began experimenting with color photography, the medium in which his work is best known. His "Magic Images of New York," a twenty-four-page color photo essay, which appeared in *LIFE* in 195 , was both his and *LIFE's* first long color feature in print. Throughout the 1950s and 1960s, Haas worked in both black-and-white and color, contributing to *LIFE*, *Look*, *Vogue*, and *Holiday*. He also worked as a still photographer for films, among them *The Pharaohs*, *The Misfits*, and *Little Big Man*. Haas served as president of Magnum in 1959–1960, and as second director for *The Bible* (John Huston was first director) in 1966. *The Creation* (1971), a book of his photographs, eventually sold more than 300,000 copies.

Ernst Haas pioneered the use of color photography at a time when it was considered inferior to black and white as a medium for serious creative photographers. His innovative use of the slow shutter speed, which gave many of his pictures the illusion of movement, and his emphasis on audio-visual presentations (works involving sound,

poetry and pictures) opened many possibilities in color photography and in multimedia art. Although he is famous for his color photography, Haas's black-and-white images are among the most incisive, evocative, and beautiful of postwar Europe and America, as was demonstrated in ICP's exhibition of his work in 1993.—LH

Hiroshi Hamaya
(Japanese, 1915–1999)
Hiroshi Hamaya is one of the best-known of contemporary Japanese photographers. Born in Tokyo, he became interested in photography at age fourteen. After completing high school, he worked as a photographer for the Oriental Photo Industry Company. In 1935 he bought his first Leica and the next year had a photograph published in *Home Life* magazine. He has worked as a freelance photographer since 1937, in Tokyo until 1945, then in Takada City, Niigata Prefecture, and in Oiso, Kanagawa Prefecture, since 1952. Throughout his career, he traveled to a variety of international destinations, including Manchuria, China, Thailand, Western Europe, North America, Nepal, Australia, and Algeria. Among his many books are *Yuki Guni* (The Snow Country, 1956), *The Red China I Saw* (1958), *Landscapes of Japan* (1964), and *Mount Fuji: A Lone Peak* (1978). A member since 1960 of Magnum, the international cooperative photography agency founded by Henri Cartier-Bresson, Robert Capa, George Rodger, and Chim (David Seymour), Hamaya had been included in such exhibitions as Cornell Capa's "The Concerned Photographer," "Hamaya's Japan" at Asia House in New York, and "Hiroshi Hamaya: 50 Years of Photography" at ICP, in conjunction with which he received the Master of Photography Infinity Award in 1986.

Hamaya's first two published photographic series, "Yuki Guni," and "Ura Nihon [Back Regions of Japan]," were based on his mid-1950s studies of the people of Japan's rural areas, where folk customs remained strong. During this time Hamaya began to develop his theory of *fudo*, an individual's conception of and attitude toward his or her general environment, including its topography, flora and fauna, climate, and ecology. The interest in nature eventually superseded his previous focus on people, and became his main area of concentration during the second half of his career.—LH

Robert Heinecken
(American, born in 1931)
Robert Heinecken was born in Denver and raised in Iowa and California. He enrolled at the University of California at Los Angeles in 1951, then interrupted his studies to serve as a naval cadet and jet fighter pilot in the Marines. Heinecken completed a B.A. in 1959, and an MFA in design, drawing, and printmaking the following year, and was then hired by UCLA to teach a photography course. He began experimenting with the medium and also made the acquaintance of Van Deren Coke, Jerry Uelsmann, Ray Metzker, and Harry Callahan. Throughout his career, Heinecken has used photography as a medium for manipulation to explore

his interest in content and form. His first important series, "Are You Rea," published as a set of twenty-five prints, derives its title from the partial text that became visible when several pages of magazine advertising and text were layered over a light box and rephotographed. A thematic investigation of sexuality, the media, and the nature of desire has been a frequent undercurrent of Heinecken's diverse body of work, which includes collage, montage, abstraction, manipulation of large-scale advertising and commercial imagery, and portraiture. Heinecken has taught at Harvard, the San Francisco Art Institute, the School of the Art Institute of Chicago, and elsewhere. His work appeared in the landmark 1978 Museum of Modern Art exhibition "Mirrors and Windows: American Photography Since 1960," and a major retrospective will be presented by the Museum of Contemporary Art in Chicago in 2000.

Heinecken's use of photographs and other images as raw material for manipulation represents a departure from the tradition of straight photography. While emphasizing the banality of the media, his work also suggests our collective responsibility in having perpetuated objectification and exploitation. An exploration of form without rigid formality, his puzzle collages of the mid-1960s allow viewers to move small mounted abstract photographs in prismatic variations, barely affecting their overall Cubist aesthetic.—MF

Udo Hesse
(German, born in 1955)
Udo Hesse was born in Troisdorf, and began his photographic education in Berlin in 1976. His first project, in 1978, involved photographic documentation of industrial architecture in Great Britain. Since then, a freelance commercial photographer, Hesse works primarily in black and white, and in all camera formats. His project "Haut und Haar," a series of extremely close-up images of human skin and hair, differs greatly from his portrait, dance, and architectural photographs of the last twenty years. Hesse's photographs, especially his portraits, have appeared in *ARTnews*, *Interview*, and *Stern*, among other publications. He is working on two book projects, one concentrating on photographs of East Berlin in the 1980s, and the other presenting a selection of portraits of architects. Helmut Newton, Richard Avedon, and Irving Penn are important influences on his work.

Hesse's macroscopic examination of human skin and hair is part of the wealth of body-based imagery created by artists in the 1980s. Exploring the topography of the body in photographs not unlike those of his contemporary John Coplans, Hesse uses a large-format camera to capture the texture and substance of flesh in crisp, intense detail. He treats our basic corporeal material as simple fact, but effectively makes strange what is most intimate and universal to us all.—CF

Lewis W. Hine
(American, 1874–1940)
Born in Oshkosh, Wisconsin, Lewis W. Hine studied sociology before moving to New York in 1901 to work at the Ethical Culture School, where he took up photography to enhance his teaching practices. By 1904 he had begun a series of photographs documenting the arrival of immigrants at Ellis Island; this project, along with his pictures of harsh labor conditions published in the *Pittsburgh Survey*, brought his work to the attention of the National Child Labor Committee. He served as its official photographer from 1911 to 1916, and later traveled with the Red Cross to Europe, where he documented the effects of World War I in France and the Balkans for *Red Cross Magazine*. After returning to the United States in 1922, he accepted commercial assignments, produced another series on Ellis Island immigrants, and photographed the construction of the Empire State Building. Several of these construction pictures were published in *Men at Work* (1932), a book celebrating the individual worker's interaction with machines in the modern world. Despite the success of this book, Hine's financial situation became desperate and his photography was virtually forgotten. Berenice Abbott and Elizabeth McCausland learned of his work through the New York City Photo League and in 1939 mounted a traveling retrospective exhibition of his work to revive interest in it.

Hine is best known for the documentary images of child labor practices that he produced under the aegis of the National Child Labor Committee from 1911 to 1916. These photographs not only have been credited as important in the passing of child labor laws, but also have been praised for their sympathetic depiction of individuals in abject working conditions. Hine labeled his pictures "photo-interpretations," emphasizing his subjective involvement; this approach became the model for many later documentary photographers, such as Sid Grossman and Ben Shahn.—LH

Horst P. Horst
(American, born in Germany in 1906)
Born Horst Paul Albert Bohrmann in Weissenfels-an-der-Salle, Horst P. Horst studied architecture in Hamburg and apprenticed in Le Corbusier's studio in Paris in 1930. While there, he gave up architecture for photography, which he had learned from George Hoyningen-Huene, a fashion photographer working for *Vogue*. In 1932 he went to work for *Vogue* in New York, but differences of opinion with the publisher caused him to return to Europe. In 1935, however, Condé Nast invited Horst back, and when Hoyningen-Huene left *Vogue* for *Harper's Bazaar* in 1935, Horst took over his job as chief photographer for French *Vogue*. At the outbreak of World War II, he immigrated to the United States, and he worked as a photographer for American *Vogue* until the early 1980s, with an interruption for military service from 1942 to 1945. By the 1950s, Horst's trademark elegance was considered outdated in editorial fashion photography, and he did more advertising work. Diana Vreeland, editor in chief at *Vogue*, en-

couraged him to photograph international high society; he spent most of his time between 1961 and 1975 traveling and photographing for *Vogue*, *Vanity Fair*, and *House & Garden*. He published several books of his photographs, including *Photographs of a Decade* (1945), *Patterns from Nature* (1946), and *Salute to the Thirties*, with Hoyningen-Huene (1971).

Although heavily influenced by Hoyningen-Huene in his early work, Horst quickly developed an original style through innovative lighting that enhanced his subjects' best features. His expertise contributed to the success of his architectural and life-style photographs, which established a new standard for the field in the 1960s. The resurgence of luxury in fashion photography in the late 1970s and early 1980s renewed interest in Horst's pictures from the 1930s. Several exhibitions of his work have been mounted, including two retrospectives at ICP, one of which coincided with his receiving the ICP Master of Photography Infinity Award in 1996.—LH

George Hurrell
(American, 1904–1992)
Born in Kentucky and raised in Cincinnati, George Hurrell displayed an interest in drawing at an early age. He attended the Art Institute of Chicago briefly, then the neighboring Academy of Fine Arts in his teens, but he left school in 1922 and attempted a career as a painter. He took a job hand-painting photographs in a commercial studio, and accepted a series of temporary positions with other commercial studios, learning technical skills that didn't interest him. In 1925 he moved to California, where he discovered that his photographs sold better than his paintings; he cultivated a reputation for his photographic portraits. Hurrell met Edward Steichen in 1928, when the elder photographer borrowed his darkroom to develop his photographs of Greta Garbo. Hurrell's first major Hollywood commission was to photograph the actor Ramon Novarro. He went on to work as a freelance or staff photographer for five movie production companies between 1930 and 1956, and at the Pentagon during World War II. Hurrell resumed freelance work between 1960 and 1975, when the demand for his portraits had waned. Rediscovered during the 1970s, he enjoyed a brief second career, and his work was the subject of several monographs, including *The Hurrell Style: 50 Years of Photographing Hollywood* (1976) and *Hurrell's Hollywood Portraits: The Chapman Collection* (1997).

Hurrell revolutionized Hollywood portraiture between 1925 and 1950 through his ability to capture and create glamour, allure, and celebrity of his subjects. In many of his images, elegant artifice renders them almost as living sculptures. Before Hurrell's time, promotional stills throughout the movie industry were in a homogeneous style, characterized by soft-focus generic studio settings and standard lighting placement. Changing public tastes and the popularization of television altered Hollywood marketing priorities in the 1950s and 1960s, and Hurrell's approach to portraiture fell out of favor. —MF

Graciela Iturbide

(Mexican, born in 1942)

Born in Mexico City, Graciela Iturbide studied filmmaking at the Centro Universitario de Estudios Cinematográficos between 1969 and 1972, and worked as an assistant to photographer Manuel Alvarez Bravo, who stimulated her interest in photography. She met Henri Cartier-Bresson while traveling in Europe, and in 1978 was one of the founding members of the Mexican Council of Photography. Besides Cartier-Bresson and Alvarez Bravo, Tina Modotti was an important influence on Iturbide. A major exhibition of her work, "External Encounters, Internal Imaginings: Photographs of Graciela Iturbide," was presented at the San Francisco Museum of Modern Art, and retrospectives of her work have been shown at the Museo de Arte Contemporáneo de Monterrey in Mexico and the Philadelphia Museum of Art. A monograph on her work, *Graciela Iturbide: Images of the Spirit* (1996), accompanied her Philadelphia show.

Iturbide's exquisite high-contrast black-and-white prints convey the starkness of life for many of her subjects. Traveling through Mexico, Ecuador, Venezuela, Panama, and the Mexican community of East Los Angeles, Iturbide documents the uneasy cohabitation of ancient cultural rituals and contemporary adaptations and interpretations. One of her particular interests has been the role of women, and since 1979 she has photographed the Zapotec Indians of Juchitán, Oaxaca, among whom women are commonly accorded places of power and stereotypical gender roles are frequently subverted. Iturbide uses photography to try to understand Mexico in its totality, as a combination of indigenous practices, imported and assimilated Catholic religious practices, and foreign economic trade.—MF

Alfredo Jaar

(Chilean, born in 1956)

Born in Santiago, Alfredo Jaar studied architecture and film at the University of Chile. He exhibited his work in Chile in the late 1970s, and in 1982, moved to New York where he established a significant international reputation. His work has appeared regularly, in exhibitions at the New Museum of Contemporary Art, Documenta VII in Kassel (1987), the Museum of Modern Art, the Hirshhorn Museum, the Moderna Museet in Stockholm, and the Museum of Contemporary Photography in Chicago, among many other institutions. Jaar has completed public art projects for the University of Washington in Seattle and for "Stockholm 98." Among his books are *Let There Be Light, The Rwanda Project 1994–1998* (1998), *The Eyes of Gutete Emerita* (1996), *A Hundred Times Nguyen* (1994), and *Two or Three Things I Imagine About Them* (1992).

Jaar's installations investigate preconceptions about people living in the Third World. He makes photographs of individuals in Brazil, Rwanda, and other countries who look less like pitiful, oppressed victims than like powerful survivors of oppressive economic, political, and social structures. His installations are typically elaborate environments of oddly positioned mirrors and tilted supports. In most instances, his photographs are shown as transparencies mounted in light boxes, which are placed at unusual heights and angles. These displays deliberately disturb the viewer's relationship to the images. The result is an intensely focused and startling experience that challenges our received notions.—LH

Lotte Jacobi

(American, born in Germany, 1896–1990)

Lotte Jacobi was born in Thorn, and took her first photograph with a pinhole camera at the age of twelve. She studied literature and art history at the Academy of Posen from 1912 to 1917, before continuing the tradition established by her photographer father, grandfather and great-grandfather (who had studied with Daguerre), and attending the Bavarian State Academy of Photography and the University of Munich. She managed her father's studio in Berlin from 1927 until 1935. Her Berlin portraits of such figures as Lotte Lenya, Kurt Weill, and László Moholy-Nagy were stylistically influenced by both Alfred Steiglitz and Albert Renger-Patzsch, and illustrate the city's vibrant cultural life. Jacobi fled the Nazis and opened her own studio in New York, which she maintained until 1955. Her first solo American exhibition was held in 1937, and she was included in the Museum of Modern Art's 1942 exhibition "Twentieth Century Portraits." After closing her studio, Jacobi moved to Deering, New Hampshire, where she maintained a studio and gallery from 1963 to 1970. She cofounded the photography department at the Currier Gallery of Art in Manchester in 1970. Jacobi's work was shown at ICP in the 1979 exhibition "Recollections: Ten Women of Photography" and was also featured in a retrospective at the museum in 1993.

When Jacobi left Germany, she had already established herself as a leading photographer of major cultural personalities. She built her reputation on the strength of her portraiture, but later in her career, as her surroundings changed, so did the character of her work; in the 1950s, she began to make abstract images and landscapes. Her "photogenics" of the 1950s are cameraless photographs, in which pieces of glass or twisted cellophane were used to interrupt the beams from a flashlight positioned above a piece of photographic paper. —MF

Clemens Kalischer

(American, born in Germany in 1921)

Clemens Kalischer immigrated with his parents to Paris from his native Bavaria in 1933, when Hitler came to power, and then to the United States in 1942. After studying photography at Cooper Union and the New School for Social Research, he worked as a photojournalist for the France Press news agency and for *Coronet* magazine. By 1949 he was a successful freelance photographer and photojournalist, with work published in such magazines and newspapers as *The New York Times, Newsweek, Time, Fortune, Du,* and in the alternative press as well, including *In Context* and *Common Ground*. Kalischer's architectural photographs have appeared in *Architectural Forum, Urban Design International,* and *Progressive Architecture*. He has operated the Image Gallery in Stockbridge, Massachusetts, for more than thirty years, and maintains an archive of some 500,000 stock photographs, supplied to publications worldwide. As both photographer and teacher, he works extensively with institutions such as Bennington and Hampshire colleges, Georgetown, and Harvard. Kalischer has recently been an active member of One by One, an international dialogue group for survivors and perpetrators of the Holocaust that seeks emotional healing.

Kalischer's work extends the tradition of photojournalism inspired by Henri Cartier-Bresson and André Kertész. His recent interest in agriculture, architecture, education, the environment, music, religion, and socioeconomic matters, however, adds a level of personal dedication to his images that pushes his body of work beyond its aesthetic precedents. —LH

Consuelo Kanaga

(American, 1894–1978)

Born in Astoria, Oregon, Consuelo Kanaga came from a family that valued ideals of social justice. After completing high school, she began writing for the *San Francisco Chronicle* in 1915. Within three years, she had learned darkroom technique from the paper's photographers and become a staff photographer. She met Imogen Cunningham, Edward Weston, and Dorothea Lange through the California Camera Club, and was interested in the fine-art photography in Alfred Stieglitz's *Camera Work*. A series of three marriages and one canceled engagement precipitated Kanaga's periodic relocations between New York and San Francisco, where she established a portrait studio in 1930. While not an official member of the f/64 group, her images were exhibited in its first exhibition, at San Francisco's M. H. de Young Memorial Museum in 1932. Kanaga was involved in West Coast liberal politics, and when she returned to New York in 1935, she was associated with the leftist Photo League; she lectured there in 1938 with Aaron Siskind, then occupied with his "Harlem Document." Her photography was championed by Edward Steichen, who included her in the "Family of Man" exhibition in 1955. Kanaga's work was featured in the 1979 ICP exhibition "Recollections: Ten Women of Photography," and she was the subject of a retrospective at the Brooklyn Museum of Art in 1992.

In terms of photographic technique and depiction of subjects, romantic instincts characterize Kanaga's work. An advocate for the rights of African-Americans and other people of color, Kanaga distinguished her portraits from the documentary images of the Farm Security Administration by conveying her subjects' physical comfort and personal pride. The tactile sense of volume in her work is reinforced by strong contrasts in printing light and dark forms.—MF

Gertrude Käsebier

(American, 1852–1934)

Born in Fort Des Moines, Iowa, Gertrude Käsebier married and brought up three children before she dedicated herself to art. She enrolled at Pratt Institute in Brooklyn in 1889 to study portrait painting, but by 1893 she was devoting herself to photography. After apprenticeships with a chemist and a portrait photographer, she opened her own studio in 1897 and published her work in journals such as *Camera Notes, The Craftsman,* and *The Photographic Times*. She showed her photographs in exhibitions, such as the Philadelphia Photographic Salons of 1898 and 1899, F. Holland Day's "The New School of American Photography" in 1900, and "American Pictorial Photography" at the National Arts Club in New York in 1900, the exhibition that led to Stieglitz's founding of the Photo-Secession. Käsebier was a highly visible member of that group, and her work appeared in most of its exhibitions between 1903 and 1909, and in the first two issues of Stieglitz's *Camera Work*. In 1912, by the time the Photo-Secession had moved away from Pictorialism, Käsebier resigned. Until her retirement in 1927, she continued actively supporting the Pictorialist movement, participating in exhibitions worldwide and cofounding the Pictorial Photographers of America with Clarence H. White and Alvin Langdon Coburn in 1916.

As one of the most prominent American photographers of her day, Käsebier played an important role in the acceptance of photography as a fine art. Her practice of painting on her negatives and her use of the gum bichromate, gum platinum, and bromoil printing techniques yielded photographs that revealed the hand of the artist and enforced the medium's expressive potential. Furthermore, Käsebier's portrayal of motherhood and related themes proved photography's capacity for allegory, which also supported its artistic ambition. Furthermore, her leadership in the Women's Federation of the Professional Photographers Association of America and other organizations allowed her to disseminate such ideas to a widespread audience.—LH

André Kertész

(American, born in Hungary, 1894–1985)

André Kertész was born in Budapest and studied at the Academy of Commerce. He bought his first camera in 1912. He served in the Austro-Hungarian army during World War I, and in 1925 had one of his photographs published on the cover of *Erdekes Ujsag*. That same year, he moved to Paris, where he did freelance work for many European publications, including *Vu, Le Matin, Frankfurter Illustrierte, Die Photographie, La Nazione Firenze,* and *The Times* of London. He bought his first 35-millimeter camera, a Leica, in 1928, and his innovative work with it on the streets of Paris was extremely influential. In 1936 he came to the United States and began freelancing for *Collier's, Harper's Bazaar,* and *House & Garden,* among other mass-circulation magazines. Eventually, and until 1962, he worked under contract to Condé Nast. Between 1963 and his death, his independently produced

photographs became more widely accessible, and Kertész became one of the most respected photographers in America. His work was the subject of many publications and exhibitions, including solo exhibitions at the Bibliothèque Nationale in Paris and at the Museum of Modern Art, and a major retrospective, "Of Paris and New York," at the Art Institute of Chicago and the Metropolitan Museum of Art. Among his many honors and awards were a Guggenheim Fellowship, admission to the French Legion of Honor, and ICP's Master of Photography Infinity Award.

Kertész's work had widespread and diverse effects on many photographers, including Henri Cartier-Bresson, Robert Capa, and Brassaï, who counted him as a mentor during the late 1920s and early 1930s. His personal work in the 1960s and 1970s inspired countless other contemporary photographers. Kertész combined a photojournalistic interest in movement and gesture with a formalist concern for abstract shapes; hence his work has historical significance in all areas of postwar photography.—LH

William Klein
(American, born in 1928)
New York native William Klein's innovative view of camera processes has challenged prevailing notions of "good photography." He graduated from high school at age fourteen and was enrolled at the City College of New York when he joined the Army in 1945. After his demobilization in Paris, he stayed to study art with Fernand Léger, and while there he met several other artists, including the American painters Ellsworth Kelly and Jack Youngerman. In the early 1950s, Klein began making experimental abstract photographs of his paintings while they were in motion. These pictures led to a job offer from Alexander Liberman at *Vogue*, and Klein returned to New York in 1954. While doing fashion photography for Liberman, Klein worked on what would become his classic photographic book, *Life Is Good and Good for You in New York: William Klein Trance Witness Revels* (1956), which he designed, wrote, and typeset. Klein received the Prix Nadar in 1957 for this book, and followed it with three other expressive portraits of cities: *Rome* (1958), *Moscow* (1962), and *Tokyo* (1964). Shortly after ending his contract with *Vogue* in 1965, he stopped making still photographs, returned to Paris, and devoted himself to filmmaking. Among his many films are *Cassius the Great*, *Muhammad Ali the Greatest*, and *The Little Richard Story*. Klein resumed still photography part-time in 1978.

Klein's photography of the 1950s was unusual for its time: grainy, blurry, high-contrast photographs—qualities generally considered defects in the popular photographic community. Klein not only accepted but cultivated these qualities by using a 35-millimeter camera, slow film, and a wide-angle lens, for both his fashion photography and his personal work. His approach set a precedent for many street photographers of the 1960s, whose work draws upon many of his innovations.—LH

Mark Klett
(American, born in 1952)
Mark Klett's landscape photography is informed equally by irony, criticism, conservationism, and residual pastoral romanticism. Like the New Topographics photographers, he considers history and human activity part of the natural landscape. He photographs evidence of human interaction with the land, using formal beauty to invite the critical reflection of the spectator.

Klett, born in Albany, New York, earned a B.S. in geology in 1974 from St. Lawrence University and an MFA in photography from the State University of New York, Buffalo, in conjunction with the Visual Studies Workshop in Rochester in 1977. From 1977 to 1979, he worked as a field assistant for the United States Geological Survey in Denver. In 1977, with Ellen Manchester and Jo Ann Verburg, Klett conceived and initiated the Rephotographic Survey Project, which was funded by Polaroid and the National Endowment for the Arts. The project, which retraced the work of nineteenth-century geological survey photographers, was published under the title *Second View* in 1984. More than 120 sites of initial documentary images—images made by William Henry Jackson, Timothy O'Sullivan, and Alexander Gardner, and others—were photographed, and the book pairs the images for comparison. Klett has received four National Endowment for the Arts Fellowships and was named photographer of the year by the Friends of Photography in 1993. Since 1982 he has been at the School of Art at Arizona State University. His work has been included in several group exhibitions of landscape photography, including "Perpetual Mirage: Photographic Narratives of the Desert West" at the Whitney Museum of American Art in 1996, and he has had solo exhibitions at the Los Angeles County Museum of Art, the Art Institute of Chicago, and the Amon Carter Museum. Klett's publications include *Traces of Eden: Travels in the Desert Southwest* (1986), *Revealing Territory: Photographs of the Southwest* (1992), and *Desert Legends: Re-Storying the Sonoran Borderlands* (1994).—LS

Dorothea Lange
(American, 1895–1965)
Born in Hoboken, New Jersey, Dorothea Lange was training as a teacher when she decided to become a professional photographer in 1913. She worked at the studio of the Pictorialist photographer Arnold Genthe in 1914 and studied at the Clarence H. White School in 1917. Upon completing the White course, she moved to San Francisco, where she opened a portrait studio, which she operated from 1919 to 1940. In 1929 she began to photograph people in the context of their daily lives, and thus made regular excursions into San Francisco's Depression-afflicted streets. Her photographs caught the attention of Paul Taylor, an economist at Berkeley; they married in 1935 and collaborated on the book *An American Exodus* in 1939. Between 1935 and 1939, Lange traveled extensively for the Farm Security Administration, for which she made many of her best-known photographs, including *Migrant Mother*. Lange received the first Guggenheim Fellowship awarded to a woman in 1941, and from 1942 to 1945 she worked for the government photographing such subjects as the Japanese-American internment camps and the founding of the United Nations in San Francisco. In 1954 she joined the staff of *LIFE* magazine, and from 1958 to 1965 traveled to Asia, South America, and the Middle East as a freelance photographer. Diagnosed with terminal cancer in 1965, she devoted herself to preparing for a retrospective exhibition at the Museum of Modern Art, held posthumously in 1966.

Dorothea Lange is one of the nation's greatest documentary photographers. Her respectful empathy for people and her keen ability to communicate the essential elements of the situations she photographed endow her work with unforgettable power. Although best known for her FSA photographs, she produced other work, including the images of home and family life published in *American Country Woman* (1964). —LH

Nathan Lerner
(American, 1913–1997)
Nathan Lerner was an influential graphic designer, photographer and educator who helped transmit Bauhaus ideas in the United States during the 1940s. A native of Chicago, he began making photographs while a teenager, documenting the effects of the Depression on his neighborhood. Initially his goal was to be a painter, but when he grew frustrated with a teacher's preference for Impressionism over the art of Picasso and Matisse, he sought out Alexander Archipenko at the New Bauhaus in Chicago. After interviewing with László Moholy-Nagy, the founder and director of the school, and being offered a scholarship, Lerner entered the New Bauhaus in 1937. He then began to make experimental photographs in addition to his documentary work. From 1941 to 1943, Lerner was head of the photography department at the Institute of Design (a later incarnation of the New Bauhaus), and from 1945 to 1949, the head of production design and dean of faculty and students. Lerner left the Institute of Design in 1949 in order to establish Lerner Design Associates, which produced many famous industrial designs, including those for the Honey Bear and Neutrogena soap; he remained there until his retirement in 1973.

Consistent with the teaching and philosophy of Moholy-Nagy, Lerner's mature photographs were experimental in nature and probed the structural characteristics of light and dark. In order to study these properties of the medium more thoroughly, Lerner developed new photographic instruments and techniques. He is credited with developing the light box, a tool for studying the tonal and directional behavior of light that is still in use in art schools today, and Moholy-Nagy considered him the inventor of "montage without scissors," a process of distorting images by combining dissimilar objects.—LH

Mikael Levin
(American, born in 1954)
Born in New York City, Mikael Levin grew up in Israel, the United States, and France. He attended Williams College and received a B.A. in film and photography from Hampshire College in 1976 before studying at the Academy of Fine Arts in Stockholm. Levin's first published project was *Silent Passage* (1985), a series of romantic, reflective landscape photographs inspired by a pond in Sweden. This was followed by several other series, including "Les Quatre Saisons du Territoire," a study of the changes in land use in western France; "Borders," which focused on the political, practical, and conceptual transformation of national borders in contemporary Europe; and "War Story," Levin's reconstruction of the journey his father, the war correspondent Meyer Levin, made while traveling with the photographer Eric Schwab during World War II. Meyer Levin wrote of these experiences in *In Search* (1950), which described his view of the final battles of World War II and the liberation of the Nazi concentration camps in 1944–1945. Levin photographed sites his father and Schwab had visited as they appear today. These photographs and passages from the elder Levin's writings formed an installation work at ICP in 1997, and were also published as a book. Levin's most recent project, "Common Places: Cultural Identity in the Urban Environment," considers the relationship between the past and present in the urban environments of four European cities: Katrineholm, Cambrai, Erfurt, and Thessaloniki.

Although inflected differently in each series, Mikael Levin's photographs have in common their interest in the emotional, intellectual, and historical significance of landscape. His work ignites landscape's capacity simultaneously to recall and to overwrite the events of the past, especially in works such as "War Story" and "Common Places." His photographs represent a new approach to landscape photography that reinvigorates this traditional genre.—LH

David Levinthal
(American, born in 1949)
David Levinthal was born in San Francisco and studied art at Stanford; he received an MFA from the Yale School of Art in 1973. After graduation, he worked with a classmate, cartoonist Garry Trudeau, on *Hitler Moves East*, a book of photographs published in 1977, in which models and toy figures are used to re-create scenes from World War II. Levinthal's first two solo exhibitions were held at the California Institute of the Arts and at Harvard, and were followed by an exhibition at the George Eastman House. After teaching photography for several years, Levinthal returned to school at the Massachusetts Institute of Technology, where he received a degree in management science in 1981. In 1982 he opened a successful public relations firm near San Francisco. His work has been exhibited frequently throughout the 1980s and 1990s in exhibitions such as "In Plato's Cave" at the Marlborough Gallery and "More Than One Photography" at the

Museum of Modern Art; ICP presented a retrospective exhibition of his work in 1997. Levinthal has won a National Endowment for the Arts grant and a Guggenheim Fellowship.

In their use of miniature figures and artificial settings to construct an elaborate, three-dimensional fiction for the camera, Levinthal's photographs for *Hitler Moves East* suggest a strong affinity with postmodern critical theory. His appropriation of a journalistic style to restage events that occurred before his birth have earned *Hitler Moves East* recognition as one of the earliest examples of postmodern photography. Many of Levinthal's more recent photographic series also employ constructed scenes and take a similar approach, but they address a wide range of themes, including the combination of anxiety and sentimentality induced by nostalgia ("The Wild West"), and the disturbing sensuality of horror ("Mein Kampf"). Levinthal's controversial "Blackface" series employs more subtly minimal means to depict articles of mass-produced kitsch representing African-Americans. —LH

Helen Levitt

(American, born in 1918)
Born and raised in New York, Helen Levitt has made most of her photographs in the city's streets. Her interest in photography began in 1931; she learned darkroom technique while working for a portrait photographer, and by age sixteen had decided to become a professional photographer. She was especially inspired by the photographs of Walker Evans and Henri Cartier-Bresson, both of whom became friends. Following Cartier-Bresson's lead, Levitt bought a 35-millimeter camera and settled on the subject matter she would pursue for the next forty years—community street life, especially the activities of women, children, and animals. In 1939 her images began appearing in magazines such as *Fortune*, *U.S. Camera*, *Minicam*, and *PM Weekly*. Levitt won a Museum of Modern Art photography fellowship in 1946, and that same year Beaumont and Nancy Newhall mounted her first solo exhibition. Her work found devoted advocates in Walker Evans and James Agee, the latter of whom wrote the text for *A Way of Seeing* (produced in the 1940s, but not published until 1965), a monograph containing many of her best-known images. In addition to the black-and-white images for which she is known, Levitt has been active in color photography since the 1950s, and her film projects include *The Quiet One* and *In the Street*, made with James Agee. Levitt won a Guggenheim Fellowship and was a National Endowment for the Arts Photography fellow; in 1997 she received ICP's Master of Photography Infinity Award.

Celebrated for their perceptive depiction of everyday life in New York City's close-knit neighborhoods of the 1940s and 1950s, Levitt's photographs create a palpable sense of place. Her familiarity with the subjects and scenes she photographed imparts a unique candor to her observations. Although her early works are particularly beloved, her more recent work, which represents a different kind of urban environment, is equally effective. —LH

Alfonse Liébert

(American, born in France, c. 1826/1827–1914)
Alfonse Liébert was an officer in the French navy in the 1840s when he resigned to pursue his interest in photography. In 1851, while commanding a ship off the California coast, he received papers incorrectly identifying him as an American. He settled in Nevada City, California, and opened a daguerreotype portrait studio in 1857. The studio proved successful, as did Liébert's submission of his pictures to local exhibitions and competitions beginning in 1860. They won prizes as well as critical praise, and he closed his studio in 1862 in order to fill a commission from a European periodical for a series of California views. The next year he returned to France and opened a studio in Paris specializing in tintypes. Between 1867 and 1876 he wrote about photography, produced a book on American photographic practices, and exhibited his work regularly at international expositions. In addition to his roles as practitioner of and authority on photography, Liébert was an innovator of photographic techniques. He invented an enlarging device that needed no reflector (1863), was the first to open a studio equipped with electric light in Paris (1879), and patented a technique for mechanically and uniformly applying an unlimited number of liquid dyes onto a print.

Liébert is best known for his photographs made during the time of the Paris Commune, which illustrated Alfred d'Aunay's 1872 work *Les Ruines de Paris et de Ses Environs*, published in two volumes and containing one hundred albumen silver prints. These pictures contain especially accomplished images of the felling of the Vendôme column. They are among the most thorough and impressive documents of Paris during the Third Republic. —LH

Danny Lyon

(American, born in 1942)
Brooklyn native Danny Lyon received a B.A. in history in 1963 from the University of Chicago, where he served as staff photographer for the Student Non-Violent Coordinating Committee. A self-taught photographer, he traveled with the Chicago Outlaws motorcycle club in 1965–1966 and published his pictures of the club members in *The Bikeriders* (1968). Since 1967 he has been an independent photographer and an associate at Magnum, the cooperative photo agency founded in 1947 by Henri Cartier-Bresson, Robert Capa, George Rodger, and Chim (David Seymour), and he has made films since 1969. Lyon has received Guggenheim Fellowships in photography and filmmaking, and his work has been included in many major exhibitions, including "Toward a Social Landscape" at the George Eastman House. His first solo exhibition was held at the Art Institute of Chicago. In addition to *The Bikeriders*, Lyon has published a number of photographic books based on his experiences with a group of people or in a particular place, among them *The Movement* (1964), about the civil rights movement, and *Conversations with the Dead* (1971), a study

of life in Texas prisons. Among the films he has produced are *Social Services 127*, *Los Ni Services 127 I*, and *Little Boy*.

Personal participation in the lives of his subjects is vital to Danny Lyon's photography. His subjects often deviate from societal norms, yet he is dedicated to communicating their character and sensibility honestly, sympathetically and nonjudgmentally; for him this requires firsthand knowledge of their experiences. Whereas in his earlier work he seemed to withhold his own personality from the images in order to emphasize that of his subjects, his recent work includes more of himself. Lyon has consistently produced effective, sincere documents of real people's lives that have inspired many photographers since the 1960s. —LH

Don McCullin (British, born in 1935)

Born in London, Don McCullin studied painting at the Hammersmith School of Arts and Crafts from 1948 to 1950, and worked for British Railways and as a color-mixer for Larkins Cartoon Studios before entering the military. There he was an assistant in aerial reconnaissance photography. Three years after returning to London, in 1956, he published his first photo essay, on his own youth gang, in *The Observer*; in 1961 he became a full-time photojournalist after his reportage on the construction of the Berlin Wall brought him widespread acclaim. By 1964 he had joined the staff of *The Sunday Times*, which sent him on assignment to Vietnam, Biafra, India, Northern Ireland, and other areas of political conflict. In 1967, McCullin became a member of Magnum, the cooperative photo agency founded in 1947 by Henri Cartier-Bresson, Robert Capa, George Rodger, and Chim (David Seymour); in 1984 he left *The Sunday Times* to return to freelance photojournalism. McCullin's work has appeared in *Time*, *LIFE*, *Der Spiegel*, and other periodicals, as well as the books *The Destruction Business* (1971), which was revised and expanded as *Is Anyone Taking Notice?* (1973), and *Sleeping with Ghosts: A Life's Work in Photography* (1994). His awards include the World Press Photographer Award in 1965 for his documentation of the 1964 war in Cyprus, and he has had exhibitions at such institutions as the Victoria & Albert Museum and ICP.

McCullin is best known for his horrifying, graphic photographs of the Vietnam War. The emotional intensity of those images, often of physically repulsive and psychologically disturbing subjects, resonates within our collective historical memory. Although his recent landscapes and still lifes portray less volatile situations, they are nonetheless pervaded by a sense of lost innocence that recalls McCullin's earlier photojournalism. —LH

Frances McLaughlin-Gill

(American, born in 1919)
Frances McLaughlin-Gill was born in New York City. She decided on a career in photography at the age of eighteen, but before pursuing it, she studied painting at the New School for Social Research and the Art Students League. She graduated with a BFA in art and design from Pratt Institute

in 1941. That same year, one of her photographs won *Vogue*'s Prix de Paris contest, and she went to work for the magazine in 1943. During her eleven years there, she photographed theater and film personalities, beauty still lifes, and fashion features; at the same time, she produced covers and editorial pages for *Glamour* and *House & Garden*. Alexander Liberman, *Vogue*'s art director, encouraged her toward photographic reportage, and she became particularly skilled at using the small-format camera and fast film. From 1964 to 1973, after the death of her husband and fellow photographer Leslie Gill, in 1958, she worked as an independent film producer and director, and made television commercials for major corporate clients. In 1959 she won a gold medal at the International Film and Television Festival for her film *Cover Girl: New Face in Focus*. Since the late 1970s, she has taught photography seminars at the School of Visual Arts.

Continuing the tradition of outdoor location shooting and action photography for fashion work pioneered by Martin Munkacsi and Toni Frissell in the late 1930s, McLaughlin-Gill was often considered the ideal interpreter of junior fashions. Her ability to communicate the appearance and sensibility of a passing moment or a glimpsed smile in her pictures led Liberman to liken her work to "improvisational theater." It was this quality, among others, that made her photographs subtle but provocative contributions to the development of realistic fashion photography. —LH

Ralph Eugene Meatyard

(American, 1925–1972)
Ralph Eugene Meatyard built both of his careers—photographer and optician—on vision. He was born in Normal, Illinois, and graduated from University High School at Illinois State University in 1943. He served in the military until 1946, became a licensed optician in 1949, and accepted a job in 1950 with an optical firm in Lexington, Kentucky, where he remained until he opened his own shop in 1967. His involvement with photography began in 1950, after the birth of his first son. By 1954 he was studying photography with Van Deren Coke and had joined the Lexington Camera Club and the Photographic Society of America. The blurred figure, a hallmark of his work, began to appear the following year. In 1956, Meatyard's images were presented along with those of Ansel Adams, Aaron Siskind, and Harry Callahan in "Creative Photography," an exhibition curated by Coke for the University of Kentucky. Although Beaumont Newhall considered him in a 1961 article for *Art in America* entitled "New Talent in Photography U.S.A.," Meatyard received scant recognition during his lifetime; he joked that he had the only copy of Newhall's *The History of Photography* with his work included, since he had glued one of his own images into the book. The posthumous release of a first monograph on Meatyard in 1974 coincided with the publication of his book *The Family Album of Lucybelle Crater*.

His work was the subject of a retrospective at the Akron Art Museum, accompanied by a companion monograph, *Ralph Eugene Meatyard*.

Meatyard was an experimental artist and is now considered a key figure in American "visionary" photography. With its recurrent masked figures and other ghostlike apparitions, all borne from his imagination, his work suggests a world that is not our own.—MF

Joel Meyerowitz
(American, born in 1938)
Joel Meyerowitz studied painting and medical drawing at Ohio State University, where he received a BFA in 1959, and initially worked as an advertising art director in his native New York City. He taught himself photography after collaborating on an advertising project with Robert Frank in 1962. Inspired by Frank, his early work consisted mainly of black-and-white street photographs made with a Leica; by 1976 he had turned primarily to color photographs of architectural light and space made with a large-format view camera. He began producing books in 1978 with *Cape Light*, and has continued with *St. Louis and the Arch* (1980), *Wild Flowers* (1983), *Redheads* (1990), *Bay/Sky* (1993), and most recently *At the Water's Edge* (1996). He coauthored *Bystander: A History of Street Photography* (1994) with Colin Westerbeck and has taught photography at Cooper Union and other institutions. Meyerowitz has been the subject of solo exhibitions at the Museum of Modern Art, the Museum of Fine Arts in Boston, the Art Institute of Chicago, and elsewhere, and he has participated in group exhibitions such as "Mirrors and Windows: American Photography Since 1960" at the Museum of Modern Art and "The Art of Fixing a Shadow: 150 Years of Photography" at the National Gallery in Washington, D.C. He has received many grants and awards, including two Guggenheim Fellowships and a National Endowment for the Arts grant.

Meyerowitz was one of the first photographers to make a successful transition from black-and-white to color in fine-art photography. He has been equally adept at changing subject matter. The evocation of mood in his recent color photographs, with their apparent lack of grain and their clarity of detail, matches the incisive perception of everyday irony for which his early street photographs were known and admired.—LH

Duane Michals
(American, born in 1932)
Duane Michals was born in McKeesport, Pennsylvania, and after taking art classes at the Carnegie Institute in Pittsburgh, he attended the University of Denver, where he received his undergraduate degree in 1953. After his military service ended in 1956, Michals moved to New York, where he studied at Parsons School of Design and worked as a graphic designer for *Dance* and *Time*. A three-week tour of Russia in 1958 with a camera borrowed from a friend marked the beginning of Michals's artistic career, although he still accepted commercial photography assignments. His Russian photographs are portraits, while his images

from the mid-1960s catalogue deserted sites in New York. In 1966, Michals started to structure his photographs as multiframe compositions, with subjects enacting set narratives. He began writing captions in the margins of his photographs in 1974, and incorporated painting into his treatment of the printed images in 1979. Recent books, such as *Salute, Walt Whitman* (1996), veer away from the artist's characteristic interest in questions of mortality and sexual identity, and instead address textual sources for subject matter. Michals received ICP's Infinity Award for Art in 1991.

Duane Michals's narrative pieces rely on the sequencing of multiple images to convey a sense of alienation and disequilibrium. In his world, the literal appearance of things is less important than the communication of a concept or story. In his portraiture, however, Michals relies wholly on his subjects' appearance and self-chosen poses to establish their identity; asserting that "we see what we want to see" and that photography is incapable of revealing a person's private nature, he eschews his usual interest in Surrealism, dreams, and nightmares in favor of a more direct approach.—MF

Hansel Mieth
(German, 1935–1998)
Hansel Mieth left her native Germany with her future husband, Otto Hagel, at the age of fifteen. She traveled through Eastern Europe, then arrived in the United States in 1930, in the midst of the Depression. She and Hagel found migrant agricultural work and photographed their experiences in a series eventually published as "The Great Hunger" in *LIFE* in 1934. In the mid-1930s, besides working as a seamstress for the Works Progress Administration in San Francisco, Mieth photographed several of the city's ethnic neighborhoods, as well as waterfront and freightyard workers, for the West Coast Youth project. The appearance of her photographs in *LIFE* and *Time* led to her employment in 1937 as a staff photographer for *LIFE*'s New York office. Although she produced many important photo essays, including those on single motherhood, yellow fever, and animal experimentation, among other topics, she disliked the harried pace of photojournalism in New York. She and Hagel moved to a sheep ranch in California in 1941, and Mieth continued to publish photographs in *LIFE*. After the war, the couple returned to Germany to document the psychological and physical devastation there; the essay "We Return to Fellbach," was published in *LIFE* in 1950. During the McCarthy era, Mieth and Hagel relied on raising livestock to survive. Toward the end of her life, Mieth's photographs were the subject of a solo exhibition at ICP in 1994 and were included in several traveling exhibitions.

Mieth's photographs are penetrating documents that evoke a striking range of emotional depth. The photographs she made on assignment for *LIFE* were often edited out of the magazine for being too graphic, or were published out of the context of their original intention. Despite such

misrepresentation, however, her images are among the strongest and most successful works of photojournalism produced in the United States during the years surrounding World War II.—LH

Gjon Mili
(American, born in Albania, 1904–1984)
Gjon Mili immigrated to the United States in 1923, and studied electrical engineering at the Massachusetts Institute of Technology. Upon graduation in 1927, he worked for Westinghouse as a lighting research engineer until 1938. Through experiments with Harold Edgerton at MIT, he developed tungsten filament lights for color photography; further innovations in stroboscopic and stop-action images brought his work to the attention of *LIFE*. Mili worked freelance for the magazine from 1939 until his death, producing thousands of photographs—action shots of dance, sports, and theater events; portraits of artists, musicians, athletes, dancers, and actors. He made films about artists, among them *Jamming the Blues*, *Eisenstaedt Photographs "The Tall Man,"* and *Homage to Picasso*. Mili taught at Yale, Sarah Lawrence, and Hunter College. Among his many exhibitions were "Dancers in Movement" and "On Picasso" with Robert Capa, both at the Museum of Modern Art. A retrospective of his work was held at ICP in 1980, the same year that the book *Gjon Mili: Photographs and Recollections*, which spanned fifty years of his photographs, was published.

Mili was a pioneer in the portrayal of movement in photography. Not only did his engineering of photographic lighting tools and techniques in the 1930s change the possibilities for depicting movement, but his photographs themselves altered the public's general understanding of motion in general. Through the sheer number of his motion photographs and their frequent publication in *LIFE* magazine, Mili revealed the mechanics of human kinetics to postwar society. His dynamic fashion and advertising images demonstrate his ability to adapt his discoveries creatively without overwhelming the image in photographic pyrotechnics.—LH

Benn Mitchell
(American, born in 1926)
Benn Mitchell was born in New York City, and he received his first camera at age thirteen. Shortly afterward he decided to become a photographer, and by age sixteen had sold his first photograph to *LIFE*. In 1943 he went to Hollywood, where he made portraits of celebrities, including Marilyn Monroe, Benny Goodman, Humphrey Bogart, and Lauren Bacall. While he was in the Navy during World War II, he continued to photograph for his own interest; upon his discharge, he worked at a photography studio in New York and took classes in film studies at Columbia. He opened his own commercial studio in 1951, and his pictures have since appeared in such major publications as *LIFE*, *Newsweek*, *Travel & Leisure*, *The New York Times Magazine*, and *Reader's Digest*. In addition to ongoing commercial work, Mitchell has always made photographs for

his own creative satisfaction. These have been included in a number of recent exhibitions at the Museum of the City of New York, the Fondation Cartier pour l'Art Contemporain in Paris, and elsewhere. Mitchell continues to make photographs today, both for himself and for several Fortune 500 companies.

Although his personal work is not the best-known of its type, Benn Mitchell's photographs of New York street life are among the most effective images produced at mid-century. A good portion of them depict the nightlife of New York City, particularly in Times Square, and include spectacular images of the grand movie-palace marquees of the 1940s and 1950s. Mitchell's work, which is just now being reappraised by scholars, critics, and collectors, adds subtlety to our perception of the extent and variety of postwar life in New York and enhances our understanding of the city's street photography during its most active phase.—LH

Lisette Model
(American, born in Austria, 1901–1983)
Lisette Model was born in Vienna, where she studied piano and compositional theory with Arnold Schönberg before moving to Paris. She discontinued her musical career in 1933, and discovered photography through her sister Olga and her friend Rogi André, André Kertész's wife. Model decided to become a full-time photographer soon after, and in 1937 served a short apprenticeship with Florence Henri. The next year, she and her husband, the painter Evsa Model, immigrated to New York City, where she came into contact with important figures in the photographic community, such as Alexey Brodovitch and Beaumont Newhall. Her photographs were very successful and appeared regularly in *Harper's Bazaar*, *Cue*, and *PM Weekly*. Model was among the group of photographers included in "Sixty Photographs: A Survey of Camera Aesthetics," the 1940 inaugural exhibition of the Museum of Modern Art's Department of Photography. Her work has been the subject of many major exhibitions, at the Photo League, the New Orleans Museum of Art, and the National Gallery of Canada. Model also taught photography, her most famous student being Diane Arbus.

Model's best-known work consists of series of photographs she made with a 35-millimeter camera of people on the Promenade des Anglais in Nice and on the streets of New York's Lower East Side. Her work is notable for its emphasis on the peculiarities of average people in everyday situations, and for its direct, honest portrayal of modern life and its effect on human character. As one of the most influential street photographers of the 1940s, Model redefined the concept of documentary photography in America, and through her roles as teacher and lecturer she shaped the direction of postwar photography. —LH

Inge Morath
(American, born in Austria, 1923)
Inge Morath was born in Graz, and educated in France and Germany. She studied languages at the universities of Berlin and

Bucharest, and worked as an editorial translator and interpreter for U.S. Information Service Publications in Salzburg, and then as a radio writer and as literary editor for Vienna's *Der Optimist* magazine. In 1952 she apprenticed in London to Simon Guttmann, a major figure in photojournalism and one of the founders of *Berliner Illustrierte Zeitung*; in 1954 Morath joined Magnum, the cooperative photo agency founded in 1947 by Henri Cartier-Bresson, Robert Capa, George Rodger, and Chim (David Seymour). She was assistant to Cartier-Bresson in 1953–1954. More than a dozen books resulted from her travels in the following thirty years, including *Fiesta in Pamplona* (1954), *Tunisia* (1961), *In Russia* (1969), and *Chinese Encounters* (1979), and her warm and intimate portraits were reproduced in such magazines as *LIFE*, *Paris-Match*, *The Saturday Evening Post*, and *Holiday*. She moved to the United States in 1962 and married the playwright Arthur Miller. Two monographs on her work, *Inge Morath* (1975) and *Portraits by Inge Morath* (1986), have been published, and a retrospective of her work traveled in Europe in 1993–1994.

Something conversational emanates from Morath's black-and-white portraits of artists, writers and other members of the cultural elite who reveal themselves before her camera. She researches her subjects and cultivates their trust and openness before asking to photograph them in their homes, among their personal possessions. She first saw Saul Steinberg's drawings published in *The New Yorker* in the late 1940s, and a decade later became fascinated by the paper masks of faces he drew. She made numerous photographs of friends wearing Steinberg's masks.—MF

Barbara Morgan

(American, 1900–1992)
Born in Buffalo, Kansas, Barbara Morgan moved with her family to California shortly after her birth. She studied at the University of California at Los Angeles, then taught high school and college art courses after her graduation in 1923. In 1925 she helped Edward Weston install an exhibition of his work at the UCLA Gallery. With her husband, the photographer Willard Morgan, she moved to New York City in 1930, and concentrated on painting until 1935, when the birth of a child brought her to photography, a medium that could be practiced quickly and efficiently. Through it, Morgan was able to combine a number of her interests: dance, the iconographic power of gesture, and the simultaneity of visual stimuli. Her first book was *Martha Graham: Sixteen Dances in Photographs*; a decade later came *Summer's Children: A Photographic Cycle of Life at Camp* (1951). The dynamic human figure disappears from works done after her husband's death in 1967, replaced by abstract photograms, photomontages, and landscape images that echo her earliest experiments with Russian Constructivist-inspired photographs in the 1930s.

While Morgan is best known for the vibrancy of her dance photographs, equally characteristic of her diverse work is her ability to capture ephemeral gesture. In the mid-1930s, her choice of abstract photographic styles set her apart from the preponderance of American documentary photographers. Along with Ansel Adams, Beaumont Newhall, Dorothea Lange, and five others, Morgan will be remembered as a cofounder of *Aperture* magazine in 1951, one of the few publications at the time to nurture a dialogue among photographers and treat photography as a fine art.—MF

Nickolas Muray

(American, born in Hungary, 1892–1965)
Nickolas Muray was born in the town of Szeged, and began his study of photography, photoengraving, and lithography at the age of twelve at the Graphic Arts School in Budapest. He continued his training at the National Technical School in Berlin, where he learned color photogravure and worked as a photoengraver at the Ullstein publishing house. After immigrating to the United States in 1913, he found work at Condé Nast in New York and Chicago, making color separations and halftone negatives. In 1918, Muray began a forty-year career in freelance advertising, fashion, commercial, and magazine photography; around 1925 he opened what would be a highly successful portrait studio in New York's Greenwich Village. His portraits of the cultural elite of his day were published in *Harper's Bazaar* and *Vanity Fair*, and they made a celebrity of Muray himself. After the 1920s, he concentrated more on magazine work. Muray was a man of many accomplishments: an Olympic champion in fencing, an aviator, and a dance critic. He later made photographs to illustrate a book on Pre-Columban art. *The Revealing Eye*, a collection of his portraits of 1920s personalities, was issued in 1967. In 1974 the George Eastman House presented the first retrospective exhibition of Muray's photography.

While Muray is best known for his work as a celebrity portraitist, his magazine and fashion pictures from the 1930s and 1940s are superb examples of both color photography and the postwar American advertising aesthetic of excess. A master of the difficult carbro printing process, Muray combined technical expertise with sparkling wit to create elegant yet telling portraits and exuberantly commercial images.—CF

Yasushi Nagao

(Japanese, active 1960s)
The Japanese photographer Yasushi Nagao was a correspondent for the Tokyo newspaper *Mainichi Shimbun* in 1960 when he captured a single dramatic image that was circulated worldwide by United Press International. Nagao recorded a remarkably graphic picture of the assassination of Socialist Party chairman Inejiro Asanuma, or what was the last exposure of the roll of film Nagao was using to cover an otherwise unremarkable event. The picture captures the exact moment when the assassin, a right-wing student named Yamaguchi Otoya, removed his sword from Asanuma's body before thrusting it into him again. The astonishing timing and close perspective of Nagao's photograph reveal both Asanuma's expression at this mortal moment and Otoya's murderous determination—sights rarely seen together in a still photograph. Nagao won a Pulitzer Prize for this photograph in 1961.—LH

Hans Namuth

(American, born in Germany, 1915–1990)
Born in Essen, Hans Namuth produced his first major body of photographic work in Madrid during the Spanish Civil War, while he was working on assignment for *Vu* and *LIFE*. He studied photography later with Joseph Breitenbach in Paris, and with Alexey Brodovitch at the New School for Social Research after immigrating to New York in 1941. During World War II, Namuth worked for the French Foreign Legion and the U.S. Army Intelligence Service; afterward he returned to freelance photography, publishing in *LIFE*, *Look*, *Time*, *Newsweek*, *Harper's Bazaar*, and *Vogue*. At the same time, he produced portraits of artists working in informal settings. His most famous of these is his series of Jackson Pollock; among the more than two hundred other artists are Willem de Kooning, Ad Reinhardt, Joseph Cornell, and Mark Rothko. Namuth's other major photographic series are "Early American Tools," made in the 1970s and based on tools from the eighteenth century, and "Guatemala: The Land, the People," a project begun in 1949 in which he periodically returned to a Guatemalan town to document its development.

In addition to his photography, Namuth made a number of films, on such artists and architects as Pollock, Josef Albers, Constantin Brancusi, Louis Kahn, and Alexander Calder. Viewed in combination with his still photographs, these attest to Namuth's deep involvement with portraiture. Among the honors he received for his film and photography are the Merit Award from the Film Council of Greater Boston and a U.S. Department of State Public Service Award.—LH

Nicholas Nixon

(American, born in 1947)
A native of Detroit, Nicholas Nixon chose to become a photographer while a student of American literature at the University of Michigan. He served as a VISTA volunteer in St. Louis in 1969–1970, and received an MFA in photography from the University of New Mexico in 1974. Nixon moved to Boston, where he began using a black-and-white 8x10 view camera to photograph his adopted city. His work was included in the 1975 exhibition "New Topographics: Photographs of a Man-Altered Landscape" at the George Eastman House, and his Boston images appeared in his first solo exhibition at the Museum of Modern Art the next year. His work was also presented in "Mirrors and Windows: American Photography Since 1960" at the Museum of Modern Art in 1978. Since 1975, Nixon has taught at the Massachusetts College of Art. The first monograph on his work, *Nicholas Nixon: Photographs from One Year*, was released in 1983, and five years later *Nicholas Nixon: Pictures of People* was published to accompany a mid-career retrospective at the Museum of Modern Art.

Nixon has used his bulky 8x10 view camera since the 1970s to capture spontaneous gestures and emotions more typically associated with photographs taken with a hand-held 35-millimeter camera. His preference for the large-format camera is due in part to the exquisite detail it imparts to resulting prints, and its ability to sharpen the foreground and background of an image simultaneously. Nixon began his career with urban and landscape photography, but has become increasingly associated with portraiture, in which he often tries to communicate the difference between public behavior and private moments. He is perhaps best known for the ongoing series of portraits of his wife, Bebe, and her three sisters ("The Brown Sisters," begun in 1975), yet he has documented also the residents of old age homes, people terminally ill from AIDS-related complications, and people interacting with their neighbors from the simultaneously public and private spaces of their front porches.—MF

Dorothy Norman

(American, 1905–1997)
Dorothy Norman was born in Philadelphia and educated briefly at Smith College and then at the University of Pennsylvania. She moved with her husband to New York, where during the 1920s and 1930s she dedicated herself to working with organizations such as Planned Parenthood and the New York League of Women Voters. She first met Alfred Stieglitz at his Intimate Gallery in 1927, and the pair became close friends and were lovers until the elder photographer's death in 1946. Norman had developed a strong affection for Stieglitz even before meeting him, on the basis of his photography. By 1928 she had completed a series of articles that formed the basis of her memorial book *Alfred Stieglitz: An American Seer* (1973). With the loan of a Graflex camera from Stieglitz in 1931, she began taking her own photographs, which Stieglitz often inscribed with comments. Norman edited and published *Twice a Year: A Semi-Annual Journal of Literature, the Arts and Civil Liberties* between 1938 and 1948, and wrote a column "A World to Live In" three times a week for the *New York Post* from 1942 to 1949. After Stieglitz's death, she became involved with the Indian independence movement, and in the early 1950s she founded and chaired two committees to aid India. By the mid-1950s, Norman ceased taking photographs.

Norman was better known for her writing, humanitarianism, and work done on behalf of Alfred Stieglitz and his legacy than for her own photography. She worked as a photographer primarily between 1931 and the mid-1950s, and her efforts received little attention. Although she was working at the same time as Margaret Bourke-White and other prominent women photographers in New York, she never identified herself as a photographer, and never took professional assignments. Her work is appreciated best for its personal, intimate qualities, which are richly apparent in her still lifes and portraits.—MF

Lorie Novak
(American, born in 1954)
Lorie Novak was born in Los Angeles and received a B.A. in art and psychology from Stanford University in 1975. After completing an MFA at the School of the Art Institute of Chicago in 1979, she began exhibiting photographs that depicted rooms filled with colored light and slide-projected images of shadows, light patterns, and landscapes. The character of the installations she photographed changed over time as she projected slides of family photographs onto empty white studio spaces and, in 1987, onto landscapes at night. Other works of the 1980s and 1990s included *Critical Distance, Traces, Playback,* and *Collected Visions,* in which the slide-projected installations she had previously used as raw material for her photographs became the final works. In 1996, Novak launched *Collected Visions* on the Internet (http://cvisions.cat.nyu.edu). Visitors can donate family snapshots to the site's archive of more than 1,200 images or create sequenced "exhibitions" of pictures from that resource. Her work has been exhibited at institutions such as the Museum of Contemporary Art in Chicago, the Museum of Modern Art, and ICP, and she has received a number of grants and awards, including a National Endowment for the Arts Fellowship. She teaches photography at Tisch School of the Arts, New York University.

Although the source material and method of presentation have changed, Lorie Novak's work has continually explored personal and cultural memory. Her installations and photographs encourage viewers to investigate their own history and family relationships by transforming rooms, landscapes, and cyberspace into spaces of the mind. By acknowledging memory's foundation in imagery and casting its presence onto areas in the contemporary world, Novak's art demonstrates the importance of recognizing our own individual and cultural history.—LH

Ruth Orkin
(American, 1921–1985)
Boston-born Ruth Orkin grew up in Los Angeles, and the movie industry and music were both formative influences. She attended Los Angeles City College briefly in 1940 before becoming the first female studio messenger hired at Metro-Goldwyn-Mayer in the early 1940s; but with no hope for promotion, she joined the Women's Auxiliary Army Corps, tempted by the promise (empty, as it turned out) that she would be taught cinematography. After completing her service in 1943, she moved to New York and worked as a nightclub photographer. Orkin honed her skills in portraiture by spending the summer of 1946 documenting the Tanglewood Music Festival; later that year, *LOOK* published her first major photo essay, "Jimmy, the Storyteller." She sent the series to Edward Steichen at the Museum of Modern Art in 1947, and he subsequently included her in every group photography show at the museum until his retirement, including the great 1955 exhibition "The Family of Man." Orkin married photographer Morris Engel in 1952, and the couple collaborated on a prize-winning film, *Little*

Fugitive. Their filmmaking endeavors continued through the mid-1950s, and while Orkin continued to photograph, she admitted that still photography "held little interest" after her experience of making a film. Her views of Central Park taken from her apartment were published in the 1978 book *A World Outside My Window.*

Orkin's photography is a celebration of fearlessness and vitality. While she accepted specific assignments from *The New York Times* and various magazines, she also had the freedom to work independently, creating photo essays and photographing famous people with the knowledge that she would be able to sell the resulting work. Like a film director, Orkin created images that appear to be private moments, and lent a Hollywood-style personality to her subjects and landscapes.—MF

Timothy H. O'Sullivan
(American, born in Ireland[?], 1840–1882)
Little is known about the early years of Timothy O'Sullivan's life, except that he was probably born in Ireland and grew up on Staten Island. By 1860 he was working as an "operator" in Mathew Brady's photographic studio in New York, and later he was employed by Alexander Gardner in Washington, D.C. Both employers engaged him to document the battlefields of the Civil War, and he produced many moving depictions of the aftermath of Bull Run, Gettysburg, and Appomattox. His keen observation of the American scene continued after the war, when he joined Clarence King's U.S. Government Fortieth Parallel Survey documenting the areas west of the Mississippi River. Despite the difficulties of the wet-plate collodion process, which required him to carry large-format camera, glass plates, and darkroom equipment and chemicals through harsh terrain, O'Sullivan produced astounding photographs of the western landscape. In addition to these images, he made some of the first photographs of mine interiors, using a magnesium flash. His work on the expedition recommended him for several future trips, including the 1869 Darien Survey, of the area that was to become the Panama Canal, and George M. Wheeler's Geological Surveys West of the One Hundredth Meridian, in California, Nevada, and Arizona in 1871–1875; he led his own expeditions to the Southwest in 1873 and 1875 to document Native Americans. O'Sullivan returned east in 1875, and served as the chief photographer for the Department of the Treasury from 1880 until his death.

Timothy O'Sullivan's photographs are distinctive among similar work by other nineteenth-century landscape photographers. Not only do they document the features and terrain of previously uncharted areas of the West, but also they leave the viewer with a strong impression of the vastness, intimidating scale, and overwhelming force of such landscape. O'Sullivan revealed the West as a beautiful, breathtaking environment and unforgiving, difficult adventure.
—LH

Mickey Pallas
(American, 1916–1997)
Born in Belvidere, Illinois, Pallas was placed in an orphans' home in Chicago at age thirteen after his parents were unable to care for him adequately with the onset of the Depression. When he was older, he found employment as a musician, truck driver, insurance salesman, dry cleaner, and auto worker, and in the mid-1940s began to photograph weddings and labor union activities. Not only did he sympathetically photograph the latter, he was an organizer for the Congress of Industrial Organizations and chair of the Anti-Discrimination Committee of the local United Automobile, Aerospace, and Agricultural Implement Workers of America. By the 1950s, Pallas's clientele expanded to include Standard Oil of Indiana, ABC-TV, *Ebony* magazine, the Harlem Globetrotters, and several black churches on the South Side of Chicago. He documented subjects as diverse as a sugar workers' strike in Louisiana, the 1960 Democratic National Convention in Los Angeles, an annual Halloween transvestite ball in Chicago, and burlesque performers across the country. Pallas applied his straightforward style to making portraits of common people—fathers and brides, children and dogs, meatpackers and refinery workers and welders—and less common ones—beauty pageant contestants, circus performers, and celebrities. His work is perhaps most noteworthy for the usual comfort with which he crossed social, racial, and class boundaries.

Pallas joined the American Society of Magazine Photographers in 1953, and was a founding member of the Chicago chapter. He opened Gamma photo lab in Chicago in 1959; the business grew until it was sold in 1973, when Pallas opened the Center for Photographic Arts as a forum for making accessible his substantial collection of vintage photographs, photography books, and equipment. His work was recognized in a one-man show in 1986 at the Chicago Public Library Cultural Center and has been shown at ICP.—LS

Gordon Parks
(American, born in 1912)
Gordon Parks moved from his native Fort Scott, Kansas, to Minneapolis in 1928 and became a photographer in 1937 after seeing examples of Farm Security Administration photographs reproduced in a magazine. He was a fashion photographer in Minneapolis and Chicago, before going to Washington, D.C., and finding work with Roy Stryker at the FSA; he subsequently photographed for the Office of War Information and Standard Oil Company of New Jersey. Parks worked as a fashion photographer at *Vogue* beginning in 1944, and when *LIFE* hired him as a staff photographer in 1948, he accepted assignments in both fashion and photojournalism. He remained at *LIFE* until 1970, producing many of his most important photo essays, such as those on Harlem gangs, segregation in the South, and his own experiences with racism; on Flavio da Silva, a poor child living in Brazil; and on Malcolm X, Martin Luther King, Jr., and the Black Panthers. Parks's many books include *Camera*

Portraits (1943), *A Choice of Weapons* (1966), *Born Black* (1971), *Moments Without Proper Names* (1975), and *Half Past Autumn: A Retrospective* (1997). Solo exhibitions of his work have been held at the Art Institute of Chicago, ICP, and the Corcoran Gallery of Art. ICP presented Parks with an Infinity Award for Lifetime Achievement in 1990.

Parks's photographs are among the most effective documents of their era. In several cases, as in that of the Flavio da Silva series, they moved people to action and changed lives. Parks's photography is only one among many talents; he is also an accomplished musician, composer, poet, novelist, and filmmaker, whose films include *Shaft* and *Leadbelly.* Parks has recently been experimenting with digital imagery and creating subjective, abstract color landscape and still life photographs. —LH

Jack Partington
(American, 1914–1987)
Jack Partington was born in San Francisco and attended Princeton University from 1933 to 1935, before working as an assistant to Louise Dahl-Wolfe, who encouraged him to enroll at the Clarence H. White School. Upon his graduation in 1936, he was hired by New York's Roxy Theater to photograph its performances, which included dance, music, vaudeville, and other forms of popular entertainment. Drafted into the U.S. Army Signal Corps during World War II, he brought his camera with him and documented basic training as well as the devastation of Germany in 1945. After the war, he opened a studio in New York, where he specialized in theatrical photography and celebrity portraiture; he also worked for CBS as a television cameraman. In 1953 he turned to advertising, and produced television commercials for various agencies. His photographic work was published in many periodicals during the course of his career, including *Popular Photography, The Camera,* and *Dance,* and exhibited at Lincoln Center and ICP, among other venues.

Although he is remembered best for his charming performance images from the Roxy, one of Partington's major achievements as a photographer was his facility with carbro color printing. This process, which he learned from its inventor while at the Roxy in the late 1930s, was complicated and labor-intensive, involving specially sensitized carbon tissue and wet bromide prints. Unlike other color printing processes at time, it allowed the photographer to make a color print larger than the original negative. A pioneer of this technique, Partington employed it almost exclusively for his personal work long before color photography was accepted among fine-art photographers.—LH

Irving Penn
(American, born in 1917)
Irving Penn, born in Plainfield, New Jersey, studied with Alexey Brodovitch at the Philadelphia Museum School of Industrial Art. Upon graduation in 1938, he moved to New York and worked as a freelance graphic artist. *Vogue* hired him to design the magazine's covers in 1943, but his work

was interrupted by his wartime service as an ambulance driver. He resumed his job after the war, and contributed his own photographs for some covers. By the 1950s, Penn had become one of the magazine's prominent editorial, fashion, and portrait photographers. His collaborations with Lisa Fonssagrives, the celebrated fashion model whom he married in 1947, were especially successful. In 1952, he also began making advertising photographs in his New York studio. His work has been shown widely, in exhibitions at the National Portrait Gallery in Washington, D.C., the Museum of Modern Art, the Metropolitan Museum of Art, and elsewhere. Penn has produced a number of books of photographs, including *Worlds in a Small Room* (1974), *Flowers* (1980), and *Passage: A Work Record* (1991), which won ICP's Infinity Award for Publications in 1992.

As one of the most influential fashion and portrait photographers of the postwar era, Irving Penn has come to epitomize fashion photography of the 1950s and 1960s. During his early years at *Vogue*, along with Alexander Liberman, the magazine's art director, Penn developed a bold graphic sensibility that complemented his own chic images and embodied modern taste. His use of monochromatic backdrops of black, white, or gray, as well as his construction of the light tent—a configuration of painted white boards that allowed him complete control of natural lighting conditions— enhanced the visual simplicity of his photographs. In an era when elaborate artificial lighting was the norm, his work stood out from the rest and influenced subsequent fashion photography.—LH

Gilles Peress
(French, born in 1946)
Born in Neuilly-sur-Seine, Gilles Peress made his first photographic series in 1970 after attending the Institut d'Études Politiques (1966–1968) and the Université de Vincennes (1968–1971). By 1971 he had established himself as a freelance photographer, publishing work in *Du*, the London *Sunday Times*, *The New York Times Magazine*, *Photo*, and other periodicals. In 1972 he joined Magnum, the international cooperative photography agency founded in 1947 by Henri Cartier-Bresson, Robert Capa, George Rodger, and Chim (David Seymour); he has served twice as the organization's president. A National Endowment for the Arts grant in 1979 allowed him to travel to Iran, where he made the photographs published as *Telex: Iran—In the Name of Revolution* (1984), his first book. Other major projects include his documentation of the Irish civil war from 1971 to 1979, published as *An Eye for an Eye: Northern Ireland* (1986), and "Hate Thy Brother," an ongoing cycle of photographs documenting the resurgence of extreme nationalism around the world. Peress's work has been included in group exhibitions at the Musée d'Art Moderne in Paris, the Corcoran Gallery of Art, ICP, and elsewhere. He has received, among other honors, a W. Eugene

Smith Award, the Ernst Haas Award, a Guggenheim Fellowship, and ICP's Infinity Awards for Journalism in 1995 and for Publications, for *The Silence*, in 1996.

Gilles Peress's photography demonstrates his uncommon ability to navigate and communicate the atmosphere and urgency of volatile political environments. While his early work identified him as a "concerned photographer," his more recent efforts suggest an increasing concern with form and a more obvious sense of subjectivity. In this respect, Peress's photographs echo the photojournalism of Henri Cartier-Bresson, whose conflation of aesthetics and reportage set the precedent for artistic photojournalism earlier in the century.—LH

Julia Pirotte
(Polish, born in 1911)
Julia Pirotte pursued a variety of occupations in Poland before moving to Brussels in 1934 to study photography. In May 1940, she escaped Nazi-threatened Belgium and settled in Marseilles for the duration of World War II. There, she worked in an aircraft factory and as a beach photographer until she was hired by *Dimanche Illustré* in 1942. She was assigned to cover entertainers (Edith Piaf among others), but she used her press pass also to work against the Nazis. As a reporter, she documented the disastrous state of Marseilles after the 1942 German occupation without raising the suspicions of authorities. She photographed the activities of the French Resistance, including the August 1944 national insurrection, and managed to pass a group of her photographs, entitled "France Under Occupation," to a Czechoslovakian refugee, who had them published in magazines in the United States. At the war's end, Pirotte discovered that her entire family had been killed in the ghettos of Poland or in Nazi concentration camps, except for her sister, who was guillotined in 1944 for working with the French Resistance. Pirotte returned to Poland in 1946 and worked as a journalist until her retirement in 1968. Her work has been exhibited at the Rencontres Internationales de la Photographies in Arles, and at the International Center of Photography.

Although not as well known as the World War II photographers who recorded battles and military campaigns, Julia Pirotte made equally valuable documents of the war. Her bravery in the face of danger provides us with images of important aspects of the war that would otherwise be largely forgotten. In poignantly describing the misery, hunger, and fear that characterized life in Marseilles during the Nazi occupation, her work reminds us that the horrors of war include the day-to-day struggle for survival of civilians, in addition to that of soldiers and prisoners.—LH

Eliot Porter
(American, 1901–1990)
Porter began to photograph birds and landscapes with a Kodak box camera as a child at his family's summer home in Maine. He earned a B.S. in chemical engineering from Harvard in 1924 and an M.D. from Harvard Medical School in 1929, then taught and researched there until 1938. Porter acquired

a Leica in 1930 and in 1933 was powerfully moved by the photographs of Ansel Adams, who encouraged him to work with a large-format camera. Porter did so upon meeting Alfred Stieglitz, who exhibited his work at An American Place in 1939, after which Porter devoted himself to a photographic career. In 1940 he began to specialize in color, and learned to make his own separation negatives and dye transfer prints. Porter was awarded a Guggenheim Fellowship in 1941 to photograph birds; the Museum of Modern Art exhibited his "Birds of Color" in 1943. He settled in Santa Fe in 1946, and his Guggenheim grant was renewed three years later. In the early and middle 1950s, Porter traveled to Mexico to photograph church architecture, and thereafter continued traveling and documenting his travels. Glen Canyon, Adirondack Park, Baja California, the Galapágos, Greece, Turkey, the Grand Canyon, Appalachia, Africa, Iceland, Antarctica, and China were the subject of books and portfolios. Porter had numerous individual exhibitions at major institutions, and his extensive awards included the Conservation Award from the U.S. Department of the Interior, the Gold Medal of the Academy of Natural Sciences in Philadelphia, and honorary doctorates from Colby College, the University of Albuquerque, and Dickinson College.

Ansel Adams described Porter as "master of nature's co or," and Porter's contemplative intimate landscapes bear witness to his enduring affection and respect for the wilderness and its animal inhabitants. Influenced by Henry David Thoreau, Porter sought to create visual equivalents of passages from Thoreau that inspired him. Indeed, he included selections from Thoreau in his first monograph, *In Wildness Is the Preservation of the World* (1962), published by the Sierra Club, on whose board of directors Porter served from 1962 to 1968. —LS

Marc Riboud
(French, born in 1923)
Marc Riboud became interested in photography in 1937, when he took his first photographs with his father's Vest Pocket Kodak camera. It was not until 1953, however, that he became a full-time photographer. During the intervening years, Riboud studied engineering and fought for the French Resistance in World War II, earning the Croix de Guerre in 1945. After meeting Henri Cartier-Bresson, Robert Capa, and Chim (David Seymour) in Paris in 1951, he left his job as a research engineer to make a living through photography. He worked freelance until 1953, when he was invited to join Magnum, the cooperative photographic agency founded by Cartier-Bresson, Capa, Chim, and George Rodger. Through Magnum, he traveled to Asia and Eastern Europe several times and gained recognition as a specialist in documenting Asian cultures. Riboud was a very active member of Magnum, in terms of his photographic production and his official capacity, serving as vice-president, president, and chairman of the board. Riboud retired in 1979, but the

agency maintains his archives. He continues to photograph, most recently devoting his energy to personal projects.

Riboud is known particularly for his photographs of the Cultural Revolution in China and the Vietnam War. His ability to communicate with sensitivity the experience of daily life under extreme political circumstances has been widely celebrated, and his images have served as touchstones for those times. Riboud's pictures from China and Vietnam have been published in *Three Banners of China* (1966), *The Face of North Vietnam* (1972), *Visions of China* (1980), and *Marc Riboud in China: Forty Years of Photography* (1996). His work has been the subject of exhibitions at ICP in 1975, 1988, and 1996.—LH

Eugene Richards
(American, born in 1944)
Born in Boston, Eugene Richards received a B.A. in English from Northeastern University in 1967, and began studying photography with Minor White at the Massachusetts Institute of Technology the following year. The two years (1968–1970) he spent working as a health advocate in eastern Arkansas through VISTA served as source material for his first book, *Few Comforts or Surprises: The Arkansas Delta* (1973). Since 1974 he has worked as a freelance photojournalist for such publications as *LIFE*, the London *Sunday Times*, and *The New York Times*, and since 1979 he has been a member of Magnum, the cooperative photo agency founded in 1947 by Henri Cartier-Bresson, Robert Capa, George Rodger, and Chim (David Seymour). Richards was an artist-in-residence at ICP in 1978; he founded the Many Voices Press to publish two of his books, *Dorchester Days* (1978) and *50 Hours* (1983). Among his honors are the 1986 Nikon Book Award for *Exploding into Life* (1986), in which he combined his photographs and his wife's journal entries in a chronicle of her battle against malignant breast cancer; the 1987 ICP Infinity Award for Journalism, for his documentation of American poverty in *Below the Line: Living Poor in America* (1987); and the 1995 Infinity Award for Publications in 1995 for *American We* (1994). ICP exhibited his series "Cocaine True, Cocaine Blue," also published in book form in 1995.

Richards, one of the best-known photojournalists in this country, for more than twenty-five years has been recording aspects of urban lives and painful human experiences that many people never witness. Emergency room panic, the desperation of junkies shooting heroin, housing project squalor: through Richards's compassionate photography we are faced with moments so brutal, personal, and painful that they can only be real. As Cornell Capa has said, Richards "is a concerned photographer, and his concern is honest without a doubt."—MF

Henry Ries
(American, born in Germany in 1917)
A native of Berlin, Henry Ries began studying photography in 1937, a year before his immigration to the United States. He served in the U.S. Army Air Corps as an aerial

photographer in World War II, and was a photo-correspondent for *The New York Times Magazine* from 1947 to 1952. During those years he produced many features on the postwar situation in Western Europe, including stories on the Italian elections of 1947, the Berlin blockade of 1948–1949, and the 1948 Winter Olympics. Upon his return to New York in 1952, Reis produced food and fashion features for the *New York Times* studio, and in 1955 he opened his own studio, through which he photographed for major advertising agencies and magazines until 1991. In the 1970s, before the age of computer-enhanced imagery, Ries created abstract color images with various camera lenses and other optical devices, images that he termed "Helioptix;" these were used for advertisements, logos, and book jacket designs and were exhibited at photography shows and fairs such as Photokina in Cologne. Ries has published several books, including *German Faces* (1949), *Berlin Portraits* (1980), and most recently *The Berlin Blockade* (1998). His personal work and photojournalism have been exhibited at ICP and the Gropius Museum, among many other institutions.

Henry Ries's best-known work involves his ongoing observation of postwar Berlin. By juxtaposing symbols of its history, such as the Reichstag and the Berlin Wall, with scenes of contemporary life and interviews with residents, visitors, and survivors of the Holocaust, his work makes visible the city's difficult and complex past. His photographs remind us that while history is both constantly present and often forgotten in the modern world, it leaves traces in our collective memory that cannot and should not be suppressed as we go on with our lives.—LH

Jacob Riis
(American, born in Denmark, 1849–1914)
A pioneer in the use of photography as an agent of social reform, Jacob Riis immigrated to the United States in 1870. While working as a police reporter for the New York *Tribune*, he did a series of exposés on slum conditions on the Lower East Side of Manhattan, which led him to view photography as a way of communicating the need for slum reform to the public. He made photographs of these areas, and published articles and gave lectures that had significant results, including the establishment of the Tenement House Commission in 1884. In 1888, Riis left the *Tribune* to work for the *Evening Sun*, where he began making the photographs that would be reproduced as engravings and halftones in *How the Other Half Lives*; this celebrated work documenting the living conditions of the poor was published to widespread acclaim in 1890. During the last twenty-five years of his life, Riis produced other books on similar topics, along with many writings and lantern slide lectures on themes relating to the improvement of social conditions for the lower classes. Despite their success during his lifetime, however, his photographs were largely forgotten after his death; ultimately his negatives were found and brought to the attention of the Museum of the City of New York, where a retrospective exhibition of his work was held in 1947.

Riis was among the first in the United States to conceive of photographic images as instruments for social change; he was also among the first to use flash powder to photograph interior views, and his book *How the Other Half Lives* was one of the earliest to employ halftone reproduction successfully. At a time when the poor were usually portrayed in sentimental genre scenes, Riis often shocked his audience by revealing the horrifying details of real life in poverty-stricken environments. His sympathetic portrayal of his subjects emphasized their humanity and bravery amid deplorable conditions, and encouraged a more sensitive attitude toward the poor in this country.—LH

George Rodger
(British, 1908–1995)
George Rodger began photographing while in the British merchant marine, under whose auspices he traveled around the world twice between 1927 and 1929. Subsequently he worked in America as a machinist, wool buyer and steelrigger and in other occupations before returning to England in 1936. There he worked for the BBC and freelanced for the Black Star agency, before joining the staff of *LIFE* in 1939. As a war correspondent for the magazine during World War II, he traveled some 75,000 miles throughout Europe, North Africa, the Middle East, and India, and covered the Japanese invasion of Burma, the North African and Italian campaigns, the D-Day assault, and the liberation of the Belsen concentration camp, and other events. Much of his epic journey was published as an eight-page story in the August 1942 issue of *LIFE*. After the war, Rodger wished to reject the intense destruction and violence he had witnessed, and stopped working for *LIFE*. In 1947 he joined Henri Cartier-Bresson, Robert Capa, and Chim (David Seymour) |in founding the international cooperative photography agency Magnum, and established himself as the group's correspondent for Africa. He participated in many exhibitions during his career, including "Masai Moran" in 1979, which presented photographs that he made during his return to Africa at the age of seventy.

Although Rodger originally viewed photography as a supplement to his documentary writing, he came to accept the descriptive value and emotional force of the medium as vital to his stories. In order to represent his experiences accurately, he committed himself to producing straight, unmanipulated photographs that he described as "honest and true." As one of the first European photographers to produce extensive reportage in Africa during the immediate postwar years, Rodger made photographs that provided Westerners access to an unfamiliar but increasingly important area of the world.—LH

Thomas Ruff
(German, born in 1958)
Thomas Ruff has investigated a wide range of subject matter in his photographs, while maintaining a minimal authorial presence alongside the production of work in groups

or series. Born in Zell-am-Harmersbach, he studied photography under Bernd Becher from 1977 to 1985. His early work consisted of color views of German apartments. These compact, minimalist interiors depicting the conventional details of everyday life reflect the influence of Bernd and Hilla Becher, and of such American photographers as Walker Evans and Stephen Shore, in their respect for the objects that constitute their subject matter.

Around 1981, Ruff began a series of formulaic portraits of fellow art students that consistently frame the sitter within an institutionalized format appropriated from passport, police, and commercial studio photographs. In the earlier, smaller portraits, the sitter could choose from among several plain colored backdrops, and was positioned frontally, in profile, or in a three-quarters view. The equivalence of these portraits is underscored by their even lighting, and by their uniform title, *Portrait*, signaling a typology recalling the work of August Sander. Ruff's portraits, however, do not attempt to document social classification, since they draw on a relatively homogeneous population. They emphasize sameness rather than individual distinction and, in their impassivity, tend toward abstraction as they resist interpretation or identification. In 1986, Ruff shifted the scale of the portraits, making dramatic, larger-than-life prints. Their almost cinematic presence is nevertheless confounded by the persistently ordinary people depicted. Concurrent with the portraits, Ruff has rephotographed ten years' worth of clipped newspaper reproductions, printing them at twice their original scale. The emotional and pictorial flatness characteristic of Ruff's work is otherwise deployed in his "Stars" series, begun around 1990. These photographs, enlarged from negatives found in an observatory, reach a physically overwhelming verticality up to seven feet high, and their inestimable depth flattens out to pure photographic surface. —LS

Sebastião Salgado
(Brazilian, born in 1944)
Born in Aimorés, Sebastião Salgado trained as an economist before becoming a photographer in the early 1970s. He earned an M.A. in economics from São Paulo University in 1968 and a Ph.D. in the subject from the University of Paris in 1971. His work at the International Coffee Organization in London required him to make frequent trips to Africa, and his desire to document these experiences sparked his interest in photography; by 1974 he was freelancing as a photojournalist for the Sygma agency in Paris. He then worked for Gamma from 1975 until 1979, when he joined Magnum, the international photography cooperative founded in 1947 by Henri Cartier-Bresson, Robert Capa, George Rodger, and Chim (David Seymour). Salgado has produced a number of extended documentary series throughout his career, several of which have been published. These include *Sahel: L'Homme en Détresse* (1986), *Other Americas* (1986), *An Uncertain Grace* (1990), and *Workers* (1993), a worldwide investigation of the increasing obsolescence of manual labor. Salgado has won many honors for his work, among

them the W. Eugene Smith Award for Humanitarian Photography, two ICP Infinity Awards, the Erna and Victor Hasselblad Award, and the Arles International Festival prize for best photography book of the year for *Workers*.

Sebastião Salgado's straightforward photographs portray individuals living in desperate economic circumstances. Because he insists on presenting his pictures in series, rather than individually, and because each work's point of view refuses to separate subject from context, Salgado achieves a difficult task. His photographs impart the dignity and integrity of his subjects without forcing their heroism or implicitly soliciting pity, as many other photographs of the Third World do. Salgado's photography communicates a subtle understanding of social and economic situations that is seldom available in other photographers' representations of similar themes.—LH

Erich Salomon
(German, 1886–1944)
Born in Berlin, Erich Salomon studied zoology, mechanical engineering, and law at Rostock University, where he received a law degree in 1913. He was drafted into the German army that year, and spent the war years in a prisoner-of-war camp in France after the Battle of the Marne. After the war he worked at the Berlin stock exchange, then in a piano factory, and later in his own car and motorcycle rental agency, until he found a position in the advertising department of the Ullstein publishing house in 1925. While working on a campaign for billboard advertising in rural areas in 1927, he discovered photography. Soon after, he purchased his first camera, an Ermanox, whose small size allowed him to take pictures indoors and remain relatively inconspicuous. Salomon used this camera to make photographs of a famous murder trial in 1928; although photography was not permitted in the courtroom, his camera was small enough to conceal in a bowler hat, and he was able to obtain the only pictures of the trial. Their publication in *Berliner Illustrierte Zeitung* launched his career, and he went on to cover many international diplomatic conferences. He spent much of 1930 in the United States, where he photographed Marlene Dietrich and William Randolph Hearst's San Simeon estate; in 1931 he published *Berühmte Zeitgenossen in Unbewachten Augenblicken* (Famous Contemporaries in Unguarded Moments). Salomon, who was Jewish, fled Germany for the Netherlands in 1932 and continued to work as a freelance photojournalist, traveling in England, France, and Switzerland until the Nazis occupied Holland in 1940. In 1943 he was imprisoned and deported. He died at Auschwitz in 1944.

Erich Salomon was the original "candid camera" photographer. He was famous for his ability to gain entrance to events involving dignitaries and members of high society and for making memorable photographs of them while they were not conscious of having their picture made. This gave his work its characteristic intimate, privileged sensibility, which has been especially influential during the second half of the century.—LH

August Sander
(German, 1876–1964)
Born in Herdorf-an-der-Sieg, August Sander received his first camera from an uncle in 1892 and promptly set up a darkroom and taught himself photography. After serving in the German military, he took up photography full-time. He established studios, first in Austria, then in Cologne, where he settled in 1910 and made photographs of local peasants. This activity inspired his life's work—a comprehensive document of the German people entitled "Menschen des 20. Jahrhunderts" (Citizens of the Twentieth Century). He worked on the project throughout the next two decades, while also producing photographs of architectural and industrial subjects. By the early 1930s, Sander was recognized as an authority on photography in Germany and delivered a series of popular radio lectures, "The Nature and Development of Photography." As Hitler rose to power in the early 1930s, Sander was forced to discontinue "Citizens of the Twentieth Century": his son (who died in prison in 1944) was a member of the Communist Party, and this made Nazi officials suspicious of Sander's work. When five books of Sander's "Deutsche Lande, Deutsche Menschen" (German Land, German People) appeared in 1933–1934, they were readily confiscated by the Nazis, who destroyed the plates and confiscated his negatives. Fortunately, Sander salvaged a number of his negatives after the war and reprinted some; the images are now in collections worldwide. Sander's archive, including his negatives, is now held by SK Stiftung Kultur in Cologne. He received many honors and awards in his lifetime, and his work has been included in a number of important international exhibitions.

The photographs from August Sander's "Citizens of the Twentieth Century" are matter-of-fact portraits of people from all social classes and all walks of life. His interest in his subjects' roles in society makes his photographs an indispensable record of life in Germany between 1911 and 1933. His style, the conceptual basis of his project, and its sweeping scope have influenced postwar photographers around the world. —LH

Naomi Seigler Savage
(American, born in 1927)
Born in New Jersey, where she now resides, Savage studied photography with Berenice Abbott at the New School for Social Research in 1943, and studied art at Bennington College from 1944 to 1947. Her trademark exploration of innovative techniques was influenced by an apprenticeship with Man Ray, her uncle, and further evolved amid increasing experimentation with alternative photographic, mechanical, and electronic processes throughout the 1960s and 1970s. Her approach represents an involvement with "process as medium," and an interest in art as image manipulation, a pursuit shared by such contemporaries as Robert Heinecken, Betty Hahn, and Bea Nettles. Savage says that she has explored various techniques "in an attempt to stretch photography with a personal interpretation." She has experimented extensively with photogravure and photoengraving, employing these mechanical printing techniques for aesthetic effects rather than duplication.

Savage uses inked and intaglio relief prints to explore variations in color and texture, and considers the metal plate on which the photograph has been etched a work of art in its own right. She has also combined media—collage, negative images, texture screening, multiple exposure, photograms, solarization, toning, printing on metallic foils—and made laser color prints. Her eclecticism has accompanied a variety of subject matter and imagery, which has included portraits, landscapes, human figures, mannequins, masks, toys, kitchen utensils, dental and opthalmological equipment. In 1971 she installed a large mural of etched magnesium panels commemorating Lyndon Baines Johnson's life for the Presidential Library in Austin, Texas. Savage has received numerous awards and prizes, including a National Endowment for the Arts grant. —LS

Andrew Savulich
(American, born in 1949)
Self-taught photographer Andrew Savulich was born in Wilkes Barre, Pennsylvania, and has lived in New York City since 1975. Currently a staff photographer for the New York *Daily News*, Savulich was a freelance newspaper photographer from 1977 to 1993, having previously worked as a landscape architect, construction worker, and cabdriver. He has spent the last two decades covering the news in New York City, from tree-lighting ceremonies and races to the top of the Empire State Building, to suicide attempts and tragic car accidents. Savulich's work has been published in *Spy*, *The Independent* (UK), *Tempo Photonews*, and *Artforum*, and in 1986 he was awarded a National Endowment of Arts Fellowship. In 1994, Savulich's photographs were included in ICP's "New Documentarians" series of exhibitions. His work has also been exhibited at the Photographer's Gallery in London and the Photographic Resource Center in Boston, and is included in the collections of the Metropolitan Museum of Art and other institutions.

Savulich's pictures present New York City—its violence, its extremes, its disasters, its curiosities—with a dry irony and a visual punch that distinguish them from ordinary news photographs. Like his predecessor Weegee, Savulich listens to police communications channels to find out where news is happening and arrives on the scene to photograph his subjects quickly. His use of pithy handwritten captions and pairings of seemingly unrelated images add a personal touch of absurdist humor to his work. —CF

Victor Schrager
(American, born in 1950)
Born in Maryland, Victor Schrager grew up in New York City and earned a B.A. at Harvard in 1972 and an MFA at Florida State University in 1975. Schrager took his first job at the Light Gallery in New York, where his interest in photography deepened as he grew familiar with the many leading photographers on the gallery's roster, including Emmet Gowin, Harry Callahan, and Aaron Siskind. Since the late 1970s, Schrager has been photographing still lifes and collages, as well as other forms of combined imagery and text. He received a National Endowment for the Arts Award in 1980, and in 1993 a Guggenheim Fellowship. His work has been shown in numerous important group exhibitions, including the 1981 Whitney Biennial and "The Photography of Invention: American Pictures of the 1980s," organized by the National Museum of American Art in 1989. He has been given one-person exhibitions in New York City at commercial galleries and at P.S. 1, and his work is held by many major museum collections.

Victor Schrager's photographs explore how different modes of information, especially visual, literary, historical, and scientific, function to produce and communicate knowledge. In the works for which he is best known, he photographs still lifes composed of layered images and texts—among them reproductions of paintings, maps, magazine pictures, pages from books, and photographic prints—in an investigation of how context structures the meaning of all representations. Schrager is one of several artists of the 1980s who made use of strategies such as appropriation and montage in works that examine the proliferation of information in contemporary culture. —CF

Sarah Sears
(American, 1858–1935)
Sarah Sears was born in Cambridge, Massachusetts, into a prominent Boston family. Trained as a painter, she received prizes for her watercolors at the World's Columbian Exposition in Chicago in 1893, the 1900 Exposition Universelle in Paris, the 1901 Pan-American Exposition in Buffalo, and the 1904 Louisiana Purchase Exposition in St. Louis. She began taking photographs in the 1890s, and pursued a photographic career between 1900 and 1909. Her work was first included in "The New American Photography," an exhibition curated by Boston photographer F. Holland Day, which traveled to London in 1900 and Paris in 1901. Beyond her talent for portraiture and flower studies, Sears was valued by Day and Alfred Stieglitz for her potential as a benefactor. When Day was courting Stieglitz's support for the creation of the American Association of Artistic Photography, a never-established counterpart to London's Linked Ring Brotherhood of fine-art photographers, Sears was considered a possible financial resource who could use her power to arrange for the Boston Museum of Fine Arts to host the Association's first exhibition. She was elected to the Linked Ring in 1904, and promoted from associate to elected fellow of Stieglitz's Photo-Secession that same year. Her work was reproduced in 1907 in Stieglitz's journal *Camera Work*; the last exhibition of her photography was at a 1909 group show at the National Arts Club in New York.

Sears was one of the few women photographers to gain entry into Alfred Stieglitz's Photo-Secession and have her work reproduced in *Camera Work*. Her images are distinguished by their lush tonality and the fullness of their forms. Following the standard set by such contemporaries as Edward Steichen and others in Stieglitz's circle, Sears declined to identify her sitters in publication captions. —MF

Andres Serrano
(American, born in 1950)
Born in New York City, Andres Serrano attended the Brooklyn Museum of Art School from 1967 to 1969, and is self-taught in photography. He gained widespread notoriety in the late 1980s, when his work was deemed obscene by conservatives and thus sparked a controversy about federal funding of the arts. In 1988, Serrano's photograph *Piss Christ*, which depicts a plastic crucifix submerged in the artist's urine, was included in a group exhibit at the Southeastern Center for Contemporary Art in Winston-Salem, North Carolina, an institution partially funded by the National Endowment for the Arts. The subsequent crusade against the NEA was led by Senator Jesse Helms, who called Serrano's work "immoral trash."

Piss Christ typifies much of Serrano's work in its use of shocking and confrontational subject matter, and in its literal corporeal material. Serrano has used his own body fluids in many of his photographs, submerging Christian and other symbols, and at times variously combining blood, urine, sperm, and milk, all evocative and symbolic essential fluids. Serrano was raised Catholic, and this formative experience seems to drive his explorations of the intimate relationship between the sacred and the profane. He has executed series of images of homeless people (or nomads, as he titles their portraits), members of the Klu Klux Klan, members of the Catholic clergy, and guns, and an extended series on dead bodies in a city morgue. Serrano seeks to portray the most compelling subject matter in a technically polished manner that eliminates extraneous elements. He frames central objects and scenarios, and renders them in lush color.

Serrano has had numerous individual exhibitions internationally, and has received grants from the National Endowment for the Arts and the New York State Council on the Arts. He has been the subject of several monographs, including one accompanying a retrospective exhibition at the Institute of Contemporary Art in Philadelphia—the other institution targeted by the Senate in 1989—and most recently *A History of Andres Serrano: A History of Sex* (1997). —LS

Fazal Sheikh
(American, born in 1965)
Fazal Sheikh was born and grew up in New York City, and graduated from Princeton University in 1987. In 1992 he traveled to Africa on a Fulbright scholarship in order to document Sudanese refugee camps in northern Kenya. The son of a Kenyan father and an American mother, Sheikh had spent many summers in Nairobi with his father's

extended family and became interested in the experiences of refugees in that area. Once he began photographing in the Kenyan camps, he decided to study camps in the surrounding countries of Ethiopia, Somalia, Mozambique, and Rwanda. When his photographs from this project were first exhibited in 1994, they attracted immediate attention and launched his career. Over the next few years, he received many honors for his photography, including the 1994 ICP Infinity Award for Young Photographer, the 1995 Leica Medal of Excellence, and a National Endowment for the Arts Fellowship in 1994. ICP produced an exhibition of his work in 1994 entitled "A Sense of Common Ground," which was accompanied by a book of the same title. Sheikh's most recent work, a series of photographs depicting Afghan refugees in Pakistan, was published as *The Victor Weeps: Afghanistan* (1999).

Fazal Sheikh treats his portraits as collaborative efforts with his subjects, and thus his work emphasizes each subject's individual character. He titles photographs with the names of the subjects, thus resisting the conflation of their identities through generic references such as "Refugees from X," as appear in many journalistic studies of African people. His inclusion of the edges of the negative in his sepia-toned finished prints imparts warmth and intimacy to his work.—LH

Cindy Sherman (American, born in 1954)
Cindy Sherman's work is probably the most broadly successful of any of the artists who emerged in the late 1970s and were described by critics as "postmodern." She has consistently and prolifically produced photographs that incorporate theoretical concerns with subtlety and sophistication into visually compelling and psychologically powerful images. Unlike many of her fellow contemporary artists, she has avoided the use of text, and has resisted making theoretical pronouncements about her work.

Sherman's first one-person exhibit was held in 1979 at Hallwalls in Buffalo, New York, where she had attended college, receiving a B.A. in 1976. From 1975 to 1980, Sherman produced a large body of "Untitled Film Stills": small black-and-white prints depicting herself in costume in simulated scenarios evocative of film noir, B movies, and French New Wave films. She continued to explore feminine stereotypes through a characteristic directorial approach in which she employs herself as model. From 1982 to 1984 her treatment of conventional gender roles and commercial images began to include exaggerated and unsettling makeup, costumes, and garish lighting. By 1985, her prints grew in scale, and her imagery became unambiguously repulsive, depicting warped fairy-tale scenarios, surreal scenes of disaster and dismemberment, and grotesque mixtures of bodily waste and putrefaction. Her own physical presence in these images was largely fragmented or withdrawn. Sherman intermittently pulls back from her descent into total abjection; from 1988 to 1990 she produced a series of ironic art-historical portraits parodying Old Master paintings. Her use of physical imperfections and distortions

evolved into a series of prosthetic-sex pictures begun in 1992. With this period, Sherman almost entirely eliminated her own body from her photographs. Sherman has exhibited extensively, having had numerous individual shows internationally and a major retrospective at MOCA. She has also been the subject of several monographs, including a substantial critical interpretation of her work from 1975 to 1993 by Rosalind Krauss.—LS

Aaron Siskind
(American, 1903–1991)
Born in New York City, Aaron Siskind graduated from the City College of New York in 1926 and taught high school English until he became interested in photography in 1930. In 1933 he joined the Film and Photo League in New York, a group of documentary photographers devoted to improving social conditions in contemporary society through their pictures. While involved with the League, Siskind made some of his most successful and well-known documentary photographs, including those for "The Harlem Document" (1937 to 1940), but he had a falling-out with the organization in 1941. At the time, his work was assuming a new, more abstract focus, as evident in "Tabernacle City," a series of photographs depicting the vernacular architecture of Bucks County, Pennsylvania. When his exhibition of this series at the Photo League caused many members to protest his photography outright, he left the organization and found support among Mark Rothko, Franz Kline, and other painters, who recognized his elimination of pictorial space and his concentration on the arrangement of objects within the picture plane as qualities aligning his work with their own. Siskind's photographs have been widely exhibited, and he won many awards for his photography, including a Guggenheim Fellowship and the Distinguished Photography Award from the Friends of Photography. Siskind was a photography instructor at Chicago's Institute of Design and served as head of the department there from 1961 to 1971.

Siskind's abstract photographs from the late 1940s and early 1950s were a major force in the development of avant-garde art in America. In rejecting the third dimension, this work belied the notion that photography was tied exclusively to representation. As such, Siskind's work served as an invaluable link between the American documentary movement of the 1930s and the more introspective photography that emerged in the 1950s and 1960s.—LH

W. Eugene Smith
(American, 1918–1978)
Born and reared in Wichita, Kansas, W. Eugene Smith became interested in photography at the age of fourteen, and three years later had begun to photograph for local newspapers. He received a photography scholarship to the University of Notre Dame, but he left after a year for New York, where he joined the staff of *Newsweek* and freelanced for *LIFE*, *Collier's*, *Harper's Bazaar*, *The New York Times*, and other

publications. In 1939, Smith began working sporadically as a staff photographer for *LIFE*, with which he had a tempestuous relationship throughout the rest of his career. During World War II he was a war correspondent in the Pacific theater for the Ziff-Davis publishing company and *LIFE*, for whom he was working when he was severely wounded in Okinawa in 1945. After a two-year recuperation, he returned to the magazine and produced many of his best photo essays, including "Country Doctor," "Spanish Village," and "A Man of Mercy." In 1955, he joined Magnum, the international cooperative photography agency founded by Henri Cartier-Bresson, Robert Capa, George Rodger, and Chim (David Seymour), and worked on a large photographic study of Pittsburgh, for which he received Guggenheim Fellowships in 1956 and 1957. Smith continued to freelance for *LIFE*, *Pageant*, and *Sports Illustrated*, among other periodicals, for the rest of his career. From 1959 to 1977, he worked for Hitachi in Japan and taught at the New School for Social Research and the School of Visual Arts in New York and the University of Arizona in Tucson. His last photo essay, "Mimimata," completed in the 1970s, depicted victims of mercury poisoning in a Japanese fishing village.

Smith is credited with the developing the photo essay to its ultimate form. He was an exacting printer, and the combination of innovation, integrity, and technical mastery in his photography made his work the standard by which photojournalism was measured for many years. In recognition of his outstanding contribution to the development of photojournalism, the W. Eugene Smith Memorial Fund was established after his death to support the projects of photographers working in the tradition he established.—LH

Edward Steichen
(American, born in Luxemburg, 1879–1973)
Edward Steichen was a key figure of twentieth-century photography, directing its development as a prominent photographer and influential curator. Steichen came to the United States in 1881. He painted and worked in lithography before undertaking photography in 1896, and first exhibited his photographs at the Philadelphia Salon in 1899. Steichen became a naturalized citizen in 1900, and after exhibiting in the Chicago Salon, he received encouragement from Clarence White, who brought him to Alfred Stieglitz's attention. Steichen practiced painting in Paris intermittently between 1900 and 1922; there he met Rodin and was exposed to modern art movements, and thus was able to advise Stieglitz on exhibition selections. He was elected a member of London's Linked Ring Brotherhood in 1901, and in 1902 cofounded the Photo-Secession and designed the first cover of *Camera Work*, in which his work was often published. In New York, Steichen helped Stieglitz establish The Little Galleries of the Photo-Secession, which became known as "291," and in 1910 he participated in the International Exhibition of Pictorial Photography in Buffalo. During World War I he directed

aerial photography for the Army Expeditionary Forces. He renounced painting shortly thereafter, along with the vestiges of Pictorialism, and adopted a modernist style. He served as chief photographer for Condé Nast from 1923 to 1938, while also doing freelance advertising work. Commissioned a lieutenant commander in 1942, Steichen became director of the U.S. Naval Photographic Institute in 1945; he oversaw combat photography and organized the exhibitions "Road to Victory" and "Power in the Pacific." He was director of photography at the Museum of Modern Art from 1947 to 1962, and was responsible for more than fifty shows, including "The Family of Man" in 1955, the most popular exhibition in the history of photography.

Steichen received innumerable awards and honors, including Knighthood in the French Legion of Honor, an Honorary Fellowship in the Royal Photographic Society, the Distinguished Service Medal, the Art Directors Club of New York Award, the *U.S. Camera* Achievement Award for "Most Outstanding Contribution to Photography by an Individual," and the Presidential Medal of Freedom. Major shows of his work have been held at the Baltimore Museum of Art, the Museum of Modern Art, the Bibliothèque Nationale in Paris, ICP, and the George Eastman House.—LS

Alfred Stieglitz
(American, 1864–1946)
Alfred Stieglitz played a seminal role in the development of art photography and the dissemination of modern art in the United States. Not only did his photography revolutionize the medium, but his intellectual and cultural leadership was largely responsible for the success of important American artists such as Georgia O'Keeffe, Marsden Hartley, and Paul Strand. Stieglitz's promotion of fine-art photography was vital to the international acceptance of the medium's aesthetic value.

Stieglitz was born in Hoboken, New Jersey, in 1864 and moved with his family to Germany in 1881, where he studied engineering at the Berlin Polytechnikum from 1882 to 1885. By 1883 he had developed a profound interest in photochemistry, which led him to purchase his first camera. From 1886 to 1890, Stieglitz traveled throughout Europe making photographs, organizing exhibitions, and winning photographic competitions. He returned to the United States in 1890 and became involved in the New York amateur photographic community. He pioneered techniques for making photographs during a snowfall, in the rain, and at night. Dissatisfied with the lack of serious artistry in most of the photography he saw, Stieglitz organized an exhibition, "Photo-Secession," at the National Arts Club. That same year he began publishing *Camera Work*, which became a forum for presenting the images and ideas of the Photo-Secessionists. In 1905 he opened The Little Galleries of the Photo-Secession, the first in a series of four galleries he would direct in New York—"291," The Intimate Gallery, and An American Place. The opening of "291" signaled a new phase of Modernism in Stieglitz's photography. Inspired in part by

the contemporary European art he showed there, including works by Picasso and other members of the avant-garde in prewar Paris, his own photography passed from Pictorialism through formalism to his symbolic "Equivalents," and finally to a series of late city pictures. —LH

Paul Strand
(American, 1890–1976)
Paul Strand sought to express the feeling of the land and its inhabitants directly, honestly, and with respect. His prints are masterly in detail and tonality, and his approach has greatly influenced American photography. Strand advocated "straight photography," and photographed street portraits, city scenes, machine forms, and plants with a distinctive clarity, precision, and geometric form. From 1904 to 1909, he studied photography under Lewis Hine at the Ethical Culture School in New York, where he was born. Hine introduced Strand to Alfred Stieglitz, who encouraged him and gave him an exhibition in 1915, and published his work in the two final issues of *Camera Work*. Active as both a still photographer and a filmmaker, Strand has been extremely influential.

After completing military service as an X-ray technician in the Army Medical Corps, Strand collaborated with Charles Sheeler in 1921 on the short film *Mannahatta*, and from 1923 to 1929 he worked as a freelance cinematographer. For the next several years he photographed in Maine, Colorado, New Mexico, and Canada. He served as chief of photography and cinematography for the Mexican government's Department of Fine Arts from 1932 until 1934, and supervised production of the government-sponsored documentary *The Wave*. In 1935 he traveled with directors of the Group Theatre to Moscow, where he met film director Sergei Eisenstein. Upon his return, he worked on Pare Lorentz's film *The Plough That Broke the Plains* for the Resettlement Administration. Strand settled in Orgeval, France, in 1951; there his attention to "the world at his doorstep" shifted to the simple beauty of his garden. He published a series of books on his travels around the world. Strand's work from this later period is less abstract than that from the 1910s and 1920s.—LS

Thomas Struth
(German, born in 1954)
Born in Geldern, Germany, Thomas Struth graduated in 1980 from the Academy of Fine Arts in Düsseldorf, where he had studied with Gerhard Richter and Bernd Becher. He dedicated himself to photography full-time in 1983 and exhibited urban landscapes of Rome, Tokyo, and other cities that he had been producing since 1980. In 1983–1984, he worked with the psychologist Ingo Hartmann on an anthology of photographs entitled *Familienleben* (Family Life), which presented families through groups of individual portraits. In the late 1980s he began a series of large color photographs of people looking at paintings in major museums

around the world—an observation of observation that has attracted a great deal of critical attention. Struth's photographs have been shown at P.S. 1 in New York City, Documenta IX in Kassel, the Venice Biennale, the Hirshhorn Museum in Washington, D.C., and Boston's Institute of Contemporary Art. Struth has also done architectural studies of districts and towns in Europe and made black-and-white enlargements of hitherto unpublished negatives by the turn-of-the-century German photographer Heinrich Zille.

Building on the foundation of first- and second-generation Neue Sachlichkeit (New Objectivity) photography in Germany, Struth makes photographs that cohere in their suggestion of individual interiority despite a range of subject matter. His seemingly objective observations of twentieth-century subjects, ranging from urban topography to family resemblance to cultural consumption, successfully identify a sense of place and character behind generic public façades. His work demonstrates our visual complacency by pointing out the habitual viewing patterns of contemporary culture.—LH

Josef Sudek
(Czech, 1896–1976)
Born in the town of Kolin, Josef Sudek began his working life as an apprentice bookbinder. He lost his right arm while serving in the army and then turned to photography. He was a member of the Prague Club for Amateur Photographers from 1920 to 1924, and studied photography at the State School of Graphic Arts in Prague from 1922 to 1924. His early work was influenced by that of Clarence White, who espoused a Pictorialist approach to light and form. During the 1920s, Sudek created a series of photographs of disabled Czech soldiers; in 1927 he was one of the founding members of the renegade Czech Photographic Society, dedicated to documentary photography. His series of photographs of the renovation of St. Vitus's Cathedral, in which he juxtaposed architectural details of the cathedral with the abstract forms of workers' tools, won him the title of official photographer for the city of Prague in 1928. After his first solo exhibition, in 1933, Sudek's work was shown alongside that of László Moholy-Nagy, Man Ray, and Alexander Rodchenko at the city's International Photography Exhibition in 1936. Another twenty-five years passed before he received international acclaim for his tender scenes of Prague street life, still lifes, and views from his window. Solo exhibitions of his work have been held at the George Eastman House, ICP, and the Musée National d'Art Moderne in Paris.

With the exception of his military service in Italy and a brief trip through Italy and Belgium in the late 1920s, Sudek spent his entire life in Czechoslovakia, photographing Prague with intimacy and affection. He is perhaps best known for "The Windows of My Studio," a series created between 1940 and 1954. Greatly concerned with print quality, Sudek preferred to make large-format contact prints of his work and experimented with the demanding technique of pigment printing. —MF

Gerda Taro
(German, 1911–1937)
Gerda Taro was born in Stuttgart and educated in Leipzig. She left Germany for Paris in 1933 when Hitler became chancellor, and the next year, met Robert Capa. They became lovers, and as she promoted and captioned Capa's photographs, he taught her photographic technique. When the Spanish Civil War broke out in 1936, they covered it as a team on assignment for *Vu* magazine. Siding with the Popular Front, they concentrated on the activities of Loyalist troops attempting to defeat the Nationalist army. By 1937, Capa had become famous for his documentation of the war, and Taro had emerged as an independent photojournalist in her own right. She and Capa covered several aspects of the war that year together, including the plight of Spanish refugees in Almeria and Murcia. By the summer, Taro was confident enough to make photographic excursions alone. While covering the Republican offensive in Brunete in July 1937, she was crushed by a Loyalist tank in the confusion of retreat, and died several days later. Although Taro's photographs of the Spanish conflict have been overshadowed by those of Capa and other photographers, her pictures are effective portrayals of individuals at war. Their graphic simplicity and emotional power make her small body of work a memorable chronicle of a complex war. —LH

Val Telberg
(American, born in Russia, 1910–1995)
Val Telberg's career as a photographer followed several years of travel and a number of jobs that had little to do with photography. Born Vladimir Telberg-von-Teleheim in Russia, he immigrated with his family to China in 1918. Ten years later, he came to the United States on a scholarship to Wittenberg College in Ohio and graduated with a B.S. in chemistry in 1932. He returned to China, where he worked in book publishing, magazine editing, multilingual broadcasting, and pharmaceutical sales. This last profession brought him back to the United States in 1938, and he worked at a pharmaceutical company in New Jersey until 1941. In 1942 he began to study painting at the Art Students League in New York City; there he met Kathleen Lambing, who taught him photography and whom he married in 1944. His first professional photographic experience came that year, when he was employed as a nightclub photographer in Florida and later at a portrait concession in Fall River, Massachusetts. In 1948 he returned to New York and did freelance photography. In addition to his commercial endeavors, Telberg did his own work, much of which involved experimental printing from multiple negatives. His pioneering work in this method was exhibited as early as 1948, in a solo exhibition at the Brooklyn Museum of Art. He was included in "In and Out of Focus," Edward Steichen's first major curatorial project as head of the Museum of Modern Art's Department of Photography, and in many major exhibitions in the United States and abroad. Telberg was the first photographer to receive the Huntington Hartford Fellowship, in 1952. —LH

Tessaro Studio
(active mid–nineteenth century)
Little information is available about Tessaro Studio, presumably one of the numerous Italian firms that made and sold photographic prints of city views, and images of buildings, sculptures, and paintings. The photograph credited to Tessaro in ICP's collection reproduces a painting of a praying man by the fifteenth-century Netherlandish artist Dieric Bouts, the original of which is now in the Royal Museum in Antwerp. During the 1850s and after, companies such as Tessaro flourished; the more established among them, for instance Fratelli Alinari in Florence, published and distributed these reproductions widely. Such enterprises functioned much as today's stock photo agents, offering images of virtually all possible subjects—famous monuments and works of art as well as rarely seen artifacts.

These relatively inexpensive images were sold to travelers, artists, and other individuals as well as to art schools in Europe and abroad. As photographic technologies progressed through the nineteenth century, reproductive images improved in quality, accuracy, and availability. Their existence allowed scholars and students to examine and compare a broad range of works of with ease, thus revolutionizing the study of visual art, its history, and its practices.—CF

Ruth Thorne-Thomsen
(American, born in 1943)
Born in New York City, Ruth Thorne-Thomsen worked in a variety of artistic media and as a dancer before earning a BFA in photography from Columbia College in 1973 and an MFA in photography from the School of the Art Institute of Chicago in 1976. In 1978 she was a staff photographer at the *Chicago Sun-Times* and later taught photography at the University of Colorado. She produced a number of series, including "Expeditions," "Door," "Prima Materia," "Views from the Shoreline," "Messengers," "Songs of the Sea," "Journey," "Mythologies," and "Proverbs." Her work has been shown at the Art Institute of Chicago, the St. Louis Art Museum, and the Museum of Contemporary Art in Chicago, which mounted a retrospective exhibition of her work in 1993; she has received, among other awards, a Lifetime Achievement Award from Columbia College in Chicago and three National Endowment for the Arts grants.

Ruth Thorne-Thomsen is best known for her constructed landscape photographs made with a cigar-box pinhole camera. In these works, she sets cropped pictures and miniature props in real landscapes, exposes them onto paper negatives, and produces sepia-toned contact prints. The resulting images feature an infinite depth of field, freedom from linear distortion, a high level of contrast, and a soft grain. Because of her choice of subjects, the printing method, and the pinhole camera's rendering of sharply focused but ambiguously scaled subjects, her images recall both nineteenth-century calotype landscapes and the uncanny juxtapositions of Surrealist imagery from the 1920s and 1930s.—LH

George Tice
(American, born in 1938)
George Tice was born in Newark and grew up in an itinerant family who divided their time between traveling the country by automobile and trailer, and stopping periodically at their home in New Jersey. He became involved with camera clubs at age fourteen, studied commercial photography briefly at the Newark Vocational and Technical High School, and worked as a darkroom assistant before enlisting in the Navy, where he served as a photographer's mate. Museum of Modern Art curator Edward Steichen saw Tice's widely reproduced 1959 photograph of a fire aboard the USS Wasp and helped bring the young photographer to national prominence. After leaving the Navy, Tice worked as a home portrait photographer in West Orange, New Jersey, from 1960 to 1969. After a brief attempt at starting a photographic career in Hollywood, he returned to New Jersey. Since 1970, Tice has taught at the New School for Social Research in New York, and elsewhere. He is the author of eleven books, including *Paterson* (1972), *Urban Landscapes* (1975), and *Fields of Peace: A Pennsylvania German Album* (1970). Whether he is documenting the crumbling industrial architecture and deserted urban core of Paterson, silent street corners in Atlantic City, the crossed legs of a female model, or the rocky coasts of Maine, Tice's photography is exceptional for its controlled compositions and superb printing. He is a master printer and darkroom technician whose images are characterized by a flattening of space, skies with uniformly gray hues, and the abstraction of nature. —MF

John B. Trevor
(American, 1878–1956)
Born in Yonkers, New York, John B. Trevor was a prominent lawyer, a decorated veteran of World War I, and an amateur photographer who worked with the autochrome process. An outspoken critic of unrestricted immigration to the United States, he used his position and influence to advocate for a quota system limiting immigration. He was a frequent advisor to Congress, and served as counsel to the Senate Foreign Relations Committee. He also founded the American Coalition, a collection of patriotic societies opposed to fascism and communism. He served as vice-president of Paul Smith College of Arts and Sciences, and was a trustee of the American Museum of Natural History.

The autochrome technique, invented in 1904 and available in 1907, was the first commercially available color process, but each plate was unique, fragile, technically difficult to develop, and expensive; the use of autochromes was thus limited primarily to wealthy amateur and professional photographers. For a brief period in 1907, the autochrome became popular with Alfred Stieglitz and associates, who treated color as an element of artistic expressiveness, not just a tool for literal reproduction. Trevor was typical of amateur photographers working with the new color process, as he

documented activities in and around the home. His autochromes present an array of subjects, from rugs, lamps, and other possessions, to people and automobiles, landscapes and seascapes. Some of his images display a strong aesthetic sensibility, especially the portraits and floral still-lifes. The long exposure time of the autochrome necessarily caused Trevor's sitters to appear static. ICP's collection holds sixty-four autochromes by Trevor, which were donated soon after the founding of the institution. Some of these were shown in the permanent collection gallery in 1982 to complement a larger exhibition entitled "Autochromes: Color Photography Comes of Age."—JM

Shi-Ming Tsay
(Taiwanese, born c. 1930)
Shi-Ming Tsay (also transliterated as "Shiu-Min Tsay") was one of the most active and successful of the "first-generation" Taiwanese photographers. Tsay gained fame in Taiwan for his daring nude photographs of his wife, made during the 1960s. His print *The Duck March* was included in the last of the Photography in the Fine Arts exhibitions, organized by Ivan Dmitri in 1967. These popular exhibitions, which toured museums throughout the United States in two or three editions each, were intended to advance the appreciation of photography as fine art. Photographs were selected by a jury of museum directors and curators from a previously screened group of prints (often unidentified as to artist) obtained from various sources, including galleries, magazines, camera clubs, and advertising agencies. Through this process, works by international photographers little-known in the United States, as well as by amateurs, were often exhibited alongside those by leading American and European photographers—a sometimes controversial aspect of the PFA exhibitions.

Tsay's image of a flock of ducks seen from a high vantage point is a hybrid of abstract and representational concerns. Amid growing experimentation in color and technique in the 1960s, many photographers chose to focus on expanding the graphic and formal possibilities of the straight photograph. *The Duck March* can be seen not only as a lyrical descriptive of reality, but also as a dynamic abstract composition of rhythmic texture. —CF

Doris Ulmann
(American, 1882–1934)
Born in New York City, Doris Ulmann became interested in photography when training to become a teacher at the Ethical Culture School in her native New York City, while Lewis Hine was an instructor there. She took photography courses with Clarence H. White at Columbia University and continued to study with him at the Clarence H. White School of Photography between 1913 and 1917. In 1918, she decided to pursue a career in photography, devoting herself to studio portraiture. Her Pictorialist-inspired portraits were published in books, including *A Portrait Gallery of American Editors* (1925), and in journals such as *Pictorial Photography in America* and *Photo-*

Era. Around 1925, in the wake of increasing urbanization and modernization in the United States, Ulmann became interested in preserving rural traditions and folklore. She traveled extensively throughout southern Appalachia, as well as in Pennsylvania, Virginia, and New York, where she photographed Dunkard, Shaker, and Mennonite communities. She collaborated on several projects with her traveling partner, John Jacob Niles, who was working on a similar project involving American folk songs and musical traditions. Ulmann made the photographs for *Roll, Jordan, Roll* (1933), Julia Peterkin's novel that explored the folk life of African-American Gullah residents on Peterkin's Lang Syne Plantation in South Carolina. Ulmann continued to travel and photograph in the South until her death.

Doris Ulmann's photographs of people in the Appalachian regions of Virginia, Kentucky, Tennessee, Georgia, and South Carolina produced between 1927 and 1934 are her best-known works. Although often idealized views, her finely printed images have become invaluable documents of African-American and white southern folk life of the time. Not only are her images among the limited evidence of these traditions, but they mark an important shift in American photographic portraiture from Pictorialism to documentary.—LH

Roman Vishniac
(American, born in Russia, 1887–1990)
Roman Vishniac's work holds significance in the fields of documentary photography and scientific microphotography. His earliest endeavors were scientific; he received a Ph.D. in zoology and a doctorate of medicine from Moscow's Shanyavsky University in 1920, and then continued scientific research in Berlin, where he also studied Asian art and developed an interest in photography. As the Nazis rose to power, he made photographic excursions to Poland, Czechoslovakia, and many parts of Germany, in order to document the traditional way of life of Jews before the Nazis extinguished it. In 1935 he moved to France, where he was interned as a stateless person by the Vichy government before gaining passage abroad in 1940. Upon arrival in the United States, he worked as a portrait photographer and researched innovations in scientific microphotography in his spare time. In 1942 he sold to *Nature* magazine a series of photographs depicting the mating of the fly, and by 1950, he had stopped making portraits to devote himself full-time to freelance microphotography.

Microphotography was especially rewarding for Vishniac because it allowed him to combine his two passions—science and the photographic documentation of life. An expert microphotographer, as well as an inventor and pioneer in the field, he received worldwide recognition for his efforts; the American Society of Magazine Photographers praised him for "showing mankind the beauty of the world it cannot see." Later in his life, he was appointed to professorships at the Albert Einstein College of Medicine and Yeshiva University, and received grants from the National Science Foundation to pursue microcinematography.

Although his documentary work and his scientific photography may seem disparate, both demonstrate his interest in preserving various forms of life for the benefit of future generations.—LH

Wilhelm von Gloeden
(German, 1856–1931)
Baron Wilhelm von Gloeden was born near Wismar, on the Baltic Sea, and grew up in an affluent family. Poor health in his early twenties brought him to seek the warmer climate of Taormina, Sicily. From there he traveled often throughout Italy, and in Naples visited his cousin Wilhelm von Plüschow, a commercial photographer who taught him photographic techniques. Von Gloeden's interest in photography and the gift of a camera led him to pursue photography as a career in 1889. At first he sold postcards picturing landscapes, monuments, and people of Sicily but soon his nude studies of young men and boys of Taormina became his principal work and were avidly collected. Some of his portraits and scenes of Sicily were eventually published in *National Geographic*. After his death, Italy's fascist government destroyed or damaged many of von Gloeden's 3,000 glass-plate negatives, all of which were confiscated as pornographic material. By the time his negatives were returned to the caretakers of his work after World War II, only a few hundred remained intact; nonetheless, what survived was enthusiastically rediscovered in the late 1960s and early 1970s.

Von Gloeden's great success as a photographer of the male nude was in part due to his preference for setting his subjects in the theater of the antique. His suggestion of allegory, selection of classical sites, and use of artifacts aestheticized and thus softened the obvious and often charged eroticism of his images. His pictures are of interest today as celebrations of male sensuality and beauty in photographic art.
—CF

Jeff Wall
(Canadian, born in 1946)
Jeff Wall was born in Vancouver, and received an M.A. in fine art from the University of British Columbia in 1970. He then pursued doctoral research in art history at the Courtauld Institute in London before returning to Canada. He experimented with Pop Art, Minimalism, and Conceptual Art early in his artistic career, before developing his signature style, the use of the light box as an artistic medium, in 1977. With the success of *The Destroyed Room* (1978), his first work for the light box, it became his medium of choice, and it has remained so for most of his career. His subject matter has changed frequently, however: his early work addressed sociopolitical issues and feminist critical theory, while later concerns have included investigations of portraiture as an artistic genre and, more recently, narratives. He has varied his medium to include digitally manipulated images, and since 1995 has exhibited black-and-white and color photographs on paper in addition to light boxes. Wall has participated in many exhibitions, including Documenta VII in Kassel in 1982

and the 1995 Whitney Biennial, and has had solo exhibitions at the Art Gallery of Ontario in Toronto, the Museum of Contemporary Art in Chicago, and elsewhere.

Jeff Wall's photography constitutes an unusual hybrid of styles and techniques. His work is technically innovative in its employment of devices associated with cinematography, such as day-for-night shooting, which, combined with the strong narrative thrust of his photographs, brings his work very close to film. Wall's typically postmodern content incorporates allusions to art history and the mass media into seemingly realistic scenes to confuse any potentially documentary implications. The result is a heterogeneous body of work that admits its artificiality without sacrificing social significance and visual meaning.—LH

Weegee (Arthur Fellig)
(American, born in Austria, 1899–1968)
Weegee, born Usher Fellig in the town of Lemburg (now in Ukraine), first worked as a photographer at age fourteen, three years after his family immigrated to the United States, where his first name was changed to the more American-sounding "Arthur." Self-taught, he held many other photography-related jobs before gaining regular employment at a photography studio in lower Manhattan in 1918. This job led him to others at a variety of newspapers until, in 1935, he became a freelance news photographer. He centered his practice around police headquarters and in 1938 obtained permission to install a police radio in his car. This allowed him to take the first and most sensational photographs of news events and offer them for sale to publications such as New York's Herald-Tribune, Daily News, Post, Sun, and PM Weekly, among others. During the 1940s, Weegee's photographs appeared outside the mainstream press and met success there as well. New York's Photo League held an exhibition of his work in 1941, and the Museum of Modern Art began collecting his work and exhibited it in 1943. Weegee published his photographs in several books, including Naked City (1945), Weegee's People (1946), and Naked Hollywood (1953). After moving to Hollywood in 1947, he devoted most of his energy to making 16-millimeter films and photographs for his "Distortions" series, a project that resulted in experimental portraits of celebrities and political figures. He returned to New York in 1952 and lectured and wrote about photography until his death.

Weegee's photographic oeuvre is unusual in that it was successful in the popular media and respected by the fine-art community during his lifetime. His photographs' ability to navigate between these two realms comes from the strong emotional connection forged between the viewer and the characters in his photographs, as well as from Weegee's skill at choosing the most telling and significant moments of the events he photographed. ICP's retrospective exhibition of his work in 1998 attested to Weegee's continued popularity: his work is frequently recollected or represented in contemporary television, film, and other forms of popular entertainment.—LH

Dan Weiner
(American, 1919–1959)
Born in New York City, Dan Weiner studied painting at the Art Students League in 1937 and at Pratt Institute from 1939 to 1940. While at Pratt, he joined the Photo League, a group of photographers active from 1935 to 1947 who aimed to use photography to effect social change. Through the League he was exposed to the history of documentary photography and the work of Jacob Riis and Lewis Hine, and he became familiar with the photographs of Dorothea Lange, Walker Evans, Henri Cartier-Bresson, and Brassaï. In 1940 he taught at the Photo League and opened an advertising studio. During World War II, while in the U.S. Army Air Corps, he discovered the 35-millimeter camera. His experiments with small-format photography led him to close his studio in 1949 and dedicate himself full-time to photojournalism. Throughout the 1950s, with his wife, Sandra Weiner, also a photographer, he produced features for publications such as Collier's and Fortune. In 1956 he traveled to the Soviet Union, Romania, Czechoslovakia, and Poland to document life-styles of people there; he planned to publish a book of those journeys, but was killed in a plane crash while on assignment in 1959. Weiner's photography, along with that of Robert Capa, Werner Bischof, Chim (David Seymour), Leonard Freed, and André Kertész, was included in the 1967 exhibition "The Concerned Photographer" and formed part of ICP's original collection.

Weiner's photographs documenting the United States in the 1950s are known for their poignant demonstration of a society's fascination with business and consumption. His chronicle of the civil rights struggle in Montgomery, Alabama, is among the most effective records of those dramatic events. Weiner was able to describe his subjects plainly, without pretension, and to impart a sense of concern for the crucial social topics of his time.—LH

Sandra Weiner
(American, born in Poland in 1921)
Born in the town of Drohiczan Sandra Weiner immigrated with her parents to the United States in 1928. She met the photographer Dan Weiner in 1940 and took photography courses from him as well as from Paul Strand at the Photo League; she and Weiner were married in 1942. In 1947 she began working with her husband on his freelance assignments for Fortune, LIFE, Sports Illustrated, Harper's Bazaar, and other publications, and continued collaborating until his death in a plane crash in 1959. Sandra Weiner worked as a picture editor for Sports Illustrated afterward, and in the late 1960s wrote children's books, which she illustrated with her own photographs. The first, It's Wings That Make Birds Fly (1968), included an introduction by Gordon Parks; it was followed by Small Hands, Big Hands (1970), They Call Me Jack (1973), and I Want to Be a Fisherman (1977). Weiner taught photography at New York University and at the City University of New York. Her work has been exhibited at several New York galleries, the Akron Museum of Art, and the Port Washington, New York, Public Library.

Sandra Weiner is the author of many exceptional pictures constituting a distinctive body of work. Her acute perception of individual character, especially that of children, and her subtle rendering of neighborhood atmospheres make her documentary pictures of New York some of the most insightful works of their time and genre.—LH

Edward Weston
(American, 1886–1958)
Born in Highland Park, Illinois, Edward Weston received his first camera from his father in 1902; he attended the Illinois College of Photography from 1908 to 1911. From 1911 to 1922 he operated a portrait studio in Tropico, California. The Pictorialist style in which he was working earned him commercial and critical success, but by 1919 he had turned to abstract photographs based on body parts and employing unusual angles. On a trip to Ohio in 1922, he photographed the clean lines and abstract shapes of the Armco Steelworks, and when he met Alfred Stieglitz, Paul Strand, and Charles Sheeler in New York later that year, he gained their support when he showed them this Armco work. Weston subsequently abandoned his Pictorialist style and concentrated on precise studies of such forms as fruits, vegetables, shells, and rocks. In 1928, after a year managing a Mexico City studio with Tina Modotti, he returned to California and photographed the landscape at Point Lobos, incorporating his studies of natural forms. In 1932, he cofounded, along with six other photographers, the f/64 group, which required its members to use the large-format view camera, a small lens aperture, and contact printing in order to achieve precise detail and careful tonal variations. The landscape photographs that Weston created around this time followed the tenets of f/64 and are some of his most celebrated works. Weston received the first Guggenheim Fellowship awarded to a photographer, among many honors. The Museum of Modern Art held major retrospectives of his work in 1946 and 1975. His Daybooks, daily records of his life as a photographer, were published in the 1960s.

Edward Weston was instrumental in establishing an identity for the West Coast school of photography in the early years of modernism in America. His eloquent combination of expansive landscapes and other natural subject matter with precise technique created a prototype for the f/64 group's purist style. His legacy continues to this day in the work of contemporary photographers such as Emmet Gowin and Robert Adams.—LH

Clarence White
(American, 1871–1925)
An influential teacher and leading Pictorialist, Clarence White photographed intimate and idyllic studies of family and friends. He used natural light to create a rich atmosphere and a quiet domestic sensitivity that resist sentimentality. White was influenced by the paintings of John Singer Sargent, James Whistler, and the early Impressionists, as well as Art Nouveau and Japanese art.

Born in Newark, Ohio, White worked as bookkeeper in his father's grocery business as a young man. He took his first photographs on his honeymoon in 1893, and first exhibited work in 1896. In 1898 he founded the Newark Camera Club and met Gertrude Käsebier, F. Holland Day, and Alfred Stieglitz. White was elected an honorary member of the New York Camera Club in 1899, and had his work exhibited there, and he was named to England's Linked Ring Brotherhood in 1900. He was a founding member of the Photo-Secession in 1902, along with Stieglitz, Käsebier, Alvin Langdon Coburn, and others. He moved to New York in 1906 and exhibited at "291." The following year he taught the first photography courses offered at Columbia, and from 1908 to 1921 he taught at the Brooklyn Institute of Arts and Sciences. White's work was reproduced in Camera Work, and he participated in the International Exhibition of Pictorial Photography in Buffalo in 1910. He quarreled with Stieglitz in 1912, and soon established his own school; his students included Margaret Bourke-White, Dorothea Lange, Laura Gilpin, Ralph Steiner, and Paul Outerbridge. White cofounded the Pictorial Photographers of America in 1916 and organized its national exhibition two years later. He died while accompanying students in his summer school to Mexico City. Exhibitions of White's work have been held at the Museum of Modern Art, the Delaware Art Museum, and ICP. In 1996 the George Eastman House and the Detroit Institute of Arts presented an exhibition and publication entitled Pictorialism into Modernism: The Clarence H. White School of Photography, which explored White's legacy through his students' work.—LS

Minor White
(American, 1908–1976)
Minor White was born in Minneapolis, and received a B.S. degree in botany from the University of Minnesota in 1933. In 1937 he moved to Portland, Oregon, where he worked as a photographer for the Works Progress Administration and taught photography until he was drafted in 1942. Upon his military discharge, in 1945, he went to New York, where he studied art history and aesthetics with Meyer Schapiro. White met Beaumont and Nancy Newhall, the photography curators at the Museum of Modern Art, as well as Edward Weston, Paul Strand, and Alfred Stieglitz, whose concept of "equivalents" had a profound effect on White's thinking. In 1946 he accepted a teaching position in the California School of Fine Arts photography program, which was run by Ansel Adams. Adams and White became friends, and founded Aperture magazine with Dorothea Lange, the Newhalls, Barbara Morgan, and others in 1952. From 1953 to 1957, White worked with the Newhalls at the George Eastman House in Rochester. He taught photography at the Rochester Institute of Technology and the Massachusetts Institute of Technology, cofounded the Society for Photographic Education, and edited Aperture until 1970. White won a Guggenheim Fellowship in 1970. Exhibitions of his work have been

held at the San Francisco Museum of Modern Art, the George Eastman House, the Philadelphia Museum of Art, and the Princeton Art Museum. Among his publications are *Sequence 6* (1951), *Mirrors, Messages, Manifestations* (1969), and *Octave of Prayer* (1972).

Through his mystical approach to photography, Minor White has become one of the most influential photographers of the postwar era. His landscape photographs often create abstract images that disorient the viewer and penetrate beneath the surface of the subject. White developed sequences for these pictures that underscored the meditative possibilities of reading photographs as a means of spiritual self-knowledge—a practice that continues to inspire many contemporary photographers. —LH

Garry Winogrand
(American, 1928–1984)
Garry Winogrand was born in New York City and became interested in photography while serving in the military as a weather forecaster. He studied painting at City College (1947–1948) and at Columbia University (1948–1951), where he learned how to develop and print. In 1951 he studied photography with Alexey Brodovitch at the New School for Social Research. Afterward he worked commercially for photography agencies, freelanced for magazines, and also did personal work. Winogrand's photographs were exhibited widely during his lifetime, in Edward Steichen's "The Family of Man" at the Museum of Modern Art, "Towards a Social Landscape" at the George Eastman House, and "New Documents" at the Museum of Modern Art. He was often grouped with photographers such as Danny Lyon and Lee Friedlander as a documentarian of the "social landscape." Winogrand received three Guggenheim Fellowships, to produce "photographic studies of American life," to study "the effect of the media on events," and to photograph California. He taught photography at the School of Visual Arts and Cooper Union in New York, and the Art Institute of Chicago, among other institutions; and published seven books of photographs, including *The Animals* (1969), *Women Are Beautiful* (1975), and *Public Relations* (1977).

Garry Winogrand's photographs are sophisticated, chance observations of daily life that demonstrate his mastery of the 35-millimeter camera. He was fond of visual puns and tilted exposures; he photographed, he said, "to see what the world looks like in photographs." Although his approach was lighthearted, his formal acuity and absurdist appreciation for the visual world were serious innovations that reverberate in the work of many contemporary photographers.—LH

Neil Winokur
(American, born in 1945)
Neil Winokur was born in New York, and graduated from Hunter College in 1967 with a degree in math and physics. He began photographing with a borrowed camera, and in the early 1970s concentrated on black-and-white photographs of urban scenes. He left his job at the Strand bookstore to work in a photographer's studio, where he operated a large-format view camera and made black-and-white prints. Frustrated by the lack of time for his own work, however, he returned to the bookstore, where he is now in management. Winokur came to prominence in the 1980s with close-up color portraits of friends and acquaintances made with his view camera.

The early portraits employed a white background and gel-colored strobe lights, but in the interest of creating a more "unnatural" effect, he placed his subjects in front of brightly colored seamless backdrops, and positioned strobe lights fitted with color filters in front of and behind his subjects. Life-size images are Winokur's trademark, whether he is photographing a person, an object, or an animal. Expanding on the concept of portraiture in the late 1980s, he created "totems," or multiple-frame installations composed of his human portraits and singular photographs of objects chosen by the subject for their personal significance. Winokur's work was included in "The Photography of Invention: American Pictures of the 1980s," at the National Museum of American Art, as well as "The Pleasures and Terrors of Domestic Comfort" at the Museum of Modern Art. A monograph on his work, *Everyday Things: Photographs by Neil Winokur*, was published in 1994.

Winokur's photography belongs to the Pop Art tradition, with its elevation of the commonplace, and to the history of portraiture. He is interested in the idea of granting a moment of fame to each subject photographed as a way of recognizing our collective impermanence and mortality. His work questions what it means to be an icon, and asks viewers to consider the values they ascribe to themselves and their possessions. —MF

Marion Post Wolcott
(American, 1910–1990)
Marion Post Wolcott was born in Montclair, New Jersey, and educated at the New School for Social Research, New York University, and at the University of Vienna. Upon graduation in 1932, she returned to New York to pursue a career in photography and attended workshops with Ralph Steiner.

By 1936, she was a freelance photographer for *LIFE*, *Fortune*, and other magazines. She became a staff photographer for the Philadelphia *Evening Bulletin* in 1937 and remained there until Paul Strand recommended her to Roy Stryker at the Farm Security Administration, where she worked from 1938 to 1942. Wolcott suspended her photographic career thereafter in order to raise her family, but continued to photograph periodically as she traveled and taught, in Iran, Pakistan, Egypt, and New Mexico. In 1968 she returned to freelance photography in California and concentrated on color work, which she had been producing in the early 1940s. Wolcott's photographs have been included in group and solo exhibitions at the Museum of Modern Art, ICP, and elsewhere. Among other honors she has received are the Dorothea Lange Award and the 1991 Society of Photographic Education's Lifetime Achievement Award. The several books on her life and career include Paul Henrickson's *Looking for the Light: The Hidden Life of Marion Post Wolcott* (1992).

Wolcott's documentary photographs for the FSA are notable for their variation in subject matter. Because she joined the organization late in its existence, Stryker often gave her assignments intended to complete projects already begun by others. Wolcott's photographs show wealthy and middle-class subjects in addition to the poor people and migrant workers who appeared in most FSA photographs. Her body of work provides a view into another side of the 1930s in America, among that small percentage of people who could afford to escape the damaging effects of the Depression.—LH